PHOTOGRAPHY
1900 to the Present

Diana Emery Hulick

WITH

Joseph Marshall

Prentice Hall, Upper Saddle River, New Jersey 07458

Library of Congress Cataloging-in-Publication Data

Photography—1900 to the present / [compiled by] Diana Emery Hulick
 with Joseph Marshall.
 p. cm.
 Includes bibliographical references and index.
 ISBN 0-13-254095-9
 1. Photography—History—20th century. I. Hulick, Diana Emery.
 II. Marshall, Joseph

 TR15.P478 1998
 770'.9'0904—dc21
 97-13651
 CIP

Publisher: Bud Therien
Production Editor: Jean Lapidus
Prepress and Manufacturing Buyer: Bob Anderson
Copy Editor: Michele Lansing
Indexer: Richard Genova
Cover Design: Bruce Kenselaar

This book was set in 10.5/12.5 Times Roman by NK Graphics,
and was printed and bound by Courier Companies, Inc.
The cover was printed by Phoenix Color Corp.

© 1998 by Prentice-Hall, Inc.
Simon & Schuster/A Viacom Company
Upper Saddle River, New Jersey 07458

Printed in the United States of America
10 9 8 7 6 5 4 3 2 1

ISBN 0-13-254095-9

PRENTICE-HALL INTERNATIONAL (UK) LIMITED, *London*
PRENTICE-HALL OF AUSTRALIA PTY. LIMITED, *Sydney*
PRENTICE-HALL CANADA INC., *Toronto*
PRENTICE-HALL HISPANOAMERICANA, S.A., *Mexico*
PRENTICE-HALL OF INDIA PRIVATE LIMITED, *New Delhi*
PRENTICE-HALL OF JAPAN, INC., *Tokyo*
SIMON & SCHUSTER ASIA PTE. LTD., *Singapore*
EDITORA PRENTICE-HALL DO BRASIL, LTDA., *Rio de Janeiro*

This book is dedicated to all those ancestors both known and unknown who made it possible for me to be here and who taught me about perseverance, process, and craft, particularly Charles E. Hulick Jr., my father, Helen Hulick Beebe, my aunt, and Rolf Eliassen, my uncle, all of whom set the highest professional standards for my generation to follow. It is also dedicated to my mother, Suzanne Barbos Hulick and to my aunt Mary Hulick Eliassen, who both nurtured my interest in art. Finally, this book is dedicated to William Sebastian Heckscher, my mentor, who helped me with my prose and taught me that "reality is flexible."

Contents

2 The Period 1920–1940 53

3 The Period 1940–1960 125

4 The Period 1960–1980 175

5 The Period 1980–2000 244

Preface

To begin our journey into the history of twentieth-century photography, imagine the world without the camera. Try to conceive of a world with no movies, no videotapes or laser disks, no television, no family albums, no photographic advertisements in magazines, no photographs of people and places in the news, no giant pictures on billboards, in shopping malls, department, and discount stores, no Xerox copies, no library microfilm or microfiche, no high school yearbooks, no wedding pictures—millions of pages of books, magazines, and newspapers without a photograph in any of them.

That imaginary world without the camera would sharply divide our experience into two halves. First would be our immediate neighborhood, full of the things we could actually see—directly recognizing sizes, shapes, and colors. That visible world also would be full of relationships in space and time—above and below, left and right, before and behind, earlier and later, and now—all of which we could directly experience. At the most, our neighborhood would extend no more than about fifty miles in any direction from where we stood and would be visible in reasonable detail only about 100 feet around us. We could see nothing further than fifty miles but the sun, moon, and stars. Everything else in the world we would recognize only through reading and listening or through an artist's rendering. We would have no objective means of discerning the accuracy of any person's description of the world beyond our personal experience. We would have to trust another person's perceptions completely.

Today, because of the camera, we actually know what most of the planets look like, and, with the exception of our immediate neighborhood, photography *is* our world. Few facts in twentieth-century life have been more important. The history of photography is the history of our visual knowledge of the world. This knowledge has both a manifest form in the sum total of all of the pictures we view and a hidden dimension of people and processes that shaped what those pictures look like and why we

are able to see them. This book will deal with all of these factors and will summarize what they have meant for the rapidly vanishing century in which almost all of us were born.

You are probably reading this text as part of a college art history course. If so, you also are likely to be familiar with the three major components of art history: the names and biographies of artists, the technological timeline of changes in media and techniques, and the "museum without walls" of major artworks and art movements. The history of photography has all of these, which we will study. But there are other components to the history of photography that go beyond what the art historian typically studies about eras before our own. Photography is part of a general revolution in communications, whose roots extend back to the invention of the printing press, about 500 years ago. A moment ago we imagined the sharp boundary that would exist between our neighborhood and the world without photography. Broadly speaking, the communications revolution of the past half millennium has expanded our range of reading, writing, speaking, listening, and looking from the neighborhood to the world, and it has done so for virtually everyone in the world. The general name for the process of that revolution is "mechanical reproduction." This means that copies of books, newspapers, magazines, pictures, speech, and music are all made by machine, in large quantities, and widely distributed. Before the communications revolution, all of these things were rare and outrageously expensive, and some, such as magazines and newspapers, did not even exist. Today, all are common and cheap, and with the advent of digital technology our access to them is not only easy, it is almost instantaneous. All of these things have greatly influenced the history of photography, and they all will be examined in this text.

Millions of photographers have lived—and thousands of them have contributed significantly, in at least some small way, to photography's history. The notion of "major artists" and "major works" in photography is considerably more ambiguous than in painting, sculpture, or architecture. All histories of this kind must be selective if they are to be anything more than an encyclopedic list of names. One should understand, however, that the photographers discussed in this text were selected by Drs. Diana Hulick and Joseph Marshall, based upon their experience teaching the courses that are perhaps similar to the ones you are now taking. These selections were *not* the product of a universal consensus of some hidden panel of "experts." Not only does no such panel exist, such a consensus is virtually impossible given the sheer number of potentially significant photographers. We are perfectly aware that there are other worthy alternatives. Because we have written an art history book, not an encyclopedia or a directory, we *must* be selective.

In particular, the pictures were chosen according to the following criteria:

We first selected images that were described extensively in the edited writings. We then selected representative photographs by important photographers, when these photographs were *not* included in the other two major surveys of the field—Beaumont Newhall's *The History of Photography from 1839 to the Present* and Naomi Rosen-

blum's *A World History of Photography*. These photographs are also intended to broadly represent the photographer's work, in addition to being characteristic of the historical period. Finally, we chose pictures that we found visually arresting.

Pictures reproduced in surveys have a habit of becoming widely repeated through the literature in a field and frequently take on an importance of their own through their very reproduction. They often find their way into guide and survey collections, most likely images you will see in class.

For reasons of cost and space, this text is not a picture book. Yet, photographs exist not only in photographic books, but all around us. Instead, this book concentrates on the major ideas with which critics grapple. Both the pictures and articles present a paradigm or model for what certain visual statements look like and how they may be discussed.

Do not hesitate to look at the arguments that these critics and historians present, and apply them to the photographs that surround you, not only historically but on a daily basis. To the degree that you are responsible for your own education, you also are responsible for integrating and testing this new information about the medium of photography with your own experiences.

Your photographic experiences reflect the fact that this medium is embedded in a general communications culture of books, magazines, galleries, and museums. The history of photography is as much about how these institutions—and the people who control them—have responded to photographers as it is about who made what pictures when. Certain photographers are part of that process, and the story of photography must include them. For example, in this book you will shortly encounter Alfred Stieglitz. Stieglitz was not only a fine photographer, he was an innovative technician and craftsman, a major gallery director, and the publisher of one of the most important photography magazines, *Camera Work*. Stieglitz also was an advisor to Beaumont Newhall, the first permanent curator of photography at the Museum of Modern Art in New York City, as well as photography's first major historian. In short, the history of twentieth-century photography cannot be told without Stieglitz. It is the authors' conviction that the relationship of photography to the general communications culture is the most important process of that twentieth-century history. Our choices for both photographers and pictures in this book stem from that conviction.

Because photography has been an integral part of communications culture, its twentieth-century history also has been highly self-conscious. The story of photography is not just about pictures and artists. It also is about critical responses, both to pictures and artists. Such responses are best read in their original form. Therefore, in addition to our own historical narrative, this book includes edited excerpts from many major critical essays written by others about photography and its issues. It is our belief that one of the most important facts about twentieth-century photography has been the plurality of voices and attitudes that have contributed to its criticism. To this end, we sought authors who discussed artists and issues in general terms, whose writings illuminated issues beyond the immediate topics they addressed. We were particularly in-

terested in writers who could describe how a type of picture or cultural process worked. We were committed to having the reader understand what photographs are about, recognizing their larger meaning in our culture, and what decisions bring photographs into being, not simply what photographs *are*. These voices should be heard as much, if not more, as our historical summaries.

For example, at key points in the twentieth century, photographers Lewis Hine, Walker Evans, and Robert Frank each produced works that made incredibly compelling statements about the social conditions of American life. These pictures have stimulated a constant flow of critical writing, because the issues they raise are central to photography's relationship to the life we share. Hence, the history of twentieth-century photography cannot be told without them.

The important critical literature of photography is not as voluminous as is the number of compelling photographs or significant photographers, but it is still larger than what can be squeezed into a single textbook, more than one can reasonably be expected to be read in a one-semester survey. To provide the maximum exposure to different voices and major issues, we have condensed most of the contributions from other authors, concentrating on the main lines of their critical arguments and eliminating complicating digressions. The reader should be aware that in doing so we have had to sacrifice much material that is rich and interesting. If, as it is likely, you yourself wish to practice the art of photography, you would do well to regard our book as a sampler where you can get a taste of critics and ideas whose flavor you like, and thus plan further reading in more specialized seminars accordingly. If, on the other hand, your interest extends only as far as a general historical overview, we assure you that we have done our best to present the major critical issues that such an overview requires, in their simplest and clearest form.

The critical controversies of twentieth-century photography are still alive and kicking. Consequently, considerable disagreement will be evident among the critical voices we present, which has made assembling this book a pleasure, and we have done so with the belief that a controversial question is immensely more entertaining—and immensely more important—than a so-called "right answer" to a complex question. You also should remember that a book of this kind can only include brief samples of this much larger critical culture. It is our hope that you will find these independent voices satisfying enough for further reading on your own. Such independent reading is how one truly becomes engaged in photography and its history. Further, keep in mind as you are reading that the critical dialogue about an artist or a set of works is ongoing and not confined to the period in which the artist worked. We have carefully dated each of the articles we have excerpted, and careful attention should be paid to the fact that such criticism has its own historical development, which is not exactly the same as that of the pictures.

For example, although Walter Benjamin's "Art in the Age of Mechanical Reproduction" was published in 1937, an excerpt from this piece is included in the selection of writings from 1960 to 1980. We included it here because it is at this later time that

Benjamin influenced such critics as Susan Sontag. We would have liked to include Susan Sontag and a number of other critics and photographers, but some artists and authors were not available for inclusion or their work did not address the issues as we present them. In certain cases, artists or their representatives requested editorial control over what we wrote about their work, or the layout of their images. In other cases, we could not come to satisfactory agreements concerning reproduction. For example, we were unable to reproduce a Diane Arbus photograph because the publisher could not reach an agreement with the estate that the publisher found equitable and legally sound. Availability influences the contents of this textbook as well. As these examples show, a textbook is subject to many influences beyond the authors' original ideas. So too the critics we have not excerpted and the photographs we did not reproduce (like those of critics and photographers we did select), have shaped our perceptions of photography's past as well as its future.

We also wish to provide a feeling for the style and approaches various critics have used. Works that review the writings at the time the photographs were made will have a different sensibility than works that were written about a period well after it transpired. This differing vantage point reveals how history evolves, and how critics refer to each other and to the same photographs over a period of years and within different contexts.

Consider the fact that one of the liveliest and most controversial sets of issues in all of the arts of the late twentieth century are gender and culture. We are all in the middle of ongoing controversies about how these issues relate to the lives of artists, and what the depiction of gender and culture means in artwork. In this, as in so many things, the story of photography reflects the late twentieth-century world. The four photographers previously mentioned were men of European background, whose pictures reflect relatively narrow segments of American life. The story of twentieth-century photography cannot be told without them. But there are many more things contained in that story than they or their work represents. So, where we have a choice among several photographers to illustrate broad trends in our historical narrative, we have deliberately chosen individuals such as Gertrude Kasebier, James Van Der Zee, Margaret Bourke-White, Diane Arbus, or Carrie Mae Weems, all of whose work enters into this most lively set of issues in contemporary art and life.

Having made these choices, however, we must be candid about some of the difficulties they present. First, despite late twentieth-century attempts to write a "world history of photography," the fact remains that photography has had a much more extensive and coherent history in America in the twentieth century and has had a much more central impact on the general culture of the United States than it has had elsewhere. Even when the rest of the world adopted new forms of twentieth-century photographic culture, it generally has followed the American historical lead in doing so. To take an immediate example, world television is still largely dominated by American commercial forms, such as the anchored news broadcast, with its quick film clips, its behind-the-announcer graphics, and its talking heads. Hence, in the later twentieth

century there are far fewer figures outside of America to discuss in this book, such as Eugene Atget in France or Bill Brandt in Britain. Second, the centrality of women photographers or photographers of color to the general photographic history has largely been a latter twentieth-century phenomenon: a figure such as Barbara Kruger is as central to understanding the last twenty years as Lewis Hine and Alfred Stieglitz are to the century's first twenty years, but this has become commonplace only as the climate of tolerance for cultural diversity in the arts has improved. Third, in the critical writing on photography there still exists a certain "old master" or "blue chip artwork" sensibility. Writings directly engaging the critical significance of women photographers or photographers of color in the history of photography still are relatively scarce and recent, though biographical writings about them have become much more common. One of this text's authors, Dr. Diana Hulick, has spent much of her career writing critical articles about such photographers. Both of this text's authors are practicing photographers as well as photographic historians. We are part of the photography culture of which we write.

As a result, we have observed the growing diversity of the college population and the unflagging desire of all students to know more about women photographers and photographers of color. Thus we feature this significant segment in this book. More importantly, to encourage a future generation of potential critics and scholars to range more widely in their writing, at the end of each chapter in this book a list of photographers, which time and space did not permit us to discuss is provided. We highlight those on the list whose work is of specific interest to anyone who wishes to examine the issues of cultural diversity.

The critical response to pictures changes over time, and the debates of the present constantly alter our views of the past, so the potential for fruitful historical controversy is never exhausted. Such controversy is one of the major reasons why photography is worthy of study at all. This has shaped the book we have written into a novel form. We have chosen to divide the history of twentieth-century photography into five twenty-year periods: 1900–1920, 1920–1940, 1940–1960, 1960–1980, and 1980–2000. These segments correspond much more closely to the major changes in world social history than they do to the art historical model in other media of art "movements": Futurism, Cubism, Surrealism, and so forth. Specifically, the chapter breaks correspond roughly to World War I, World War II, the emergence of an independent "third world" of former European colonies, and a major shift toward political and economic conservatism in Europe and the United States, combined with the growing economic power in the countries of the Pacific Rim.

Photography is both a "mass medium" of popular culture and an "art medium" of museum culture, and its twentieth-century history has been largely shaped by the interaction of the mass medium with the art medium. The historical currents in the mass medium of photography have followed world social history and technological change much more closely than they have followed any "movements" in other media. Those same currents also have had the most powerful influence on the history of photography

as a whole. To restate, photography *is* our world, and we treat the history of photography from that vantage point.

In other words, we are in open disagreement with the view that only the "art medium" and the museum culture of photography are of any real significance, or the view that the "mass medium" and the popular culture of photography is in some way secondary and subordinate to the "art medium." In this we have been influenced by those critics we have included here, who stress the link between photography and the social life that surrounds it. We are convinced that claims of historical neutrality about this issue are simply false, and we do not make any. The reader should be aware that our vantage point makes a genuine difference in what we have written and organized. When the popular culture of photography is ignored or slighted, a different kind of history book than ours results. The inclusion of criticism in a book of this kind is an invitation to read critically and to not accept our vantage point at face value.

The interaction of the museum culture of photography with its popular culture in the context of an ongoing communications revolution presents the writer with an art history of photography that has some unique problems. It is predominantly a history of events rather than one of artifacts and individual artists. These events include major technical changes in photographic equipment and processes, the establishment of galleries, the initial publications of magazines, the commitment of major museums to collecting photographs, the commitment of serious periodicals to reviewing photographs, the addition of photography to college curricula, the discovery of unheralded photographers, and, most important of all, the creation of significant and influential exhibitions and photography books. This makes for a much more complicated story than the typical art historical survey of general trends, major artists, and key monuments. Consequently, we have included a detailed timeline of many of these significant events.

Finally, we have some specific recommendations about how to use this book. The major problem we encountered when teaching the history of photography was how to communicate its genuine complexity without creating confusion.

As you can see, this book is modular in structure. If, as we hope, it becomes a useful and widely-used text, it will undergo revisions as new information becomes available. The different sections of the book—the preface, edited articles, timeline, history of photographers, and bibliography can be changed without the inevitable dilution of focus that often accompanies revisions in a more conveniently crafted text. As the sections now stand, they also may be construed as differing ways of structuring material about the twentieth century.

To use this book effectively, one should first read the historical summary at the beginning of each chapter, which outlines the major historical issues of the chapter and presents photographers whose life and work typify these issues. When these issues have been clearly grasped, proceed to the timeline of significant events. Try to understand how the chronological sequence of events interacts with the historical development of the major issues.

Notice the correlation of events in each twenty-year period. These twenty-year

divisions are not exact; there are instances in which precipitating events occur *before* a period as well as *during* one. The general trends of these periods also will overlap.

If a particular critic discussed in the excerpts sections seems difficult to understand, ask how he or she relates to the issues outlined in each period's introduction and in each section's heading. When these various views and controversies have been grasped, proceed to the list of photographers, which provides an opportunity for further study.

Since much material written about individual photographers is monographic (about that individual) and often occurs in periodicals as well as in books, information about these photographers can be accessed in a library and computer network through names and dates alone.

The bibliography included at the end of this book is therefore not intended to reflect the books the authors have read on the subject, nor is it intended to supplant the careful study of individual photographers. Rather, it is intended to provide the reader with a list of general works in several categories, for guidance in a variety of issues. Like the text, it presents an overview.

About a quarter century has passed since the authors first encountered photography as a field of serious study. We continue to find the medium fascinating, full of lively issues and colorful characters, and central to understanding our knowledge of the world, as well as a way to gain knowledge about the world. We welcome you to this world and hope your encounter with photography will prove both informative and enjoyable. Best of luck.

ACKNOWLEDGMENTS

We would like to acknowledge the following individuals for their help: Darcy Alexander, The Museum of Modern Art, for locating photographers; Joseph Young and Patricia Perigo for help with the final paperwork; and Heather Seneff, Barbara Lucero Sand, Rikke Cox, Joelle Minor, Aimee Linhoff, and Julie Sasse for their work with dates, artists, and events and their questions about the text. Thanks also to Pamela Quick of the M. I. T. Press for her helpful advice, and to Peter C. Bunnell, Arnold Gassan and Van Deren Coke for information about photographic education. Lloyd Morgan's encouragement and help was also appreciated.

Reasonable effort has been made to trace the ownership of all copyrighted material included in this volume. Any omissions or errors that have occurred are inadvertent and will be corrected in subsequent editions, provided notification is sent to the publisher and to the author, in written form.

Diana Emery Hulick

Joseph Marshall

1

The Period 1900–1920

Topics Addressed

The Development of the Mass Amateur Market • Being Modern and the Notion of Quality: a Photo-Seccession from Mediocrity • The Arts and Crafts Movement and its Relation to Camera Work and Gallery 291 • Symbolist Synthesis of the Arts, All Art Tends to the Condition of Music • Photography and the Power of Fact: Lewis Hine and the Ethical Culture School • Being Modern and the Notion of Truth to Media: "Purism" or "Straight" Photography.

OVERVIEW OF THE PERIOD 1900–1920

Our examination of the first two decades of twentieth-century photography may conveniently begin with three Americans—George Eastman, Alfred Stieglitz, and Lewis Hine. Literally speaking, all three men were photographers, and two of them, Stieglitz and Hine, have become justly famous for the power of their photographs. But, in a curious way, their importance in the history of twentieth-century photography stands slightly to one side of their achievements as photographers. Each had great personal impact on the history of photography, and together their careers embody virtually all of the major issues which dominate that history: the development of easy-to-use photographic equipment and processes, the synthesis and hierarchy of the arts, and the development of the "straight" as well the documentary photograph. Moreover, the impact that they made was directly connected to the fact that they were Americans living at the dawn of the new century, when America's place in the world was unique.

To understand why three American men could be so pivotal to an entire century's history of a medium practiced by so many, we must briefly examine the world as it

stood in 1901, the first official year of the new century. Politically, the world was neatly divided into three parts: Europe, the United States, and the rest of the globe, which was effectively, if not absolutely, under the sway of European colonization, military force, and trade. Economically, the world was dominated by technological innovation and industrial capitalism, both of which were concentrated in Western Europe and the United States. The enormous profits of world trade rebounded to the advantage of all in Western Europe and the United States, making each places of opportunity and potential luxury, where a meteoric rise from humble origins to great wealth was possible. But by far the largest percentage of those European and American profits was confined to a small group of enormously wealthy people. Unthinkable wealth existed side by side with both grinding poverty and a relatively large middle class of wage earners and professionals who were the cogs in the societal machinery of these industrial countries. Finally, in Europe, the wealthy were commingled with a political and cultural elite, culminating in a highly interbred set of royal families who were the European heads of state. The culture of this aristocratic and bourgeois group dominated the world.

Throughout the rest of the world, the political and cultural hegemony of Europe would drive many peoples and countries to "westernize" in imitation of European models. Even the United States, whose independent cultural development had been inhibited by the immensely destructive American Civil War of 1861 to 1865, largely looked to Europe for its standards of culture. But the position of the United States was unique in that the only real way in which Europe dominated there was through culture. Indeed, by 1901, the United States was the first formerly colonial nation and the first nation on the planet to have reached economic and industrial parity with the dominant European economic powers of Great Britain, France, and Germany. Moreover, the law, tradition, and popular feeling in the United States were all decidedly hostile to the hereditary aristocracy that was the historical basis for the European synthesis of great wealth, political power, and high culture. This European synthesis reached its pinnacle of world power and influence as the new century emerged.

Returning to our three Americans, let us first consider George Eastman. Eastman was one of those fabulous success stories of industrialism, a man who made an unthinkable fortune because he had a "better idea." After his death in the early 1930s, his estate was valued at $20 million, a fabulous sum for the period, and, more than sixty years later, his business, the Eastman Kodak Company, is still a dominant force in the worldwide industry of photography. Here we can identify the first major issue of twentieth-century photography. The fact that photography itself was a technological miracle that blossomed into a worldwide industry is representative of the larger history of the world. It also is central to understanding the camera's overwhelming influence on the twentieth century.

A new technology does not automatically create its own market. The invention of photography was first announced in 1839. It prospered in the nineteenth century because a vast number of people were persuaded to pay money for pictures. As the article by Reese Jenkins, later in this section points out, what Eastman, as a fledgling

businessman in the mid 1880s, could count on, was a public that wanted to own photographs and was willing to subsidize the professionals and processes that made them. Large industries had emerged to supply this demand. Of particular importance was the immense turn-of-the-century trade in stereographic cards, which subsidized hordes of globe-trotting professional photographers.

The stereo card was an earlier paradigm of the interaction between invention, industry, enterprise, and consumption that built mass-market photography. By 1849, Scottish scientist David Brewster had developed an early stereo viewer. By 1856, a camera with two lenses set the same distance apart as the two human eyes, was designed by John Benjamin Dancer. This machine constituted stereography's hardware. The stereo card itself was what we would call the "software." The two pictures from the camera were pasted on a small and convenient standard-sized cardboard. The stereoscope magnified the pictures and allowed the left eye to see only the left picture and the right eye to see only the right picture. A person with normal depth perception would thus see the card as a single, larger, truly three-dimensional photograph. The cheap manufacture of stereoscopes allowed a wide range of consumers to purchase stereo viewers. The high-quality manufacture of the very small and convenient camera allowed thousands of entrepreneurs both to shoot and market equally cheap stereo cards around the world. The creation and marketing of these cards quickly became an interconnected industry based upon mass production, cheap consumption, and volume distribution. Because of the stereoscope and the stereo card, for the first time in human history, millions of consumers in Europe, its empires, and the United States were able to truly "see the world." Along with portraiture, these views created most of the global picture culture and the consumer craving behind it, which helped to make possible the twentieth-century photographic picture press of illustrated newspapers and magazines.

Eastman's better idea went further than marketing professional photography. He reasoned that consumers of this picture culture would pay to be some of its producers if photography was made simple enough and cheap enough so they could shoot their own pictures. Eastman made one technological breakthrough on his own, inventing the flexible photographic film that eventually replaced glass negatives, a version of which we still use today. In 1888, he combined his film with another innovation of his day, the simple hand-held box camera, essentially a derivation of the small stereo camera, with only one lens. Finally, Eastman organized his company to both market the camera and process and print the pictures for the consumer, under the telling slogan, "You press the button, we do the rest." Thus he created a worldwide mass market of amateur "snapshot" photography. The snapshot made us all participants in photographic culture, as well as observers. It gave everyone speaking knowledge of photography's universal language, instead of the passive reading knowledge to which most people were confined during photography's first fifty years.

The importance of the amateur photographic market in twentieth-century photography extends even further. During this century camera images have become easier to make, cheaper to distribute, and more ubiquitous and important in our lives than

even George Eastman could have dreamed. This has occurred because of a steady progress of technical innovation that has created cameras that are smaller and more controllable, photographic materials that are more sensitive to light and true color, mass market printed reproduction, projected motion pictures with sound, and, finally, electronic and digital images. When we occasionally encounter nineteenth-century photographs, we can easily see that these changes, taken together, have made the twentieth-century photograph a different kind of picture in a radically different world. All of this innovation depends on the vast amateur market for economic support and on an organized industry of amateur photography as a technological base. George Eastman created that market and industry by taking amateur photography more seriously than many of his peers.

Taking photography more seriously is the attitude that has made America and Americans so prominent in its twentieth-century history. But taking it more seriously has meant different things to different people. To Alfred Stieglitz, it meant "art." And "art" meant a degree of personal excellence and a high culture philosophically opposed to industry and to the mass market, a culture based in the aristocratic traditions of Europe. Stieglitz was born in 1864, in Hoboken, New Jersey, during the American Civil War. The cultural roots of his life work and attitude are found in that war and in the American "Gilded Age" that followed. The Civil War destroyed the two major cultures of early nineteenth-century America, one directly, the other indirectly. These were the aristocratic slavery and plantation culture of the American South and the college-bred puritan culture of New England. The southern culture was largely a rural culture and New England's largely a culture of trading and industrial cities and college towns. Both presupposed the dominance in American life of the British cultural past as a common ground for all free men.

The American South was physically decimated by war and economically strangled by reconstruction. Like the South, the Northeast and the Midwest were also psychologically destroyed by the heavy loss of life. The years that followed saw an immense explosion of industrial activity, migrating populations, overnight fortunes, and societal violence throughout America. Both the newly freed African Americans and the newly arrived immigrants from China, Southern Europe, and Eastern Europe placed unprecedented strains on the unity of American culture, challenges with which we are still coming to terms. These peoples collectively made up a large proportion of the impoverished and exploited labor that had turned America into both a world agricultural and industrial power by 1901.

The year 1901 is the approximate center of a period between 1860 and 1940 when Americans interested in creating art or writing literature would often settle permanently in Europe, to avoid the raw antagonism between culture and commerce in United States. Some of the most famous among them were the painter James MacNeil Whistler; the novelist Henry James; the poets T. S. Eliot, H. D. (Hilda Dolittle), and Ezra Pound; the woman of letters Gertrude Stein, and the novelists Ernest Hemingway and Henry Miller. The year 1901 also is the center of the period when the "new money"

in the hands of the recently rich was occupied with transporting the high cultural forms of Europe wholesale into American cities: the opera, the art museum, the educational art institute, the rare manuscript library, and the symphony orchestra. It was largely this money spent in these years that brought to the United States its present rich holdings in the art of Europe, Asia, and the Middle East.

The life and work of Alfred Stieglitz was part of this process. Stieglitz's father, a German Jewish immigrant and a Civil War veteran, was a highly successful New York dry goods merchant. Despite the economic uncertainties of America, Stieglitz managed to live his entire life, except for one brief foray into the engraving business, off of family investments, as a frugal *rentier,* engaged constantly in various pursuits in the arts. He took up photography in 1883 while in engineering college at the Berlin Polytechnic in Germany and studied with the greatest photographic chemist of the day, Herman Wilhelm Vogel. Vogel was responsible for the basic research that allowed photographic materials to be made sensitive to all colors of light. Photography catalyzed a latent but incredibly deep strain of emotion in the nineteen-year-old Stieglitz, and he quickly became involved in its European artistic circles of magazines, contests, exhibitions, and prizes. Stieglitz eventually won 150 such prizes, and, in a mere five years, he had already become much in demand as a contest judge, despite his youth. He also became known for his determination to explore and expand the medium's technical limits, demonstrating at the Berlin Jubilee Exhibition of 1888, for example, that a completely finished print could be produced from a picture exposed less than forty minutes previously, an extraordinary technical feat in the days of much clumsier processes. Later, Stieglitz would be among the first to explore the creative potential of the new, high-quality, single lens reflex hand camera, the Graflex, and the first widely used process of full color photography, the Lumière Autochrome transparency, marketed in 1907.

Stieglitz also made use of a generous parental allowance to experience the cultural delights of a major European city. He sampled everything from street cafés, to theater, to opera, to billiards, becoming in the process the German amateur champion in the latter. His abrupt return, in 1890, to a New York City virtually bereft of such amenities was extremely traumatic. The constant noise and squalor of the ballooning center of American commerce, and a life of business conducted American-style—with price and speed meaning everything and quality and care meaning nothing—in the middle of one of the world's worst slums on New York's Lower East Side, left Stieglitz indelibly convinced of the opposition of commerce to culture. After five years, and an arranged marriage to the sister of his business partners, a young woman of independent means, Stieglitz shed himself of commerce and devoted his life exclusively to culture.

The opposition of commerce to culture is a dominant theme in the arts of the later nineteenth and early twentieth centuries, and the search for the means to reintegrate them is one of the major artistic concerns of the same period. The problem can be very simply stated. Up until the last two centuries, the products of the "fine" arts of painting, sculpture, and architecture were produced under the same general conditions—

those of slow and careful handcraft—as objects of ordinary use. Consequently, both "fine art" and "utilitarian craft" often shared the same values of aesthetic beauty and physical durability. Broadly speaking, in Europe, the "art" was often (though not always) more sophisticated, worldly, and urban, while the "crafts" were simpler and more rustic—but between the two there was a strong family resemblance. With the industrial and technological revolutions of the nineteenth century, it gradually became possible to produce most utilitarian objects cheaply, quickly, and in large quantity through factory labor. Photography itself was part of those revolutionary technological processes. This technology led to the spread of large capitalist enterprises to produce such objects in enormous volume. It also led to the consequent deterioration of profits from intense competition, and the erosion—through cost-cutting—of both the aesthetic quality and the durability of utilitarian wares.

Since about 1860, artists and critics have held one of two broad attitudes toward this problem. One camp posited an absolute philosophical separation between art and life. It viewed art as a realm of transcendent beauty with no essential connection to use, profit, or ethics. At the beginning of the twentieth-century, this position was known as "art for art's sake." The other camp pointed toward the practical unity of art with craft in the pre-industrial past and sought ways to restore that unity in an "arts and crafts" movement that would beautify ordinary life. Both attitudes have persisted throughout the twentieth century, though the philosophical ideas that surround them have undergone many changes.

Most important for our story is the fact that Stieglitz, the dominant figure of American twentieth-century "art photography," was an unwavering member of the "art for art's sake" camp, and this has been the essential attitude of most American art photography ever since. The two most important and permanent components of that attitude have been, first, that a photograph should be *personal;* it should reflect the experience and attitude of the photographer; second, that a photograph should be *beautiful;* it should, on some level, be an emotionally satisfying thing for the viewer to look at. The changes and the quarrels of American art photography in the twentieth century have centered around the constant ambiguity of what is really meant by "personal expression" and "beauty." Some sense of where art photography stood on these issues just after the turn of the century can be gained by reading the articles by Charles Caffin and Sadakichi Hartmann that have been excerpted.

In the last decade of the nineteenth century, Stieglitz busied himself with involvement in American organizations such as the Society of Amateur Photographers and the New York Camera Club, and with editing their magazines *American Amateur Photographer* and *Camera Notes.* Stieglitz considerably improved the quality of both, but his intransigent insistence on a high standard of artistic exclusiveness, in the manner of the British photographic organization the Linked Ring, of which he was also a member, was the cause of constant friction, leading to his resignation from the organizations and the magazines. So, in the opening years of the new century, in 1902, Stieglitz founded a new organization of like-minded photographers, the Photo-

Secession. In 1905, he also opened the "Little Galleries of the Photo-Secession" at 291 Fifth Avenue in New York. Finally, from 1903 to 1917, he published his own magazine, *Camera Work*. With these three acts, Stieglitz established the extremely durable tradition of twentieth-century American art photography. Virtually all threads of that tradition trace back to Stieglitz and his three institutions.

The aforementioned historical continuity has been somewhat obscured by the fact that notions of "expression" and "beauty" in art photography have changed considerably throughout the century. The art photography of the early part of the century often *looks* quite different from what came later. To understand why, we must examine more closely the ideas of "expression" and "beauty" as they appeared to the artist, or to the cultivated viewer, of 1901. Behind such notions were two implied assumptions: the "synthesis of the arts" and the "hierarchy of the arts." In other words, all art media, such as painting and sculpture, were assumed to be related to one another and this underlying relation was viewed as more important than the distinctions between individual media. This assumption encouraged a great deal of what we would today call mixed-media photography or photography using more than one photographic process, particularly by certain members of the Photo-Secession. Moreover, it was assumed that the basis connecting media was the attempt to impose aesthetic form on recalcitrant content. Consequently, in this view, the highest and most perfect art form was music, which is a nearly contentless and an almost exclusively aesthetic form. The "beauty" of work in all other forms was judged by the closeness of its approximation to the effects of instrumental music. As a result, the first major quarrel in American art photography would involve the gradual rejection of attempts at artistic synthesis, and of mixed-media, in favor of an unmanipulated or "straight" camera image.

The Photo-Secession was composed of a majority of the best American "art photographers" of its day. *Camera Work* and the "Little Galleries" provided exposure to both their work and to important art photographers of Europe. The "Little Galleries" (whose name was soon shortened to "291") also inaugurated in America the twentieth-century exhibition standard of pictures hung on plain walls in a single line. And *Camera Work* was the world's best-printed, and most eclectic, arts quarterly journal of the century's first two decades. Behind these overt successes of Stieglitz and his close co-workers Edward Steichen and Joseph T. Keiley were several important attitudes and practices, some of which can be traced to the notion of "art for art's sake" and others to the "arts and crafts" movement. *Camera Work,* in particular, was an amalgam of the artistic exclusiveness of Stieglitz and the attitude of Steichen, who drove a trade as a society portrait photographer and was also a practicing painter. Consequently, Steichen was much more receptive than Stieglitz to the possibility of an arts and crafts synthesis between commerce and culture.

First and foremost of these attitudes that *Camera Work* embodied was the "fight for photography as art," which, practically, consisted of linking the camera image to similar modes of representation in the graphic arts, most particularly the "etching revival" of the late nineteenth century and the work of its most famous exponent, the

American artist James MacNeil Whistler. The Photo-Secessionists borrowed both the overt Whistlerian attitude of "art for art's sake" and the standard of "beauty" in Whistler's late painting practice. This beauty was an overall atmospheric tonality, combined with an indefiniteness of pictorial detail, which was explicitly "musical" both in its technique and in its effect. Photographically, this indefiniteness and atmosphere was achieved in one of two ways. First, many related photographic printing processes were available, which consisted of colored pigment, suspended in a soft, light-sensitive binder—such as gum arabic combined with potassium dichromate. Processes sharing these characteristics were variously named gum bichromate, bromoil, carbro, and carbon transfer. They permitted the photographer to work the final image by hand, as in the other graphic arts, by using hot water and a stiff brush to obscure or reduce lens-rendered detail and create nonphotographic forms. These processes also could be directly printed on top of the less flexible metal-salt printing processes—such as silver, platinum, palladium, or the iron salt process cyanotype—mixing media for even subtler atmospheric effects. Steichen was the acknowledged master of these subtle combinations, and other photographers, such as Robert Demachy, also achieved significant work in these graphic arts hybrids.

While the distinctions among the art photographers of the early twentieth century were by no means hard and fast, photographers such as Stieglitz, Clarence White Sr., the American expatriate in England, Alvin Langdon Coburn, and the Englishman Fredrick Evans continued to rely heavily upon the high degree of informational detail in the lens image. Consequently, they were generally described as "pure" or "straight" photographers. But they, too, were under the sway of the Whistlerian aesthetic. The straight photographers used inclement weather, unusual conditions of natural light, camera lenses that were deliberately made to be slightly soft in focus, or their skill in light placement and value massing to achieve a similarly evocative sense of atmosphere. For printing, these photographers favored either the metal-salt processes, particularly platinum, or the continuous tone ink process of photogravure. Indeed, Stieglitz, who supervised the printing of *Camera Work,* brought all of his considerable skill as a former commercial printer to the making of gravure illustrations for the magazine that were effectively, if not literally, original photographic prints, and have been collected and displayed as such by major museums ever since.

The "fight for photography as an art" was also, as our timeline suggests, an international effort to place photographic exhibitions in prestigious venues such as museums, art institutes, national art galleries, universal expositions in major European capitals, and so forth. Stieglitz, because of his unstinting efforts and his beautiful magazine, was at the forefront of this process, but he was not alone. Similar and significant achievements were the product of the British Linked Ring, the Photo-Club of Paris, and other efforts in Germany and Austro-Hungary. The aesthetic attitudes surrounding artistic photography were also international and widely shared. In the process, photography itself attracted the critical attention of such distinguished individuals as the Anglo-Irish playwright and music critic George Bernard Shaw. But the vigor of

the new American presence in art photography, represented at its best by the Photo-Secession, was central to this trans-Atlantic effort. And the closeness in sensibility of the art photography of Europe and America would be shattered, as was so much else in Europe by World War I.

Stieglitz's craftsmanship in *Camera Work,* and Steichen's involvement with the compelling and overwhelmingly "tasteful" design of both the magazine and the 291 gallery, are representative of the contribution of the "arts and crafts" sensibility to what became known more generally as "pictorial" photography. The photographers of the Photo-Secession, and their later followers, went to great efforts to achieve an apt and decorative presentation of their pictures on the walls of galleries and in private homes. The "tastefulness" of this work was also Whistlerian and strongly influenced by the steadily growing contact of Europe and America with Japan, particularly Japanese prints. These prints confronted the artist in the West with a contrasting set of aesthetic standards to those of late nineteenth-century Europe, standards based on simplicity, suggestiveness, strong aesthetic respect for organic material and plant forms, and an overall harmony of design. Japanese art also confronted the Western artist with a radically different set of boundaries for "fine" compared to "applied" art, the most prominent of these being the Japanese veneration of both calligraphy and ceramics as major art forms. As the article by Sadakichi Hartmann, which we have included, suggests, an "arts and crafts" revolution in interior decoration, with a strong flavor of *Japonisme,* was implicit in the work of the Photo-Secession, which is one of the major reasons why this work still retains considerable aesthetic appeal.

Finally, the "art for art's sake" attitude that Stieglitz brought to the enterprise of art photography had major ramifications far beyond photography itself. Stieglitz deliberately conceived the Photo-Secession as an "avant garde" movement opposed to a conservative photographic establishment, and the name was suggested to him by his awareness of a similar art movements in Austro-Hungary and Germany, known as the Vienna Secession and the Berlin Secession, respectively. He also was aware of the political implications that the notion of "secession" had for a country such as the United States, where there were still vigorous living memories of the Civil War, which had been fought over the attempted "secession" of the Southern states from the Union. In other words, Stieglitz was "modern" in the sense that to be modern in the arts was to be deliberately provocative and challenging.

More precisely, one of the major implications of "art for art's sake" in Europe as a whole was the notion that art was an ongoing and open-ended experiment carried on by an avant garde, an experiment of constant changes both of artistic technique and of subject matter in response to the rapid changes in the surrounding society. This attitude carried with it an implicit demand to be "modern" in the sense that we have all come to understand that word when applied to art—a demand to be in opposition to the established art of the immediate past. Thus, in Stieglitz's view, the 291 gallery was a laboratory for such experimentation, and *Camera Work* was the scientific journal publishing the results.

Edward Steichen, who studied painting in Paris, was Stieglitz's entrée into the world of the Parisian avant garde, particularly the painters in the circle of the art patrons, and American expatriates Gertrude Stein and her brother Leo Stein. Most prominent among these painters were the Cubist Pablo Picasso and the Fauvist Henri Matisse. Because of Steichen's contacts, 291 and *Camera Work* became the first introduction to America of the art of the Fauves, Cubists, and others of importance in the early twentieth-century school of Paris. They also were the introduction of America to the fledgling tradition of abstracted modernism practiced by American artists such as John Marin, Marsden Hartley, Arthur Dove, and Georgia O'Keefe. These same painters have been called collectively the "Stieglitz circle" because of Stieglitz's unstinting efforts of patronage and dealership on their behalf throughout the latter part of his life. Both *Camera Work* and 291 were the focus of growing controversy from their founding, in 1903 and 1905, respectively, until their demise, under the growing pressures of World War I, in 1917. Much conflict and much excitement surrounded the entire enterprise of twentieth-century European art, and Stieglitz was its major impresario in New York from 1907, the year of the first nonphotographic show at 291, until the famous Armory Show of 1913.

Alfred Stieglitz and the dominant trends in American "art photography" notwithstanding, the discipline of working in a sympathetic professional market could bring out the best even in an "art photographer." The Photo-Secessionist Gertrude Kasebier is a case in point. Kasebier's career also is indicative of the conflicting social, personal, and economic pressures on the middle-class American woman of the Progressive Era.

Under the stimulus of a typical, financially comfortable, but loveless and strained bourgeois marriage, Kasebier began her career in 1889 by enrolling in art courses at Pratt Institute in New Jersey, which was then widely known for taking seriously the education and career preparation of women. She was then thirty-seven, her three children had reached adolescence, and personal incompatibility with her husband—in a time and among a social class where divorce was unthinkable—had led them to lead effectively separate lives. At about the same time, she became an amateur photographer, learning the rudiments of the craft from an elderly priest she met in a camera store. Kasebier graduated from Pratt in 1893, but continued to study drawing and painting both in America and in Europe until 1896. These seven long years of incubation suggest that Kasebier was deeply entangled in the dilemma of financially comfortable women in her era: she possessed a merely relative freedom, bought at the cost of chronic emotional strain and with the societal reservation that her activities could only be a mere anodyne for idleness and not be truly productive or satisfying work.

In 1896, at the age of forty-four, she was told that her husband, who was in the shellac business, was expected to live for only another year. This proved to be untrue, but to sustain her financial independence as a future widow, Kasebier was galvanized to act and decided to become a professional portrait photographer. This was one of the few "genteel" occupations open to a woman of her social status. Due to her unique combination of art training, good business sense, and vivacious social nerve, her pro-

fessional and artistic rise to fame was meteoric. By 1901, a mere five years after she had talked her way into a working apprenticeship with a mediocre portrait professional in Brooklyn, Kasebier was ensconced in her own expensive Fifth Avenue studio, a few numbers south of what shortly became the 291 gallery, and was making a considerable sum of money from her work. By then, or shortly thereafter, Kasebier was producing photographs of celebrities such as Mark Twain and Booker T. Washington for magazines like *The World's Work, Everybody's Magazine, The Ladies Home Journal,* and *The Craftsman.* She also had exhibited widely in important venues in Boston, Philadelphia, New York, London, and Paris. Finally, Kasebier had become part of the circle of photographers involved with Alfred Stieglitz at the New York Camera Club, and her work appeared prominently in *Camera Notes.*

Kasebier was among the first Stieglitz approached when he founded the Photo-Secession in 1902, and during the next decade her work was a staple in *Camera Work* and in the Photo-Secession group exhibitions at 291. When she finally quarreled with Stieglitz in 1912, it was at least in part over the growing inflexibility of his "art for art's sake" stance and his deepening commitment to the view of art as an avant garde activity incompatible with working to a public market. Yet Kasebier was indebted to that public market. In contrast to her purely personal work, which often was suffused in a Whistlerian and sentimental atmosphere, her professional portraits had to acknowledge the contrasting aesthetic of photographic description, while relying on many of the artistic devices of "art photography." This dedication to the subject in front of the lens, coupled with a clear understanding of formal visual conventions, gives Kasebier's commercial work a permanence that relies on the synthesis of art and professional technique.

Kasebier's later life is emblematic of the shifts in photographic practice that would occur in the following decades of 1920 to 1940, for those decades would see a widening growth of professional photographic opportunity, particularly in the area of halftone publication. They also would see the dominant "art photography" become "straight" or "purist" as it attempted a complete and authoritative synthesis of the values of "art for art's sake" with the aesthetic of photographic description.

Among the visitors to 291 in the first two decades of the twentieth century was Lewis Hine, who would become a chief exponent of straight photography. Hine was an instructor of biology and photography at the Ethical Culture School, a private, progressive high school on New York's Upper West Side. Moreover, Hine brought with him a young and precocious pupil by the name of Paul Strand, whose purist photographs would be featured in the last issue of *Camera Work,* in 1917.

Between 1904 and 1918, Lewis Hine photographed the life of the newly arrived immigrant and of the exploited poor, particularly labor-exploited children. Hine began in 1904 with a series of portraits of fresh arrivals at the immigration station Ellis Island, in New York harbor. From the Irish potato famine of the 1840s forward, European economic pressures and/or political pressures of persecution drove first the Irish, then the Germans, Scandinavians, Italians, and finally the Jews of Eastern Europe to immi-

grate to America to seek better lives. Generally speaking, this change in ethnic character of the immigration was a function of the growing industrialization of Europe. In any given period, the majority of immigrants would typically come from those places in Europe where capitalization and industrialization was less complete. This occurred because it was in the least industrialized countries that the discrepancy was greatest between the economic promise of life in the United States and the facts of life at home.

By the time Hine started photographing, the flow into the United States, particularly from Eastern Europe, had become an overwhelming flood, which was just barely being managed and channeled at stations like Ellis Island. The majority of the people who came were poor, conditions of travel in the "steerage" of the lowest decks of boats were harsh and squalid, and people's possessions often consisted merely of what they could wear and carry. As Hine photographed them, their faces are a curious compound of weariness, fear, and hope. As an amateur photographer, and a working educator, Hine published this work in periodicals such as *The Photographic Times* and *The Elementary School Teacher,* writing articles that carefully articulated the aesthetics of his camera practice and the significance of photography as an educational tool.

In 1907, Hine published some freelance photographic work in *Charities and the Commons,* the magazine of the National Child Labor Committee. By 1908, he had quit teaching to work as a full-time investigator and professional photographer for the Committee, a position he held until 1918. His pictures of child labor—produced throughout the country and carefully correlated with his eyewitness reports—constitute Hine's most important contribution to twentieth-century photography. These appeared in *The Survey* (the renamed *N. C. L. C. Magazine*), in other published reports of the Committee, and on placards Hine designed for N. C. L. C. exhibitions. In these years, Hine quickly became the most important and widely credited photographer of social and economic conditions in the world.

In 1912, Hine returned to New York to photograph the residents of the Lower East Side, usually still the immigrant families from Eastern and Southern Europe, doing labor-exploitive "homework" in the poor and crowded living conditions of the tenements of lower Manhattan. This working procedure had evolved as a cost-cutting response to the same pressures of capitalist organization that had separated "art" from "craft." In certain trades such as lace-making, where machine production was not profitable and items still had to be made largely by hand, the manufacturer received the most work for minimum cost by paying the worker for each item made, and by not providing physical space for the work. The result was "homework." Hine had been preceded in this picture-making in the tenements by the immigrant Danish photographer Jacob Riis, in the New York of the 1880s. The noteworthy difference between the two photographers is that the conditions that Hine depicts, while still difficult, are considerably improved from the unrelieved misery portrayed by Riis.

This is an important testimony to the political atmosphere in which Hine worked and to the economic development that occurred during late nineteenth and early twentieth century in America. Both Hine and Riis photographed in the context of what was

then called "progressive" reform. This was a cluster of related ideas that were grounded in the attitudes of the broad American middle class and were generally what we would today call politically "liberal." Progressivism was an effort to mobilize government action to relieve the most obvious economic inequities, political outrages, and human miseries resulting from America's industrialization. It embraced a wide range of ideas, including curtailing child labor; establishing mandatory levels of public education; establishing a system of central banks—the Federal Reserve—to control currency and banking practices; imposing graduated taxes on income, with the highest incomes paying the greatest percentage; and passing national anti-trust legislation to prevent companies from strangling economic competition within specific industries. The progressive movement was, as well, the spearhead of efforts to clean up government by reducing corruption and establishing a civil service of government employees chosen and promoted by merit, rather than through political patronage. Also related to it, and drawing upon the same reforming zeal, were parallel movements for the prohibition of alcohol, suppression of open gambling and prostitution, and granting women the right to vote.

The most visible and prominent vehicle for these efforts of reform was the turn-of-the-century, middle-class, general interest, magazine—such as *The Saturday Evening Post, Cosmopolitan, McClure's Magazine,* and *Harper's Weekly.* In these magazines, a new breed of "star" reporters and writers such as Lincoln Steffens, David Graham Phillips, and S. S. McClure—who were known as the "muckrakers"—wrote constantly of the massive abuses and the need for various reforms in American economic and political life.

With roots in the depressed years of the 1870s, the progressive movement expanded in the boom years of the 1880s when American economic growth and development reached parity with England, the leader in world capitalism. Progressivism reached a climax of reforming zeal and effectiveness during the first two decades of the twentieth century. These years were also, on the average, years of steady economic growth, following a sharp decline in the 1890s after the bank panic of 1893. Both the general American prosperity and the heightened public awareness of Lower East Side poverty from the work of Jacob Riis had contributed a share to the improved conditions Hine found in the New York tenements.

The function of photography in the progressive context was, first, to provide vivid and convincing evidence of the consequences of bad social conditions, and, second, to convince the viewer of the essential humanity of the victims. Riis was at first constrained to make the most effective use of his photographs in small lectures illustrated with "lantern slides," the ancestors of our modern color slides. But Hine began his work at the beginning of a revolution in photographic reproduction made possible by the invention of the halftone screen in the early 1890s. By the early twentieth century, the photograph reproduced in halftone was quickly becoming the standard of popular illustration for factual magazine articles, at a cost of about five times less than the hand-drawn wood engravings it replaced. The first major piece of progressive propa-

ganda illustrated with the new photographic halftones was David Graham Phillips's "The Treason of the Senate," which appeared in *Cosmopolitan* magazine in 1906. After this example of the newfound power of photographic illustration in the service of reform, the N. C. L. C. swiftly exploited both Hine's incredible talent and the detailed fidelity to photographic evidence the halftone offered.

It is important to examine the terms of the halftone revolution a little more closely here. As we pointed out earlier, there was a large mass market for cheap commercial pictures, such as stereo cards, in the late nineteenth century. Although these images often had titles and a generalized text on the back of each card, the halftone magazine photograph represented a somewhat different popular use of photography because it was tied to an extended documentary text. Highlighting subjects as individuals, Hine's work is a paradigm of this new function because of the care he took to report the surrounding context of each picture: who the child was and how old; where the factory was and what it made; what the child did besides work; and so forth. Later, in the 1930s, pictures such as Hine's would be called "documentary," and Hine's work and reputation would experience a revival. But it is important to understand that this label "documentary" actually describes how a picture is *used* rather than what it is in and of itself.

In this context, Hine's direct encounter early in his career with 291, and with Alfred Stieglitz, is a matter of first importance, because Hine's picture-making practices were, on their own terms, as self-consciously aesthetic as those of the Photo-Secession. The literature and tradition of American art photography has been dominated by the attitude of "art for art's sake" and the particular philosophical developments of that idea. In consequence, both the photographs and the attitude of Lewis Hine have undergone periods of major critical eclipse and compensatory critical revivals. The declines and the revivals, however, have each been largely based on the assumption that Hine's work is "documentary," as compared to "artistic," and that photographers who somehow manage to make powerful and moving "documents" are aesthetically primitive or naive.

Nothing could be further from the truth. Hine and his work are the paradigm of a different attitude about the aesthetics of photography than the notion of "art for art's sake." First, since it relies upon the power of photography as concrete factual description, this attitude is essentially indifferent both toward the notion of the synthesis of the arts and that of a hierarchy of aesthetic abstraction. Such photographs parallel written prose much more closely than they ever approach the abstract properties of music. As in the case of "art for art's sake," photographs made from this vantage point have specific authors, but instead of stressing "personal expression," they emphasize clarity, precision, and relevance in the description of subject matter. And, instead of pursuing a decorative "beauty," this attitude, like prose literature, relies for emotive effect upon the natural drama of commonly understood cultural meanings inherent in the subject matter.

As our excerpt from Alan Trachtenberg makes clear, this aesthetic attitude of

photography as pictorial description of culture predates "art for art's sake"; indeed, its birth is virtually the same as that of photography itself. It also represents a continuous, worldwide tradition parallel to "art photography," and it is still pervasive throughout both the popular culture of photography and the professional use of the medium. This attitude can be summarized by the notion that "every picture tells a story," and that the quality of the storytelling is the center of the aesthetic experience.

The international critical dominance of "art photography" in the years 1901 to 1920 was, to some degree, achieved at the expense of this contrasting aesthetic. Two French photographers working in this period make this point clear. One, Jacques Henri Lartigue, was an amateur, the other, Eugene Atget, a professional. Both were geniuses who photographed in the aesthetic of pictorial description, and both were critically neglected until considerably later than 1920, Atget being "discovered" in 1927 and Lartigue in 1963. Atget and Lartigue represent the pinnacle both of professional photographic practice and of popular photographic culture as they stood in Europe before the overwhelming disaster of World War I. And the story their pictures tell is of Europe at a cultural, political, and economic pinnacle never to be repeated.

Lartigue was born in 1894 to a French family of means. At the age of seven he was given a good amateur camera and a sturdy tripod by his father, who also photographed for recreation. The camera transformed Lartigue from a merely precocious and intelligent small boy into a child prodigy. One of the reasons for this, of course, was that the photographic techniques of the early twentieth century were just barely within the capabilities of a boy so young. In meticulous and voluminous diaries, the young Lartigue recorded that his tripod was taller than he was and that making pictures was difficult, intensely focused, and time-consuming play. The young boy's first camera made pictures on heavy and delicate glass plates instead of with George Eastman's flexible film, and Lartigue himself handled the chemistry and did the processing. Hence, Lartigue was an amateur photographer in the same sense that Stieglitz could be called an amateur photographer, rather than the hundreds of thousands of amateurs whose pictures were processed by the Kodak company. Photography for Lartigue was a young boy's serious hobby, undertaken with the determination and concentration that young boys often manifest when a hobby both touches deep inner feelings and presents a barely surmountable challenge. Lartigue's zealous pursuit of his hobby drew forth pictures of tremendous talent.

Both what Lartigue photographed and the fact that a tiny boy could spend so much time and effort with the camera were the direct result of the European economic pinnacle. In France, the period before World War I later became known as the Belle Epoque, the "Beautiful Period," and it was preeminently the time of the *bourgeoisie*. These were the people, like the Lartigues and the Stieglitzes, who had made a significant amount of money from some form of commerce, trade, or investment. They could afford servants to cook, clean, and care for and tutor children who often would subsequently attend a boarding school. They also could spend a lot of time and money on new and expensive toys in a world that was a continuous and extended picnic on a Sat-

urday summer afternoon. Lartigue captured them playing with the most expensive and engaging of their toys: the kites, gliders, and airplanes of the recently realized dream of human flight; and the new internal combustion automobiles racing faster and faster in pursuit of the incredible and mythic speed of 100 miles per hour (Fig. 1.1).

The passion of Lartigue's relatives and their friends was for flight and speed. The passion of Lartigue himself was the photography of motion—the motion of kites flying, cars racing, women walking, or even his older sister leaping down a flight of steps. In this he was linked both to Stieglitz and Hine by the rapidly changing technology of the camera, particularly the smaller and lighter "hand" cameras, which were portable enough for an adult to shoot without a tripod, though still, by our standards, big and clumsy. The most famous of these, the Graflex, used by both Hine and Stieglitz, had the new "focal plane" shutter, a curtain in the back of the camera that could expose film for very brief intervals of time, making the arrest of motion possible when outdoor light was bright enough to permit it. Lartigue's camera also had a similar shutter.

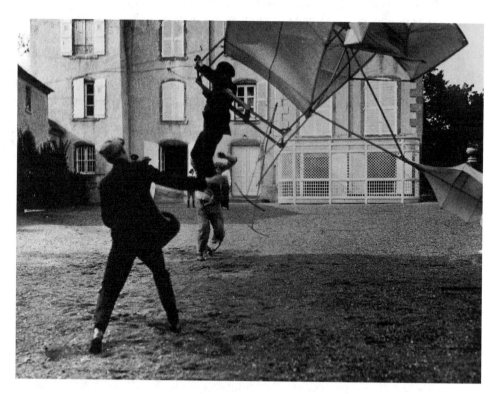

Figure 1.1 Jacques Henri Lartigue.
Château Rouzat, Airplane Turning over in the Air, 1912.
Gelatin-silver print, 1 1¾" x 15½," (29.8 x 39.4 cm).
The Museum of Modern Art, New York. Gift of the photographer.
Copy print © 1997 The Museum of Modern Art, New York.

A decade earlier than Lartigue, Stieglitz had quite deliberately and consciously taken such hand cameras into the streets of the city to take pictures of its bustling pedestrians, horse-drawn carriages, and streetcars. Some of the most vivid and spontaneous of Hine's pictures were also of laboring men, women, or children leaving the factory gate or prowling the city streets. But, in historical hindsight, Lartigue's photography of motion has a more poignant meaning than the similar motifs in the pictures of the two Americans. For the vivid frantic rush, the steadily increasing speed, and the flirtation with genuine danger (Lartigue actually photographed the crash of a glider that killed a cousin) of the participants in Europe's bourgeois amusements seems to echo the headlong, unconscious plunge of Europe itself into the military and financial disaster that was World War I.

In contrast, Europe's long and continuous history of habitation created dense and layered artifacts, and the photography of them was Eugenè Atget's professional trade. Much of Atget's story is still obscure, but, before turning to photography in the early 1890s, Atget had been both a sailor and theatrical actor and had attempted as well to become a painter. It was this contact with the world of the visual arts that probably suggested to him the freelance career of making photographic "Documents For Artists," which was his own designation for his work. His professional niche was made possible by two particularly French facts: Paris was the greatest center for art and art training in the world, and the French government had made a practice, almost from the inception of photography, of commissioning photographers to record aspects of French life and culture for official archives.

For two and one-half decades, from about 1892 until his death in 1927, Atget comprehensively created pictures of the public and private artifacts of greater Paris, arranged them into systematic marketing categories, and sold the prints to a regular clientele of painters, sculptors, and craftsmen (Fig. 1.2). He also photographed selected segments of Parisian society, such as street vendors and, on commission from the government, prostitutes and licensed brothels. As the excerpted article by John Szarkowski points out, however, this exterior professionalism, shared with other commercial photographers, does not define Atget's genius, just as Hine's exterior activities do not encompass the power of Hine's pictures. Both rely on a deeper sympathy with the aesthetic of pictorial description than the average working professional and, when compared with one another, the basis of that deeper sympathy becomes clear.

This lies in the atmosphere that surrounds the subject matter of the pictures. In contrast to the "atmosphere" derived from Whistler, and imposed on all content one finds in the "art photography" of the day, the pictures of Hine and Atget are contrasting amalgams of time and historical specificity. Hine's subjects are exclusively in the present tense: they are new, raw, and crude—and the people among them are mirrors of the immediate moment, the more so for being mostly children. These are all qualities that American people and American subject matter have largely retained during the twentieth century. Atget photographed not just the present, but the *age* of his artifacts—the ineffable patina of time and culture that still clings to so many things in Eu-

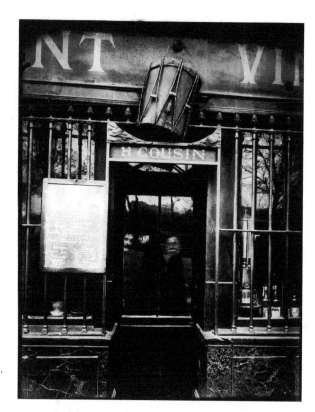

Figure 1.2 Eugène Atget.
*Au Tambour, 63 quai de la Tour-
nelle.* Paris, France, 1908.
Gelatin-silver print, 9" x 7," (22.9 x
17.7 cm).
The Museum of Modern Art, New
York. Purchase. Copy print © 1996,
The Museum of Modern Art, New
York.

rope. How these intangible qualities of atmosphere in subject matter are actually communicated by mere photographic description is one of the unresolved, and perhaps unresolvable, riddles of the camera—but both Hine and Atget possessed that sense of proper balance between timing, lighting, and vantage point that draws them out. And the comparison between them is paradigmatic of the historical moment of the first years of the twentieth century. The immense body of work Atget accumulated is a monument not only of European culture but also of the unshaken European confidence in that culture as the vanguard of human progress. And the child labor decade of the work of Lewis Hine is eloquent testimony to the American progressive willingness to face the ugly facts in modern life with the confidence that public action could relieve them. Both these beliefs did not endure much beyond World War I, which ended in 1918.

EXCERPTS FROM THE PERIOD 1900-1920

"Technology and the Market: George Eastman and the Origins of Mass Amateur Photography." (1975)
*Reese Jenkins**

"From the time of the introduction of commercial photography in 1839 until the late 1870s, the technical complexities of the photographic process were so great that only professional photographers and a very few avid amateurs chose to pursue the practice. . . . Twenty years later nearly anyone interested in obtaining photographs, regardless of his practical knowledge of optics or of photographic chemistry, could at least press a button on a simple hand camera, remove the exposed film from the camera, and in a few days obtain finished prints from a local photographer or a distant factory. The change in practice of photography from the dominance of the professional to that of the amateur revolutionized both the photographic industry and the social role of photography . . . the Rochester entrepreneur George Eastman stood at the heart of the subsequent key conceptual and technical changes which created the mass amateur market and played the commanding role in the consequent transformation of the industry. . . .

"Early in 1884 Eastman, like so many photographers during the previous thirty years, sought a suitably flexible, tough, relatively inert, and transparent substitute for glass. . . . By early March he had developed a stripping film which consisted of a photographic paper base. . . . In the processing of the film, the paper base remained attached during the exposure, development, and fixing; then the emulsion was detached from the paper and attached to a sheet of glass, which was varnished and from which positive prints were initially obtained. . . . By early fall of 1884 the three basic elements of the roll film system (holder mechanism, film, and production machinery) were developed and patents on the elements were applied for in the United States and in several Western European countries. Clearly, the development of a system of patents on the new form of photography was an integral part of the entire invention-innovation strategy . . . which contributed substantially to the eventual dominant position of the Eastman Kodak Company in the mass amateur market. . . .

"Initially the leaders of photography reacted favorably to the new system. . . . Yet, the enthusiasm seemed largely confined to the roll holder mechanism. . . . The

*From *Technology And Culture* vol. 16, no. 1, (January 1975) pp. 1–19. Chicago: The Society for the History of Technology and the University of Chicago Press.

stripping film was so complicated and delicate—requiring development, soaking, separation, squeegeeing, and varnishing—that after two years of further minor improvements and promotion of the stripping film, professional photographers continued to reject the roll film system as being too complicated. Eastman began to recognize that his roll film system was a failure. . . . The development of the roll film system did provide some new sources of sales and profit as a by-product. The experience of producing negative paper film on a continuous basis provided the opportunity to provide factory-sensitized positive print paper on a large scale. . . . As a means of exploiting the enlargement market, the Eastman company also developed a printing and enlarging service whereby customers could mail negatives to the company and regular or enlarged prints would be produced using the Eastman bromide paper. By 1887 the service reached a volume of 5,000–6,000 prints per day and employed mechanized printing techniques. . . .

"Eastman conceived of utilizing these resources to transform the roll film system intended for the professional to an amateur system of photography consisting of a simple-to-operate camera, stripping film, and a factory service for developing and printing the delicate and hard-to-operate film. . . . This change in conception of who was to practice photography constituted one of the most revolutionary ideas in the history of photography. . . .

"In December of 1887 Eastman created the name "Kodak" for the new camera. . . . From January to late June 1888 . . . Eastman personally arranged the marketing details, including instruction manuals, advance literature to supply dealers, and advertising in appropriate publications. Late in June the first Kodak cameras were in production, and early in July Eastman exhibited the new camera at the annual photographers' convention in Minneapolis. The panel of judges at the convention awarded it the medal as *the* invention of the year in photography. . . . Soon the camera, loaded with a 100-exposure roll of film, was on the market for $25. The novice photographer had only to point the camera toward the desired subject and "push the button." When he had exposed the film, he had only to return the camera to the factory where for $10 the film was removed and replaced with a fresh roll of film and the exposed film processed. . . . By late summer the demand for Kodak cameras and film astounded the usually unexcitable Eastman. . . .

"During the next several years the Kodak system won an enthusiastic reception throughout the world and laid the foundation for American leadership in the photographic industry. . . . The change from professional to amateur performance not only transformed the photographic industry from one characterized by decentralized, handicraft modes of production in 1879 to one characterized by centralized, mechanized modes of production in 1899, but, more important, signaled the growth of a mass market in photography."

"Pictorial Photography." (1899)
*Alfred Stieglitz**

"Pictures, even extremely poor ones, have invariably some measure of attraction. The savage knows no other way to perpetuate the history of his race; the most highly civilized has selected this method as being the most quickly and generally comprehensible. Owing, therefore, to the universal interest in pictures and the almost universal desire to produce them, the placing in the hands of the general public a means of making pictures with but little labor and requiring less knowledge has of necessity been followed by the production of millions of photographs. It is due to this fatal facility that photography as a picture-making medium has fallen into disrepute in so many quarters; and because there are few people who are not familiar with scores of inferior photographs the popular verdict finds all photographers professionals or "fiends."

"Nothing could be further from the truth than this, and in the photographic world to-day there are recognized but three classes of photographers—the ignorant, the purely technical, and the artistic. To the pursuit, the first bring nothing but what is not desirable; the second, a purely technical education obtained after years of study; and the third bring the feeling and inspiration of the artist, to which is added afterward the purely technical knowledge. This class devote the best part of their lives to the work, and it is only after an intimate acquaintance with them and their productions that the casual observer comes to realize the fact that the ability to make a truly artistic photograph is not acquired offhand, but is the result of an artistic instinct coupled with years of labor. . . .

"In the infancy of photography, as applied to the making of pictures, it was generally supposed that after the selection of the subjects, the posing, lighting, exposure, and development, every succeeding step was purely mechanical, requiring little or no thought. The result of this was the inevitable one of stamping on every picture thus produced the brand of mechanism, the crude stiffness and vulgarity of chromos, and other like productions.

"Within the last few years, or since the more serious of the photographic workers began to realize the great possibilities of the medium in which they worked on the one hand, and its demands on the other, and brought to their labors a knowledge of art and its great principles, there has been a marked change in all this. Lens, camera, plate, developing-baths, printing process, and the like are used by them simply as tools for the elaboration of their ideas, and not as tyrants to enslave and dwarf them, as had been the case.

"The statement that the photographic apparatus, lens, camera, plate, etc., are pliant tools and not mechanical tyrants, will even to-day come as a shock to many who

**Scribner's Magazine*, 26, (November, 1899) pp. 528–537.

have tacitly accepted the popular verdict to the contrary. . . . Consider, for example, the question of the development of a plate. The accepted idea is that it is simply immersed in a developing solution, allowed to develop to a certain point, and fixed; and that, beyond a care that it not be overdeveloped or fogged, nothing further is required. This, however, is far from the truth. The photographer has his developing solutions, his restrainers, his forcing baths, and the like, and in order to turn out a plate whose tonal values will be relatively true he must resort to local development. This, of course, requires a knowledge of and feeling for the comprehensive and beautiful tonality of nature. As it has never been possible to establish a scientifically correct scale of values between the highlights and the deep shadows, the photographer, like the painter, has to depend upon his observation of and feeling for nature in the production of a picture. Therefore he develops one part of his negative, restrains another, forces a third, and so on; keeping all the while a proper relation between the different parts, in order that the whole may be harmonious in tone. . . .

"An examination of either the platinum or the gum process, the two great printing media of the day, will at once demonstrate that what has already been asserted of the plate is even more true of these. Most of the really great work of the day is done in one of the other of these processes, because of the great facility they afford in this direction, a facility which students of the subject are beginning to realize is almost unlimited. In the former process, after the print has been made, it is developed locally, as was the plate. With the actual beauties of the original scene, and its tonal values ever before the mind's eye during the development, the print is so developed as to render all these as they impressed the maker of the print; and as no two people are ever impressed in quite the same way, no two interpretations will ever be alike. To this is due the fact that from their pictures it is an easy matter to recognize the style of the leading workers in the photographic world as it is to recognize that of a Rembrandt or Reynolds. . . .

"In the "gum-process" . . . the photographer prepares his own paper, using any kind of surface most suited to the result wanted, from the even-surfaced plate paper to rough drawing parchment; he is also at liberty to select the color in which he wishes to finish his picture, and can produce at will an india-ink, red-chalk, or any other color desired. The print having been made he moistens it, and with a spray of water or brush can thin out, shade, or remove any portion of its surface. Besides this, by a system of recoating, printing-over, etc., he can combine almost any tone or color effect. . . .

"A cursory review of the magazines and papers the world over that devote their energies and columns to art and its progress will convince the reader that to-day pictorial photography is established on a firm and artistic basis. In nearly every art-centre exhibitions of photographs are shown that have been judged by juries composed or artists and those familiar with the technique of photography, and passed upon as to their purely artistic merit; while in Munich, the art-centre of Germany, the "Secessionists," a body of artists comprising the most advanced and gifted men of their times, who (as the name indicates they have broken away from the narrow rules of custom and tradition) have admitted the claims of the pictorial photograph to be judged on its

merits as a work of art independently, and without considering the fact that it has been produced through the medium of the camera. And that the art-loving public is rapidly coming to appreciate this is evidenced by the fact that there are many private art collections to-day that number among their pictures original photographs that have been purchased because of their real artistic merit. . . . Of the permanent merit of these pictures posterity must be the judge, as is the case with every production in any branch of art designed to endure beyond the period of a generation."

"Alfred Stieglitz and His Work." (1901)
*Charles Caffin**

"There are few, if any, who will not concede to Alfred Stieglitz the first place among American exponents of pictorial photography. It is his own, both for what he himself has done, and also for what he has encouraged and enabled others to accomplish.

"His influence upon the progress of the art has been so widely diffused that it is difficult to estimate it accurately. We have to consider him as an artist, following his own ideal, and reaching certain definite results of personal expression—but as much more than an individual factor. . . . In fact, he has been the incarnation of the movement—artist, prophet, pathfinder. . . .

"In this connection allusion may be made to the propaganda he has maintained by voice and pen. His correspondence with photographers throughout the world and contributions to periodicals, apart from his editorial work, have been continuous and influential. His writings are terse and to the point; backed with so much knowledge and so disinterested that they command respect even from those who are disinclined to accept his views . . . even those who resent his de facto leadership among American photographers are bound to admit that he has not sought the honor, but that it has grown around his personality through his qualifications fitting so admirably the circumstances and needs of the time. . . .

"It was mentioned above that he has always combatted the doctrine that the end justifies the means. His attitude upon this subject is that the photographer should rely upon means which grown out of and belong to the technical process. For example, he objects to the "touching up" of a negative by taking out the high-lights or by deepening shadows, because this imparts a foreign element. The operator ceases to rely upon the actual scientific process and is "getting around" the deficiencies of his plate or of his own skill by what is, after all, a subterfuge. He does not deny that in certain cases

*Charles Caffin. *Photography As A Fine Art*. Hastings on Hudson, N.Y. 10706: Morgan and Morgan, 1971. (Reprint of 1903 edition.)

a beautiful effect has been obtained, but, detecting the trick, feels a jar. The picture is not exclusively a photograph. . . .

"In common with all the best photographers, he lays great stress upon the mounting and framing of the prints. Size, shape, color, and texture of the mount and the color and character of the frame are all considered with a special regard for the color and character of the print, so that a complete harmoniousness may be obtained. In this respect the photographers as a body have shown themselves more artistic than the painters, who are gradually realizing the inappropriateness of most of the gilded abominations in which they frame their pictures. . . . The reason is that the photographers have more completely realized the beauty of tone, and this from the nature of their craft. For, whether they print their pictures in gray, black, brown, or some other tint, they are practically limited to one color and must obtain variety and harmony by playing upon subtle gradations from the darkest to the lightest parts. . . .

"*Gossip*—how simple it is and what impressive realism in the simplicity! (Fig. 1.3). The broad sweep of open sky, the strip of waves following one upon another, and the stretch of sand, over part of which the water slides, are racy of free, fresh vastness. You may feel the scene to be a little drear, yet what invigoration there is, echoed in the sturdy forms and energetic action of the two women and the blunt strength of the boat.

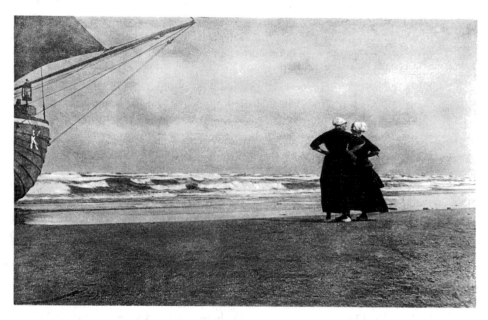

Figure 1.3 Alfred Stieglitz.
Gossip, Katwyk, 1894.
Halftone, 5⁵⁄₁₆" x 8⅜" (13.5 x 21.3 cm).
The Philadelphia Museum of Art, Alfred Stieglitz Collection.
Gift of Carl Zigrosser.

Boat, ocean, and wives, and a sense of isolation—the life and romance of a little fishing village admirably epitomized. The highest praise one can give the picture is to say that it reaches the heart of the matter with the same directness and sympathy that characterize the works of the Dutch artists Israels and Bloomers. . . . They have the intimate feeling that usually Dutch artists alone can impart to Dutch subjects. . . .

"It is in his treatment of the human subject in relation to outdoor scenes that Mr. Stieglitz has exhibited the most distinguished skill. Nor is he one of those who despair of discovering pictorial motive at home. The human nature which attracts him he finds most free from artificiality in the streets of cities. New York in its scenic and human aspects he has studied exhaustively, and one hopes that the results will some day be published, for they would give a record of city life without a parallel. . . . Another famous New York series is the one of snow scenes, of which a well-known example showed a Fifth Avenue stage ploughing through the newly fallen snow; a picture fine in composition and in its suggestion of solemn desolation, full of atmosphere and wonderfully true in the receding distances of the waste of snow. Like all his work, it represents a conception thought out and vividly realized before the camera was set in place. . . .

"In final summary of the appreciation of Mr. Stieglitz and his work, I would reiterate that the personal qualification, which has made his influence upon pictorial photography so widely felt and valuable, is the rare balance in him of scientific knowledge and artistic feeling, joined to a character enthusiastic, powerful and sympathetic. . . . In his hands the "straight photograph," in the broadest sense of the term, is triumphantly vindicated."

"Gertrude Käsebier and the Artistic Commercial Portrait." (1901)
*Charles Caffin**

"What shall we say of *Mother and Child?* (Fig. 1.4). Beautiful it certainly is, if only for the delicacy of light and shade in the folds of the lady's white gown. It seems to have been the result of a sudden impulse of enthusiasm. One may imagine the general conception of the picture settled and the artist waiting for her opportunity. The baby suddenly glides into a pose with the head thrown back and eyes raised. It is like an infant Christ or wingless cherub. Exquisite! Even the mother shares the excitement of the moment, as one may see from the tense action of the head and fixity of the gaze. The picture is taken and is very spiritual and beautiful, yet the pose and expression of the child have not the unaffectedness of a baby. The result is, baby plus the enthusiasm

*Charles Caffin. *Photography As A Fine Art.* Hastings on Hudson, N.Y. 10706: Morgan and Morgan, 1971. (Reprint of 1903 edition.)

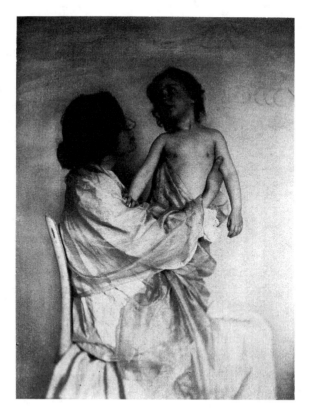

Figure 1.4 Gertrude Käsebier.
Adoration, 1907.
Gum on platinum, 12" x 8¹⁵⁄₁₆" (30.4 x 23.7 cm).
The Museum of Modern Art, New York. Gift of Mrs. Hermine M. Turner. Copy print © 1996, The Museum of Modern Art, New York.

of the artist for something she did not expect to get, and could only have got by accident; certainly not normal, simple, characteristically childlike. . . .

"To sum up one's impressions of Mrs. Käsebier's work, as illustrated by these portraits, it is, in the first place, sympathetic, influenced by love and enthusiasm as well as knowledge. She has a keen intuition of character, and a wonderfully swift inventiveness of means to express it, for we may conclude that certainly the majority of these pictures have been done under the ordinary conditions of fulfilling appointments. Each has an unexpectedness of treatment, presupposing a mind stored with artistic resources and an imagination alert and fertile. Equally spontaneous is her sympathy. She has a remarkable power of focusing her interest upon her subject and of discovering the best qualities. The means by which she gives expression to her conceptions are those of a thorough artist. . . . Her resources are the management of line and form, and of light. These she handles, not merely with knowledge, but with a vivid imagination and poetic instinct; securing, as she needs it, dignity or delicacy of line and mass and fullness or evanescent charm of color. The quality of the latter can only be guessed from the illustrations, but many of the originals urge one to use that much-abused term "orchestration of color." No other seems so fitting; for example, her dark passages have a

resonant, sonorous quality; elsewhere the effects of light are flute-like in their tremulous purity, or the impression upon own may be of the vibration of stringed instruments, and all are fused into a harmony of tone and feeling."

"Methods of Individual Expression." (1901)
Charles Caffin*

"The goal of the best photographers, as of all true artists, is not merely to make a picture, but to record in their print and transmit to others the impression which they experience in the presence of the subject. This sounds like "Impressionism," and indeed it is, in the broadest meaning of that term, which, however, in common usage has been whittled down to a narrow significance, to particularize that group of artists whose fondness for painting light would better justify the distinguishing name of "luminarists." In a broad sense all artists are impressionists. They do not picture the object itself, but what they are conscious of seeing. One man may be satisfied to represent merely the external facts of the object; but if nine other men, facing the same object, set about doing the same thing, the ten would not produce identical results. In each case it would be tinged by the individual's particular way of seeing. The thing pictured would not be the object, but a record of the impression made by it on each of the separate pairs of eyes; every one of the ten would be involuntarily an impressionist. . . .

"In the early stages of photography man's interest was captured by the camera's ability to record facts; today, the artist's aim is to make it record his impressions of the fact, and to express in the print his personal feeling. The camera's ability was overrated. Because it can take in so much more detail than the human eye, its accuracy of vision was regarded as infallible; whereas, in effect, it is less accurate than the trained eye, falsifying the record by undue enlargement of the objects near, and diminution of those more remote. . . . Suppose the vista to be photographed is a mile in length, every yard of it gradually receding from the foreground. If the camera jumps the middle distance, and extends the horizon in appearance to two miles away, the whole character of the scene is falsified. The photographer in the printing seeks to correct this deviation from the truth. This is his first argument in favor of manipulating the print; and some photographers have another. "That scene," says one, "excites a certain impression in my imagination, the result partly of association, partly of my individual temperament. I want to express that phase of the scene and communicate it to you. The unresponsive eye of the camera will not see what I am striving for. . . .""

*Charles Caffin. *Photography As A Fine Art*. Hastings on Hudson, N.Y. 10706: Morgan and Morgan, 1971. (Reprint of 1903 edition.)

"Other Methods of Individual Expression." (1901)
Charles Caffin *

"Mr. White[1] appears to find in the platinotype process the best expression of his purpose. When platinum paper is exposed to light in the printing frame the dark parts come out first in a temporary image of iron or silver, which in the subsequent process of development is, in some cases, overlaid with, in others exchanged for, a permanent image in metallic platinum. This is the scientific statement which may mean much or nothing to the reader; but the main thing is that the platinum, being distributed over the paper with exceeding fineness, yields exquisitely graduated tones of black and gray. This black, blue-black or brown-black, but deep and full of color, and the delicate differences of gray are the distinguishing characteristics of the process. It lends itself, therefore, equally to rich and dainty effects, and is invaluable when tender differences of tone are desired or sumptuous depth of color. For an example of the former may be cited the Portrait of Mrs. D., which the stiffness and glare of a white piqué costume is reduced to a mingling of soft radiance and equally soft shadow, daintily differentiated from the light wall behind the figure. The picture recalls a somewhat similar subject by the painter John S. Sargent, . . . although the painting has more style, the print is equally artistic in a more gracious manner. . . .

"If I am addressing any one who has hitherto regarded art as the mere imitating of objects, this picture should open up a new idea. It would seem that it is not so much the objects as the use which the artist makes of them that constitutes art, the little something of himself mixed in with the ingredients, the personal alchemy that transmutes the commonplace into the beautiful. So, if you want your portrait taken, it may may be less important what clothes you wear than whom you select to photograph them."

"A Visit to Steichen's Studio." (1903)
Sadakichi Hartmann **

"The artistic photograph answers better than any other graphic art to the special necessities of a democratic and leveling age like ours. I believe this, besides some technical charms like the solidity of dark tones and the facility with which forms can be lost

*Charles Caffin. *Photography As A Fine Art.* Hastings on Hudson, N.Y. 10706: Morgan and Morgan, 1971. (Reprint of 1903 edition.)

**Sadakichi Hartmann. *The Valiant Knights of Daguerre.* ed. Henry W. Lawton and George Knox. Berkeley: University of California Press, 1978.

[1]Mr. White is Clarence H. White, a member of the Photo-Secession, early teacher, and founder of the Clarence H. White School of Photography (see timeline).

in shadows, is the principal reason why Steichen has chosen it as one of his mediums of expression.

"He never relies upon accidents; he employs in his photographic portraits the same creative faculty which he employs in his paintings. That is the secret of his success. Look at his portraits of Lenbach, Stuck, Watts, Maeterlinck, Besnard, Bartholomé, and Rodin. In each, with the exception of Maeterlinck—and Maeterlinck's face seems to be one of those which do not lend themselves to pictorial representation, being too subtle, perhaps—he has fully grasped the sitter's personality. . . .

"But the masterpiece of this collection is the Rodin (Fig. 1.5). It cannot be improved upon. It is a portrait of Rodin, of the man as well as the art, and to me by far more satisfactory than Alexander's portrait of the French sculptor, excellent as it is. It is a whole man's life condensed into a simple silhouette, but a silhouette of somber splendor, powerful and personal, against a vast background, where black and white seem to struggle for supremacy. This print should, once and for all, end all dispute whether artistic photography is a process indicative of decadence, an impression under which so many people and most artists will seem to labor. A medium, so rich and so complete, one in which such a masterpiece can be achieved, the world can no longer ignore. The battle is won!"

"The Influences of Artistic Photography in Interior Decoration." (1903)
Sadakichi Hartmann*

"The elaborate way in which the artistic photographers mount and frame their prints has attracted attention everywhere and called forth critical comment, favorable as well as the reverse, from various quarters. Nobody can deny that they go about it in a conscientious, almost scientific manner, and that they usually display a good deal of taste; but the general opinion seems to be that they attach too much importance to a detail which, although capable of enhancing a picture to a remarkable degree, can do but little toward improving its quality. The artistic photographers differ on this point. They argue that a picture is only finished when it is properly trimmed, mounted and framed, and that the whole effect of print, mounts or mat, signature, and frame, should be an artistic one, and the picture be judged accordingly. . . .

"Their style is largely built up on Japanese principles. The Japanese never use solid elevated "boundary lines" to isolate their pictures, but on the contrary try to make

*Sadakichi Hartmann. *The Valiant Knights of Daguerre* by Sadakichi Hartmann. ed. Henry W. Lawton and George Knox. Berkeley: University of California Press, 1978.

Figure 1.5 Edward Steichen.
Rodin, Le Penseur, 1902.
Photogravure.
Reprinted with permission of Joanna T. Steichen. Courtesy George Eastman
House.

the picture merely a note of superior interest in perfect harmony with the rest of the *kakemono,* which is again in perfect harmony with the wall on which it is placed. . . .

"The artistic photographers try to be like the Japanese in this respect. They endeavor to make their prints bits of interior decoration. A Käsebier print, a dark silhouette on green wall-paper in a greenish frame, or a Steichen print mounted in cool browns and grays, cannot be hung on any ordinary wall. They are too individual; the rest of the average room would jar with their subtle color-notes. They need special wall-paper and special furniture to reveal their true significance.

"That is where the esthetic value of the photographic print comes in. It will exercise a most palpable influence on the interior decoration of the future. People will learn to see that a room need not be overcrowded like a museum in order to make an artistic impression, that the true elegance lies in simplicity, and that a wall fitted out in green and gray burlap, with a few etchings or photographs, after Botticelli or other old masters, in dark frames is as beautiful and more dignified than yards of imitation gobelins or repoussé leather tapestry hung from ceiling to floor with paintings in heavy gold frames. . . .

"But it is, after all, an open question whether these efforts will be crowned with success. We are too much interested in the utilitarian equipments of our homes ever to give, as the Japanese do, first consideration to harmony. And harmony, perfect harmony, is necessary to adapt their style of interior decoration successfully. . . .

"If our interiors were as simple and artistic as the Japanese ones, we should have a good basis to work on. As it is, the photographic prints are finger-posts in the right direction. Whether we can pursue the indicated path to the very end is a question which the future has to decide."

"The Photograph Beautiful 1895–1915." (1992)
*Christian Peterson**

"Like its predecessor in England, the Arts and Crafts movement in the U.S.A. was based on the concept of the 'simple life' and the combination of beauty with utility. It pointed its finger at the disturbing effects of the Industrial Revolution, criticising the overmechanization of work, the decline of aesthetic standards, and impersonalization of society in general. . . . It was posited that beauty and utility were not mutually exclusive elements, and it was shown that the most successful products and objects were those in which form followed function. The Arts and Crafts movement also advocated that people become reacquainted with the natural world. . . . The products of

*From *History of Photography,* vol. 16, No. 3 (Autumn 1992). pp. 189–232. London: Taylor and Francis, 1992.

the movement ranged from craftsman bungalows and Prairie School dwellings to a variety of hand-tooled leather and metal items. Almost every aspect of human activity, from diet to dress, was touched by the Arts and Crafts movement, to the extent that it became a full-fledged way of life for those who embraced it. . . .

"Against this backdrop of Arts and Crafts ideals another important movement developed in the U.S.A. during the period from the mid-1890s to about World War I: pictorial, or artistic photography. Normally associated only with Alfred Stieglitz and his elitist Photo-Secession group, pictorial photography was, in fact, a popular movement that paralleled that of the Arts and Crafts. . . . Philosophically, these two groups were also aligned, and they both sought to erase the border between fine, or 'high', and applied, or 'low,' art. While the pictorial photographer made art with a machine (the camera), the craftsman produced household items that were attractive as well as useful. Pictorial photography and the Arts and Crafts movement simultaneously encompassed artistic goals, utilitarian means and an abiding popular appeal. Ultimately, members of both movements shared a mutual pursuit of the 'object beautiful.'. . .

"Craftsmen and pictorial photographers attempted to achieve the beautiful in their work and in their lives largely by establishing a physical and spiritual closeness with nature. Invoking simplicity represented another aspect of the quest for beauty in art and life. Simplicity, with its roots in the natural world, could be effectively applied to one's home, one's handicrafts and one's artistic photographs. For pictorialists and craftsmen it became a guide for modern-day living and working and a means of rejecting nineteenth-century excess and over abundance. . . . [they] simultaneously reacted against this world of superfluity by calling for elimination rather than accumulation . . . busy wallpaper gave way to solid painted colors, heavily carved woodwork was replaced by the clean lines of 'mission' furniture, ornate oriental rugs lost out to more neutral floor coverings, and every room was cleared of unnecessary objects, bric-à-brac, and decorations. . . .

"Similarly, pictorial photographers also preached and practiced simplicity . . . to avoid cluttering their images with the multitude of objects indiscriminantly framed by the lens. Simple treatment usually translated into soft-focus effects that helped eliminate detail and direct the viewer's attention. 'Simplicity of tone' was also pursued, resulting in prints of a very limited, but suggestive range of greys . . . *Japonisme* was a major influence on pictorialists in making images of restraint and simplicity. . . . [Their] photographs contain all the formal attributes of Japanese art that attracted Western artists at the turn of the century: an elongated format, an asymmetrical composition and the flattening of three-dimensional space. . . . Nevertheless, their pictures radiated a strong sense of atmosphere, achieved by the use of the Japanese technique *notan*—a careful patterning of light and dark areas. . . . Pictorialists broke from the tradition of putting photographs on dark, stock mats and in heavy wood frames; instead they used light, custom-made mounts, and simple narrow moulding. . . . Quality publications like Alfred Steiglitz's *Camera Notes* and *Camera Work* usually presented their superb photographic illustrations mounted on one or more layers of paper to replicate the appearance of the originals. . . .

"The heightened attention pictorialists paid to the presentation of individual pieces was also evident in the appearance of their exhibitions. Emulating both the aesthetics and the philosophy of the Arts and Crafts movement, creative photographers created exhibitions that were unified entities, installing their work on neutral backgrounds in simple surroundings with ample viewing space. Pictorialists and craftsmen alike revolted against the 'kaleidoscopic effect' of nineteenth-century exhibitions where a plethora of pictures indiscriminately packed the walls, 'tier upon tier,' surrounded by heavy architecture and dusty draped materials. . . . Alfred Stieglitz was probably most successful at creating what might be termed the 'exhibition beautiful.' Utilizing work primarily by photographers in his Photo-Secession group, Stieglitz produced unrivalled installations at extablished American art museums and in his own New York City gallery, '291.'. . . . Every installation at '291' was coherant and beautiful, in part because of the gallery itself. . . . This environment typified the look and feel of an ideal Arts and Crafts interior—simple, warm and comfortable. Photographs were hung in a single row, the colours and fabrics were natural (including curtains made by Edward Steichen's wife, Clara), and the few decorations served as visual accent marks. . . .

"Besides elevating standards of interior design, pictorial photography encouraged a marked improvement in the work of the nation's commercial and professional photographers. In addition, pictorial images were widely reproduced in popular books and magazines, thus advancing the art of photographic illustration. Craftsmen, too, were instrumental in changing graphic design in America. . . .

"The most significant example of an Arts and Crafts designed photographic publication was Stieglitz's sumptuous journal *Camera Work,* over which he labored in true craftman style. Highly regarded during the years it was published, from 1903 to 1917, *Camera Work* is still considered the most well-produced periodical in the history of photography. . . . The text was letter-press printed in justified old-style type on thick, hand-made paper with deckle edges. . . . Heavy black ink, ornamental initials, capitalized heads, and characteristically wide margins were evidence of a layout inspired by William Morris and used by most small presses. The cover of the magazine, designed by the Photo-Secession photographer Edward Steichen, also reflected the Arts and Crafts aesthetic. Consisting of three well-proportioned rectangles of artistic type carefully arranged on a flat field of textured paper, Steichen's design was both simple and elegant. . . . Printed grey on grey, it had all the understated refinement of a Japanese print. . . . Stieglitz conceived of copies of *Camera Work* as pieces of collectable bookmaking: he printed them in limited quantities and priced them far above other photography journals. His standards of quality were exacting, and all the craftsmen who assisted him (from papermakers to binders) were acknowledged at the back of the magazine. . . .

"This union of the artistic with the commonplace was central to both pictorial photography and the Arts and Crafts movement in America. While craftsmen wished to express art in everyday life and utilitarian objects, pictorialists used the lowly camera to produce works of creative art. Both groups looked to nature for inspiration, pro-

ducing work of startling simplicity and organic unity. And their handsome objects and images elevated design standards and artistic taste throughout society. Pictorial photography and the Arts and Crafts were wide and popular movements that embraced educational reform and the involvement of women. The coincidence of their timing was matched only by the compatibility of their individuals, institutions, and ideals."

"What Remains?" (1911)
Sadakichi Hartmann*

"The photographic exhibition at the Albright Art Gallery is a thing of the past. There are many rooms in that white marble mansion, and they will be devoted as heretofore to the display of art in all its varied aspects. But its hospitable doors may never swing open again for a similar array of photographic prints. It was not an ordinary exhibition, this November show at Buffalo. It was a conquest, the realization of an ideal. Its triumph will rarely be repeated and even if repeated will assume a different aspect. It is not my intention to dwell upon any official reports of this successful venture. It is not a question of favorable comments or the number of visitors that availed themselves of the intellectual treat. They fail to tell the story. May it suffice to say that the general consensus of opinion agreed that pictorial photography had never been presented to the public in so effective, comprehensive, and beautiful a manner. I endorse this estimate with absolute sincerity. I have seen numerous exhibitions, photographic and otherwise, but I do not remember any which excelled this one in clarity and precision of presentation. This is now a matter of history and its harmony of lines, the charm of its individual exhibits, and the artistic excitement which was evident in assembling them, are merely a memory.

"After hearing a symphony the score remains. After seeing a play the text remains. An exhibition, as soon as it is dispersed, leaves nothing but the general impression and a few cherished recollections, that we may realize again according to their general sensitiveness and strength.

"What is it that remains of the exhibition? Of what significance is photography artistically in these days of eclectic art expressions? This, I maintain, is what interests the true lover of photography most of all. Questions like these have nothing to do with the style of presentation, of mounting, hanging, and the exquisite proportions of the exhibition halls. It is the print itself, stripped of all embellishment, and the eye, brain, and hand behind it which must tell the story.

"I believe the old cry "art for art" has become meaningless. That some pictorialists have fashioned for themselves a personal mode of expression is an established

*Sadakichi Hartmann. *The Valiant Knights of Daguerre.* ed. Henry W. Lawton and George Knox. Berkeley: University of California Press, 1978.

fact. . . . The contention has become a much subtler one. What we would like to fathom is what photography can do better than any other monochrome medium, not what it may do eventually, but what it has done. . . . Photographic draftsmanship commands three technical preferences which are always evident when photography is at its best. . . . **1.** The image is actually drawn by light, and no other black and white medium can compete with this conveyance of the actual flow and shimmer of light, as it flits from object to object to the deepest shadows, still capable of preserving a degree of delicacy in the most solid black. . . . **2.** Line is invariably suggested by the gradation of tonal planes. Precise or blurred, it is drawn entirely by the differentiation of values. This absence of actual line is possible also in other mediums but achieved only with great difficulty, while it is natural to photography and consequently one of its most powerful characteristics. . . . **3.** As it is impossible to emphasize line except by juxtaposition of values . . . tone (a subtle variation of hues within one tint) is one of the most favorable formulae of photographic picture-making. . . . Tone in this sense has never been produced with equal perfection except by American wood engraving. . . .

"In subject matter the studio print and landscape photography have advanced but few new themes, if any have been brought out. They are borrowed largely from the other arts. It is the men who have preferred the city streets, the impressionism of life, and the unconventional aspects of nature to costuming and posing, who have occasionally enriched our wealth of pictorial impressions. In many instances they have discovered and subdued new and unusual motifs and improvised upon the laws of composition with the skill of true virtuosos. I refer particularly to Stieglitz's skyscrapers and dock scenes. . . .

"One can hardly say that photographic picturemaking up to this day has revealed much of spiritual gravity. It is mobile and complete, but not splendidly audacious conceptually. Only in rare instances does it reflect actual mentality. . . . Perhaps this is a limitation of the pictorial print of portfolio size. Its masterpieces may be defined as perfect beauty of visional appreciation joined to perfect beauty of technical expression. Elaborate figure compositions belong rather to the domain of snapshot photography. It is the single image, the attitude of a figure, the tonal fragment, a glass among shadows, a fleeting expression or some atmospheric condition, which adds something to our consciousness of beauty. . . .

"But there was something else which could not be seen, but only felt, which emanated as it were from the walls, and which pervaded the entire exhibit. It is difficult to express in words. . . . It can only be the result, I mused, or the natural exaltation of a mind free from prejudices . . . solely as the pursuit of some lofty ideal. And I must confess that I have never met a group of men who have taken their vocation more seriously and disinterestedly than these pictorialists. . . .

"Like the delicious odor in some mirrored cabinet that lingers indefinitely for years, this spirit will not fade. It will be remembered long after individual efforts have lost their immediate usefulness. The few masterpieces will remain, the rest will be forgotten, but the spirit will continue to remain an active force, and produce fresh impressions of light and tone, of form and grace."

"Is Photography a New Art?" (1908)
*Roland Rood**

"When photography was first discovered, and it was realized that machinery and chemicals could make what had hitherto been held to be exclusively the product of man's most superior faculties, many asked the question, 'What will the artists do when this process becomes more nearly perfected?' The amazement at the almost magical result that had been achieved was so great that enthusiasm, and expectation of further and equally startling revelations, knew no bounds. Perfect results in color were confidently expected to follow shortly—then the artists were to go into bankruptcy. The painters for their part denied the possibility of machinery ever producing art, they engaged in controversy with the photo-enthusiasts, and argued the case endlessly.

"This was in the first part of the last century. What is said of photography now? Are the portrait- and landscape-painters told that their doom is sealed, and that when color photography shall be discovered, their stuff will no longer be a desideratum? To the contrary, the word photographic, in the minds of the general public, is synonymous with pedantic exactitude, illogical selection, absence of imagination, and feeling in general; in fact, anti-art. Of course, as everyone interested in pictorial photography knows, there are little oases like the Secession, and corresponding European organizations, in which the tradition that photography is an art is still kept up; but, as a widespread rule, the discussion is looked upon as closed—the public has made up its mind, and so far to the other extreme has its feeling swung, that even painters dare not say that they sometimes use the camera as an aid to their work for fear of being thought inartistic.

"Now it appears to me that the whole discussion as to whether photography is or is not an art has always been, and is still being, conducted on an illogical basis. The question rightly put is, 'Is photography one of the fine arts?' To either prove or disprove this question, the disputants have always entered upon long definitions of painting, etching, charcoal, water-color, and what not, in order to find what resemblemces or dissemblences there were between these arts and photography. But on the face of it, this method of reasoning is fallacious, for the question asked is not, 'Is photography one of the graphic arts?' but is, 'Is photography one of the *fine* arts?'—and even if it can be proven beyond doubt that photography is not one of the graphic arts, it does not at all follow that it is not one of the fine arts. The conclusion I have come to after much investigation is that photography is not one of the graphic arts, but that it is one of the fine arts, and more closely allied to architecture than to painting. To prove my point, I will ask the reader to follow me through a short analysis of the different fine arts. . . ."

"It will be seen from this analysis that the fine arts differ from each other, not in

**Camera Work*, 21, January 1908, pp. 17–22.

that their components are totally unlike each other, but more in that the proportions of these components vary in quantity. Music and dancing have much to do with time; poetry, a little less; sculpture, still less, and painting, not at all. Poetry has much to do with literary thought; painting, a great deal less; dancing, and sculpture, still less, and music, not at all. Poetry and music are independent of the space-element; sculpture and dancing could not exist without it, and painting makes believe it possesses it. None of the fine arts possess all of the possible qualities, but each has at least one quality in common with another, and thus they all blend into each other, sometimes so subtly that it is impossible to tell where one begins and the other ends.

"It would appear, however—at least according to the dictum of many learned philosophers of many ages—that there is one quality which all arts must possess, and that is what is termed the personal touch. I concede that proposition, but as almost the whole controversy as to whether photography is or is not a fine art, has turned on this single point, let us make an inquiry as to what the nature of this 'personal touch' is. . . . What is, and has always been, wrong, is the conception photographers attach to the term, personal touch. There are two meanings of the word: the first is the kind . . . of which the orator has the most; the sculptor, very little, and the architect, none—the corporeal touch. The second is the true and philosophic meaning, namely, to create with the brain, and bring into concrete existence . . . as by the hand. But to give life by the touch of the hand does not at all imply that, after life has been given, any evidence of how it was produced shall remain—in architecture . . . it is eliminated, and whole schools of even the graphic arts, as the Asiatic, demand that the personality of the creator shall be suppressed as much as possible.

"And what does creation by the brain, and bringing into existence by the hands, mean? It means only one thing—composing. Man cannot truly create; but he can stick things together in such a way as to illude into the belief that he has created; and it is this esthetic quality of composition which all the fine arts must possess, but is the only one which they must possess in common. . . . Now just why a series of facts, possibly commonplace enough in themselves, and entirely uninteresting in the combinations they are usually found in nature, should suddenly become interesting when 'composed,' nobody knows. Why the same rocks, fields, trees, and sky seen from one point of view should look ordinary, but when looked at from another, should tell a story which affects to our innermost depths, is a mystery that has never been solved. . . . Therefore, all we can say is, that to compose is to give order. The sculptor and architect give order through lines and proportions, and light and shade. . . . The painter produces order through lines and colors, and also by means of that peculiar *painter touch,* which those entering photo-polemics have so frequently mistaken for the true personal touch. The musician orders through sounds and silences, leading the mind, we know not how, agreeably from one note to the other. All art is a matter of order, and nothing else, and where order has been produced, art has been produced. . . .

"The conclusion, then, that we have come to is, that photography is one of the fine arts, but no more allied to painting than to architecture, and quite as independent

in the series as any of the other arts. As a necessary corollary, photography can not be pictorial, any more than music or oratory. Photography is photography, neither more nor less."

Camera Work; Social Work. (1989)
*Allen Trachtenberg**

"Why did it take so long for Hine's radically reformative achievement to win recognition? Why even today is he still described as a "documentary" photographer, confined to that limiting category, as if his work consisted only of making illustrations for a future history textbook, rather than the making of a new order of social art in photography? We cannot enter directly into Hine's work, into its historical place, except through pathways indicated by these questions. For example, the matter of his recognition leads to questions about the instruments and institutions of fame, the forms of cultural authority through which decisions are made and communicated—decisions to exhibit, publish, interpret in certain ways. . . .

"Hine cannot be seen historically except in light of his reception and belated acceptance in the 1930s. He cannot be seen and understood as a maker of American photographs, a figure in the evolution of American photographs, except in light of the emergence of a field of serious photography after the heroic age of Brady, Gardiner, and O'Sullivan. He cannot be seen and grasped except in the light of Alfred Stieglitz. . . . Both a photographer and an arbiter of value in photography, Stieglitz built the first major institutions of art photography in America—his gallery known as "291," and his journal, *Camera Work*—institutions which took no notice of Hine, although Hine took notice of them. Both gallery and journal closed in 1917, but they had established both an idea of seriousness in photography and a method (small gallery exhibition and fine-art publication), which gained strength in the 1920s and provided the capital of theory and strategy (for example, winning access to metropolitan museum collections and exhibition spaces) upon which the expanding photographic community in the 1930s drew. Stieglitz, what he represented, provided the terms through which Hine gained his recognition in the 1930s, and through which he has, on the whole, been seen and understood since. . . .

"Hine performed his artistic labors within the institutional framework of Progressive reform movements, structures which included organized networks of association, publications, systematic methods of investigation and communication, and an ideology which sought to control what were perceived as anarchic, destructive forces let loose in America by urban industrial capitalism. Progressivism was a movement of

*Allen Trachtenberg, *Reading American Photographs*. New York: Hill and Wang, 1989. Copyright © 1989 Allen Trachtenberg.

reform, not revolution; it saw itself as a liberal alternative to revolutionary change of the sort proposed by the socialist movement, which in these years, under Eugene Debs, had grown in size and influence. Many socialists participated in reform movements, but the thrust of the liberal outlook Hine endorsed was toward legislative change fostered by an enlightened and activated public opinion—correctives in the system in order to mitigate conflict in the name of presumed American values of equality, justice, and progress. . . . If the Civil War represented a life-and-death threat to the values Brady celebrated in his Gallery of Illustrious Americans, the social crisis to which Progressivism responded in the early twentieth century represented another (as would the Depression of the 1930s). And Hine can be seen as engaged in a project similar to Brady's in its ends, though thoroughly different in its methods: to promote a liberal idea of America through photographs in order to reshape reality in liberalism's image.

"In light of Hine's photographic social work, Stieglitz's camera work takes on a sharper historical outline. The issues between them concern, broadly speaking, the notion of a photographic subject, the relation of the medium to American realities, and the effect of photographs upon their audiences. Hine's stance toward America was critical but hopeful—critical of social and economic injustices in view of conventional American values of common sense and fair play. His typical method was to show contradiction between the rhetoric and the reality of American life. . . . Stieglitz's stance is less simple to define: critical of business culture to the point of cynicism, but more attached to aesthetic, individualist alternatives than to social or political solutions. In the late teens and 1920s an influential group of intellectuals who found reformist liberalism too pragmatic . . . celebrated Alfred Stieglitz as an American idealist in the tradition of Emerson and Whitman, an advocate of freedom in the arts (he had championed modernist nonrepresentational art at "291") and of the autonomy of individuals. . . . Stieglitz stood at the center of a movement which sought to produce a new American art and culture, a movement openly critical of the aggressive commercialism, hypocritical moralism, and empty conventionality of the reigning culture. . . .

"Hine diverged from Stieglitz's romantic modernism in two key regards: he saw himself not as an individual genius breaking convention but as a working photographer performing a certain kind of cultural (and political) labor; he focused his work not on the photograph in exhibition but on the published image—not the single photograph as a fine print (its tonal values intact), but on the published image within an ensemble of images and words. The word "documentary," regularly applied to Hine's pictures, fails to capture the full character of his work and consciously held theory informing it. Rather than "art" versus "documentary" photography, what distinguishes Stieglitz's camera work from Hine's social work are competing ideas of art itself, and of the cultural work of the camera in early twentieth-century America. . . . Social workers sought to relieve social pressures by combining direct help to the poor with legislative correction or "reform" of injustices such as child labor. Hine would make pictures to raise public awareness of social conditions among the working-classes, and in the process he developed a new style of depicting city life, its working-class streets and homes. . . .

"American photography split over the fundamental question: What made for "art" in photography?. . . . Thus the paradox that the most ardent and influential American spokesman for photography propagated the notion, at least implicitly, that there was no photographic art in America of any importance before the self-conscious pictorialism he himself represented. Stieglitz's influence on thinking about the history of the medium proved decisive. . . . Largely through Stieglitz's influence, a polarized language entered photography criticism: factual reporting versus personal expression; art versus document. As editor, collector, gallery keeper, and occasional curator, Stieglitz selected pictures which met criteria not only of form but of intention—pictures made deliberately for exhibition or display as art. . . . Moreover, pictorialism . . . assumed one had to *be* an artist, to possess a certain sensibility and genius, in order to make it. Only a conscious effort to defeat and transcend the factual report which lurks in all photographs can lead to art. An art of the literal and the useful seemed to the pictorialists a contradiction in terms. . . .

"Stieglitz and his followers oversimplified the question of art in photography. Their real thrust lay not in their claim that photographs can be art pictures, but in their legislation of what is and is not art, their identification of "aesthetic" with certain formulas, Symbolist, Impressionist, or modernist—and their isolation of the aesthetic from social functions. . . . The pigeonholing of Hine as a "documentary" photographer exemplifies the reductive simplification of the Stieglitz line in criticism and history. The polarized vocabulary of art and document cannot account for the originality and force of Hine's pictures. It also fails to account for the special qualities of Stieglitz's own pictures, which are better understood when removed from the honorific category of art and viewed in the light of the era in which they were made. The idea of fine art belongs to the institutional superstructure of presentation rather than to the inner character of Stieglitz's pictures. The same is true of Hine's rhetoric of "social photography.""

"On the Invention of Photographic Meaning." (1975)
*Allan Sekula**

"The meaning of a photograph, like that of any other entity, is inevitably subject to cultural definition. The task here is to define and engage critically something we might call the "photographic discourse." A discourse can be defined as the arena of information exchange, that is, as a system of relations between parties engaged in communicative activity. In a very important sense, the notion of discourse is a notion of

**Art Forum*, Vol. XIII no. 5., Jan 1975, pp. 36–45. The essay will be reprinted in its entirety in Allan Sekula, *The Traffic In Photographs*, M.I.T. Press, forthcoming. Copyright © Allan Sekula.

limits. . . . All communication is, to a greater or lesser extent, tendentious; all messages are manifestations of interest. No critical model can ignore the fact that interests contend in the real world. We should from the start be wary of succumbing to the liberal-utopian notion of disinterested "academic" exchange of information. The overwhelming majority of messages sent into the "public domain" in advanced industrial society are spoken with the voice of anonymous authority and preclude the possibility of anything but affirmation. . . . With this notion of tendentiousness in mind, we can speak of a message as an embodiment of an argument. In other words, we can speak of a rhetorical function. . . . We might formulate this position as follows: a photograph communicates by means of its association with some hidden, or implicit text; it is this text, or system of hidden linguistic propositions, that carries the photograph into the domain of readability. (I am using the word "text" rather loosely; we could imagine a discourse situation in which photographs were enveloped in spoken language alone.)

"Photographic "literacy" is learned. And yet, in the real world, the image itself appears "natural" and appropriate, appears to manifest an illusory independence from the matrix of suppositions that determines its readability. Nothing could be more natural than a newspaper photo, or, a man pulling a snapshot from his wallet and saying, "This is my dog." Quite regularly, we are informed that the photograph "has its own language," is "beyond speech," is a message of "universal significance"—in short, that photography is a universal and independent language or sign-system. Implicit in this argument is the quasi-formalist notion that the photograph derives its semantic properties from conditions that reside within the image itself. . . . The photograph is imagined to have a primitive core of meaning, devoid of all cultural determination . . . [but] . . . any meaningful encounter with a photograph must necessarily occur at the level of connotation. The power of this folklore of pure denotation is considerable. It elevates the photograph to the legal status of document and testimonial. It generates a mythic aura of neutrality around the image. . . . Photographs are used to sell cars, commemorate family outings, to impress images of dangerous faces on the memories of post-office patrons, to convince citizens that their taxes did in fact collide gloriously with the moon, to remind us of what we used to look like, to move our passions, to investigate a countryside for traces of an enemy, to advance the careers of photographers, etc. Every photographic image is a sign, above all, of someone's investment in the sending of a message. Every photographic message is characterized by a tendentious rhetoric . . . in short, the overall function of photographic discourse is to render itself transparent. But however the discourse may deny and obscure its own terms, it cannot escape them . . . We need a historically grounded sociology of the image, both in the valorized realm of high art and in the culture at large. What follows is an attempt to define, in historical terms, the relationship between photography and high art. . . .

"In other words, the photograph, as it stands alone, presents merely the *possibility* of meaning. Only by its embededness in a concrete discourse situation can the photograph yield a clear semantic outcome. Any given photograph is conceivably open to appropriation by a range of "texts," each new discourse situation generating its own set of messages. We see this happening repeatedly. . . . Hine prints that originally ap-

peared in social-work journals reappear in a biographical treatment of his career as an artist only to reappear in labor-union pamphlets. Furthermore, it is impossible even to conceive of an *actual* photograph in a "free-state," unattached to a system of validation and support, that is, to a discourse. . . .

"How, then are we to build a criticism that can account for the differences or similarities in the semantic structures of the Hine and Stieglitz photographs?. . . . The question to be answered is this: what, in the broadest sense, was the original rhetorical function of the Stieglitz and the Hine?

"Stieglitz's *Steerage* first appeared in *Camera Work* in 1911 (Fig. 1.6). *Camera Work* was solely Stieglitz's invention and remained under his direct control for its entire 14-year history. It is useful to consider *Camera Work* as an artwork in its own right, as a sort of monumental container for smaller, subordinate works. In a profound sense, Stieglitz was a magazine artist; not unlike Hugh Hefner, he was able to shape an entire discourse situation. The covers of *Camera Work* framed avant-garde discourse, in the other arts as well as photography, in the United States between 1903 and 1917, and whatever appeared between those covers passed through Stieglitz's hands. Few artists have been able to maintain such control over the context in which their work appeared.

"Through *Camera Work* Stieglitz established a genre where there had been none; the magazine outlined the terms under which photography could be considered art, and stands as an implicit text, as scripture, behind every photograph that aspires to the status of high art. . . .

"The point quite simply is this: the photographs in *Camera Work* are marked as precious objects, as products of extraordinary craftsmanship. The very title *Camera Work* connotes craftsmanship. This may seem like a trivial assertion when viewed from a contemporary vantage point—we are by now quite used to "artful" reproductions of photographs. But it was *Camera Work* that established the tradition of elegance in photographic reproduction; here again is a clear instance of sign emergence. For the first time the photographic reproduction signifies an intrinsic value, a value that resides in its immediate physical nature, its "craftedness." The issue is not trivial; consider the evolving relationship between craftsmanship and the large-scale industrial reproduction of images in the nineteenth and early twentieth centuries. With the invention of the ruled cross-line halftone screen in the late 1880s photographs became accessible to offset printing, allowing rapid mechanical reproduction of photographic copy. *Camera Work's* 14-year history parallels the proliferation of cheap photographic reproductions in the "mass" media. By 1910 "degraded" but informative reproductions appeared in almost every illustrated newspaper, magazine, and journal. Given this context, *Camera Work,* stands as an almost Pre-Raphaelite celebration of craft in the teeth of industrialism. . . .

"With all this said, we can return finally to Lewis Hine. Hine stands clearly outside the discourse situation represented by *Camera Work;* any attempt to engage his work within the conditions of that discourse must necessarily deprive him of his history. . . . The original discourse situation around Hine is hardly esthetic, but politi-

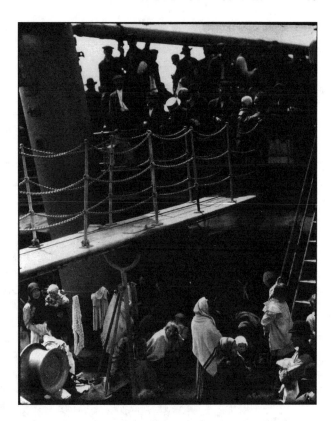

Figure 1.6 Alfred Stieglitz.
The Steerage, 1907.
Photogravure.
Courtesy George Eastman House.

cal. In other words, the Hine discourse displays a manifest politics and only an implicit esthetics, while the Stieglitz discourse displays a manifest esthetics and only an implicit politics. A Hine photograph in its original context is an explicit political utterance. As such, it is immediately liable to a criticism that is political, just as *The Steerage* is immediately liable to a criticism that is political. . . .

"A photograph like *Immigrants Going Down Gangplank* is embedded in a complex political argument about the influx of aliens, cheap labor, ghetto housing and sanitation, the teaching of English, and so on. But I think we can distinguish two distinct levels of meaning in Hine's photography. These two levels of connotation are characteristic of the rhetoric of liberal reform. If we look at a photograph like *Neil Gallagher, Worked Two Years in Breaker, Leg Crushed Between Cars, Wilkes Barre, Pennsylvania, November 1909* (Fig. 1.7) . . . we can distinguish the two connotations. . . . *Gallagher* is standing next to the steps of what looks like an office building. His right hand rests on a concrete pedestal, his left leans on the crutch that supports the stump of his left leg. About fifteen, he wears a suit, a cap and a tie. He confronts the camera directly from the center of the frame. Now I would argue that this photograph and its caption

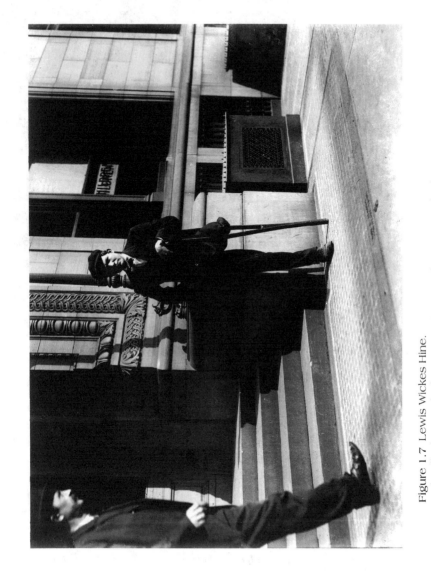

Figure 1.7 Lewis Wickes Hine.
Neil Gallagher, Worked Two Years in a Breaker. Leg Crushed Between Cars.
Wilkes-Barre, Pennsylvania, November 1909.
Gelatin-silver print.
Library of Congress, Prints and Photographs Division, National Child Labor
Committee Collection, LC H5-954.

have the status of legal document. The photograph and text are submitted as evidence in an attempt to effect legislation. The caption anchors the image, giving it an empirical validity, marking the abuse in its specificity. At the same time, Neil Gallagher stands as a metonymic representation of a class of victimized child laborers. But the photograph has another level of meaning, a secondary connotation. . . . What is connoted finally on this secondary level is "the dignity of the oppressed." *Neil Gallagher,* then, functions as two metonymic levels. The legend functions at both levels, is both an assertion of legal fact and a dispensation of dignity to the person represented. Once anchored by the caption, the photograph itself stands, in its typicality, for a legally verifiable class of injuries and for the "humanity" of a class of wage laborers. What I am suggesting is that we can separate a level of *report,* of empirically grounded rhetoric, and a level of "spiritual" rhetoric. . . .

"Hine is an artist in the tradition of Millet and Tolstoy, a realist mystic. His realism corresponds to the status of the photograph as report, his mysticism corresponds to its status as spiritual expression. What these two connotative levels suggest is an artist who partakes of two roles. The first role, which determines the empirical value of the photograph as report, is that of *witness.* The second role, through which the photograph is invested with spiritual significance, is that of *seer,* and entails the notion of expressive genius. It is at this second level that Hine can be appropriated by bourgeois esthetic discourse, and invented as a significant "primitive" figure in the history of photography.

"I would like to conclude with a rather schematic summary. All photographic communication seems to take place within the conditions of a kind of binary folklore. That is, there is a "symbolist" folk-myth and a "realist" folk-myth. The misleading but popular form of this opposition is "art photography" vs. "documentary photography." Every photograph tends, at any given moment of reading in any given context, toward one of these two poles of meaning. The oppositions between these two poles are as follows: photographer as seer vs. photographer as witness, photography as expression vs. photography as reportage, theories of imagination (and inner truth) vs. theories of empirical truth, affective value vs. informative value, and, finally, metaphoric signification vs. metonymic signification.

"It would be a mistake to identify liberal and "concerned" documentary entirely with realism. As we have seen in the case of Hine, even the most deadpan reporter's career is embroiled in an expressionist structure. From Hine to W. Eugene Smith stretches a continuous tradition of expressionism in the realm of "fact." All photography that even approaches the status of high art contains the mystical possibility of genius. The representation drops away and only the valorized figure of the artist remains. . . .

"The celebration of abstract humanity becomes, in any given political situation, the celebration of the dignity of the passive victim. This is the final outcome of the appropriation of the photographic image for liberal political ends; the oppressed are granted a bogus Subjecthood when such status can be secured only from within, on their own terms."

EXCERPT FROM:

"Atget and the Art of Photography." (1981)
John Szarkowski*

"Eugenè Atget was a commercial photographer who worked in and around Paris for more than thirty years. When he died in 1927, his work was known in part to a few archivists and artists who shared his interest in the visible record of French culture. Little is known about his life, and less about his intentions, except as they can be inferred from his work.

"In his lifetime Atget made perhaps ten thousand photographs; almost all of these describe the historic character of French life, as indicated in its architecture, its landscape, its work, and its unconsidered, vernacular gestures. To many photographers today his work stands not only as a heroic and original achievement, but as an exemplary pedagogical lesson, the full implications of which are even now only intuitively perceived.

"One might say that the mystery of Atget's work lies in the sense of plastic ease, fluidity, and responsiveness with which his personal perceptions seem to achieve perfect identity with objective fact. There is in his work no sense of the artist triumphing over intractable, antagonistic life; nor, in the best work, any sense of the poetic impulse being defeated by the lumpen materiality of the real world. It is rather as though the world itself were a finished work of art, coherent, surprising, and well constructed from any possible vantage point, and Atget's photographs of it no more than a natural and sweet-minded payment of homage. . . .

"It is now clear that Atget built his collection not through the random accumulation of subjects that interested him, but rather by the systematic exploration of topics that were consciously chosen for their relevance to one abiding idea: the creation of a body of photographs that would describe the authentic character of French culture.

"Throughout his career, Atget added new topics to those already in process. Some of these were pursued briefly or fitfully; others were continued throughout his lifetime. The most rewarding topics evolved and changed their nature through the years, accommodating themselves to the growing simplicity and gravity of Atget's perceptions. The subjects that fulfilled these topics became with the years less categorical, more plastic and relative, their meanings dependent upon growth and decay, season, quality of light, point of view, on the unreplicable reality of a given moment. Subjects of this kind were in their nature inexhaustible, as long as the photographer's attention held.

"The intensity of Atget's attention might be measured by the frequency with

which he returned to certain families of subject matter. He loved dooryards, with their climbing vines, window boxes, caged canaries, and worn stone doorsteps; and courts with neighborhood wells in them, immemorial centers of sociability, news, and contention. Atget's pictures describe such places with a sharp but tactful scrutiny. They define a meeting ground between domestic and civil life, the innermost plane of the private person's public face.

"To pictures such as these Atget often assigned the general term *coin,* a word, in Atget's meaning, for which the word "corner" is too bald and geometric a translation and "nook" or "cranny" too quaint. Of these options "corner" is perhaps the best, if one thinks of that word as meaning a place where one turns and changes one's orientation, not necessarily to a different point of the compass, but to a different human pace and atmosphere. These pictures describe sites of social transition and transaction, places where we might meet a friend or a stranger, and say a graceful or a gauche thing. . . .

"Throughout his career Atget was fascinated by trees of all types and functions; on many occasions he revisited the same tree or grove in different years and seasons, knowing that a tree would not twice propose the same problem. Perhaps more clearly than any other segment of Atget's work, these pictures illuminate Atget's original and profoundly photographic understanding of the idea of the pictorial subject.

"The history of Western painting, as perceived by recent generations, has led us to assume that the subject exists prior to the picture, that it is a point of departure, a known given, the raw material on which an artist acts, violently or subtly, in order to produce a work of art. We know that there are no two Crucifixions or still lifes with apples or abstractions that share the same content; nevertheless we refer to these approximate iconographic categories as subjects of specific pictures.

"We will better understand the art of photography if we approach the question differently. Let us say that the subject of the photograph is not the photographer's starting point, but his stopping place. Let us say that the true subject of the photograph is the same as—is identical with—its total content. Then the photographer's problem will be seen to be not the revision of a received model, but the discovery and precise definition of a new subject—a coherent idea, plucked from an inchoate sea of subject matter.

"The photographer seeks his subject in what seems promising cover. The boundaries that encompass his search can be formal, intellectual, or psychic; they can be broad or narrow; they can be defined intuitively, to meet the needs of the photographer's spiritual life, or intellectually, to meet his understanding of a social or cultural role. On the record of the past, no one of these opinions would seem more likely than the others to assure either success or failure. Alfred Stieglitz (like Thoreau, who boasted that he had traveled much in Concord) found ample range within limits circumscribed by the reach of his private affairs. Atget worked within boundaries defined in rigorously impersonal terms. But the success of each man's effort depended finally not on the superiority of his concept, but on the grace of his intuition. In the hands of smaller talents, Stieglitz's idea has grown large market gardens of indistinguishable narcissus, and Atget's, desiccated catalogs of archaeological data. No philosophical

rubric will lead the photographer to an image that describes a new subject; at best it will tell him when he has arrived at his own proper hunting ground. . . .

"The idea was once prevalent (although strenuously contradicted, most clearly by Bernice Abbott) that Atget was a primitive, in the popular sense of that term—a kind of idiot-savant, who made splendid pictures that were beyond the reach of his own comprehension. . . . Atget can now be seen to represent not the ahistorical principle of the lonely and eccentric genius, but a flowering of coherent traditions of nineteenth-century French photography and French intellectual life. . . . By Atget's own time, the photographing of architectural monuments and places of historic or cultural resonance was a firmly established professional specialty, and several excellent photographers in Paris competed with Atget for the favor of the same clients. When they photographed similar subject matter, their work sometimes looked much like Atget's. . . .

"And yet, after he has been thus clearly placed, the best of his pictures remain as mysterious as before, transcending both the categorical functions that they presumably served and the past out of which they grew. The character of his oeuvre, taken as a whole—for the breadth and generosity of its imagination and the precision of its intel-ligence—can be confused with that of no other photographer.

"Nevertheless, to our eyes it would seem simpler and more reasonable if Atget's work had been done by at least two photographers—one who worked with a perceptive but rather pedestrian intellect and another who saw the world with the sure intuitions of a great lyric poet. For us, perhaps 20 percent of Atget's work attains the kind of for-mal surprise or original grace by which we identify a successful work of modern art. Another, larger segment of the work is deeply nourishing in terms of the subtlety and responsiveness of its photographic sensibility. This leaves us with something like half the work which, viewed alone, we might guess to be the product of a representative, if somewhat eccentric, professional photographer of that time and place. . . .

"To these considerations it should be added that in a photograph failure is final. To the degree that we believe in a photograph as factual, it cannot escape far from its first conception. It cannot be significantly revised or recast except by beginning again. Thus for a photographer every decision of high consequence begins with an empty sheet, and the process of revision is carried forward not on the physical body of a sin-gle picture, but in the photographer's mind, during the interstices between pictures.

"For these reasons a photographer's oeuvre, if studied from too close a viewing distance, may, like a tapestry, appear to form an irresolute or random pattern. But if we step back we may see another pattern, composed of broader forms. . . .

"Much of Atget's most beautiful and original work was done in his last years, as he approached seventy. This is exceptional in the history of photography, which gener-ally shows a very different and cruel pattern of success. With few exceptions, the best photographers have completed their original contribution within a very short time—of-ten within a decade. There have of course been many photographers who have sus-tained a high level of achievement over extended periods, but their work has rarely grown in concept, and extended its grasp of photography's creative potentials, for more than a few years.

"Two photographers who might seem the most conspicuous exceptions to the general rule—Alfred Stieglitz and Edward Steichen—did indeed escape the common pattern, but they did so not by sustaining and developing a single, coherent impulse, but rather by being repeatedly born again—by living a series of almost independent careers, one after the other, as though each man was his own dynasty. Perhaps a more telling exception is Edward Weston, whose mature work grew in stature and richness, and changed in spirit, over more than twenty years, without self-contradiction or fracture of continuity, until it was finally slowed and stopped by illness. . . .

"There is at the heart of Atget's work a profound paradox. The premise on which the work was based and the function to which it aspired depend on our acceptance of the objective reality of the past: we are to believe that these facts are not only true but significant, that each picture refers to events that were part of the meaningful narrative that we call history. And yet the photographs themselves, the means by which this past is reported to us, are formed not in accordance with disinterested and repeatable rules, but according to the mysterious promptings of an individual sensibility. The photographs in fact insist on demonstrating their own historical capriciousness, by showing us that an ancient tree or stone wall is never twice the same, and by delighting us with the recognition of the anarchistic truth.

"Granting this, we are still not tempted to say of Atget that his subject matter was merely the material from which he invented a private world. The demeanor of his work—its air of rectitude and seriousness—and the quality in it of wonder and deep affection persuade us of Atget's untroubled faith in the coherence and logic of the real world. Poetic intuition was the means by which he served the large, impersonal truth of history. In artistic terms, if not in those of logic, this strategy would work, if the photographs themselves could resemble in their own lineaments, in their own invisible style and structure, the mute disinterest of ancient things."

PHOTOGRAPHERS FROM THE PERIOD 1900-1920

Editor's Note

This list and the ones that follow at the end of each chapter provides the names, and if known, the dates and nationalities of twentieth-century photographers you might wish to research. This is not a list of all photographers worthy of study, but rather is a list of photographers the authors deem worth studying. If you are interested in a particular subject in photography, an encyclopedia article should guide you to photographers in that area. A number of general reference books on photography are listed in the bibliography. Many photographers on this list will have monographs published on their work. Since much photographic literature is found in periodical sources, use your library's computer to search for literature about photographers whose work interests you. To obtain a preliminary list of periodicals about the art and art history of photography, refer to the bibliography.

The photographers are listed in the twenty-year period in which they create their first important work. Many of them retain prominence a number of decades later, or conversely, make contributions in the decade preceding their first listing.

It also is useful to study the lists in their entirety, to see how the number of photographers changes. More photographers are listed from 1960 to 1980 than in other periods. This figure coincides with the peak of the photography art market and with an increased interest in photographic collecting. The period corresponds with the institutionalization of photography in the museums and in academe. The next largest number of photographers exists in the period 1940–1960, which concurs with the apogee of the picture press and jobs in photojournalism and fashion photography, as well as other aspects of commercial photography.

Photographers whose work is significant for the study of cultural diversity are indicated with an asterisk (*). Many, but not all, of these photographs were taken by minority photographers.

1900–1920

Anderson, Paul Lewis (1880–1956), American
Annan, James Craig (1864–1946), Scottish
Arbuthnot, Malcolm (1874–1967), American
Armer, Laura Adams (1874–1963), American
Atget, Jean-Eugenè-Auguste (1857–1927), French
Austin, Alice E. (1866–1952), American
Barnack, Oskar (1879–1936), German
*Battley, Cornelius Marion (1873–1927), American
Beals, Jesse Tarbox (1870–1942), American
Beck, Heinrich (1874–1960), German
*Bedou, Arthur (1882–1966), American
Bellocq, E. J. (1895–1940), American
Ben-Yusuf, Zaida (active c. 1896–1915), American
Benda, Arthur (1886–1969), Austrian
Bonfils, Marie Lydie Cabannis (1837–1919), French
Boughton, Alice (1865–1943), American
Bragaglia, Antonio Giulio (1889–1963), Italian
Bragaglia, Arturo (1893–1962), Italian
Brigman, Anne W. (1869–1950), American
*Buechel, Eugene S. J. (1874–1954), b. Germany
Bullock, John C. (1854–1939),
Byron, Joseph (1846–1923), b. England

Casasola, Agustin Victor (1874–1938), Mexican
Coburn, Alvin Langdon (1882–1966), American
*Collins, Herbert (active 1890–c. 1920), American
*Curtis, Edward Sheriff (1868–1952), American
D'Ora, Mme. Dora Kallmus (1881–1963), Austrian
Day, F. Holland (1864–1910), American
Dayal, Raja Lala Deen (1844–1910), Indian
de Meyer, Baron Adolf (1868–1949), German
Demachy, Leon Robert (1859–1938), French
Devens, Mary (active 1898–1905), American
Drtikol, Frantisek (1883–1961), Czechoslovakian
Dubreuil, Pierre (1872–1944), French
Duhrkoop, Rudolph (1873–1929), German
Duhrkoop, Minya (1848–1918), German
Eastman, George (1854–1934), American
Echague, Jose Ortiz (active 1906–1940), Spanish
Eder, Josef Maria (1855–1946), German
*Eickemeyer, Rudolf Jr. (1862–1932), American
Einbeck, Georg (active early twentieth century), German
Emerson, Peter Henry (1856–1936), British
Emmons, Chansonetta Stanley (1858–1937), American
Eugene, Frank (1865–1936), American
Evans, Frederick H. (1853–1943), British
Fuguet, Dallet (1868–1933),
*Genthe, Arnold (1868–1942), American
Gloeden, Wilhelm von (1856–1931), German
Haviland, Paul B. (1880–1950),
Henneberg, Hugo (1863–1918), German
Hine, Lewis Wickes (1874–1940), American
Hinton, Alfred Horsley (1863–1908), British
Hoppe, Emile Otto (1868–1943), German
Jackson, William Henry (1843–1942), American
*Johnson, Frances Benjamin (1864–1952), American
Johnston, John Dudley (1868–1955), British
*Kasebier, Gertude (1852–1934), American
Keighley, Alexander (1861–1947), British
Keiley, Joseph Turner (1869–1914), British
Kuehn, Heinrich (1866–1944), Austrian
Lartigue, Jacques-Henri (1894–1986), French
Leeson, Adelaide Hanscom (1876–1932), American
Lumière, Auguste (1862–1954), French

Lumière, Louis (1864–1948), French
Martin, Paul (1864–1944), British
*Miner, Leigh Richard (1864–1935), American
Montserrat, Tomas (1873–1944), Spanish
Nicholls, Horace W. (1867–1941), British
Perscheid, Nicola (1864–1930), German
Ponting, Herbert (1871–1935), British
Prataprao, Ramchandrarao (active early 1900s), Indian
Primoli, Count Giuseppe (1851–1927), Italian
Prokudin-Gorskii, Sergei Milhailovich (1863–1943), Russian
Puyo, Emile Joachim Constant (1857–1933), French
Rau, William (1855–1920), American
Reece, Jane (1869?–1961), American
Reutlinger, Studio (1850–1937), French
Rey, Guido (active 1890s–mid 1920s), Italian
Scharf, Otto (1858–1957), German
Schohin, Waldimir (1862–1934), Finnish
*Scurlock, Addison N. (1883–1964), American
Seeberger, Frerés (active 1905–1945), French
Shaw, George Bernard (1856–1950), British
Sipprell, Clara (1880–1975), American
*Smith, Hamilton S. (1857–1924), American
Steichen, Edward (1879–1973), American
Stieglitz, Alfred (1864–1946), American
Struss, Karl (1886–1981), German
Sutcliffe, Frank Meadow (1853–1941), British
Tournassoud, Jean (active early twentieth century), French
Underwood and Underwood (1877–1931, as firm), American
*Vroman, Adam Clark (1856–1916), American
Watson-Schutze, Eva (1867–1935), American
Watzek, Hans (1848–1903), Austrian
White, Clarence Hudson (1871–1925), American
Zille, Heinrich (1858–1929), German
Zola, Emile (1840–1902), French

*Photographers whose work is significant for the study of cultural diversity. Many, but not all, of these photographs were taken by minority photographers.

2

The Period 1920–1940

Topics Addressed

The Development of Purism by Stieglitz, Strand, and Weston • The Invention and Use of the Hand Camera, Sprocket Film and Fast Lens of the Leica and Ermanox • The Emergence of the Picture Press • The Russian Revolution, Constructivism, the Bauhaus, and Photography as a Politicized Language • The Power of Fact Develops into the Notion of Documentary in Line with the Development of the Documentary Film • Surrealism.

OVERVIEW OF THE PERIOD 1920–1940

In the two decades between 1920 and 1940, photography was affected by several interconnected revolutions. One revolution was aesthetic. The international "art photography" movement collapsed—its aesthetic premises were superseded by the European artistic avant-garde and its institution did not survive the general disruption of World War I. Another revolution was technical. New cameras, new lighting systems, and new media forms for disseminating photographs to the general public quickly emerged during these two decades. The final revolution was economic and political. The aftermath of World War I transformed both European and American life. Hence, there were many new things to photograph.

This last revolution had markedly different political effects in Europe than it did in America. Consequently, in the years that followed, photography was strikingly different on the European side of the Atlantic than on the American side. Both sets of photographers confronted cultures that were undergoing radical change—predominantly economic and social change in America and predominantly political change in Europe,

but their respective responses to these changes were markedly different. Europe was better placed to take advantage of both the technical and media revolutions, and it was generally the place where such innovations appeared first.

Underlying European photography was both a developed political consciousness and an intense focus on revolutionary pictorial *form* and explicit political *meaning* in pictures. These factors meant that photography was viewed as a symbol structure, like language, and that its significance lay either in the intentions of the photographer or in the photograph's cultural context (Fig. 2.1). This implied that no photograph could ever be self-contained, self-explanatory, or philosophically complete. As the readings that follow demonstrate, European avant-garde photographers believed that photography's potential as a symbol structure that communicated context and intent was still relatively undeveloped. Innovations in pictorial form were seen as the way to develop photography as a visual language.

In America, on the other hand, the attitude toward camera images was essentially conservative rather than revolutionary, grounded in the assumption that a "good" photograph was indeed self-contained and philosophically complete as a "truthful" mirror

Figure 2.1 Bill Brandt.
A Lyons Miss Nippy (Miss Hibbott),
1939.
Gelatin-silver print.
Copyright © Bill Brandt (1939).

of the "objective" world. At its most extreme, this particular attitude quickly acquired the labels of "purism" or "straight photography," and the most consistent American practice of photography with this style was known as "documentary photography." Philosophically, purists believed that the *meaning* of the subject matter in a photograph was self-evident. This is in stark contrast to the European view that one cannot know the "truthfulness" of a photographic representation until one knows what the subject matter means—no matter how literally the camera portrays it—and photographic meaning is *always* a matter of subjective cultural context.

From 1920 to 1940, American attention in general, and American photography in particular, was mesmerized by economic and social change rather than by the political causes of that change. Underlying American photography was a visceral response to the pervasive physical and visual changes imposed on American life by the post-World War I economy, a response which, for many years, was comparatively isolated from the European world and was apolitical in attitude. The purist point of view championed the camera as the "faithful witness," but the willed intention of a *real* witness to tell the truth is not the same thing as the automatic literalness of a lens image. However, this confusion of the moral with the aesthetic implied in "straight photography" gave an American photographer one distinct advantage over a European counterpart: the American could make a "straight" photograph whose magnificent aesthetic assurance and power embodied confidence in photography's truth. The European attitude simply did not permit such assurance. Consequently, American photographs between 1920 and 1940 frequently have an aesthetic power that European ones lack.

On both sides of the Atlantic, however, the technical process of photography experienced three separate revolutions, two major ones, which resulted primarily from developments in commercial cinematography, and one minor one, stemming largely from the economic changes in the post-World War I world. Most important was the revolution in still camera portability. New wide focal diameter lenses—known as "large aperture" or "fast" lenses—were combined with precision metal fabrication, developed for cinema cameras and projectors to create the first modern, hand-held, roll-film cameras. Hand-holding the camera was possible because the large aperture allowed more light into the film, making exposures shorter. An early and important prototype, still using small glass plates, was the Ermanox, marketed in 1924, with its extremely fast f 2.0 lens. This lens, at maximum focal diameter, collected eight times more light than the typical f 5.6 lens of larger plate cameras.

However, the two most prominent European designs, which eventually captured the market and spawned a host of imitations, were the Leica and the Rolleiflex. The Leica, invented in 1913 and marketed in 1924, was originally an exposure-checking device attached to a cinema camera. It exposed individual frames of sprocketed 35mm movie film, which could then be developed and evaluated before the cinema shot was attempted. Removed from the movie camera and eventually modified with a visual rangefinder (a focussing device) coupled to the focus of its f 3.5 lens, the Leica became the first truly pocket-sized camera that was a rugged precision tool, not merely a flimsy

toy. The preceding chapter illustrated that the economics of technical change in photography depended upon the vast market of amateur "snapshooters." The Leica was first advertised to this market, and the camera's success depended heavily upon amateur purchases. But the Leica's portability, durability, and convenience soon made it a camera of choice for the newly emerging professional "photojournalists" of Europe, such as Alfred Eisenstadt, André Kertész, or Brassaï (Fig. 2.2).

The Leica also changed the visual proportions of still photographs. The 35mm cinema camera was originally intended to hold a series of cinema frames perpendicular to the sprocket holes, with a horizontal ratio of height to length of about 1 to 1.33, which was proportioned like the typical 4" × 5" or 8" × 10" plate of the nineteenth century. Oskar Barnak, the designer of the Leica, turned the picture window in his camera parallel to the sprocket holes and made the window longer, resulting in a new proportion of 1 to 1.50, slightly longer than even the atypical 5" × 7" plate format and very close to the famous "golden section" proportion of classical Greek architecture. With this one simple change a new visual structure in twentieth-century photography was created, and the full-frame 35mm picture has been instantly recognizable ever since.

The Rolleiflex, introduced in 1929, was the application of the new lens and metal

Figure 2.2 Brassaï (Gyula Halász). *Dance Hall* (Couple fâché au bal musette), 1932.
Gelatin-silver print, 11½" x 9¼" (29.2 x 23.5 cm).
The Museum of Modern Art, New York. David H. McAlpin Fund, Photographie Brassaï, Copyright © Gilberte Brassaï.
Copy print © 1996, The Museum of Modern Art, New York.

technology to the basic reflex design of the Graflex cameras used so tellingly in preceding decades. The Rolleiflex had a metal body, used 2¼" wide roll film, added a separate viewing lens whose focus was coupled to the camera lens, and replaced both the sliding mirror and focal plane shutter of the Graflex, with a fixed, upper mirror and a lower, in-lens shutter. With these changes, the reflex design was made smaller, more rugged, and lighter, and the first "twin-lens" reflex camera was created. As an added advantage in flexibility, the Rolleiflex was designed to shoot a *square* picture, which could be "cropped" in printing to any proportion desired. Further, these cameras stimulated the development of more sensitive or "faster" roll films, culminating in the creation by Eastman Kodak Company of its famous Tri-X panchromatic film, the "workhorse" of small camera photography for over forty years.

These technical developments also found their way into larger-plate camera technology with the introduction of the metal-framed, folding Speed Graphic "press" camera. The typical plate size of the Speed Graphic was 4" × 5", which could be focused with an attached rangefinder as well as with the more conventional ground glass back of view cameras. Finally, it should be noted that all of these cameras were designed to allow pictures to be enlarged when printed, and parallel developments in metal, lens, and incandescent lamp technology created high-quality enlargers for the darkroom.

In addition to the revolution in still camera size, there was a parallel expansion of techniques for artificial lighting. Most important was a wide variety of plug-in continuous or "hot" lighting systems with incandescent bulb or carbon arc light sources that were developed for filmmaking. These new lamps would control light direction with movable "barn doors" on the lamp housing and light intensity through the use of filters and lenses in front of the light source. Cinema lighting systems found their way into the hands of commercial still photographers, particularly those working for well-funded magazines, which could afford to extensively equip photographic studios with new and expensive lights.

In addition, the first "flash bulbs" were invented in 1925 and marketed in 1929. These glass vacuum bulbs were filled with magnesium or aluminum and were ignited by electrical batteries to produce a single, one-second, burst of intensely brilliant light. Photography by magnesium—in the form of raw, messy, and dangerous "flash powder" ignited by a burning fuse—had been used since the 1860s, but with flash bulbs, instantaneous, on-location night photography finally became safe, portable, and cheap. Especially noteworthy was the equipping of the Speed Graphic press camera with a battery-operated flash gun doubling as a sturdy camera handle. This combination allowed the bulky plate camera to be truly portable and handheld under any field conditions and was central to the work of the newly emergent newspaper photography of the period. Finally, the decade of the 1930s saw the invention of the first reliable "light meters," allowing both the cinematographer and photographer to expose film according to the precise measurement of light rather than by the trial and error of accumulated experience.

The last technical change was the demise of printing that used paper that con-

tained platinum and palladium, rather than silver, for black-and-white prints. The economic changes induced by World War I caused the price of platinum and palladium metals to skyrocket, compared to the price of silver. Consequently, commercial platinum and palladium papers were squeezed off the market. In addition, platinum and palladium salts are less sensitive to light than silver, thus more time-consuming to use with the lower light levels created by enlarging small camera negatives. Since silver photographic papers produced a strikingly more contrasty image than those of the other metals, the general tonal scale of all photographic prints, particularly in America where platinum and palladium papers were quite popular, underwent a marked change after about 1925.

This technical change leads to an important, though very subtle, point of photographic connoisseurship in the study of American photography from 1920 to 1940. Photographers such as Paul Strand or Edward Weston, whose careers started with extensive platinum printing, made markedly different-looking silver prints than did Walker Evans, Dorothea Lange, or Margaret Bourke-White, whose careers began about the time platinum and palladium papers became unobtainable. The silver prints of Strand and Weston are frequently softer in contrast and often darker in overall value than are the prints of their younger contemporaries. In other words, the earlier photographers attempted to achieve effects in silver, closer to those of platinum and palladium. The contrast is particularly striking in the case of Weston, whose work was extensively printed both by Weston himself and later by his sons Brett, Neil, and Cole—since his sons belong to a later generation of photographers, their interpretations of the Weston negatives are often markedly more contrasty than Weston's own.

A revolution also took place in the periodical publication of photographs. By the early twentieth century, photographic halftones had become the medium of choice to illustrate factual articles in magazines and newspapers. At first, however, these pictures functioned no differently than the hand-drawn ones. In both cases, the text was largely dominant and the pictures largely subordinate. In the two decades between 1920 and 1940, several different forms of true "picture" periodicals developed, where the text is reduced to a mere subordinate caption and the pictures themselves are the focus of primary interest.

In America, these new layouts started with the founding in 1919 of the *New York Daily News,* America's first "tabloid" newspaper. The tabloid newspaper was quite close in size and shape to a large magazine, hence its smaller format than the traditional metropolitan dailies. Tabloids featured the most scandalous, exciting, and entertaining components of the news, at the expense of the stories that were comprehensive, informative, and dull. They also featured pictures illustrating stories throughout. Even more importantly, the tabloid reserved certain pages of the paper—typically the first page, the last page, and an interior set of "picture pages"—for the pictures to dominate. The paradigm case of this usually would be tabloid page one, where a spectacular accident, disaster, sporting event, or crime would be proclaimed with a gigantic headline, a single massive picture, and a tiny caption that told where to locate the full story inside.

In America, the space constraints, the metropolitan or local news focus, and the daily deadline pressure of newspapers favored the employment of the type of picture known in the journalism business as the "single." This is generally an easily readable, psychologically complete, and obviously self-contained picture of a piece of hard news or feature copy. The single had strong roots in the illustrative magazine photography of the two decades prior to World War I. The constraints of daily news reporting also favored the employment of photographers who could produce quantities of generic singles quickly, routinely, and on demand. Consequently, the equipment of choice was usually the sturdy Speed Graphic and flashgun, used without a tripod. The pictures were frequently blasted with flashbulb light, whatever the conditions were. The stereotypical press photographer became a popular fictional icon of American movies with his rumpled suit, his cheap fedora hat, his constant shouts of "Press!" and "Hold it!", and his blazing flashbulbs. The most famous real-life press photographer was New Yorker Arthur Fellig, who photographed under the pseudonym Weegee The Famous.

The second major American form of new picture periodical was the fashion magazine, exemplified at first by Condé Nast's *Vogue* and quickly followed by William Randoph Hearst's *Harper's Bazaar*. Fashion magazine photographers were the first to extensively exploit the new systems of artificial electric lighting, and the fashion magazines were the first to show high levels of pictorial inventiveness and artistic quality in photographic illustration. *Vogue* and *Bazaar* were predominantly magazines made for women of intelligence and leisure. Consequently, the intellectual, cultural, and artistic levels of the new fashion magazines were extraordinarily high, and the competitiveness between them was great. In addition to pictures of and reports on clothing, these magazines featured high-quality short stories, lively travel and food articles, and penetrating examinations of the cultural topics of the day. Such market demands acted like greenhouse forcing on the new trade of photo-illustration, which grew swiftly in visual sophistication and cultural influence and steadily encroached on all forms of printed product advertisements after 1920.

The most important form of the new picture periodical was, at first, largely a European phenomenon. This was the picture news magazine. The earliest of these began as a pre-World War I German magazine published in Berlin, called the *Berliner Illustrirte Zeitung,* or *BIZ.* By the late 1920s, *BIZ* editor Kurt Korff and publishing director Kurt Safranski began to use photographs heavily and to push the "picture page" in the direction of a continuous visual narrative, such as that of cinema. By 1929, this had evolved into the first true "picture story," shot by photographer André Kertész, on the lives of Trappist monks in France. Competitive German magazines such as *MIP,* the *Münchner Illustrierte Press* of Munich, quickly sprang up, and the new pictorial forms of *BIZ* and *MIP* spread to a host of German special interest magazines on sports, society, and so forth.

The profound political ferment of Europe between the wars gave rise to new forms of publication photography whose value as political propaganda was quickly recognized by both extremes of the political spectrum in Germany. Publication pho-

tography was exploited by the rising National Socialist or Nazi party in the magazine *Die Illustrirte Beobacher* and, most important for our story, by the German communist publication *AIZ* or *Arbeiter Illustrirte Zietung,* where artist John Heartfield cut and pasted news photographs and combined them with typography to create anti-Nazi political photomontage.

The picture magazine spread to the other countries of Europe, at first slowly and in direct imitation of the German prototypes, as shown by the French magazine *Vu,* founded in 1928. Later this format spread very quickly, as many of the photographers and editors fled Nazi-controlled Germany after 1933. Among the most important of these was *MIP* editor Stefan Lorant, who became the first editor of Britain's new magazines *Picture Post* and *Lilliput.* In the case of *AIZ,* the entire magazine, and Heartfield, fled to Prague, Czechoslovakia, where publication in German, for illicit German consumption, continued until the bloodless Nazi military takeover of Prague in 1938. The full flowering of this photographic diaspora and of the new form of magazine photojournalism occurred when American publisher Henry Luce hired *BIZ*'s Kurt Korff and Kurt Safranski to help him create *Life* magazine, first published in 1936. *Life* was the first American picture news magazine and was an overnight sensation and success.

This sequence of events illustrates that the causes of the radical change in photography after World War I are largely European in origin. Even before World War I, the new European art being shown in America at 291 and at the Armory Show—such as Cubism and its many derivatives—had pushed "art for art's sake" to a limit where the philosophical "synthesis of the arts" had begun to break down. Under the pressure of the experimentation of the Cubist avant-garde, the traditional media such as painting and sculpture began to take on a new distinctness, as the common conventions of "realistic" representation and emotive "beauty" among them fell away. In addition, radically new media forms emerged from Cubism—forms such as collage, *objets trouvés* or "found" sculpture, and sculpture that was assembled and constructed in cardboard, plastic, or steel instead of being modeled in clay and cast in bronze, or carved in stone.

In the darkest hours of World War I and immediately after, the refugee European artists in neutral Switzerland and in distant New York elaborated on their growing dissatisfaction with European culture as a whole and developed into the "anti-art" movement known as Dada, which also was swiftly taken up by artists in the newly defeated Germany. The greatest artist of Dada, Marcel Duchamp, who was also the inventor of *objets trouvés,* or found objects declared to be art, was part of an ad hoc circle of such artists gathered in New York around Alfred Stieglitz and patron Walter Arnenberg. Dada's avowed goal was the destruction of all pretensions to unity, beauty, and "correctness" in European culture. It used the chance juxtaposition of objects or their photographs to undermine the bourgeois logic that had, to the Dadaist mind, precipitated World War I. The first stage of Dada, begun in Zurich, Switzerland, in 1913, was primarily nihilistic in tone. By the early 1920s, Dada had spread throughout Europe, notably to Paris and Berlin. In Berlin, practitioners such as John Heartfield and Hannah

Hoch had given Berlin Dada decidedly political overtones. These political ends were in part accomplished by "phototypography," as people had come to call photocollaged images that mixed typographical messages with photographs. It was a pacifist and populist movement that rejected the placement of art in museums and embraced the premise that art was created by chance and choice.

One of the most important artists to emerge from Berlin Dada was the photomonteur Hannah Hoch. Her centrality and significance have become clearer from the vantage point of late twentieth-century life than during the days of her career. Hoch embodied the "new German woman" of the 1920s, and the bulk of her work was grounded in the emotional contradictions experienced by the "new German woman" in the recently established Weimar Republic. The changing status of women in the European and American world of the early twentieth century was a matter of debate in places other than Germany, but this controversy was most acute in Germany.

Germany was one of the three European "Great Powers" that suffered military defeat in WWI, the others being Austria-Hungary and Russia. Germany became a unified nation after 1870. As a result, the industrial revolution took place later there than in France and England, where it began in earnest in the late eighteenth century. When Germany industrialized, it capitalized on the mistakes of the early industrialists. Germans were committed to technological innovation. When World War I began in 1914, Germany's factories were converted to the production of war goods, which in turn accelerated developments in chemical and steel production. The development of these two products in turn aided the development of cameras in terms of construction, optics, and materials. When military defeat came in 1918, the German monarch Kaiser Wilhelm II was forced to abdicate and a full parliamentary government—later called the Weimar Republic—was installed in his place. Germany became indebted to the allies and its population felt ill-used by the politicians and industrialists whom they believed had led them into war. From the last years of World War I through the early 1920s, Germany successively experienced the hunger and privation of the allied economic blockade, an attempted socialist revolution aborted with violence, and the worst bout of currency inflation the world has ever witnessed, with people buying loaves of bread with literal wheelbarrow loads of million mark banknotes.

Eventually, the Weimar Republic achieved some stability with loans from American and British banks. Yet, despite this, the Weimar years in the arts are characterized by a paucity of materials coupled with a desire to produce technologically innovative art and manufactured goods for a new society. This meant that art movements like Dadaism and Constructivism in photography used innovative but technologically cheap and simple ways to produce images. Dadaists and Constructivists alike used cut-and-pasted news and magazine images in their work. Photograms were made by placing everyday objects on photosensitive paper to create patterns, tones, and shadows. When color was used, it generally was in the form of red type on a black-and-white poster or collage. Economy of means was a necessity and norm for these artists. The materials they used were often those discarded by others. In Dadaism, pictorial orga-

nization arose from random choice and chance. Its accidental quality mirrored the unstable world that gave it birth.

As one of the Dada photomonteurs, Hannah Hoch discovered in montage a form that mirrored the irrational political world. In the European context, this nightmare world was at once personal and political. In Hoch's work, these tensions are constantly played out in terms of images such as the sexually liberated and devouring "vamp" and the monstrous child—extravagant projections of the excruciating ambiguity of the "new German woman," who was at once freer than her forebears but more exploited and reviled because she was more threatening to the "established order."

In this atmosphere, the "women's revolution," generally centering around female political suffrage and occurring in most of the Western industrialized countries, took on exceptional force in Germany. Because of harsh economic conditions, a full 30 percent of the Weimar workforce was female, a figure far exceeding countries such as Britain, France, or the United States. Most working women in Weimar Germany were relatively powerless to advance to positions of responsibility and power, although they were a significant segment of the workforce and, consequently, were more economically independent than women elsewhere.

This economic independence also translated into an unprecedented degree of sexual and social independence for German women. Moreover, in the Western world in general, a text of "mannishness" in dress and style became fashionable for women after World War I. These new fashions generally consisted of shortened or "bobbed" hair, a much thinner and less full-figured body style, and a much greater gender uniformity in the design of sports and leisure wear. All such forms of feminine independence were later curbed under the Nazi regime, whose various political agendas included the forced return to what we would call today "family values," restricting women to the roles of childbearer and homemaker.

It also must be noted that the pictures used as raw material by photomonteurs such as Hoch, in montages such as Indian Dancer of 1930 (Fig. 2.3), were photographic reproductions from the magazines that constituted the mass culture of Weimar Germany. The chance juxtaposition that the monteurs used in their cut-and-pasted images was already latent in the images themselves, for they appeared arbitrarily—dropped into text at the whim of a magazine editor and circulated among thousands of readers. The irrationality and arbitrariness of European life was a mild form of the more intense irrationality and arbitrariness of Dada.

The use of photographic objectivity to create a believable dream world has existed in photography since the late nineteenth century and the works of the British artists Robinson and Rejlander. Its use continues during the 1920s and 1930s with the work of Man Ray and Moholy-Nagy in Europe and America and artists such as Clarence John Laughlin, who worked in the American South. In the late twentieth century, combination printers such as Jerry Uelsmann and set designers who photograph their creations, such as Patrick Nagatani, have carried on this tradition in new ways.

Another movement which acknowledged the arbitrariness and irrationality of

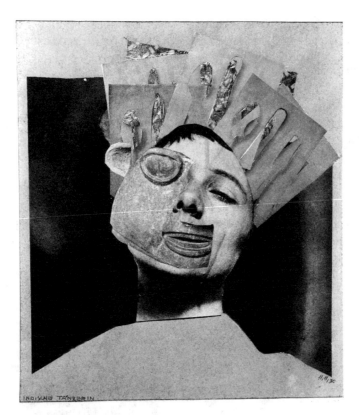

Figure 2.3 Hannah Höch.
Indian Dancer (from an Ethnographic Museum), 1930.
Collage of cut-and-pasted papers and photographs on green
paper, 10⅛" × 8⅞" (25.7 x 22.4 cm).
The Museum of Modern Art, New York. Frances Keech Fund.
Copy print © 1997, The Museum of Modern Art, New York.

modern life was Surrealism. Influenced by Freud's belief in the influence of the sub-
conscious, the movement attempted to unify interior and exterior realities. Rather than
the disjunctive relationships of one image to another in Dada, Surrealist art connected
images through association. The abrupt junctures of photomontage in Dada were re-
placed with smoother transitions between images in the work of such artists as Man
Ray. The work of French photographer Atget, with its reflections and ghostly superim-
positions of moving people made during the first decades of the twentieth century, fas-
cinated the Surrealists, who could see in Atget's work the hallucinatory reality of the
dream they wished to project.

In contrast to Dada and Surrealism, by 1920 the international Constructivist
movement that originated in the new Soviet Union conceived of objects as structures

that consisted of elements such as space, volume, color, and light. Content and form were seen as the same, which gave rise to a rigorous and abstracted art in which technology played an overt role, both in the creation of the pieces and in their appearance (Fig. 2.4).

In the decade that followed the 1917 revolution in Russia, the new Communist state was still radically experimental in its approach to the government organization of life, and many pro-revolutionary Russian artists attempted to marry the energies of the political revolution to the forms of the art of the avant-garde by designing objects for mass production and consumption. In the interregnum under the rule of Valdimir Lenin, the Soviet example and the communist point of view was a beacon for many artists in Europe, and a few in America as well.

What had been the "arts and crafts" impulse to purify the unaesthetic excesses of capitalism swiftly became, in the Soviet Union and later Germany in particular, a more revolutionary vision of a new and rational ordering of modern life where the successful marriage of art with industrial technology would inevitably benefit general human welfare. This vision remains, under the names of "graphic design" and "industrial design." It also still informs the continued—though softened and modified—"functional-

Figure 2.4 Margaret Bourke-White. *Grain Elevator Pipes*, 1932. Gelatin-silver print. Margaret Bourke-White Papers, Syracuse University Library, Department of Special Collections. Copyright © Margaret Bourke-White Estate, Courtesy *Life* Magazine, Time Warner, Inc. Contributors: Jonathan B. White and Roger B. White

ist" aesthetic of our architecture. This aesthetic of rational and functionalist design was brought to perfection and applied successfully throughout the arts in the famous post-World War I art school, the Bauhaus, located first in the German capital of Weimar, and later, as a result of adverse political pressure, in the German city of Dessau.

Three of the European "Great Powers" suffered military defeat in World War I: Austria-Hungary, Germany, and Russia. These defeats were of great consequence for twentieth-century art. Of the three powers, Austria-Hungary was dismembered into several smaller states, roughly corresponding to the various "nationalities" that had been part of its former empire. Consequently, the influence of Vienna as a European cultural capital was radically diminished, and the separate states were left as cultural backwaters where bright young artists would emigrate to Paris or Germany instead of gravitating to Vienna.

A prime example of what this meant to photography can be seen in the career of Hungarian Laszlo Moholy-Nagy, who was the most important photographer of the Bauhaus and was a profound thinker about the medium. Although he immigrated to Germany as an East European, he was profoundly influenced by developments in post-revolutionary Russia.

Moholy-Nagy was originally a painter and sculptor who explored the Constructivist form with a kinetic light modulator, which he built from 1922 to 1930. It embodied the Constructivist idea that the plastic or three-dimensional elements of a piece were conceptually the same as the intellectual or perceptual elements of light and shadow the moving parts created. Later, in the foundations program at the Bauhaus, he asked students to photograph light modulators constructed of paper. Photograms created by exposing common household and studio tools on photographic paper worked like the light modulator to bring theory, science, and artistic practice together. In the Bauhaus, it was largely the ideas of Moholy-Nagy that bridged the gap between the artist and industry in photography. In his work, the technology of photography is always evident, whether it is in the quality of light in his photograms or the overt perspective in his steeply angled pictures of architecture. In this, Moholy-Nagy's photographs resembled work being made throughout Germany and the Soviet Union, where cameras were being tilted almost straight up and down during exposure, or where extreme close-up portraits isolated part of a face, abstracting it for psychological effect. Sharp, detailed images also isolated the forms of architecture, industrial products, or animals and plants. Moholy-Nagy and other photographers understood that these unadulterated but extreme camera images helped expand the range of human vision. By 1928, an exhibit organized in Jena, Germany, featured eight photographers whose work in photomontage, portraiture, and scientific and documentary photography was shown as part of the new vision, with a like parallel movement in painting known as *Neue Sachlichkeit* or New Objectivity.

An artist who exemplified this new realism was August Sander, who traveled to towns and villages surrounding Cologne to increase his portrait business. By 1929, he had completed enough portraits to publish the book, *Anlitz der Zeit (Face of Time),*

which showed people with surgical precision, each locked by stance and the tools of their trade, into a hierarchical social order that would be dissolved by World War II. Sander was influenced by a 1918 meeting with the painter Franz Wilhelm Seiwert, who believed art should reflect society's structure.

Images of self-satisfied ample burghers contrast with cringing images of the unemployed or marginalized circus people who wear their differences defiantly, like a badge. Class and status can be read in the gestures, clothes, and demeanor of each subject. Even the slightly effete look of the young college student (Fig. 2.5) shows his membership in a leisured class. This dispassionate study of a culture, coupled with a demonstrated ability to show the effects of class and status on the physical appearance of his subjects, separates Sander's new objectivity from the purist and documentary photography aesthetic in the United States.

The primary exponent of purist photography in America was Paul Strand, the young prodigy of the Stieglitz circle in 1917, who was the featured photographer in the last glittering burst of the magazine *Camera Work* before it expired. The work Strand showed there was a disturbing and powerful amalgam of the raw factuality of his teacher Lewis Hine and of the structural abstraction of the painting being shown at

Figure 2.5 August Sander.
Abiturient, Köln, 1926, (College
Graduate, Cologne, 1926).
Gelatin-silver print.
© August Sander Archive/SK-Stiftung
Kultur; VG Bild-Kunst, Bonn 1996.

Stieglitz's gallery 291 (Fig. 2.6). It repudiated absolutely the notions of "beauty," embodied in the work of the Photo-Secession and that beauty's basis in the "synthesis of the arts."

But Strand's work did not repudiate the notion of photographic beauty itself. Rather, in his earlier work, Strand pointed toward a new definition of photographic beauty as a beauty of underlying structure or "composition," rather than a beauty of print surface and picture content. This had two important implications for the future of American photography. First, it implied that a photograph could be aesthetically "good" whatever its content—hence, early photographs such as Lewis Hine's were *ex post facto,* a variety of photographic "art" despite their unbeautiful content and direct political intent. Second, it made the "art" of photography an art of pragmatic, empirical rationality—a discovery of significant aesthetic form in the common objects such as bowls and fences. Hence, Strand's "purist" point of view was a decisive rejection of the irrational juxtaposition of objects contained in much of European photography, particularly in European photomontage, which deconstructs the illusionism and rationalism of the camera.

In the 1920s, Strand became the most potent and coherent spokesperson of the

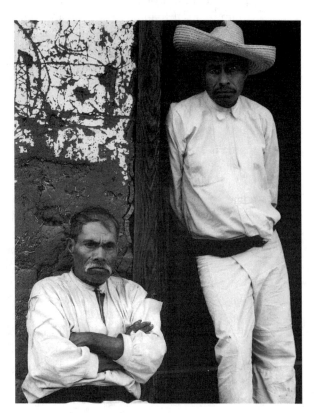

Figure 2.6 Paul Strand.
Men of Santa Ana, Lake Patzcuaro, Michoacan, Mexico, 1933.
Copyright © 1940, Aperture Foundation Inc., Paul Strand Archive.

purist view. Largely through Strand's polemic and example, American photographs were dominated by the straight photography for nearly the next fifty years. Strand's own work and life during the period embodies the tensions inherent in the contact of a "purist art photography" with politics. Strand's own politics were to the far left of the political spectrum, as were John Heartfield's. But while Heartfield found a form that expressed his political views directly, through the 1920s, Strand concentrated on developing the implications of his work of 1917 and his polemic of the purist point of view. In the process, Strand made seminal works such as his massive close-ups of precision machine forms or of New England flora, but these magnificent pictures could easily have been made by someone whose politics were the polar opposite of Strand's. During the same period, Strand worked for pay as a freelance movie cameraman, and his politics eventually led him to put aside still photography in the decade between 1934 and 1944 and turn to film as a form that could sufficiently contextualize a "straight" image to give it a durable political impact. In the process, he was the cameraman on magnificent and politically overt short films such as "The Plow That Broke The Plains" and "The Wave."

Other purist photographers remained resolutely apolitical. In 1932, Edward Weston and a number of younger photographers who were influenced by his work created Group f/64. The name refers to an aperture on a large-format camera lens. This aperture setting will produce the maximum foreground and background image sharpness (Fig. 2.7). The charter group, which included Ansel Adams, Edward Weston, and Imogen Cunningham, was dogmatic in its rigorous pursuit of "pure" photography. Their aesthetic repudiated photographs were not sharply focused throughout, betrayed any handwork, and were not contact-printed on glossy paper and mounted on white cardstock. This declared aesthetic was a reaction to the excesses of a waning pictorialism and even f/64's charter members enlarged their prints and used selective sharpness during their careers. However, their work would set standards of technical excellence for the black-and-white silver print in the twentieth century.

This period in photography also would see the emergence of an interest in social content appropriate to the purist style. In the late 1920s, films that were rooted in real problems and real situations were referred to as "documentary." John Grierson, the spokesperson for the British Group of Independent Filmmakers who coined the term, noted that though the intent of the documentary was not aesthetic, its practitioners knew that a well-seen picture was more compelling than an indifferent one.

This point also was understood by Rexford G. Tugwell. In 1935, the Resettlement Administration, headed by Tugwell, was founded as part of the Roosevelt Administration's response to the Depression. Tugwell was Undersecretary of Agriculture at the time, and he and his colleague Roy Stryker directed a vast photographic project that documented the agency's activities for rural America in general. Walker Evans, one of the first photographers to join this project, photographed his dead-on, carefully framed shots using an 8" × 10" camera. His work, apparently neutral in tone, shows both the poverty and beauty of American life, asking one to confront the telling details

Figure 2.7 Imogen Cunningham.
Magnolia Blossom (Tower of Jewels), 1925.
Gelatin-silver print.
Photograph by Imogen Cunningham.
Copyright © 1970, 1997 The Imogen Cunningham Trust.

that relate information about the environment or people. Dorothea Lange, who also joined the Resettlement Administration's photography team in 1935, worked with her sociologist husband Paul Taylor. As a result, her photographs were accompanied by copious field notes. Her attitude toward her subjects was far less neutral than was Evans'. In addition to verbally describing displaced farmers and unemployed people, she often points her camera up at a subject, or monumentalizes a subject through her point of view. Her subjects are, for the most part, seen as noble people who deserve to triumph over their current bad luck. In 1936, her photograph of a migrant mother huddled in a tent with her children on the edge of a pea field became the most reproduced photograph of that era, which lasted only seven years.

By 1937, the Resettlement Administration became part of the Department of Agriculture, under the name of the Farm Security Administration. For the next five years, nine photographers were employed, along with Lange and Evans, to document rural America and small-town life. Their photographs, now housed in the Library of Congress, form an invaluable record of life during this period.

During the Depression, America turned inward and began recording its history

and culture. Writers were commissioned to write town histories. Artists were paid to paint pictures of American traditional craft items, creating the Index of American Design. Photographers were employed to document conditions that needed change.

American cities were changing as much as her countryside. From 1915 onward, African Americans fled the South and moved north to the cities, searching for better-paying factory jobs. During the 1920s, nearly two million blacks fled the South in one five-year period. Many of them ended up in Harlem, which expanded in the '20s and '30s. Black soldiers returning home from World War I also were agents of social change, since they had experienced the lack of segregation in Europe. These social factors helped produce the Harlem Renaissance, a realist or naturalist movement in the arts that started in 1919 and lasted until approximately 1935.

Van Der Zee was an African-American commercial photographer working in Harlem during this period. As a photographic businessman, and as an African-American, Van Der Zee was doubly excluded from the rarefied circles of "art and expression" around Stieglitz and, at this time, was essentially unknown to the photography world at large. He is included here to demonstrate that there were vital parts of photographic culture that diverged from both purism and the documentary modes that still revealed important social, nonpolitical messages about a culture.

New York was also home to the Photo League, which existed from 1936 to 1951, when it was dissolved after being blacklisted during the McCarthy Era. Its members were largely Jewish, of immigrant stock, and with close intellectual and social ties to European socialism. Their photographs, although documentary in style, pointed to social inequities beneath the fast growth of America's large cities.

In the aftermath of World War I and the peace of Versailles, which ended that war, the relations between the three major political divisions of the world—Europe, the United States, and the European-dominated colonial world—were radically altered. Europe emerged economically weakened, debt-ridden, shaken in confidence, deprived by battle of the better part of an entire generation of young men, and committed to a punitive peace treaty that virtually ensured that she would remain economically diminished and stagnant. At the same time, Russia and Germany, though unstable politically and financially, provided scope for both new technologies and new relationships of art to technology.

America emerged as the major creditor of European debt, the dominant economy in the world, and the country with the greatest immediate potential for further capitalist development. Under these conditions, American picture-making was aesthetically conservative, but direct and powerful in its impact. The rest of the world, though still largely under European sway, had been planted with the seeds of its future independence, though these took a long time to germinate and grow, except for Japan and China, where self-conscious "Westernization" for the ends of industrial growth and military power would be one of the major factors of World War II.

EXCERPTS FROM THE PERIOD 1920-1940

"Photography." (1917)
*Paul Strand**

"Photography, which is the first and only important contribution thus far, of science to the arts, finds its *raison d'être,* like all media, in a complete uniqueness of means. This is an absolute unqualified objectivity. Unlike the other arts which are really anti-photographic, this objectivity is the very essence of photography, its contribution and at the same time its limitation. And just as the majority of workers in other media have completely misunderstood the inherent qualities of their respective means, so photographers, with the possible exception of two or three, have had no conception of the photographic means. The full potential power of every medium is dependent upon the purity of its use, and all attempts at mixture end in such dead things as the color-etching, the photographic painting and in photography, the gum-print, oil-print, etc., in which the introduction of hand work and manipulation is merely the expression of an impotent desire to paint. It is this very lack of understanding and respect for their material, on the part of photographers themselves, which directly accounts for the consequent lack of respect on the part of the intelligent public and the notion that photography is but a poor excuse for an inability to do anything else.

"The photographer's problem therefore, is to see clearly the limitations and at the same time the potential qualities of his medium, for it is precisely here that honesty, no less than intensity of vision, is the prerequisite of a living expression. This means a real respect for the thing in front of him, expressed in terms of chiaroscuro (color and photography having nothing in common) through a range of almost infinite tonal values which lie beyond the skill of the human hand. The fullest realization of this is accomplished without tricks of process or manipulation, through the use of straight photographic methods. It is in the organization of this objectivity that the photographer's point of view toward Life enters in, and where a formal conception born of the emotions, the intellect, or of both, is as inevitably necessary for him, before an exposure is made, as for the painter, before he puts brush to canvas. The objects may be organized to express the causes of which they are the effects, or they may be used as abstract forms, to create an emotion unrelated to the objectivity as such. This organization is evolved either by movement or the camera in relation to the objects themselves or through their actual arrangement, but here, as in everything, the expression is simply a measure of a vision, shallow or profound as the case may be. Photography is only a new road from a different direction but moving toward the common goal, which is Life. . . .

**Seven Arts,* August 1917, pp. 524–526.

"The existence of a medium, after all, is its absolute justification, if, as so many seem to think, it needs one at all, comparison of potentialities is useless and irrelevant. Whether a water-color is inferior to an oil, or whether a drawing, an etching, or a photograph is not as important as either, is inconsequent. To have to despise something in order to respect something else is a thing of impotence. Let us accept joyously and with gratitude everything through which the spirit of man seeks to an ever fuller and more intense self-realization. . . ."

"Photography and the New God." (1922)
*Paul Strand**

"In order to make this clear, it is necessary to record briefly the development of the use of the camera by the seeker after intuitive knowledge. The first of these to become interested in the mechanism and materials of photography was David Octavius Hill, a painter and member of the Royal Scottish Academy. Hill came upon photography about 1842 in the following way: he had received a commission to paint a large canvas on which were to appear the recognizable portraits of a hundred or more well-known people of the time. Faced with this difficult task and having heard of the then recently invented process of photography, he turned to it as a help to his painting. Three years of experimentation followed and it is interesting to learn that he became so fascinated by the new medium that he seriously neglected his painting. So much so in fact that his wife and friends found it necessary to remind him that he was an "artist". . . . Yet the results of Hill's experimenting have given us a series of amazing portraits which have not until recently been surpassed. They are built with utmost simplicity upon large masses of light and dark, but unquestionably the element which makes these portraits live is the naiveté and freedom from all theory with which Hill approached his new medium. . . . Despite the primitive machine and materials with which he was compelled to work, the exposures of five to fifteen minutes in bright sunlight, this series of photographs has victoriously stood the test of comparison with nearly everything done in photography since 1845. They remain the most extraordinary assertion of the possibility of the utterly personal control of a machine, the camera.

"A gap then of nearly forty years intervened during which these photographs made by Hill passed into obscurity and practically no similar experimentation was done. However, some time before their rediscovery photography had, about the year 1880, started upon a renascent and widespread development all over the world. With the invention of the dry plate, the improvements in lenses and printing papers, the

**Broom*, Vol. 3, No. 4, pp. 252–258.

process had been brought within the realm of greater certainty and ease of manipulation. And with this period begins that curious misconception of the inherent qualities of a new medium, on the part of almost everyone who has attempted to express himself through it. Without the slightest realization that in this machine, the camera, a new and unique instrument had been placed in their hands, photographers have in almost every instance been trying to use it as a short cut to an accepted medium, painting. . . .

"As a consequence, the development of photography so beautifully and completely recorded in the numbers of *Camera Work* is interesting not so much in the aesthetically expressive as in an historical sense. . . . It has taken nearly eighty years for this clarification of the actual meaning of photography to reach from the remarkably true but distinctive approach of David Octavius Hill to the conscious control embodied in the recent work of Alfred Stieglitz.

"For it is in the later work of Stieglitz, an American in America, that we find a highly evolved crystallization of the photographic principle, the unqualified subjugation of a machine to the single purpose of expression. It is significant and interesting to note that this man is not a painter and has never felt any impulse to be one. . . . We find first of all in this man's work a space-filling and formal sense which, in many instances, achieves as pure a synthesis of objectivity as can be found in any medium. We perceive upon the loveliness of paper a registration in monochrome of tonal and tactile values far more subtle than any which the human hand can record. We discover, as well, the actuality of a new sensitivity of line as finely expressive as any the human hand can draw. . . . But, above all, we become aware in these photographs of his of a new factor which the machine has added to plastic expression, the element of differentiated time. The camera can hold in a unique way, a moment. If the moment be a living one for the photographer, that is, if it be significantly related to other moments in his experience, and he knows how to put that relativity into form, he may do with a machine what the human brain and hand, through the act of memory cannot do. . . .

"Thus the deeper significance of a machine, the camera, has emerged here in America, the supreme altar of the new God. If this be ironical it may also be meaningful. For despite our seeming well-being we are, perhaps more than any other people, being ground under the heel of the new God, destroyed by it. We are not, as Natalie Curtis recently pointed out in *The Freeman,* particularly sympathetic to the somewhat hysterical attitude of the Futurists toward the machine. We in America are not fighting, as it may be natural to do in Italy, away from the tentacles of a medieval tradition towards a neurasthenic embrace of the new God. We have it with us and upon us with a vengeance, and we will have to do something about it eventually. . . ."

"The Art Motive in Photography." (1923)
*Paul Strand**

"But the camera machine cannot evade the objects which are in front of it. No more can the photographer. He can choose these objects, arrange, and exclude, before exposure, but not afterwards. That is his problem, these the expressive instruments with which he can solve it. But when he does select the moment, the light, the objects, he must be true to them. If he includes in his space a strip of grass, it must be felt as the living differentiated thing it is, and so recorded. . . . Photography, so understood and conceived is just beginning to emerge, to be used consciously as a medium of expression. In those other phases of photographic method which I mentioned, that is, in scientific and other record making, there has been at least, perhaps of necessity, a modicum of that understanding and control of purely photographic qualities. . . .

"I am simply talking to you as one student to others, out of my own experience. And I say to you, before you give your time, and you will have to give much, to photography, find out in yourselves how much it means to you. If you really want to paint, then do not photograph except as you may want to amuse yourselves along with the rest of Mr. Eastman's customers. Photography is not a short cut to painting, being an artist, or anything else."

Daybooks, V.2. (1934)
*Edward Weston***

Feb. 5, 1932

"I am "old-fashioned" enough to believe that beauty—whether in art or nature, exists as an end in itself: at least it does for me. This in no way interferes with [Louis] Sullivan's "Form follows Function," for form that is beautiful is so because its function is the ultimate expression of potentiality—and so is beauty in nature which cannot always be explained by logic, by ascribing it to efficiency—to practical or remunerative values. If the Indian decorating a jar adds nothing to its utility, I cannot see why nature must be considered strictly utilitarian when she bedecks herself in gorgeous color, assumes magnificent forms, or bursts into song. Has man the sole prerogative to use beauty as an end?—which he most certainly does!

"Of course I am on dangerous ground: rational minds, "right thinkers," will attack this credo with scholastic common sense—very common, blind sense. . . ."

*The British Journal of Photography, Vol. 70, pp. 612–615.

**Copyright © Center For Creative Photography, Arizona Board of Regents, 1981. To Read the Published Daybooks see: *The Daybooks of Edward Weston.* Vol II California. ed. Nancy Newhall. Millerton, New York: Aperture. n.d.

March 19, 1932

"Another echo from the N. Y. exhibit . . . some man viewing my show said it "lacked the dignity of Stieglitz," that I was "theatrical." This astonished me. . . .

"I must deny any "theatrical" quality in my work without hesitation. But I can try to find reason for the "critic's" viewpoint. . . . I have several times noted that Eastern people do not at once see Western values: to them our values are not "correct." I have observed painters first coming to this coast and painting here with Eastern eyes: and I have watched them change. I have had my work criticized as having false values. At times I do exaggerate, print with more contrast, with reason, but usually I feel my values are true.

"This leads to further consideration of the difference between East and West: a difference which could easily lead an unacquainted Easterner to think my work "theatrical," though I think a more just observation would be to call it "dramatic." Everything is relative. To the New Yorker of fifty years ago the present startling architecture—now accepted as a matter of course—would be dramatic, maybe called "theatrical." So to one not used to the West, to the scale of things out here—nature must seem very dramatic. But can nature ever be labeled "theatrical?" Of course not, or only by those not used to, or not big enough to feel a part of nature on a grand dimension. Only an inability to commune with, be on a close terms with a given nature, can account for the label "theatrical." It is a fear of a thing which makes it strange.

"Everything in the West is on a grander scale, more intense, vital, dramatic. Forms are here which never occur in the East—in fruits, flowers, vegetables, in mountains, rocks, trees. Go to Mexico, and there one finds an even greater drama, values more intense—black and white, cutting contrasts, am I theatrical because I see important forms importantly?

"All these forms—trees, rocks, natural manifestations of Western vitality are my neighbors, my friends—I understand and love them. I do not lie about them. After living here for ten years, I made a trip back East. Nature seemed soft there, poetic, tenderly lyrical, almost too sweet. Someone pointing out the sights to me from the train window said, "See the mountains." I looked and saw not! —then I realized they meant what, to me, were low rolling hills! But I must have had some apprehension that several of my prints would be misunderstood, probably because last year many did not know our Western kelp. I recall now laying aside one cypress, saying to myself, "I will not include this, no one would believe it true!". . . .

March 26, 1932

"But why not a more catholic viewpoint, admitting the value—the necessity, of many ways of seeing? We do not expect everyone to prefer red cabbage to white: the fragrance of a magnolia to sage. . . . And if the answer be that photography is documentary—well, why not document the extraordinary! I see no reason for recording the obvious. For example, by selecting an unusual pepper—called "grotesque" by some

who object to my seeing, I have brought attention to the dual force in this hybrid, the outer covering and inner lining, of different contractile forces inherited from diverse ancestral sources, which pull against each other like the warring elements in a mestizo—causing the strangely beautiful forms—these I have felt and recorded. Have they not more interest than the commonplace pepper which a cook might prefer to stuff?"

"Edward Weston's Late Landscapes." (1990)
*Andy Grundberg**

"It has become a convention of photography history to speak of Edward Weston's incredibly fertile and multifaceted career in terms of a number of distinct and separate subcareers. . . . There is evidence, however, that Weston's mature, modernist career is not comprised of a series of progressive periods based on biographical events; rather, it is split quite decisively and dramatically into two halves. The first, dating to 1937, is concerned primarily with formal abstraction and is expressive of Weston's libidinal preoccupations; the second, from 1937 on, is marked by an increasingly open style involved with complex spatial organization and pictorial depth, while conveying intimations of ruin, decay, and death. Weston's assertion, in 1939, that his intention during the two years of his Guggenheim grant was "photographing Life" is, in retrospective, ironic. For beginning with the Guggenheim project—and perhaps without the artist realizing it—the subject of Weston's photography became Death.

"This late work, which consists in large measure of landscapes, also contains evidence of a political consciousness absent in Weston's earlier photography, which is made up primarily of portraits, nudes, and close-ups of natural forms. In the last ten years of his working life, Weston perceived the American landscape not as something grand primordial, and innocent, but as inhabited, acculturated and, in many places, despoiled. Not only do many of his pictures from this era recall Walker Evans's photography of the 1930s, but they also point directly to the socially conscious but stylistically restrained "New Topographic" mode of landscape photography of the last ten years, by photographers such as Robert Adams, Lewis Baltz, Joe Deal, Frank Gohlke, and Stephen Shore. . . .

"It is perhaps even not too far-fetched to suggest that Weston's late landscapes helped point photography away from photographic modernism's preoccupation with reductive abstraction and toward a more capacious, complex, naturalistic, and stylistically transparent style. It is clear from the pictures in *California and the West* and from those in the Limited Editions Club's volume of Walt Whitman's *Leaves of Grass,*

*Andy Grundbreg. *Crisis of the Real, Writings on Photography 1974–1989.* New York: Aperture, 1990, pp. 23–29.

which Weston was assigned to illustrate in 1941, that the photographer's way of seeing became, in his last decade of work, less reductive, less dramatic, and less insistently graphic, while becoming more inclusive, accepting, and—given its theme—resigned. . . .

"By the time Weston set out in 1937 with a new Ford, $2,000 from the Guggenheim Foundation, and a $50-a-month contract to supply scenic photographs for *Westways* magazine, he was a much more self-confident artist than the one who had sailed for Mexico in 1923. He had the security of a mature artistic style—one that had made him a commanding figure in photography circles nationwide—and he was an articulate, admired spokesman for the purist aesthetic. He was fifty-one, a mid-career photographer with grown sons, a young, intelligent, and "liberated" lover (Charis, soon to be his wife), and the distinction of having just received the first Guggenheim ever awarded a photographer.

"But instead of pictures of phallic clouds and recumbent nudes, celebrating his artistic empowerment and vitality, Weston proceeded to take landscapes of a distinctly elegiac tenor. Among the subjects recorded on the 1,500 negatives he made between 1937 and 1939 are a burnt-out automobile, a wrecked car, an abandoned soda works, a dead man, a crumbling building in a Nevada ghost town, long views of Death Valley, the skull of a steer, the charred remnants of a forest fire, gravestones, the twisted, bleached bark of juniper trees—a virtual catalogue of decay, dissolution, and ruin.

"Not all of the Guggenheim work fits this category, of course. There are enough photographs of "innocent" subjects—dunes, cloud studies, majestic views of mountaintops, valleys, and the Pacific coastline—to suggest that Weston was not exclusively preoccupied with death. However, this does not negate the fact that decay, dissolution, and ruin were new additions to Weston's artistic repertory at the time, and that their existence signals a fundamental turn in the photographer's themes and—coincidentally—his style.

"The stylistic differences are readily obvious if one compares, for example, his Oceano sand dune pictures of 1936 (Fig. 2.8) with his Death Valley dunes of 1938. The former are dramatic, abstractly seen and ambiguous in scale; they look—remarkably enough—like American abstract expressionist painting of fifteen years later. The latter are less radically cropped and more naturalistic, with undulating lines that sweep the eye off into deep space. A similar change can be seen by comparing his 4 × 5 nudes of 1934 with a nude image of Charis taken in New Mexico in 1937. The 1934 pictures are studio constructs, studies in form and flesh tones taken against a dark backdrop; the 1937 image is more like a landscape, with Charis lying on a blanket in front of an adobe wall, a shadowed oven, like a tunnel, beyond her raised knee. The combination of figure and background gives the photograph an erotic resonance unequalled by the more decorous studio nudes.

"The change in photographic style from a strictly organized, close-up and exclusionary formalism to a more relaxed and inclusive naturalism is inseparable from the expansion of Weston's range of subject matter during the Guggenheim project. . . .

Figure 2.8 Edward Weston.
Dunes Oceano, 1936.
Photograph by Edward Weston. Gelatin-silver print.
Collection of the Center for Creative Photography.
Copyright © 1981 Center for Creative Photography,
Arizona Board of Regents.

Weston's interest in the land also extended to hayfields, vineyards, and even the harbor of San Francisco. These pictures, following by less than ten years his close-ups of shells and vegetables, represent a decisive step away from the increasingly circum-scribed high-modernist practice of Alfred Stieglitz—a break that seems to have gone unrecorded in the criticism of the time, and is barely spoken of today. . . .

"The difference between Weston's early and late styles is nowhere more appar-ent than in the gulf between the work he did on Point Lobos in the years 1929 to 1934 and his Point Lobos pictures of 1939, 1940, and 1944 to 1948—the last having been made when the progressively crippling effects of his Parkinson's disease had become unmistakable. In the earlier work, eroded rocks on the beach are isolated by the cam-era so that their scale and context are eradicated, thereby emphasizing their poetic, metonymic qualities. (Many, it goes without saying, resemble torsos.) The fluid lines

and liquid surfaces of kelp are emphasized in vivid close-ups, and the roots of cypress trees are shown to have all the potential energy and pent-up power of ocean waves. In the photographs from 1939 on, however, the Point Lobos peninsula is a veritable theater of death. Dead pelicans and dead kelp float in translucent pools; the cypress trees are shown whole, their bare limbs white and wizened; rocky cliffs appear as jumbled as if a landslide had just struck. . . .

"One can, of course, cite other influences to account for the more open, capacious style of Weston's late landscapes. There was the example of Ansel Adams, alongside whom Weston photographed Yosemite during the Guggenheim years. There was the example of Eugene Atget, whose ethereal and haunted pictures of Paris and its environs came to the American photographer's attention in 1930. And it seems likely that Weston also knew Walker Evans's pictures of the South, taken for the Farm Security Administration in the 1930s. Unlike Adams, both Atget and Evans dwelt on evidence of cultural dissolution. But whatever the reasons—and surely they were plural—Weston's shift from high modernist to late modernist style constitutes a crowning accomplishment in a career remarkable for the sheer number of achievements. That this shift occurred just at the historical moment when high modernist style was beginning to ossify into mannerism places Weston's late landscapes in the forefront of the major aesthetic watershed of mid-twentieth-century photography."

Modern Photojournalism, Origins and Evolution 1910–1933 (1972)
Tim Gidal*

"During these years, a number of mass-media, illustrated magazines came onto the German market—a phenomenon typical only of Germany. The period was visually documented by the photojournalism in these magazines; at the same time, various improvements combined to make the camera an extension of the observant eye. Two cameras came onto the market which had a determining influence on the new photojournalism—the Leica and the Ermanox. Intellectual, economic, and technical factors all played their part in the birth of modern photojournalism.

"Press photography by professionals had reached a dead end. On the one hand, it was controlled and restricted by the narrow attitude toward press photography, and on the other hand, by the outmoded equipment and the huge, unweildy, and intricate plate cameras. Press photographers "knew of nothing better," and the editors of the illustrated magazines also knew nothing—or too little—of the new technical possibilities which had been developing. Apart from this, there was a lack of ideas. There were, of

course, exceptions and experiments, above all by the *Berliner Illustrirte* whose editor Kurt Korff and publishing director Kurt Szafranski recognized the dead end which conservative press photography had reached, despite its clearly worthwhile achievements. . . .

"The year 1921 saw the foundation of the Communist *Arbeiter Illustrierte Zeitung (AIZ)* in Berlin, a class-conscious, illustrated magazine which opposed the view of bourgeois mass-media publications. Among the contributors to this magazine was John Heartfield, famous for his new style of photomontages. In Hungary, the magazine *Erdekes Ussag* was an early example of modern photojournalism. In 1923, the *Müncher Illustrierte Press* was first published, in a conscious imitation of the successful *Berliner Illustrirte;* both these publications soon reached a circulation of half a million. Unlike the bourgeois magazines, *AIZ* carried hardly any advertisements. It was not produced in free competition but by the party organization, which also guaranteed any deficit. New publications were not long in following. . . .

"Korff, of the *Berliner Illustrirte,* was always on the lookout for new talents—both writers and photographers. In the twenties he also sought out photoreporters capable of portraying a theme with strong human interest. But photoreporters of this kind did not appear until 1928–29, and it was not Korff who discovered them, except for Erich Salomon. They emerged on their own, very few coming from the ranks of the professional photographer.

"The modern photoreporter was the creator of the modern illustrated magazine and modern photojournalism—not the other way round. The editors-in-chief of the magazines recognized his importance for photojournalism and they quickly welcomed him with open arms, incorporating him into the format of the modern illustrated magazine.

"The pictorial sections of the magazines remained static during these years. A forward movement came, finally, from two sources, one expected and one totally unexpected. The first source was the continuing development of the camera and the lens. The second, entirely unforeseen, came about through the emergence of a small group of intellectual outsiders from this hitherto "unintellectual" field of press photography. . . .

"In 1928, Kurt Korff was the editor-in-chief of the *Berliner Illustrirte Zeitung.* The publishing director was Kurt Szfranski, responsible also for the monthly magazines *Die Dame* and *Uhu.* Carl Schnebel was art director.

"At the *Münchner Illustrierte Presse* the publishing director and moving spirit in modernization of the magazine was Pflaum. Paul Feinhals was the sensitive and artistic editor-in-chief. Hugo Huber was in charge of the layout.

"The *Berliner Illustrirte* (which, like the *Leipziger Illustrirte,* omitted the *e* in the word *Illustrierte)* was distinguished by the quality of its presentation, its fine photographs, and above all, the interesting serials by successful writers. In 1928, it also published short stories and essays by Kurt Tucholsky, Carl Zuckmayer, Arnold Zweig, and Bertolt Brecht. It presented many innovations which were hitherto unknown in the illustrated magazines. . . .

"The *Müncher Illustrierte Presse,* on the other hand, was somewhat provincial, failing to provide any imaginative innovations in this year. It did, however, present a series of informative, illustrated political articles on themes such as disarmament, the League of Nations, the United States, and Soviet Russia. . . .

"The year 1928 also saw the beginning of the competitive battle between the *MIP* and the *BIZ* for larger circulation figures, and thus for a larger income from advertising. Generally speaking, the production costs of an illustrated magazine were approximately ten per cent higher than the income, and it was only advertisements which brought any profit. The larger the circulation, the higher was the advertising rate and the greater the profit.

"The *Berliner Illustrirte* had at that time a circulation of around 1,600,000; the *Müncher Illustrierte* slightly less than 500,000. The Berlin magazine was fortunate enough to have on its staff a new photographer, Erich Salomon. His pictures completely changed the character of indoor reports, and his work was published mainly in the *BIZ, Die Dame,* and also the *Müncher Illustrierte.* . . . Now . . . completely unposed and undirected interior photographs of unself-conscious subjects began to appear in the magazines. . . .

"In a single picture, Salomon was able to capture the mood of the speaker, the listeners, and the whole group. He had respect for the truth of what he saw through the lens. He recognized the limits of his methods, but he made the fullest possible use of their potentialities. Salomon also took extremely impressive portraits of individuals. Here too his images reveal his conscious self-limitation.

"He made but few picture series and few complete reportages. Most of his work consisted of reportage-like single pictures. The outdoor reportage did not interest him, and he restricted himself to the field in which he was a master: the indoor photoreportage in available light. . . .

"The new editor in Berlin for the *Münchner Illustrierte* was the young Stefan Lorant, then editor of the *Filmkurier,* the Sunday supplement to the *Berliner Börsenkurier.* Lorant had previously attempted to instill a new vigor into the style and content of the *Münchner Illustrierte,* and in September 1928, the paper published a reportage in pictures and text covering several pages entitled "The Chanson Reflects Our Time" with photos by Fritzi Massary, Claire Waldorff, and other typical Berlin cabaret personalities. Such representative themes and their manner of presentation lent the *Münchner Illustrierte* a cosmopolitan accent and courted readership in northern Germany and Berlin. . . .

"When suggestions were brought to him by agencies or photoreporters, he recognized their topical potentialities and he organized the suitable graphic presentation for publication. He underlined the "essay" character of the photoreportage and identified himself with the photos as if they were his own. He emphasized graphic presentation and arrangement instead of showing a mere succession of photos, text, and captions. . . . The breakthrough to modern, lively presentation did not take place until the *Münchner Illustrierte* came under Lorant's influence. . . . The relationship of mu-

tual trust between Lorant and the photographers permitted them to treat their themes as they thought fit. The photographers could always be confident that Lorant's presentations would display their work to best advantage. They knew also that Lorant would not accept mediocre work. There were no permanently employed photographers, and thus every photoreportage accepted was a new proof of the photoreporter's ability. This mutual dependence between photoreporter and editor may explain why Lorant was seldom obliged to reject the work submitted and also why his photographers did not suffer the depressing disappointments which plagued American staff photographers in later years.

"With the delivery of the pictures, the photoreporter's task was completed. Lorant made the selection and sketched the layout according to his own views—not according to those of the publishing directors. This gave the *Münchner Illustrierte* a distinctive, recognizable character, contributing greatly to its success. The so-called artistic style of presentation became increasingly rare, imaginative cropping and embellishments even rarer. The pictures were published in as natural, simple, and unfalsified a form as possible.

"Another graphic principle was the reduction and limitation of the pictures to a double-page spread. The key photo was shown large, the rest intentionally smaller and grouped in harmonious sequence. . . .

"The increasing demand for publishable photos and reports led to the foundation, at the end of 1928, of two new photoagencies, Dephot (German Photo Service) and Weltrundschau. Unlike the existing agencies (particularly Keystone, Pacific and Atlantic Press Association, Wide World, A. B. C., and Hanke), they dealt with the programming and production of photoreportages as well as distribution. The cofounder and director of Dephot was Simon Gutmann, and Weltrundschau was directed from 1928 on by Rudolph Birnbach, a Rumanian by birth. They were in constant contact with the editors and the staff reporters of magazines and newspapers, and their work consisted of composing, perfecting, and placing photoreportages. Their stimulating influence on both editors and reporters was considerable. . . .

"Following the Dephot's and Weltrundschau's example, Keystone and Associated Press (under the direction of Leon Daniel) decided in 1930 to embark on their own production of photoreportages in addition to their distribution of single pictures. Pacific and Atlantic was already known as a distributor of picture reports from all over the world, and was taken over by Associated Press.

"The backbone of the new photojournalism, however, was still the individual photographer. In 1929 came the breakthrough of photoreportage conceived as a complete and harmonious whole, which represented the beginning of modern photojournalism. . . . The year 1929 began with a photojournalistic sensation. In the first issue of the *Berliner Illustrirte,* three pages were devoted to 'The House of Silence,' a series of pictures on the Motherhouse of the Trappist order, Notre-Dame de las Grande Trappe, in Soligny. It was unusual to devote three pages to a single theme, but in this case it was thoroughly justified. . . . The powerful photos had an impact which brought the monks

as human beings closer to the reader. The reportage did more than present a visual image of the subject. It transported the viewer into the atmosphere of the monastery, conveying vividly not only the environment, but also the monks' feelings and way of life. . . .

"Three important technical improvements contributed to the expansion of photoreportage in 1930. Agfa brought Agfa-Pan film onto the market. This film with ASA 32 (approximately 16 DIN) was equal to the sensitivity of plates. In 1931, Agfa Superpan (ASA 100) also became available. . . . In 1930, Leitz produced a Leica with interchangable lenses—a wide-angle lens with a light intensity of f:3.5 and focal length of 35mm in place of the previous 50mm; and a telephoto Elmar f:4.5 and 135mm. They also constructed a handier, attachable rangefinder. Osram produced a flash lamp which could be ignited with a flashlight battery. . . .

"Between 1929 and 1931, the photoreportage expanded to cover all areas of life. The world in front of the lens had become its natural environment. The photoreportage, now on a level with the written report, was accorded recognition as an expansion and enrichment of journalism. . . . New magazines modeled on the *Berliner* and *Münchner* appeared in other countries, and a number of existing journals went over to the new form of photojournalism. Among them were *Vu* in Paris, under its editor-in-chief Lucien Vogel. Founded in 1928, it soon became the most "modern" and successful magazine in France. The *Zürcher* was the leading publication in Switzerland. The *Leipziger Illustrirte,* the *Schweizer Illustrierte,* and *L'Illustration,* as well as the English and American magazines, remained conservative and thus outdated for some time to come. . . .

"With the exception of the party magazines *AIZ* (Communist) and the *Illustrierte Beobacher* (Nazi), German magazines were and remained independent in editorial content. The editors-in-chief, nearly all liberal-minded, were not influenced by the political views of their publishers. Their aim was to set forth basic aspects of the life of the time, honest statements presented in an interesting manner, even if this meant showing the negative sides of the social structure. Thus a retrospective view of the German illustrated magazines of 1932 provides a true reflection of an era full of contradictions and uncertainty. . . . There was dancing on a powder barrel and kissing of the pirate's plank, but we became aware of this only in retrospect. . . .

"The *AIZ* was chiefly devoted to social criticism and Communist propaganda, and among its contributors and advisors were George Grosz and John Heartfield, whose powerful and unequaled photomontages highlighted the political difficulties and economic distress of the working classes. . . . The *AIZ* frequently offered fresh ideas and experimented with new forms of presentation, at times developing striking contrasts for the cover page. For the most part, however, the texts [with pictures] were manipulated politically . . . the Nazi *Illustrierte Beobacher* . . . manipulated the texts and [picture] captions in much the same way as *AIZ*. . . .

"In January 1933, Adolf Hitler was named chancellor of the German Reich by President Hindenburg. In February, the Reichstag [the German legislative building]

was burned to the ground. The new Chancellor banned the Communist Party, and the Communist delegates were deprived of their seats in the Reichstag, to the advantage of a right-wing coalition. The right-wing parties, ready to compromise, supported Hitler's seizure of power in March.

"The illustrated magazines published reports of these events, but no one knew what might follow. The discussions were concerned chiefly with whether the situation would last eight weeks or eight months. . . . On February 19, *AIZ* published a cover picture entitled "For Work, Bread, and Freedom" and a photoreport "Six Days and Twelve More Killings by Hitler's Murderers." This was the last issue of *AIZ* to appear in Germany. Its offices were broken into and the building was burned down on Hitler's orders. Most of the editors were forced to flee and escaped to Prague.

"Number eleven of the *MIP* still carried the name of Stefan Lorant as editor-in-chief. But when number twelve appeared he was already in prison, having been arrested on March 14. The *BIZ* number twelve shows the name of Friedrich Trefz as "representing" Kurt Korff. Korff had fled to the United States. . . . One of the many Nazi "achievements" of these months was the collapse of the new photojournalism. . . . Stefan Lorant was released from prison in 1933 after intervention by the Hungarian government. . . . In 1934, he moved to London, where he became editor of the *Weekly Illustrated,* and in 1938, he was appointed editor-in-chief of the newly founded *Picture Post.* . . .

"1933 saw the decline of photojournalism in Germany. In that year, a second generation of photoreporters in other countries emerged and joined the pioneers. . . . The photoreporter has survived all aesthetic and technical trends and fashions. He pays little or no attention to them since he does not use the drawbacks, peculiarities, and possibilities of technology of photography in the interests of individual expression or new effects. Rather he accepts them as existing necessities. Only thus is it possible to explain the timeless persistence of the photoreporter. . . . The new photojournalism, which originated in Germany and which is served by the written word, has become a visual document of social history. With the help of visual media it has inaugurated a new era of mass communications. Here lies its historical importance, past and present."

"On Photomontage." (1938)
*Barbara Morgan**

"Photomontage: Photographic shorthand of the imagination; units of straight photography fused for new meanings; simultaneous images combined in one composition; photography organized with airbrush, painting, or construction materials.

The Complete Photographer, 10 vols. (Encyclopedia of Photography) New York: National Educational Alliance. 1941–43, 1949, pp. 2853–2866.

"As his imagination prompts, the photographer-designer can bring together images from more than one negative to create an entirely new picture entity—a photomontage. He is not confined to what he and his lens see at one time and place. Using straight photography as a reservoir, he plucks out picture ingredients and organizes these realistic elements in unrealistic combinations, to arouse the spectator to an experience not possible from the single parts. It carries straight photography into another dimension. The purist calls photomontage a bastard medium. I call it a challenging medium for expressing ideas that can be expressed in no other way. . . .

"Photomontage, which applies only to still composition, is often mistaken for the cinema term "montage." The American public is familiar with the word in relation to movie "effects"—phantom printing, multiple exposure, and short cutbacks, implanted into the running footage to produce heightened dramatic structure, more symbolism, and enrichment. However, "montage" in the minds of European directors who originated the term, means editing of a film, and embraces the complete fusion of parts adding up to the final cinematic form. . . . Juxtaposition of images in cinema happen in time; the picture flashes coalexce in our minds. It is a space art continually transforming in time.

"Photomontage, on the other hand, is a still composition and stays put. Unlike montage in time, photomontage is a space art which uses simultaneous images to produce its dynamic effects upon the imagination. To gain the fluid sense of things seen freely in imagination and dreams, the photomontage must juxtapose unlike images in its space format. Their reciprocal tension, scale, perspective, and tone value must be organized on unrealistic terms in dynamic balance. Knitting unlike elements causes unfamiliar mental associations, especially as to time and place. . . .

"In all it is no stranger than life itself—of which it is a part. Modern life *is* photomontage. The inner life of man has always functioned so. In our thoughts and feelings, the images vital to us move together, skipping over the factual detail. Before the industrial revolution people lived much more of a single negative existence. Now the machine age has added radio, the airplane, and wirephoto to compress life and to superimpose sights and sounds from the globe upon our already over stimulated brains. Like a photomontage print, our consciousness is literally superimposed with jostling images. If the world is chaotic and bewildering we need not passively imitate it. Within our pictures we can coordinate our images and create our own sense of order. . . .

"Photomontage as we discuss it here can be said to have sprung from the creative ferment just before and after World War I. It came from the same emotions and realizations that produced modern architecture, modern cinema, modern painting. No doubt the Eisenstein-Pudovkin-Dovshenko use of montage in cinema had the greatest stimulation for photomontage. To date, I consider the most significant body of photomontage to be the brilliant collection of political satires excoriating the Nazi régime, made by John Heartfield in Germany. They were published regularly in the German picture journal *AIZ* until the artist was forced by Hitler to flee first to Austria, then to Czechoslovakia. The journal was suspended and Heartfield had to take refuge in England. In Heartfield's hands photomontage is no bag of photographic tricks but a

weapon to deflate Hitler and his colleagues, show up their motives, and stand for freedom of the common man. . . .

"Photomontage hinges on the basic impact of the juxtapositions. Therefore the designer must produce a starting picture strong enough to obsess the memory and support correllary pictures when necessary. Once the main pictures are meshed, any supplementary photographs, painting, or construction can be dovetailed for the final knit. The conception dictates the design and technic. Delicacy of overlaying images proper to a photo-lyric would be ridiculous in a poster calling for staccato form and vigorous modeling. But regardless of the use and content of the design, there are common problems involved in photomontage that are not met in straight photography. . . .

"The dangers of photomontage are fussiness, manipulation for the sake of manipulation, and preciousness. Until there is more effective equipment for fusing images photomontage cannot reach the stature that it should inevitably reach. The paste-up plus hand work is not satisfying except in reproduction. The "natural" montage has great possibilities, but the problem of more ease in controlling superimpositions cries out for solution. In spite of the technical handicaps, there is every indication that photographers of imagination find in it an outlet for certain conceptions which straight photography cannot fully express. I believe that increasingly the pressure of such subject matter will force designers to evolve better ways of producing the non-realistic multiple image. It stands before us a great undeveloped potential in photography."

"Light—A Medium of Plastic Expression." (1923)
*Laszlo Moholy-Nagy**

"Since the discovery of photography virtually nothing new has been found as far as the principles and techniques of the process are concerned. All innovations are based upon the aesthetic representative conceptions existing in Daguerre's time (about 1830), although these conceptions, i.e., the copying of nature by means of the photographic camera and the mechanical reproduction of perspective, have been rendered obsolete by the work of modern artists.

"Despite the obvious fact that *sensitivity to light* of a chemically prepared surface (of glass, metal, paper, etc.) was the most important element in the photographic process, i.e., containing its own laws, the sensitized surface was always subjected to the demands of a *camera obscura* adjusted to the traditional laws of perspective while the full possibilities of this combination were never sufficiently tested.

Broom, vol. 4, pp. 283–284.

"The proper utilization of the plate itself would have brought to light phenomena imperceptible to the human eye and made visible only by means of the photographic apparatus, thus perfecting the eye by means of photography. True, this principle has already been applied in certain scientific experiments, as in the study of motion (walking, leaping, galloping) and zoological and mineral forms, but these have always been isolated efforts whose results could not be compared or related. . . .

"One way of exploring this field is to investigate and apply various chemical mixtures which produce light effects imperceptible to the eye (such as electromagnetic rays, X rays).

"Another way is by the construction of new apparatus, first by the use of the *camera obscura;* second by the elimination of perspective. In the first case using apparatus with lenses and mirror-arrangements which can cover their environments from all sides; in the second case, using an apparatus which is based on new optical laws. This last leads to the possibility of "light-composition," whereby light would be controlled as a new plastic medium, just as color in painting and tone in music.

"This signifies a perfectly new medium of expression whose novelty offers an undreamed of scope. The possibilities of this medium of composition become greater as we proceed from static representation to the motion pictures of the cinematograph. . . ."

"The Future of the Photographic Process." (1929)
Laszlo Moholy-Nagy

"Photography as a presentational art is not merely a copy of nature. This is proven by the fact that a "good" photograph is a rare thing. Among millions of photos which appear in illustrated newspapers and books you will find only occasionally a really "good photograph." The strange thing in this, proving our case, is the fact that after a long cultivation of the optic sense, we infallibly and instinctively choose the "good" photos independent of the novelty or the unknown quality of the "thematic" idea. A new feeling is developing for the light-dark, the luminous white, the dark-grey transitions filled with liquid light, the exact charm of the finest textures: in the ribs of a steel construction as well as in the foam of the sea—and all this registered in the hundredth or thousandth part of a second. . . .

"Most men of to-day have a view of the world dating from the period of the most primitive steam-engine. The modern illustrated newspapers are still reactionary when

Transition, 15, (February, 1929) pp. 289–293.

measured by their immense possibilities! And what educational work we could and must perform! Communicate the marvels of technology, of science, of the spirit! In big things and little things, far and near! There are doubtless in the fields of photography a whole series of important works which mediate the inexhaustible wonders of life. . . . When photography comes into the full knowledge of its real laws, the composition of representation will be brought to a height and perfection which can never be attained by manual means.

"It is still revolutionary to proclaim a basic enrichment of our optic organ with the aid or changed compositional principles in painting and the film. Most men still cling too much to an evolutionary continuity of the manual-imitative ad anologiam classical pictures, so that they are unable to conceive this complete change. . . ."

"From Pigment to Light." (1936)
Laszlo Moholy-Nagy*

"In photography we possess an extraordinary instrument for reproduction. But photography is much more than that. Today it is in a fair way of bringing (optically) something entirely new into the world. The specific elements of photography can be isolated from their attendant complications, not only theoretically, but tangibly, and in their manifest reality.

"The photogram, or camera-less record of forms produced by light, which embodies the unique nature of the photographic process, is the real key to photography (Fig. 2.9). It allows us to capture the patterned interplay of light on a sheet of sensitized paper without recourse to any apparatus. The photogram opens up perspectives of a hitherto wholly unknown morphosis governed by optical laws peculiar to itself. It is the most completely dematerialized medium which the new vision commands. . . .

"In reproduction—considered as the objective fixation of the semblance of an object—we find just as radical advances and transmogrifications, compared with prevailing optical representation, as in direct records of forms produced by light (photograms). These particular developments are well-known: bird's-eye views, simultaneous interceptions, reflections, elliptical penetrations, etc. Their systematic coordination opens up a new field of visual presentation in which still further progress becomes possible. It is, for instance, an immense extension of the optical possibilities of reproduction that we are able to register precise fixations of objects, even in the most difficult circumstances, in a hundredth or thousandth of a second. . . .

"Photography, then, imparts a heightened, or (in so far as our eyes are concerned) increased power of sight in terms of time and space. . . . All interpretations of photog-

*From *Telehov,* Vol. 1, No. 2, pp. 32–36.

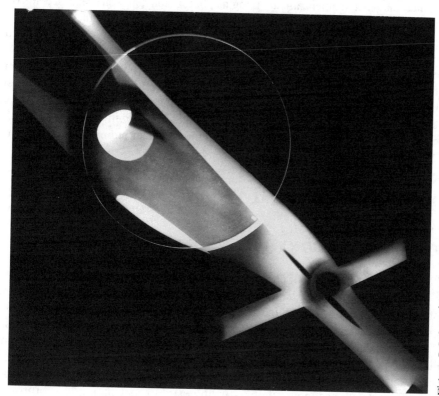

Figure 2.9 Laszlo Moholy-Nagy.
Fotogram, 1925–26.
Gelatin-silver print. Black & White.
Courtesy George Eastman House. Copyright © 1997
Artist's Rights Society (ARS), New York/VG Bild-Kunst, Bonn.

raphy have hitherto been influenced by the aesthetic-philosophic concepts that circum-scribed painting. These were for long held to be equally applicable to photographic practice. Up to now, photography has remained in rather rigid dependence on the tra-ditional forms of painting; and like painting it has passed through the successive stages of all the various art "isms"; though in no sense to its advantage. . . .

"In this connection it cannot be too plainly stated that it is quite unimportant whether photography produces "art" or not. Its own basic laws, not the opinions of art critics, will provide the only valid measure of its future worth. It is sufficiently un-precedented that such a "mechanical" thing as photography, and one regarded so con-temptuously in an artistic and creative sense, should have acquired the power that it has, and become one of the primary objective visual forms, in barely a century of evo-lution. Formerly the painter impressed his own perspective outlook on his age. We have only to recall the manner in which we used to look at landscapes, and compare it with the way we perceive them now! Think, too, of the incisive sharpness of those camera portraits of our contemporaries, pitted with pores and furrowed by lines. Or an air-view of a ship at sea moving through waves that seem frozen in light. Or the en-largement of a woven tissue, or the chiselled delicacy of an ordinary sawn block of wood."

"Photomontage as a Weapon in Class Struggle." (1932)
Durus (Alfred Kemeny)*

"The bourgeois concept of photomontage can be summed up in the following re-mark made by a well-known bourgeois art critic: "Montage, i.e., the artist and the craftsman are replaced by the engineer. Pieces of photographs are pasted together the way parts of machines are joined together with screws." Is this the actual state of af-fairs? Has the engineer actually taken the place of the artist? Are pieces of photographs installed like parts of machines? Not at all. The photo "monteur" is an artist—not an engineer. And the photo "montage" is a work of art not just a machine. A work of art that offers completely new opportunities—with regard to content, not just form—for uncovering relationships, oppositions, transitions, and intersections of social reality. Only when the photomonteur makes use of these opportunities does his photomontage become a truly revolutionary weapon in the class struggle.

"We must emphasize: In a class society there can be no "classless-revolutionary" photomontage. Like all art forms before the classless society, photomontage is deter-mined by social class. The "non-representational" stance of formalist photomontage—playing with light effects, superimpositions, overexposures, strange angles" without

*Original publication: Durus, "Fotomontage als Waffe im Klassen kampf," *Der Arbeiter-Fotograf,* 6 no. 3 (1932) pp. 55–57.

content"—merely veils the bourgeois contents, the dead-end perspective of rootless bourgeois artists. In this as in any other field, the revolutionary working class does not separate theory from practice—it sets a high value on photomontage as an extraordinarily effective propagandistic and organizational weapon in the class struggle.

"It is becoming more and more obvious that the cognitive value of photomontage is inseparable from its role in the class struggle. Could the development of photomontage take place outside the context of class struggle? Certainly not. Why did formalist photomontage grind to a halt after a few superficially interesting experiments? Because it operated in a vacuum, divorced from the decisive social conflicts of our era; because it could not carry out its essential purpose: to reveal the truth. Why did proletarian-revolutionary photomontage attain such a high level in the Soviet Union and Germany? Because it not only did not oppose the revolutionary development of humanity, but developed in close conjunction with the revolutionary workers' movement.

"And we can see that while in response to the intensified economic crisis, the bourgeois advertising industry is dispensing with more and more of its most artistically and technically expert photomonteurs, our publishing houses and our magazines require an ever greater number of qualified photomonteurs. One need only look at the display windows of our bookstores; invariably, one's eye is caught by interesting, original, and thought-provoking photomontages on the covers of books and brochures.

"The very first dadaist works using paste and photographs . . . set the course for the development of a consciously political proletarian photomontage despite the anarchist-individualist philosophy of their creators. But the rising line of German proletarian-revolutionary photomontage is most intimately associated with the epoch-making work of the brilliant "monteur" John Heartfield (Fig. 2.10).

"His works can already by considered 'classic.' He pioneered the use of photomontage for book jackets and in the design of political picture books. He always fo-

Figure 2.10 John Heartfield.
This is the Salvation They Bring,
1938.
Photomontage.
John-Heartfield-Archiv. Akademie
Der Künste, Berlin.
Copyright © 1997 Artists Rights
Society (ARS), New York/VG Bild-
Kunst, Bonn.

cused the aesthetically effective elements of photography's "gray-scale structures" of planar division, of combinations of script and photography, on maximizing the political content. All traces of "beautiful, self-contained form" have been ruthlessly swept away. In place of a bourgeois aesthetic we have the sharpest, strongest, most penetrating political militancy of a no longer "neutral" art. Faced with the powers of inertia and habitual rigidity, Heartfield never took the path of least resistance. After years of stubborn and consistent work, he won the adoption of the line which he considered the most appropriate for the proletarian liberation struggle.

"As a creator of satirical photomontages, he is unsurpassed. His satirical contributions to the *AIZ*—the "Tiger," the "Cabbage Head," "Solar Eclipse on the 'Liberated' Rhine," "6 Million Nazi Voters: Fodder for a Big Mouth," to mention just a few—are among the most significant satirical creations of our time.

"Today the ranks of revolutionary photomonteurs are increasing considerably in Germany. The best photomontages by the members of the League of Revolutionary Artists, who use this artform as a weapon in the daily practice of class struggle, are by no means simple imitations of Heartfield. The last exhibition of proletarian photographers (at the decennial IAH show in Berlin) was of high quality not only photographically, but in the use of montage. We know, however, that such quality has not yet been achieved by more than a minority of the German worker-photographers."

"Photography and Typography." (1928)
*Jan Tschichold**

"The artistic value of photography has been disputed throughout its history. The first attack came from the painters, who eventually realized that photography could not offer them serious competition. Today art historians are still quarreling about certain problems raised by photography. Book designers still deny photography the right to be part of the design of a "beautiful book." They contend that type, with its purely graphic, strongly material, form, is aesthetically incompatible with the photomechanical halftone, which, though seemingly "plastic" as a rule, is more planar in its material makeup. Focusing on the external appearance of both kinds of printing, they find the principal fault in the halftone's "plasticity," which is supposed to be inappropriate for a book. The objection amounts to very little indeed; after all, the halftone resolves itself into many tiny, opaque, individual points which are quite obviously related to type.

"But none of these theories has been able to prevent photography's victorious career in book design, especially in the postwar years. The great, purely practical value of photography resides in the relative ease with which this mechanical process can fur-

Original publication: Jan Tschichold, "Fotografie und Typografie," *Die Form* (Berlin), no. 7 (1928), pp. 221–227; and *Die neue Typographie* (Berlin: Bildungsverband der deutscher Buchdrucker, 1928), pp. 89–98.

nish a faithful copy of an object, as compared with the more laborious manual methods. The photograph has become such a characteristic sign of the times that our lives would be unthinkable without it. Modern man's hunger for images is mainly satisfied by photographically illustrated newspapers and magazines. Advertising pages (especially in America) and, occasionally, advertising posters are more and more frequently using photographs. The great demand for good photographs has had an extremely encouraging effect on the craft and art of photography: there are fashion and advertising photographers in France and America who are qualitatively superior to many painters. . . . Exceptional work is also being done by the usually anonymous photoreporters, whose pictures are often more captivating, not the least for their purely photographic quality than the supposedly artistic gum-prints of the would-be portrait photographers and amateurs.

"Today it would be quite impossible to meet the enormous demand for printed pictures with drawings or paintings. There would neither be enough artists of quality nor the time required to create and reproduce the works. There are many current events about which we could not be informed if photography didn't exist. Such extraordinary consumption can only be met through mechanical means. This consumption—which has it roots in the greatly increased number of consumers, in the growing dissemination of European urban culture and the perfecting of all the media of communication— calls for an up-to-date medium.

"The peculiar appeal of photography lies precisely in its great, often supernatural clarity and perfect objectivity. Due to the purity of its appearance and the mechanical nature of its production, photography has thus become the foremost pictorial medium of our time. . . .

"Photography may become an art in two forms in particular: as photomontage and as photogram. The word "photomontage" signifies a picture that is entirely a pasted composite of individual photos . . . or that uses the photograph as one pictorial element among others. . . . The boundaries between these genres are fluid. In photomontage individual photos are used to construct a new pictorial unity. . . . What makes photomontage different from the art of the past is the absence of an external model. It is not, like the old art, an act of continuity, but the material expression of a free imagination, in other words a truly free, human creation that is independent of nature. The "logic" of such a creation is the irrational logic of art. But a quite supernatural effect is created when a photomontage consciously exploits the contrast between the plasticity of the photograph and the inanimate white or colored surface. This extraordinary impression is beyond the reach of drawing or painting. . . .

"Photograms are photographs that are produced without a camera, using only sensitized paper. This simple method is not really new: photograms were made long ago by placing flowers on photographic paper.

"The inventor of the artistic photogram is an American living in Paris, Man Ray. Around 1922 he published his first creations of this kind in the American magazine *Broom.* They show an unreal, supernatural world that is a pure product of photography, and that bears the same relation to the usual journalistic and documentary photographs

that poetry does to everyday conversation. . . . The photogram can be used in advertising as well. The first one to do this was El Lissitzky in 1924. An absolutely excellent work by him is the photogram for Pelikan Ink. Even the writing was produced by a mechanical-photographic method. The techniques for making photograms are very simple, but too various to be described in a few words. . . . In this connection, special mention should be made of the book *Painting Photography Film* by Moholy-Nagy, which includes a thorough and very instructive discussion of these matters. . . .

"Our generation has recognized the photography as an essential modern typographic medium. We feel enriched by its addition to the earlier book printing media; indeed we regard photography as the mark that distinguishes our typography from all its predecessors. Exclusively planar typography is a thing of the past. By adding the photograph we gain access to space and its dynamism. The strong effect of contemporary typography comes precisely from the contrast between the seemingly three-dimentional structures in photographs and the planar forms of the type.

"The main question—which typeface to use in combination with the photograph—in the past met with attempted solutions of the strongest sorts: employing type that appeared to be or actually was gray, using strongly individualized or very fine types, and similar measures. As in other areas, here too the goal was superficially to coordinate the constituent parts, and thus reduce them to a common level. The result was at best a unified gray, which could not really hide, however, the obvious compromise.

"Today's unabashedly up-to-date typography has solved the problem with a single blow. In striving to create an artistic unity out of new primary forms, it simply does not recognize a problem of type (the choice of sans serif was dictated by necessity), and preferably uses the photograph itself as a primary medium, thus arriving at the synthesis: photography + sanserif! At first sight it seems that the hardness of these clear, unambiguous black letters is not compatible with the often soft grey tones of the photograph. Naturally, their combination doesn't result in a uniform grey, for their harmony lies precisely in their contrasting forms and colors. But what both have in common is objectivity and impersonal form, the distinguishing traits of a truly modern medium. Their harmony is therefore not merely the external and formal blending that was the misguided ideal of earlier designers, nor is it arbitrary; for there exists only one objective type—sans serif—and only one objective method of recording our environment—photography. Thus the individualistic graphic form, script/drawing, has been replaced by the collective form: typephoto.

"By typephoto we mean any synthesis of typography and photography. Today we can express many things better and faster with the help of photographs than by the laborious routes of speech or writing. The halftone thus joins the letters and lines in the type case as an equally up-to-date, but more differentiated, typographical element. . . .

"The great possibilities of photography itself have hardly been recognized yet, except by a narrow circle of specialists, and are certainly far from exhausted. But there is no doubt that the graphic culture of the future will make much more use of photography than is done at present. Photography will be as symptomatic of our age as the woodcut was for the Gothic period. This imposes today, on all the graphic professions,

the obligation creatively to develop the techniques of photography and reproduction, so as to ready them for the increased demands of a near future."

"A History of the Photo League: The Members Speak." (1994)
*Anne Tucker**

"The Photo League existed in Manhattan between 1936 and 1951. Its goals and membership were accurately described in a Federal Bureau of Investigation report dated 2 June 1942, which recognized the League as "a non-profit organization of amateur and professional photographers." "For the most part," the document continues, "the members are interested in the serious aspects of photography—that is documentary pictures of social significance. They are all pretty definitely pro-labor and a great many are obviously Communist in their leanings. There is certainly no member who would be considered wealthy or even ever well-off and any funds the League has to run on come entirely from membership dues, school fees and proceeds from various parties they run during the year.

"Most of the League's members were New Yorkers born between 1900 and 1925 on the lower east side of Manhattan, in Brooklyn, or in the Bronx. As the photographer Morris Engel described it, "The age span at the Photo League was mostly on the younger side; few were middle age. There were no blacks, few women and it was heavily Jewish." Many members were first-generation Americans, and had attended public schools, then college, if at all, at the tuition-free City College. They were, as a rule, left of centre politically, or as Marion Palfi wryly put it, "There probably weren't any Republicans."

"League membership was never large. It reached 80 in March 1938 before plunging as members were drafted into the war. The highest roll was 200 in November 1947, immediately before it was blacklisted. Finally, the numbers sank to 30 before the League was dissolved in 1951. Dues were always low. In 1939, annual dues were $3.50, $5 to include use of the darkrooms. By 1948, membership costs had only doubled to $7 plus $1 initiation. However, no one was denied entrance because they had not paid their dues. . . . Whatever the initial attraction, photography was the common denominator. The League ran a school, organized exhibitions, published a newsletter, sponsored lectures and symposia, and produced documentary photo-essays. Lecturers were invited who were appropriate to the current exhibition, then the newsletter *Photo Notes* would report on each lecture, but most of the noted photographers who lived or visited New York were invited to speak, and few refused. . . .

"There were at least six exhibitions each year, and six issues of *Photo Notes* were

**History of Photography*, Vol. 18, No. 2, Summer 1994, pp. 174–184. London: Taylor and Francis.

published annually between 1938 and 1948. (In the fall of 1948, *Photo Notes* became a quarterly that lasted for three issues.) Whenever possible, the Photo League circulated its exhibitions, usually to libraries, churches and union halls in New York City. "What stands out in my mind," said Sandra Weiner, "are the photographers who came to talk and [show] their work . . . and most exciting was the overwhelming large number of people that would show up. All kinds of people. . . . There were very active discussions afterward. . . .

"Each of the League's three locations had darkrooms that were also drawing cards for membership. Particularly during the Depression, many members lacked the finances, space, and privacy to set up their own darkrooms at home. . . . The League's facilities were only moderately serviceable. The darkrooms were not air-conditioned, so that when it was 100 degrees outside in midsummer, the negative developing room was like an oven. Loading film on to a reel without getting sweaty fingerprints on the negative was usually a traumatic and impossible challenge. The available enlargers were second-hand. . . . The school attracted both novices who wanted to learn the technical side of making photographs and serious amateurs who had basic technical skills but wanted to improve them. Students were screened, usually by the League secretary or whoever was manning the desk that day. Each was requested to have their own camera. . . . Students who wanted to be admitted to one of the advanced classes had to show some of their prints to register. . . .

"It was also important to many that the League gave scholarships to its classes. After her introduction to the League in 1939, Dorthea Lange offered a scholarship whose first recipient was Lou Stoumen. He went on to a career in film, winning two Academy Awards for documentaries. . . . There were other places in the city that taught photography, but none, except for Bernice Abbott's classes at the New School that had the League's documentary focus. As with the camera publications, most of what was taught elsewhere in New York was addressed to pictorial, hobby, or commercial interests. For Sid Kerner, the Photo League represented a meaningful way to combine his love of photography, his concern for people, and his anger at certain social conditions. Arthur Rothstein put it more simply. The League "was a place to talk about realistic photography," he said. . . .

"New members stayed because the League was fun and informative, led to careers for many and, for some, became their life. [Walter] Rosenblum stated, "I owe the League everything. Without that organization I might have risen to the job of head shipping clerk at some dress factory. The League taught me about life, responsibility, photography, literature, art, relationships with people—everything. . . ." Rosenblum's membership almost spans the League's existence. He joined as a teenager in 1937, and served in various offices including executive secretary and President as well as teaching in the school. He was one of the League's last members in 1951 and has devoted much of his career to keeping the League's achievements from being forgotten. When Rosenblum joined the dominant personalities at the League were two other young photographers, Sid Grossman and Sol Libsohn, who had re-formed the League from a split that had occurred in an organization called the Film and Photo League. . . .

"As its reputation grew, the modesty of its physical space surprised those attracted by its programme. Jack Manning saw the headquarters as "a seedy old loft that didn't measure up to the glamour of its reputation." . . . The lasting value of the League was the photographs produced under its auspices, either in the classes or one of its documentary projects. The school's aim was to train documentary photographers, but it was also a primary source of revenue and new members. In 1938 the school expanded from one introductory class inherited from the Film League and one intermediate class to a programme of three, fifteen-week courses: Basic Photography, Advanced Photography, and Documentary Workshop. . . . The school was the League's best organized, most consistently maintained and publicized activity. It was hoped that a student starting with the basic course would progress through the school's two advanced courses, join one of the League's documentary production groups, and become involved in other activities as well. The school fees did not pay salaries—the teachers were volunteers—but paid the League's rent, expenses for *Photo Notes,* exhibitons and postage. Although school fees were the League's primary source of income, fees were kept low throughout its history. . . .

"As developed by Grossman and Libsohn, the documentary class was structured to get the students out photographing immediately, then to work on their comprehension of what, why, and how they should photograph. The primary tenets of the class were that 1) photography had a social function, 2) this function had a historical and cultural basis, and 3) photographs should have a personal as well as a social and aesthetic significance. "It was not enough just to learn your technique or say I want to photograph," Sandra Weiner recalled. 'You really had to develop something in your head, you had to develop a point of view. . . ." Photographs made for the assignments and for the student's own projects were discussed in class and reviewed by guest lecturers. Class photographs submitted at the last session were exhibited at the League the following fall.

"While Grossman and Libsohn credited members of the Advisory Board with helping to formulate the outline and the direction with the new course, it is probable that the specific form . . . was highly influenced by the work of Aaron Siskind and the members of his Feature Group . . . Grossman neither acknowledged the Feature Group's influence nor invited Siskind or other Feature Group members to lecture to the documentary class because his relationship to the group was strained. . . . In late 1936, Siskind gathered around him a group of photographers ten years his junior. All members of the Photo League, they worked together for the next four years, producing feature projects of different complexities and lengths. Relatively modest projects took a few months to plan and execute. . . . Their most ambitious and organized effort was the Harlem Document, begun in the spring of 1938 and completed in February 1940.

"Rather than meet at the League, the group usually met weekly at Siskind's apartment on West Sixteenth Street. They became a tight-knit group. . . . Siskind's group was the most visible and the most acclaimed of the League's production units. Feature Group members frequently won the League's monthly print competitions. Some of their photographs were published in *Fortune, Look, U. S. Camera,* and *Good*

Photography. In fact the first Photo League exhibition to receive a review in the *New York Times* was *The Harlem Document.* . . .

"Belonging to the Feature Group was an honor sought by many, including Grossman. He was admitted to the group until it became clear that Grossman's other involvements would prevent him from active participation, and then the group asked him to leave. . . . Siskind remembered his irritation when Grossman tried to convert him to the Communist Party. "I would read the literature that he gave me," he commented, "but all that stuff was old hat to me and after a while I told him to stop bothering me because it was ridiculous. I was very much in sympathy with the aims of the party, but I couldn't stand doctrinaire because I was interested in taking a picture that was beautiful in relation to itself and to other pictures. . . ."

"Grossman's emphasis on photographic history and personal growth (with documentary priorities) set his methods of teaching against Siskind's as strikingly as their differences over politics. As Siskind explained in an article on the evolution of the Feature Group: "Instead of beginning with a study of critical statements on documentary photography by eminent moderns (Strand, for instance) and a review of its tradition (the procedure of Grossman's course in Documentary Photography), we concern ourselves with the problem of how an idea comes to life in a photograph, and the special characteristics of that life. We start with the simplest ideas. . . ." [Grossman felt that] historical photographs, particularly the works of Matthew Brady, Eugène Atget, and Dorthea Lange, were vivid examples of the kind of photographs that the League wanted students to make, and lent credence to the League's position that documentary photography could rise above banal reporting to become a medium of personal expression as well as social influence.

"It is difficult now to appreciate how unusual it was in 1938 for a photography course to teach photographic history, much less to insist on the aesthetic possibilities of documentary photography. Photography's acceptance as an art was embryonic. Beaumont Newhall's exhibition *Photography 1839–1937* had opened at the Museum of Modern Art only a year earlier. Newhall's catalogue was the first scholarly chronicle of photography's artistic achievements to be published in America. . . . "New contact with the heritage of photography," said Grossman, "gave us a better understanding of what its function could be. Until that time, all of our influences came from manufacturers of cameras and the editors of camera magazines who were only interested in plugging their own products. They encouraged anything, especially sensationalism that would mean sales. Amateur photographers were diverted into a craze for gadgeteering."

"Grossman encouraged his students to read Newhall's catalogue and a wide variety of other books and articles. He and Libsohn also prepared a *Photography Syllabus and Readings* for the class. . . . All of the readings stressed the importance of craftmanship and championed straight, content-laden photography.

The course's bibliography was broad in scope, including most of the existing monographs by serious photographers, even those like Man Ray and Moholy-Nagy,

whose works were antithetical to the basic purposes of Grossman's course. . . . To promote the school, copies of the syllabus were sent to various photographers, photography administrators, and magazine editors. . . . The publicity campaign seems to have had some success, for *Photo Notes* reported that registration for the fall surpassed that of all former years. Beyond its benefit to enrollment, the syllabus and subsequent notices of course offerings drew the League to the attention of those in positions of power. In January 1939, Roy Stryker wrote to thank them for their various bulletins and releases, saying that he was very interested in the educational work that the League was doing in New York. . . .

"In their classes, League teachers encouraged the students to visit museums and art galleries to look at paintings and sculptures as well as photographic exhibitions. These experiences would then be discussed at length in class. In the 1950s, when describing the teaching methods that he had evolved, Rosenblum wrote of discussing everything from bebop to Thomas Mann as well as the works of Balzac, Zola, Goya, Rembrandt, and Chaplin. . . . Most of the League's teachers learned as they taught. Few had been exposed to arts or literature in their homes or even in school. Only a small percentage of the League members in the 1930s and 1940s were college graduates. . . . Particularly in the early years of Grossman's class, critical discussions were richly laced with political ideas. In interpreting a work of art, Grossman wanted the students to understand how sociological and economic forces affected artists as well as how artists had used their materials. . . .

"Thirty years later, when giving their impressions of the classroom incidents, Grossman's students use emotionally charged words—cruelty, brutality, exhaustion, fear, anxiety. They are equally dramatic in describing his effect on their lives. . . . "I can't tell you much about the class,"wrote Sid Kerner, "but the experience of being with Sid and becoming infused with his passion was something special. I'll never forget the experience for the simple reason that it was one of the important influences that helped shape me into the human being I am."

"Amy Cooper joined the League in 1946, "just as soon as I could get my son into nursery school. My first workshop was with Sid Grossman. He was oblivious to night and day and needed only innumerable cups of coffee and a steady stream of student photographs to keep him in endless running gear. We met at 8:30 on Tuesday nights and often I drove home in the unfamiliar light of dawn. I sometimes feared I had got lost, things looked so strange and I was so sleepy, yet so stimulated. Sid made you feel inspired. You knew it was *important* to make photographs. . . ."

"The pyrotechnics were not helpful to all students. More than unpleasant, for some people it was counterproductive. Lisette Model, who frequently relied on Grossman for technical advice and who sat in on one of Sid's twelve-week sessions before starting her own teaching career, said that she was grateful to Sid for taking her under her wing, but that she thought his teaching methods were destructive. . . .

"When one speaks to members of the Photo League, their primary and impassioned responses are about photographic events: the programs in which they partici-

pated, their classes and teachers, the celebrities they met, and the works they viewed. They talk about friendships and good times. Only when pushed, do they talk about politics. However, politics are inseparable from the League's origins, history, and demise.

"Following World War II the League had incorporated, started a national membership drive, and issued broad and audacious new goals and purposes. While in 1947 the League was still predominantly an organizaiton of documentary photographers who believed in photography's persuasive powers, throughout the new by-laws the League referred to creative rather than documentary photography. Its leaders's foremost priority shifted from the school program to improving its headquarters and publications and raising the membership rolls. Whereas originally the League had cared more about the social impact of its photographs than the identity and needs of their makers, after the war there was a shift from social to personal visions, from emphasizing photography's potential as an instrument of social change to recognizing its value as a tool for creative individuals. However, before the League's perception of creative photography could be tested, before it could formulate the procedure for the changes it was proposing, the Photo League was blacklisted by the United States government. . . .

"At first the photographic community rallied to the League's defence. . . . defensive actions included an exhibition of the best of the League's work, an article placing the League's documentary style of photography in historical context. . . .

"On 29 January 1948, the League rented the basement of the Hotel Albert on Tenth Street and began converting it into offices, exhibition space, classrooms, darkrooms, and storage for the Lewis Hine Memorial Collection. With no specific charges beyond the listing itself, it was difficult to prepare a defense, but the best defense seemed to be to publicize all that the League had accomplished in the name of serious photography and to emphasize how important it could become to the future of American photography. It was agreed that the best form of publicity was a retrospective exhibition reflective of the League's past and its present talent. The survey, This is the Photo League, opened on 2 December 1948 with the work of 94 past and present members included. A catalogue was printed with an essay by Nancy Newhall and with 19 half-tone reproductions. The exhibition was well-received by the photographic press, but it was inadequate defence against the government blacklist, because from the beginning the government discounted the League's interest in photography as solely a political front activity.

"Then in April 1949, during the conspiracy trial of eleven Communist Party officials, an informant named Angela Calomaris referred to the Photo League as a Communist front organization and testified that Sid Grossman and Marion Halle had been among those who introduced Calomaris into the Communist Party. League members were shocked by her testimony for many reasons, not the least of which was her friendship with Grossman and the number of times friends remembered him working to salvage good prints from poor negatives so that Calomaris could complete a commercial assignment.

"Calomaris had only briefly belonged to the League and only mentioned it twice in a week of testimony, but such public and publicized accusations of 'Un-American'

activity was more than necessary as effective condemnation. Newspapers and magazines would no longer review the League's exhibitions or publicize its events. . . . Membership declined steadily. Some members and advisers, including the Newhalls, Barbara Morgan, and [Ansel] Adams, who had never realized that any of the League's members were Communist, resigned in anger. Anyone whose job required national security clearance, bonding or a passport—all of which were necessary to a photojournalist—could not belong to an organization on the Attorney General's list. . . . In September [1950], the McCarran-Wood act passed through Congress despite [President] Truman's veto. It required registration of all members of groups identified by the government as subversive; the League would have to identify itself as a Communist front organization on all stationery and literature. The sense of fear grew so great that Arnold Newman remembers checking his bookcase for incriminating publications just before friends arrived for supper. When the League was no longer able to pay its rent in the late summer of 1951, it disbanded.

"The Photo-League is a minor footnote in the story of the American political left, but its role in the history of American photography is rich and vital. Many fine and some great photographs were made by its members and under its auspices. The League trained and stimulated a generation of photographers. It initiated careers that otherwise might have eluded some of these sons and daughters of immigrants. It offered a rare forum for serious photographers to exhibit their work, hone their skills, develop their intellects, and meet like-minded peers. Many of the friendships begun over darkroom trays at the League have lasted a lifetime.

"The League's members were among the artists, writers, and film-makers of the 1930s who believed that art could change the world. While few contemporary artists share this optimism, political expressions in art have been revitalized; some artists and scholars insist that all art is political. Other individuals insist that art and politics are incompatible, and that artistic qualites are always subsumed by political passions. Mixing art and politics has created some explosive situations. The League can be fruitfully studied as a paradigm for these contemporary aesthetic debates."

"The F.S.A. Collection of Photographs."
(1973)
Roy Stryker*

"For nearly eight years, from 1935 to 1943, it was my great privilege to direct a small group of photographers working out of a grubby little government office in Washington, D. C. These gifted men and women of the Historical Section of the Farm

*Roy Emerson Stryker and Nancy Wood. *In This Proud Land.* Greenwich Conn.: New York Graphic Society, 1973 pp. 7–9.

Security Administration produced 270,000 pictures during that time. It is called a great collection now, perhaps the greatest ever assembled in the history of America. But I am not interested in adjectives. I am only interested in pictures.

"And what pictures they were. I had no idea what was going to happen. I expected competence. I did not expect to be shocked at what began to come across my desk. The first three men who went out—Carl Mydans, Walker Evans, and Ben Shahn—began sending in some astounding stuff that first fall, about the same time that I saw the great work Dorthea Lange was doing in California and decided to hire her (Fig. 2.11). Then Arthur Rothstein, who had set up the lab, started taking pictures. Every day was for me an education and a revelation. I could hardly wait to get the mail in the morning.

"I remember one of Walker's early pictures—one of a cemetery and a stone cross, with some streets and buildings and steel mills in the background. Months after we'd released that picture a woman came in and asked for a copy of it. We gave it to her and when I asked her what she wanted it for, she said, "I want to give it to my brother who's a steel executive. I want to write on it, '*Your* cemeteries, *your* streets, *your* buildings, *your* steel mills. But *our* souls, God damn you. . . .'" (Fig. 2.12)

Figure 2.11 Dorothea Lange.
Woman of the High Plains, Texas Panhandle, 1938.
Gelatin-silver print.
Copyright © the Dorothea Lange Collection, The Oakland Museum of California, The City of Oakland. Gift of Paul S. Taylor.

Figure 2.12 Walker Evans.
Bethlehem, Pennsylvania, 1935.
Gelatin-silver print, (19.5 x 24.2 cm).
Copyright © The Metropolitan Museum of Art, Walker Evans Archive.

"In 1936 photography, which theretofore had been mostly a matter of landscapes and snapshots and family portraits, was fast being discovered as a serious tool of communications, a new way for a thoughtful, creative person to make a statement. Flash bulbs and small cameras were being used for the first time. The rotogravure was dying; the first big picture magazines, which would take its place, were already being roughed out. In a year or so, and with a suddenness matched only by the introduction of television twelve years later, picture-taking became a national industry. We would have been insensitive indeed not to have realized that we were an important part of a movement. . . .

"Still, we had no idea that we were doing anything of the importance that later historians have credited us with. We particularly underestimated the content of our work. We know now that we helped open up a brand-new territory of American life and manners as a legitimate subject for visual commentary. We did not know it then. . . .

During the whole eight years, I held onto a personal dream that inevitably got translated into black-and-white pictures: I wanted to do a pictorial encyclopedia of American agriculture. My footnotes to the photographers' instructions ("keep your eyes open for a rag doll and a corn tester") undoubtedly accounted for the great number of photographs that got into the collection which had nothing to do with official business.

"In truth, I think the work we did can be appreciated only when the collection is considered as a whole. The total volume, and it's a staggering volume, has a richness and distinction that simply cannot be drawn from the individual pictures themselves. There's an unusual continuity to it all. Mostly, there's rural America in it. It's the farms and the little towns and the highways between. . . .

"Was it history? Of course. At least it was a slice of history. We provided some of the important material out of which histories of the period are being written. But you'll find no record of big people or big events in the collection. There are pictures that say labor and pictures that say capital and pictures that say Depression. But there are no pictures of sit-down strikes, no apple salesmen on street corners, not a single shot of Wall Street, and absolutely no celebrities.

"Was it education? Very much so, and in more ways than one. For me, it was the equivalent of two Ph. D.s and a couple of other degrees thrown in. . . . If I had to sum it up, I'd say, yes, it was more education than anything else. We succeeded in doing exactly what Rex Tugwell said we should do: *We introduced Americans to America.* We developed the camera team, in contrast to the cameraman, and the full effect to this team's work was that it helped connect one generation's image of itself with the reality of its own time in history.

"The reason we could do this, I think (and perhaps the reason it could never be done again), was that all of us in the unit were so personally involved in the times, and the times were so peculiarly what they were. It was a trying time, a disturbed time. None of us had suffered personally from the Depression, but all of us were living close to it, and when the photographers went out they saw a great deal of it. Curiously, though, the times did not depress us. On the contrary, there was an exhilaration in Washington, a feeling that things were being mended, that great wrongs were being corrected, that there were no problems so big they wouldn't yield to the application of good sense and hard work. . . . It was called the New Deal and we were proud to be in on it. . . .

"I cannot, however, attribute the success of our unit entirely to the times. I can't dismiss it all as a product of the spirit of the thirties. I was in charge of the unit. I was given more freedom in the running of it than I had any reasonable right to expect, and whatever came of it, I was—as they say in government—both accountable and responsible. I never took a picture and yet I felt a part of every picture taken. I sat in my office in Washington and yet I went into every home in America. I was both the Stabilizer and the Exciter. Now at eighty I have the honesty to advance the somewhat immodest thought that it was my ideas, my biases, my passions, my convictions, my

chemistry that held the team together and made their work something more than a catalogue of celluloid rectangles in a government storehouse.

"For thirty years I have waited to make my personal choice from the huge file that passed over my desk during those eight years. Partly it was because I did not wish to offend any photographer by leaning less toward his work than another's or by skipping over him entirely. I wanted no hard feelings among the fine people who worked for me. It has also been because the pictures needed to stew for a long time in my mind.

"I have not chosen the greatest pictures from that file—although some of the greatest ones are included. I have chosen not on the basis of the artistic merit of a picture but on the basis of what each one represents to me in terms of intent. It is a purely personal choice and future historians may argue with me. Yet this selection states what one man—Roy Stryker—believed this country to be during a certain period of its history. On that assumption I have made what I hope is a valid and meaningful selection."

Photographs of America: Walker Evans. (1938)
*Lincoln Kirstein**

"Ever since the practice of photography was invented over a century ago, there has been the question of whether the camera is a technical means or an artistic end in itself. Although fairly early in its history what was at first a labor-saving aid to pictorial reproduction acquired the prestige of an exploitable fine art, the inventors of the process were less pretentious for it than their modern heirs. The artist-photographer, in spite of the development of the daguerreotype parlor and the photographic atelier, was not seriously considered the peer of professional painters. Brush, paint, and palette can scarcely be considered a machine—the camera can never be thought of as anything else.

"Recently we have not been greatly troubled by the old-fashioned "artistic" soft-focus photographer. We all agreed to laugh him out of the magazines and exhibitions ten years ago. But new kinds of eye corrupters have arrived. These are not the facile and legitimate photographers of fashions and commodities who have replaced the commercial draftsman, the technically able workmen who suavely define the ultimate in desirability of chic or convenience. The new confusers are the candid-camera men.

"The candid camera is the greatest liar in the photographic family, shaming the patient hand retoucher as an innocent fibber. The candid camera, with its great pretensions to accuracy, its promise of sensational truth, its visions of clipped disaster, pre-

*New York: The Museum of Modern Art, 1938, pp. 223–235.

sents an inversion of truth, a kind of accidental revelation which does far more to hide the real fact of what is going on than to explode it. It is a good deal easier to look at a picture than to read a paragraph. The American reading public is fast becoming not even a looking public but a glancing or glimpsing public. The candid camera makes up in quantitative shock what it lacks in real testimony. . . . No one would suffer for a second the slipshod and ill-defined approach of the candid camera if it were transferred to the newsreels. But newsreel camera men are not stamp collectors of unrelated moments. They are sound and usually brilliant technical documenters. . . .

"And good photography has an enormous field today. The use of the visual arts to show us our own moral and economic situation has almost completely fallen into the hands of the photographer. . . . The method of the lens, the availability of classified photographic files, have eliminated the necessity of much preliminary sketching and study. Experiments in photographic montage, in the juxtaposition of images, in the play of aerial perspective, have unquestionably affected many painters, notably among them Picasso, de Chirico, Dalí, Tchelitchev, and Ben Shahn.

"This, however, although it has been one of numerous honest services, does not imply a relegation of the photographer to the painter's use. The real photographer's other services, services which take the greatest advantage of his particular medium and invoke its most powerful effect, are social. The facts of our homes and times, shown surgically, without the intrusion of the poet's or the painter's comment or necessary distortion, are the unique contemporary field of the photographer, whether in static print or moving film. It is for him to fix and to show the whole aspect of our society, the sober portrait of its stratifications, their backgrounds and embattled contrasts. It is the camera that today reveals our disasters and our claims to divinity, doing what painting and poetry used to do and, we can only hope, will do again.

"The photographic eye of Walker Evans represents much that is best in photography's past and in its American present. His eye can be called, with that of his young French colleague Cartier-Bresson, anti-graphic, or at least anti-art-photographic (Fig. 2.13). Photography in itself probably does not interest him: you do not think of him as a photographer first at all. When you see certain sights, certain relics of American civilization past or present, in the countryside or on a city street, you feel that they call for his camera, since he has already uniquely recorded their cognates or parallels. Physically the pictures in this book exist as separate prints. . . . Looked at in sequence they are overwhelming in their exhaustiveness of detail, their poetry of contrast, and, for those who wish to see it, their moral implication. Walker Evans is giving us the contemporary civilization of Eastern America and its dependencies as Atget gave us Paris before the war. . . .

"This at first may seem an extravagant claim for a young artist in relation to a subject as vast as contemporary American civilization. But after looking at these pictures with all their clear, hideous, and beautiful detail, their open insanity and pitiful grandeur, compare this vision of a continent as it is, not as it might be or as it was, with any other coherent vision that we have had since the war. What poet has said as much?

Figure 2.13 Henri Cartier-Bresson.
Alicante, Spain, 1932.
Gelatin-silver print.
Copyright © Henri Cartier-Bresson/Magnum Photos.

What painter has shown as much? Only newspapers, the writers of popular music, the technicians of advertising and radio have in their blind energy accidentally, fortuitously, evoked for future historians such a powerful monument to our moment. And Evans's work has, in addition, intention, logic, continuity, climax, sense, and perfection. . . .

"Contemporary America, even America considered in the disintegration of chaos, presents a spectacle differing in kind, in intensity, and in the actual pattern of disaster from the spectacle of Europe in collapse. Some weaker American artists, attracted by the prestige and nostalgia of European culture, have been caught in the tide of its destruction. Some, like James, Eliot, Gertrude Stein, and Pound, have survived and have stayed as Americans on the European earth to create their indictment of it almost as a moral vengeance. But others, like Dos Passos, Hemingway, William Carlos Williams, and Walker Evans, armed with the weapons of their spiritual ancestors, have turned from the breakup on the continent of Europe to attack the subject matter of their own country in their own time. . . .

"The eye of Evans is open to the visible effects, direct and indirect, of the Indus-

trial Revolution in America, the replacement by the machine in all its complexities of the work and art once done by individual hands and hearts, the exploitation of men by machinery and machinery by men. He records alike the vulgarization which inevitably results from the widespread multiplication of goods and services and the naive creative spirit imperishable and inherent in the ordinary man. It is this spirit which produces sturdy decorative letterings and grave childlike picturing in an epoch so crass and so corrupt that the only purity of the ordinary individual is unconscious.

"A sophisticated yet unaffected eye prizes the naive for the sake of its pure though accidental vision, not for the paucity of its technical means. In our architecture of the mid-nineteenth century our carpenters and builders made a human and widely acceptable familiarization of Gothic and Renaissance models. . . . Only Evans has completely caught the purest examples of this corrupt homage—innocent and touching in its earlier manifestations—which can be taken as the thematic statement in the symphony of our conglomerate taste. His eye is on symbolic fragments of nineteenth-century American taste, crumpled pressed-tin Corinthian capitals, debased Baroque ornament, wooden rustication, and cracked cast-iron molding, survivals of our early imperialistic expansion. He has noted our stubby country courthouse columns, the thin wooden Gothic crenellation of rural churches, images of an unquenchable appetite for the prestige of the past in a new land. Such ornament, logical for its place and its time, indigenous to Syracuse in Sicily or London in England, was pure fantasy in Syracuse, New York, or New London, Connecticut. Evans has employed a knowing and hence respectful attitude to explore the consecutive tradition of our primitive monuments, an advanced philosophical and ideological technique to record their simplicity. . . .

"In Evans's pictures of temples or shelters, the presence or absence of the people who created them is the most important thing. The structures are social rather than artistic monuments. The photographs are social documents. In choosing as his subject matter disintegration and its contrasts, he has managed to elevate fortuitous accidents of juxtaposition into ordained design. A clumsy FOR SALE sign clamped on a delicate pillar, a junk pile before a splendid gate, are living citations of the Hegelian theory of opposites. Photographic surprises and accidental conjunctions are not merely superficially grotesque. They are serious symbols allied in disparate chaos. . . . His work, print after print of it, seems to call to be shown before the decay which it portrays flattens all sagging roof trees and rusts all the twisted automobile chassis. Here are the records of the age before an imminent collapse. His pictures exist to testify to the symptoms of waste and selfishness that caused the ruin and to salvage whatever was splendid for the future reference of the survivors.

"Such a photographer as Walker Evans is not in any way a decorative artist. Such photography is not presentable as an accent for a wall: there is hardly ever any purchaser for the unrelieved, bare-faced, revelatory fact."

"James Van Der Zee's *Harlem Book of the Dead:* A Study in Cultural Relationships." (1992)
*Diana Emery Hulick**

Night funeral in Harlem:

When it was all over
And the lid shut on his head
and the organ had done played
and the last prayers been said
and six pallbearers
Carried him out for dead
And off down Lenox Avenue
That long black hearse sped,
 The street light
 at his corner
 Shined just like a tear—
That boy that they was mournin'
Was so dear, so dear
To them folks that brought the flowers,
To that girl who paid the preacher-man
It was all their tears that made
 That poor boy's
 Funeral grand. . . .

"This poem by Langston Hughes which as first published in 1951 exemplifies the importance of funerals to African Americans throughout the nineteenth and the first half of the twentieth century. Like James Van Der Zee's *Harlem Book of the Dead,* the poem is about the crossroads of life and death. . . . It is a book about judgement: about how the living and the dead view each other at their final encounter. . . . As on the walls of Egyptian tombs, the dead are remembered through their appearance and their deeds, while the poems by Owen Dodson that form part of the text take the place of eulogies. The portraits are memento mori for the living, but the poet pleads the case of the dead for the afterlife:

I do not mind the silence.
What I fear is the ground or the fire.
If I could only rent here,

**History of Photography,* Vol 17, No. 3. (Autumn 1993) London: Taylor and Francis, pp. 277–283.

Call my florist
For fresh roses or even dandelions.
The insurance I'd spend on me.
Do this for your mama, son. . . .

"The distinctive opulence of Van Der Zee's funeral photographs . . . is a way of showing how much the living cared for those now dead as well as using details of dress and superimposed imagery to construct visual archetypes of mothers, fathers, children, women, soldiers, and mourners. . . . This division of the book into archetypes is consistent with the archetypal reference to the dead in the book's title . . . it was Camille Billops, the book's organizer and co-author who suggested the *Harlem Book of the Dead*. . . . At that time Billops had no particular knowledge of either the Tibetan or the Egyptian Book of the Dead, but she was taken by their connotations of death and magic.

"Indeed, the title affirms the work's symbolic relation to the Harlem Renaissance, for during this period between the wars, many African-American writers used Egypt as a metaphor of their African past. . . . In 1924 Howard Carter made a much publicized speaking tour to the United States in which he described his discovery of Tutankhamun's tomb to enthralled audiences in New York and other major American cities. Because it is widely taught in the school system, Egyptian history is still the most readily accessible African past for most Americans. . . .

"The Van Der Zee book shares other symbolic and organizational aspects with the *Egyptian Book of the Dead*. . . . The corpse is represented with gods such as Anubis or Hathor who will guide the soul into the next world. The dead are also depicted with mourners and are shown with their souls being weighed to determine their status in the hereafter. The living have thoughtfully provided the departed with amulets, spells and ushabti figures placed in the tomb to carry out work in the afterlife. . . . The *Harlem Book of the Dead* likewise depicts the deceased with the objects and care necessary to insure a proper burial and successful journey to the next world: a casket, flowers, nice clothes, mourners, favorite objects, and angelic guides. . . .

"Under American slavery, people could not always practice their own funeral customs, and in many cases were denied proper burial at all . . . funerals were an important way of bringing the black community together and of maintaining traditional African customs. After the Civil War, many freed slaves could still not afford a proper burial. But from 1915 through the 1920s, African Americans fled the 1915 depression in the South and moved North in search of better-paying jobs in labor-short Northern factories. . . . Many of them ended up in Black Harlem. . . . These factors may have combined with the growing cultural awareness of the Harlem Renaissance [ca. 1919–1935], which was essentially a realist or naturalist movement in the literary arts, to produce an atmosphere where funerals and their recording coincided with important aspects of Harlem culture. . . .

"Since African Americans were barred from a meaningful participation in theater, the church became a living ethnic theater of which funerals were a part. . . .

African ritual patterns were used for the expression of Christian ideology. Death for the enslaved African American came to mean a hoped-for salvation and freedom. They compared their history to that of the Jews under the Pharaohs to nourish their own desire for freedom. . . . This combined sense of personal freedom, nobility, and continuity is demonstrated in several ways in Van Der Zee . . . heavily retouched mourners and corpses are serene and well-dressed. The nobility of the mourners is attested to by their physical restraint, while the elegance of the funeral proper confirms the deceased's personal worth. . . .

"American blacks also still shared the African belief that the dead could influence the living. Thus, for all these reasons, elaborate funerals were important. A person's possessions were often buried with the body, while broken crockery and other items were placed on the grave to break the link between the living and the dead. Clocks were also common grave decorations. They were often set at twelve to wake the person on Judgement Day or they recorded the time of the person's death. . . . The photographer's one image showing clocks . . . contains another allusion too. Judging by the banner above his casket, one of his subjects belonged to the Loyal Order of Elks. The eleven o'clock time at which both clocks in the photograph are set commemorates the eleventh hour toast at which Elks routinely offer a prayer for the departed members of their society.

"The angels and other divine beings that occur in the *Harlem Book of the Dead* have multiple functions. Like the images of the clocks, they appear occasionally in 19th century daguerreotypes and so emphasize Van Der Zee's continuity with previous funeral portrait traditions. They emphasize the salvation oriented beliefs of African-American churches while performing the more practical functions of introducing the deceased to the hereafter. They also reflect a parallel Muslim and hence African belief that angels visit the deceased at death.

"This visual religious eclecticism is also shown by Van Der Zee's repeated images of dead children (Fig. 2.14). Not only are they a testament to the the high infant mortality of Harlem between the wars, they remind one of the African-Venezuelan ritual of the *mampulorio*. In this ritual, the dead child is placed in a white coffin, surrounded by flowers and referred to as a little angel. It is a ritual that both mourns the child's passing while it rejoices in the fact that the child is liberated from the hard life of an adult. . . .

"These multiple associations which transcend one culture to function in several form a most fitting metaphor for both the *Harlem Book of the Dead* and, by extension, the Harlem Renaissance. The *Harlem Book of the Dead* . . . becomes a symbol system detailing the continuity of black culture. It shows with a certain finality that African-American participation in the literary arts has occurred to some degree because that was where the color line was most easily transcended. The more difficult and pragmatic road followed by black visual artists is shown in the work of Van der Zee, who while compelled to make a living at his trade, was still able to produce photography which transcended naturalism to expressively record the aspirations of his culture."

Figure 2.14 James Van Der Zee.
Asleep with Teddy, 1943.
Gelatin-silver print.
Copyright © 1992 Donna Mussenden Van Der Zee.

"Photography in the Service of Surrealism." (1990)
*Rosalind Kraus**

"Here is a paradox. It would seem that there cannot be surrealism *and* photography, but only surrealism *or* photography. For surrealism was defined from the start as a revolution in values, a reorganization of the very way the real was conceived. Therefore, as its leader and founder, the poet André Breton, declared, "For a total revision of real values, the plastic work of art will either refer to a purely internal model or will cease to exist." These internal models were assembled when consciousness lapses. In

*Rosalind Kraus and Jane Livingston. *L'Amour Fou: Photography and Surrealism.* copyright © 1985 Cross River Press. Washington, DC: The Cocoran Gallery of Art. New York: Abbeville Press, 1985, pp. 15–56.

dream, in free association, in hypnotic states, in automatism, in ecstasy or delirium, the "pure creations of the mind" were able to erupt. . . .

"But that did not stop Breton from continuing to act on the call he had issued in 1925 when he demanded, "and when will all the books that are worth anything stop being illustrated with drawings and appear only with photographs?" The photographs by Man Ray and Brassaï that had ornamented the sections from the novel *L'Amour Fou* (1937) that had first appeared in the surrealist periodical *Minotaure* survived in the final version, faithfully keyed to the text with those "word-for-word quotations . . . as in old chambermaid's books" that had so fascinated the critic Walter Benjamin when he thought about their anomalous presence. Thus in one of the most central articulations of the surrealist experience of the 1930s, photography continued, as Benjamin said, to "intervene."

"Indeed, it had intervened all during the 1920s in the journals published by the movement, journals that continually served to exemplify, to define, to manifest, what it was that was surreal. Man Ray begins in *La Révolution surréaliste,* contributing six photographs to the first issue alone, to be joined by those surrealist artists like Magritte who were experimenting in photomontage, and later, in *La Surréalisme au service de la révolution,* by Breton as well. In *Documents* it was Jacques-André Boiffard who manifested the sensibility photographically. And by the time of *Minotaure*'s operation, Man Ray was working along with Raoul Ubac and Brassaï. But the issue is not just that these books and journals contained photographs—or tolerated them, as it were. The more important fact is that in a few of these photographs surrealism achieved some of its supreme images—images of far greater power than most of what was done in the remorselessly labored paintings and drawings that come increasingly to establish the identity of Breton's concept of "surrealism and painting."

"If we look at certain of these photographs, we see with a shock of recognition the simultaneous effect of displacement and condensation, the very operations of symbol formation, hard at work on the flesh of the real . . . surrealist photography exploits the very connection to reality which all photography is endowed. Photography is an imprint of transfer of the real: it is a photochemically processed trace causally connected to that thing in the world to which it refers in a way parallel to that of fingerprints or footprints or the rings of water that cold glasses leave on tables. The photograph is thus genetically distinct from painting or sculpture or drawing. On the family tree of images it is closer to palm prints, death masks, cast shadows, the Shroud of Turin, of the tracks of gulls on beaches. Technically and semiologically speaking, drawings and paintings are icons, while photographs are indexes.

"Given photography's special status with regard to the real—that is, being a kind of deposit of the real itself—the manipulations wrought by the surrealist photographers, the spacings and doublings, are intended to register the spacings and doublings of *that* very reality of which *this* photograph is merely the faithful trace. In this way the photographic medium is exploited to produce a paradox: the paradox of reality constituted as a sign—or presence transformed into absence, into representation, into spacing, into writing. In this semiological move, surrealist photography parallels a similar

move of Breton's. For Breton, though he promoted as surrealist a vast heterogeneity of pictorial styles, devised a definition of beauty that is rather more unified and that is itself translatable into semiological terms. Beauty, he said, should be convulsive.

"In explaining the nature of that convulsion in the text that serves as a prologue to *L'Amour fou,* Breton spells out the process of reality contorting or convulsing itself into its apparent opposite, namely, a sign. Reality, which is present, becomes a sign for what is absent, so that the world itself, rendered beautiful, is understood as a "forest of signs." In defining what he means by this *"indice,"* this sign, Breton begins to sketch a theory not of painting, but of photography. . . .

"If we are to generalize the aesthetic of surrealism, the concept of convulsive beauty is at the core of its aesthetic, a concept that reduces to an experience of reality transformed into representation. Surreality *is,* we could say, nature convulsed into a kind of writing. The special access that photography, as a medium, has to this experience is photography's privileged connection to the real. The manipulations then available to photography . . . appear to document these convulsions. The photographs are not *interpretations* of reality, decoding it as in the photomontage practice of Heartfield or Hausmann. Instead, they are presentations of that very reality as configured or coded or written.

"The experience of nature as sign or representation comes naturally, then, to photography. This experience extends as well to the domain that is most inherently photographic: the framing edge of the image experienced as cut or cropped. . . . Photographic cropping is always experienced as a rupture in the continuous fabric of reality. But surrealist photography puts enormous pressure on that frame to make it itself read as a sign—an empty sign, it is true, but an integer in the calculus of meaning nonetheless, a signifier of signification. The frame announces that, between the part of reality cut away and this part, there is a difference; and that this segment, which the frame frames, is an example of nature-as-representation or nature-as-sign. Even as it announces this experience of reality, the camera frame, of course, controls it, configures it. This it does by point of view, as in Man Ray, or focal length, as in the extreme close-ups of Brassaï. But in both these instances what the camera frames, and thereby makes visible, is the automatic writing of the world: the constant, uninterrupted production of signs. . . .

"In cutting into the body of the world, stopping it, framing it, spacing it, photography reveals that world as written. Surrealist vision and photographic vision cohere around these principles. For in the *explosante-fixe*[1] we discover the stop motion of the still photograph: in the *érotique-voilé*[2] we see its framing: and in the *magique-circonstancielle*[3] we find the message of its spacing. Breton has thus provided us all the aesthetic theory we will ever need to understand that, for surrealist photography, too, "beauty will be convulsive or it will not be.""

[1] lit: the exploding fixed

[2] lit: the veiled erotic

[3] lit: circumstantial magic.

"Introduction." (1978)
*Maitland Edey**

"In the early days of *Life,* much of the layout was done directly by the managing editor, John Billings. Every managing editor, sooner or later, works out his own way of organizing things. Being *Life*'s first, Billings had a clean slate. Also he had a small staff. It was easier for him than for some of his successors to go any way he chose. His way was to do everything himself. By everything, I mean everything narrowly connected with the actual putting together of a magazine once a week. The finding of personnel, the organization of duties, their departmentalization, the staff meetings to discuss future work, the agreement on stories, the shooting of them—those things Billings delegated. . . .

"His testimony is those first ten years of *Life*. His tastes, his prejudices, his inspirations, his weaknesses are all there in the five hundred magazines he created. Those early ones are fascinating to look at. They reveal the mind of a man suddenly wakening to the enormous strength of photographs when used in new ways. Almost anything that looked exciting or original Billings put into *Life*. As a result, *Life* vibrated visually. Those early issues were crude but powerful, radiating a kind of raw young energy that may be felt even today, and that tended gradually to become diluted as the magazine (and its readers) grew more sophisticated.

"Part of the early vitality derived from the fact that almost everything *Life* did at first was new. It simply had not occurred to journalists thinking in one-picture terms to go to certain places and look at certain things and then tell their stories in photographs, *assigned* photographs by men sent out to get them. It had not occurred to them to write long information-stuffed captions describing the photographs; or to look beyond and behind the photographs for others that might have been taken years before or thousands of miles away, but that could be trowelled in for background enrichment of the story; or to look aside from the main event entirely to emphasize a humorous or pathetic sidelight to it. . . .

"Although any early issue of *Life* would teach much the same lessons, I choose here to describe the issue of May 30, 1938. There is nothing special about that one, only my feeling that it shows Billings at work at his most typically "Billingsish." The first story that week bears his stamp: a raw piece of contemporary Americana—marathon dancers—chosen to get the issue off to a fast start because the pictures were arresting. They show slumping people literally out on their feet, falling to the floor, being supported by their partners, being revived. They were shot by an outsider, but Billings wanted more, so a staffer, Bernard Hoffman, filled out the story. The text description was sardonic, Billings's way of justifying this seamy look at a seamy

*From *Great Photographic Essays of Life* by Matiland Edey. copyright © 1978 by Maitland Edey. By permission of Little Brown and Company. Boston: New York Graphic Society, 1978, pp. 1–21.

holdover from the Great Depression. He understood the fascination the seamy had for people, and he exploited it, but tried to take the edge off it with humor. . . .

"The bounds of taste—his bounds—were clear. Collapsing marathon dancers staggering about under the gaze of people who paid to watch their suffering: that was an easy one, made easier by the inclusion of a press-agent gag shot of an unconscious woman getting her hair waved. The story ended on that grim/funny note and was followed by the week's lead news story, a staff-assigned one on a sharply contrasting subject: factories under construction. Henry Ford planned to enlarge auto capacity and, as the headline put it: "Take a $35,000,000 Crack at Depression." Then came several spreads of miscellaneous news, followed by a mixed bag of small features: one on a beauty contest (that week's excuse for cheesecake); one on the new fad of dark glasses, and featuring another Billings trademark: emphasis on information (prominent in the layout was a box describing eight different types of sunglasses, their advantages and disadvantages, and their cost); and three or four others. The Billings mix: a generous portion of news, information, variety, several changes of pace, visual excitement, and some humor.

"Then Billings rolled up his sleeves and really went to work. The feature story in that week's issue was a sixteen-page study of Czechoslovakia, extremely timely because it was in the final throes of its effort to resist being swallowed by Hitler. It is an intriguing mixture, part news story, part picture essay, wholly absorbing. It starts boldly on a double spread, with pictures of the countryside and two large headshots of the men contending for control of Czechoslovakia: Benes, the president, and Konrad Henlein, leader of the Sudeten Germans in Czechoslovakia and Hitler's man for disrupting and ultimately taking over the country.

"If asked, Billings probably would have labeled it as a photo essay. If so, it was a double one for it was shot by two staffers, Margaret Bourke-White and Peter Stackpole, and is made uneven by the inevitable difference in their ways of looking at things. Billings took advantage of those differences by using them to impart pace—one unexpected visual jump after another.

"The story really is a sixteen-page cram course in everything one should know about Czechoslovakia. Billings assumed the reader knew nothing, and then proceeded to tell him a great deal. The opening spread is followed by a crudely drawn but informative map. Then comes a spread on political rallies, livened by three pictures of a woman selling sausages. Next a spread on the living conditions of the Sudeten Germans. Then one that is pure Billings: four large pictures that have nothing whatsoever in common, except that by the use of clever headlines they are related. And so on— through the Czech munitions industry, its peoples, its history and culture.

"Later editors of *Life* would have scorned to do such a story—I should say: scorned to do it in that headlong, scrappy, unvarnished way. The layouts are not tasteful. There are jarring differences in the scale of some of the photographs, many of which are disfigured by having ugly headlines pasted on them like labels. Nevertheless it has great power. For all its crudity it is a wonderful story, with a kind of jumping vitality, and stuffed with information. The reader, finishing it, could certainly have said:

"I know what I need to know about Czechoslovakia. I also know what it and its leaders look like."

"Why bother to describe this story in such detail? Indeed, why bother with all the other stories in the issue? Because in it, and in them, are revealed so many of the devices and attitudes, the growing appreciation of what can be done with pictures, that were gradually refining and fusing themselves into what would become the classic *Life* photo essay. The Czechoslovakia story was an essay in transition. If it had been done ten years later it almost certainly would have been slanted more self-consciously toward news, and printed boldly and baldly in the news section at the front of the magazine. Billings's genius, and his limitation, was that he did not distinguish as clearly as later editors would between news and features, between the informative and the essentially decorative, between the timely and the timeless. Almost everything he used was timely, or bent by him to become timely. In one way or another it reflected what was going on in the world around him, what people were talking about that week. Aesthetics, both in the pictures he used and in the way he used them, were secondary to impact, to his insistence that the reader be grabbed by the lapel and forced by the sheer power and inventiveness of an issue of *Life* to read it from cover to cover. Millions did."

"Country Doctor." (1978)
*Maitland Edey.**

"Eugene Smith is considered by many to have been the greatest maker of photo essays who ever lived. His work is Shakespearean in its scope and force, and in its variety. He moves majestically from one peak to the next, producing masterpieces that are all authentically his, but that are remarkably different from one another, not only in their subject matter but in the photographic means used to create them. . . .

"Smith was born in Wichita, Kansas, in 1918, and got his start as a photographer by scanning the local papers to see what celebrities were passing through town. He then took pictures of them and submitted them on spec to *Life*. He joined the staff during World War II and was working as a combat photographer in Okinawa in 1945 when he was badly wounded in the face. Several operations were required to patch up his jaw and palate, and it was two years before he was able to work again. That long and painful association with surgery certainly affected his approach to the "Country Doctor" assignment. It produced a story full of homely detail, of fear, compassion, and constant encounters with pain. The pictures lack the painterly quality that would distinguish much of Smith's later work. . . . (Fig. 2.15)

*From *Great Photographic Essays of Life* by Maitland Edey. copyright © 1978 by Maitland Edey. By permission of Little Brown and Company. Boston: New York Graphic Society, 1978, pp. 1–21.

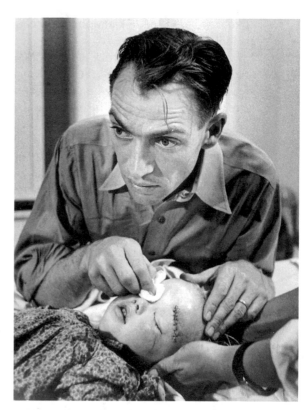

Figure 2.15 W. Eugene Smith.
From "A Country Doctor; His End-
less Work Has its Own Rewards,"
Life Magazine, Sept. 20, 1948.
Gelatin-silver print.
Copyright © Black Star and W.
Eugene Smith.

"For Smith life has always been tragic, full of injustice and hardship, but some-
thing which, if it is borne courageously and with dignity, brings out the nobility in
man. His Dr. Ceriani is such a man, dedicated, overworked, moving as best he can from
one medical crisis to another—obscure, underpaid, aware of his own fallibility, but es-
sentially noble. He is as concerned with the families of his patients as he is with the pa-
tients themselves. All this shows in Ceriani's face, which is a marvelous reflector of his
tension, his relief, his fatigue. The designers served Smith well by emphasizing that
face in two full-page pictures strategically placed in the essay.

"The photograph selected for the opener is worth a long look, for it is an extra-
ordinary picture. At first glance it says little: a man carrying a bag. But the man is pre-
occupied. He walks through weeds and past the corner of an unpainted board fence.
Clearly this is a poor rural community . . . But behind it, on a large scale, loom the pain
and disaster, the ultimate death that waits for us all, sensed in the lowering cloud that
hangs over the doctor whose days are spent dealing with such things.

"Overleaf, the wide range of Ceriani's duties is quickly disposed of in a burst of
memorable pictures. The temptation to enlarge several of them must have been over-
whelming. It is to the designers' credit that they managed to resist it, and settled instead

for a great range of sensations and emotions powerfully compressed into a single spread. . . . Overall, however, the layout is masterful. It has simplified a complicated take, given each spread a life of its own, but kept the central thread. This may seem easy after the fact. But what would-be designer, confronted with the picture of the elderly amputee staring into the camera . . . or with the grimacing boy . . . would have had the restraint to handle them as they are handled here? . . ."

"Drama Beneath a City Window." (1978)
*Maitland Edey**

"[Smith] liked his prints rich and dark, so dark that when he submitted a set he had printed for "Country Doctor," Charles Tudor said that the *Life* presses would not be able to handle them. Over Smith's objection they were redone, lighter. The most striking visual difference between "Country Doctor" and "Spanish Village" is not a difference in photographic style or subject matter. It is because the former was printed by *Life* and the latter by Smith."

"A Spanish Village." (1978)
*Maitland Edey***

"This essay moves far away from Smith's "Country Doctor" to inhabit an icy pinnacle of perfection all its own. The photojournalist's warm and running concern with one person is replaced by the painter's cool preoccupation with single compositions of awesome power. They are made by an eye that strips down its subjects to reveal intense sparks of life glowing at their cores. Smith's technique is devastatingly appropriate to its subject: strong chiaroscuro effects to reflect the true look of things in a remote tableland village where the sun is as sharp and bright as an ax and the shadows inky; an emphasis on textures—dirt, dust, stones, chaff, plaster, and black cloth; a sense of chronic hunger everywhere—the only villager who is not thin is the priest. The three husky policemen, of course, are not villagers. They draw their sustenance from afar, from Franco.

"Spanish Village" is perhaps the most famous of all *Life*'s photographic essays. I

*From *Great Photographic Essays of Life* by Maitland Edey. copyright © 1978 by Maitland Edey. By permission of Little Brown and Company. Boston: New York Graphic Society, 1978, pp. 1–21.

**From *Great Photographic Essays of Life* by Maitland Edey. copyright © 1978 by Maitland Edey. By permission of Little Brown and Company. Boston: New York Graphic Society, 1978, pp. 1–21.

am so familiar with it that it is hard for me now to imagine its pictures being rearranged in any other way, hard to remember that they came together in this particular form after a great deal of arguing, of preliminary sorting and discarding, after many other arrangements were tried and abandoned.

"The final organization seems simple, but it is a maze of subtlety. Of its seventeen pictures, no two are the same size, no two line up horizontally or vertically. The purpose of this—aided by a generous use of white space—is to isolate each picture slightly so that the reader is encouraged to look at it as an individual work of art before he goes on to consider it in relation to the other pictures in the story. . . .

"The story starts with the birth of religious experience, with the first communion of a seven-year-old girl, and ends in death, with prayers over an old man's corpse. Between are found: a spread showing people moving about within the confines of the village's alleys—with two dark figures headed inexorably toward each other from opposite pages, the giver of real food and the giver of spiritual food—then a spread devoted to labor, with people lifting, tugging, throwing, screaming, their thin energies directed every which way in a kind of semi-starved desperation; next a spread on the quieter moments that villagers spend doing things together behind walls, but even there under the eye of the detested national police.

"The story ends on one of the most stunning photographs that Smith or any other photographer has ever taken. The eye lingers over each of the six faces in turn, and then on the hands, and only belatedly discovers that there is a seventh face—and another hand."

PHOTOGRAPHERS FROM THE PERIOD 1920-1940

1920-1940

Abbott, Berenice (1898–1993), American
Adams, Ansel (1902–1984), American
Alpert, Max (1899–1980), Russian
Anderson, Paul Lewis (1880–1956), American
Ballhause, Walter (1911–), German
Baltermants, Dmitri (1912–), Russian
Bayer, Herbert (1900–1985), Austrian
Beaton, Cecil (1904–1980), British
Bell, Vanessa (1879–1961), British
Bellmer, Hans (1902–1975), German
Berka, Ladislav (active 1930s), Czechoslovakian
Biermann, Aenne (1898–1933), German

Bing, Ilse (1899–), French
Blossfeldt, Karl (1865–1932), German
Blumenfeld, Erwin (1897–1969), b. Germany
Bosshard, Walter (1889–1975), German
Bourges, Fernand (active 1930s–1950s), American
Bourke-White, Margaret (1904–1971), American
Brandt, Bill (1906–1983), British
Brassai (1899–1984), b. Hungary, French
Bruehl, Anton (1900–1983), Australian
Bruguière, Francis (1880–1945), b. United States, British
Capa, Robert (1913–1954), b. Hungary, American
Cartier-Bresson, Henri (1908–), French
Casson, Winifred (1900–1970), British
Chambi, Martin (1896–1973), Peruvian
Chim, David Seymour (1911–1956), b. Poland
Citroen, Paul (1896–1983), b. Germany, Dutch
Cole, Allen Edward (1893–1970), American
Collier Jr., John (1913–), American
Coppola, Horacio (1928–), Argentinean
Corpron, Carlotta (1901–1988), American
Corsini, Harold (1919–), American
Cunningham, Imogen (1883–1976), American
Dahl-Wolf, Louise (1895–), American
Dederko, Marian and Witold (active 1920s), Polish
Delano, Jack (1914–), American
DeMeyer, Baron Adolphe (1868–1949), b. Germany, British
Disfarmer, Michael (1884–1959), American
Drtikol, Frantisek (1883–1961), Czechoslavakian
Echague, Jose Ortiz (1886–1980), Spanish
Edgerton, Harold E. (1903–1990), American
Edwards, John Paul (1883–1958), American
Eisenstadt, Alfred (1898–1995), German
Erfurth, Hugo (1874–1948), German
Evans, Walker (1903–1975), American
Feininger, T. Lux (1910–), German
Finsler, Hans (1891–1975), b. Switzerland, German
*Flaherty, Frances (1886–1972), American
Freund, Gisele (1912–), German
Frissell, Toni (1907–), American
Funke, Jaromir (1896–1945), Czechoslavakian
Gidal, Tim N. (1909–1996), b. Germany, d. Israel

Gilpin, Laura (1891–1975), American
Goro, Fritz (1901–), b. Germany, American
Grossman, Sid (1913–1955), American
Gutmann, John (1905–), b. Germany, American
Gyorgy, Kepes (1906–), b. Hungary, American
Hanawa, Gingo (active 1930s), Japanese
Hardy, Bert (1913–), British
Hausmann, Raoul (1886–1971), European
Heartfield, John (1891–1968), German
Henri, Florence (1893–), American
*Hinton, Milton (1910–), American
Hiroshi, Hamaya (active 1930s), Japanese
Hoch, Hannah (1889–1978), German
Horst, Peter (1906–), French
Hoyningen-Huene, George (1900–1968), b. Russia, French
Hutton, Kurt (Kurt Hubschmann) (1893–1960)
*Hyman, Leonard G. (active prior to 1927–1932), American
Ignatowich, Boris (1899–1976), Russian
Jacobi, Lotte (1896–1990), b. Germany, American
Jung, Theodor (1906–), American
Kanaga, Consuelo (1894–1978), American
Keppler, Victor (1904–), American
Ker-Seymer, Barbara (1905–), British
Kertesz, Andre (1894–1985), b. Hungary, French
Kesting, Edmund (1892–1970), German
Koishi, Kiyoshi (active 1930s), Japanese
Krull, Germaine (1897–), European
Kuwabara, Kineo (1913–), Japanese
Lange, Dorothea (1895–1965), American
Laughlin, Clarence John (1905–), American
Lauschmann, Jan (1901–), Czechoslovakian
Lee, Russell (1903–1986), American
Lerski, Helmar (1871–1956), German
*Lewis, Harvey James (1878–1968), American
Lewis, Wyndham (1884–1957), British
Libsohn, Sol (1914–), American
Lissitsky, El (1880–1941), Russian
Lorant, Stefan (1901–), b. Hungary, German
Lorelle, Lucien (active 1930s), French
Lynes, George Platt (1907–1955), American
Man, Felix H. (1893–1985), b. Germany, British

Mantz, Werner (1901–), German
Mather, Margarethe (1885–1952), American
McBean, Angus (1904–), British
McNeill, Robert H. (1917–), American
Mendelsohn, Erich (1887–1953), German
Mili, Gjon (1905–1984) Albanian
Model, Lisette (1906–1983), b. Austria, American
Modotti, Tina (1896–1942) b. Italy, Mexican
Moffat, Curtis (1887–1949), British
Moholy, Lucia (1900–), Czechoslovakian
Moholy-Nagy, Laszlo (1895–1946), b. Hungary
Monck, Margaret (1911–), British
Morgan, Barbara (1900–1992), American
Mortensen, William (1897–1965), American
Munkacsi, Martin (1896–1963), Hungarian
Muray, Nickolas (1892–1965), b. Hungary, American
Muspratt, Helen (1907–), British
Mydans, Carl (1907–), American
Nerlinger, Alice Nex (1893–1975), German
Noskowiak, Sonya (1905–1975), American
Otsup, Pyotr (1883–1963), Russian
Outerbridge Jr., Paul (1896–1958), American
Paladini, Vincio (1902–1971), Italian
Peterhans, Walter (1897–1960), German
Podsadecki, Kazimierz (active 1920s), Polish
*Polk, Prentice Herman (active (1930s), American
Powys-Lybbe, Ursula (1910–), British
Ray, Man (1890–1976), b. America, French
Renger-Patzsch, Albert (1897–1966), Russian
Roh, Franz (1890–1965), German
Rosenblum, Walter (1919–), American
Rothstein, Arthur (1915–1985), American
Salomon, Erich (1886–1944), German
Sander, August (1876–1964), German
Sankova, Galina (1904–), Russian
Scaione, Egidio (died 1966), Italian
Schad, Christian (1894–1982), German
Schell, Sherril V. (active 1930s, 1940s), American
Setala, Vilho (1892–), Finnish
Shahn, Ben (1898–1969), American
Shaikhet, Arkady (1898–1959), Russian

Sheeler, Charles (1883–1965), American
Sheridan, Lisa (died 1974), British
Shishkin, Arkady (b. 1899), Russian
Skurikhin, Anatoly (b. 1900), Russian
*Smith, Marvin and Morgan (1910–), American
Smith, W. Eugene (1918–1978), American
Sougez, Emmanuel (1889–1972), French
Spender, Humphrey (1910–), British
Stackpole, Peter (1913–), American
Stankowsky, Anton (1906–), German
Steinberg, Jakob (unknown), Russian
Steiner, Ralph (1899–1986), American
Strand, Paul (1890–1976), American
Suschitsky, Edith (1908–1978), b. Austria, British
Swift, Henry (1891–1960), American
Szczuka, Mieczyslaw (1898–1927), Polish
Tabard, Maurice (1897–), French
*Taylor, Reverend Lonzie Odie (1900–1977), American
Teige, Karel (1900–1951), Czechoslavakian
Tschichold, Jan (1902–1974), German
*Ulmann, Doris (1882–1934), American
Umbo (Otto Umbehr) (1902–1980), German
Vachon, John (1915–1975), American
*Van Der Zee, James (1886–1983), American
Van Dyke, Willard (1906–1986), American
*Van Vechten, Carl (1880–1964), American
Watanabe, Yoshio (active 1930s), Japanese
Weegee (Arthur Fellig) (1899–1968), American
Weston, Brett (1911–1993), American
Weston, Edward (1886–1958), American
White, Clarence (1871–1925), American
Wilding, Dorothy (1893–1976), British
Wolcott, Marion Post (1910–), American
Yavno, Max (1911–), American
Zelma, Georgy (1906–1984), b. Uzbekistan
Zhukov, Pavel (1870–1942), Russian
Zwart, Piet (1885–1977), Netherlands

*Photographers whose work is significant for the study of cultural diversity. Many, but not all, of these photographs were taken by minority photographers.

3

The Period 1940–1960

Topics Addressed

An Art History and an Art Enclave of Photography: The Museum of Modern Art, Newhall and Steichen, Curators • Purism and Abstract Expressionism • The Picture Press at Apogee: Life and the Family of Man • The Avant-Garde Press Alternative: Aperture • Documenting Disillusionment with America: Robert Frank and the Beats.

The period from 1940 through 1960 was that of World War II and its aftermath, which was known as the Cold War. World War II began in Europe in 1939 when Germany invaded Poland, and it quickly embroiled all the rest of Europe except for Portugal, Spain, Switzerland, and Sweden. In 1941, when Germany's ally Japan invaded European dominions in the Far East—and bombed the American fleet at Pearl Harbor in Hawaii—World War II spread to Asia, and the United States entered the war. After an immensely destructive effort—on a scale and over a range of territory far surpassing the previous world conflict—World War II ended in 1945 with the defeat of Germany and Japan by the United States, the Soviet Union, and Great Britain.

The concluding weeks of the war saw the American detonation of the first atomic weapons, whose power of destruction was so great that a third World War seemed likely to cause the extinction of humanity. During the Cold War that followed, much of the world was divided ideologically into areas directly controlled or deeply influenced by the Soviet Union, a communist dictatorship, or under the strong influence of the United States, a capitalist democracy. These two "great powers" regarded each other

with hostility and suspicion, constantly foreshadowing a third World War and culminating in a near outbreak of such a nuclear war in late 1962, known as the Cuban Missile Crisis.

Between 1939 and 1945, still photography in magazines and newspapers, film newsreels, and radio offered propaganda, news, and information about the war. However, during World War II, military and political censorship by all combatants kept civilians and journalists from successfully reporting everything they had seen, particularly information involving military defeats or horrendous battlefield bloodshed. Often, journalists and photographers had no access to restricted areas, or to the immense and sometimes unnecessary casualties caused by major military decisions. Government and military leaders throughout the world justified these measures by their belief that civilian dissent would hinder the war effort. At the same time, photography, film, and radio were seen by governments, political groups, and individuals all over the world as powerful tools for the dissemination of any given political message.

Between the two World Wars, the United States had essentially pursued an isolationist policy, trying to ignore much of the rest of the world. As a result of this stance, and the previously mentioned censorship, the war as subject did not dominate the media in the United States as much as we might imagine. Even though *Life* magazine ran a school for war photographers and trained civilians like Margaret Bourke-White to cover the war in Italy, Germany, and the Soviet Union, much of the still photography published in mainstream magazines such as *Life* and *Look* used the war more as a backdrop to detail the altered American lifestyles that war brought in its wake. Indeed, in 1939, the year the war in Europe began, only ten out of fifty-two *Life* covers featured a military subject, and most of those covers were portraits of generals. In 1942, after the United States entered the war, twenty-eight *Life* covers depicted military subjects, but, in many cases, they were still portraits of soldiers. *Life's* covers were and are portraits for the most part, and they indicate that people, rather than events, were the magazine's central focus. In less politically oriented and more narrowly focused fashion magazines such as *Harper's Bazaar* or *Vogue,* the war intruded only rarely and then most often because of wartime shortages of consumer goods. What picture magazines generally did were document the continuity of civilian life, despite the war.

From the late 1930s until the early 1970s, magazines such as *Life* and *Look* produced feature stories by molding the vision of the photographer through the use of cropping, printing, reproduction size, and picture editing into a focused and coherent vision of events. The documentary style that emerged out of this collaboration between editor and photographer combined fact and strong composition with feeling. The most successful photojournalists—such as Henri Cartier-Bresson, Alfred Eisenstadt, Margaret Bourke-White or W. Eugene Smith—shared the ability to expose their photographs at the moment when the formal, narrative, and emotional elements of the picture all came together. This lasting legacy of visual sophistication has informed the best journalism and its viewers ever since. Moreover, the power of that sophisticated collaboration between photographer and editor, and the "corporate" style that emerged

from it, allowed the creation of striking and coherent photo essays, even when the photographer had only journeyman skills.

Fashion and studio photography also flourished after World War II, as both "hot" studio lights and stroboscopic flash became lighter, more powerful, and more portable in the mid-1950s. Studio lighting reduced the photographer's need to go on location with models, makeup artists, lighting, and properties. Complex and difficult effects could be achieved in the studio in a more controlled manner. Richard Avedon's 1955 photograph of the model Dovima posing with elephants required that the elephants be brought up to the studio in a freight elevator, along with their handler, who then chained the elephants to the floor. The lighting, which is sharp-edged, controlled, and stops the motion of both the model and the elephants, suggests the high-speed synchronized flashlighting that became available to studio photographers at the end of World War II. Dovima's calm profile as she poses artfully between the elephants is a tour de force in styling and lighting—the rough gestures and skin of the elephants contrasting with the model's sleek grace.

All of these elements were, of course, present in the earlier fashion photography of Edward Steichen and others, and Avedon's work exists in the context of these pictures. Avedon knew the work of earlier photographers and consciously set out to become better than them. It is this sense of measuring oneself against good photography of the past that defines much of the photographic activity between 1940 and 1960.

In the 1960–1980 section of this text, the critic Janet Malcolm notes how good fashion photography can convey a sense of glamour and wealth, while the subject's real-world existence remains somehow plausible to the viewer. In *Dovima and the Elephants,* detailed realism is coupled with formalism and a surreal treatment of subject matter, as the model airily controls the elephants. These three qualities exemplify the European influences on photography of the period; the detail of New Objectivity, the formalism of international Constructivism, and the magical and improbable qualities of Surrealism. These influences were, in large part, due to the migration of many European artists to the United States, as political pressures and censorship spread throughout those areas of Europe under Nazi and, later, under Soviet control.

For at least a decade following World War II, both the western and eastern portions of a now divided Europe were busy rebuilding their physical and social infrastructures. This was equally true of the Soviet Union and Japan. As a result, much of the postwar development in photography takes place in the United States. Americans, and, later, the Western Europeans, used fashion photography, advertising, and feature magazine journalism as weapons of the Cold War. But these uses mirrored American precedents far more closely than in the period before World War II. The products and lifestyles of capitalist democracy encouraged not only economic consumption in the West, but "westernization" throughout the world. The governments of the United States, and, later, Europe, deliberately used magazines, radio, and television to advertise the capitalist way of life to people in the Soviet Union's sphere of influence. The American values that these propaganda efforts contrasted to those of State Socialism

were free speech, the democratic election of public officials, and the efficiency of a free market economy and its benefits to the consumer. Indirectly, the example of the United States and Europe also encouraged the consumptive and materialist aspects of capitalist culture throughout the rest of the world. Since the American economy emerged as the most prosperous after World War II, it alone was such an advertisement. Consequently, America took the lead in the development of fashion and advertising photography.

In the Soviet Union's sphere of influence, the media arts were curtailed and often used directly in the service of the state. The consistent message was the Socialist way of life meant a better life for all, not just a wealthy few, and only strong authoritarian rule could prevent the exploitation of the poor by the rich. In the end, as will be seen in our discussion of the period from 1980 to the present, the Soviet effort failed, because it essentially was not true. It was particularly false in the context of the 1950s and 1960s in America, when the life of the average individual became considerably more comfortable than it had ever been before.

The images of American consumer culture did not go unnoticed by European artists of the period. In the late 1950s, an ironic but still admiring commentary on American consumer culture emerged as "Pop Art" in England. The origins of Pop Art painting and sculpture may be imputed to various sources, both in the United States and in Europe, but all of these sources use photographic imagery, much of it from contemporary advertising. Richard Hamilton's seminal 1956 collage "Just What Is It That Makes Today's Homes So Different So Appealing?" is filled with collaged elements from advertising; the television, the vacuum cleaner, the convertible sofa, and scantily clad models. Although the use of collaged elements from photographs had been pioneered by both the Cubists and Dadaists in the early part of the twentieth century, it is only in the 1950s that collages that use photographs begin to be used almost solely for their representation of a consumer-oriented lifestyle.

Almost every continent was involved in World War II—after it, an uneasy world peace marked by explosive, but regional, conflagrations prevailed. To further world peace and provide a forum for international dialogue and cooperation, the United Nations was founded in 1945. The conflicts that continued to occur were often nationalist in nature, as developing countries emerged from colonial rule by the extremely weakened European powers. Yet these and many other conflicts between 1940 and 1960 were the direct result of the communist versus capitalist alignments that took place after World War II. The most symbolic point of contact of these differing ideologies was perhaps Berlin, Germany, where the capital city of a defeated Germany was partitioned into sectors controlled by Britain, France, and the United States in West Berlin and the Soviet Union in the eastern half of the city. The contact and conflict was exacerbated by the fact that the city was wholly surrounded by the communist-dominated German Democratic Republic. Berlin epitomized the delicate balance between cold war ideologies. Its western sectors were a showcase for Western European and American lifestyles, while its eastern sector reflected the hard-line communism of the eastern half of a divided Germany. Yet in 1953, an anti-communist uprising in East Berlin was

not aided by the western powers because such direct confrontation with a Soviet-controlled area might have precipitated war among the major powers in a now-recovering Europe.

While political divisions between groups and countries still resulted in violence, they also were expressed in an increasing variety of media. Experimental television broadcasts had began in England and the United States in the late 1920s, the first commercial television broadcast took place in 1930, but the real expansion of television in the United States came after 1945, when the development of the electron tube and electron scanning methods made home television systems practical. Television ownership and programming proceeded at a somewhat slower pace in Europe, but by 1959 there were more than 50 million television sets in America.

Although influential, television in the '50s did not provide the constant and great variety of programming we now experience. Instead, the picture press continued to bring people weekly and daily news, while fashion magazines such as *Vogue, Vanity Fair* and *Harper's Bazaar* responded to the pent-up consumer demand generated by the end of the war, just as they had responded to rationing and the war effort during World War II (Fig. 3.1).

As a result, the photographers who numerically dominate the era of 1940–1960

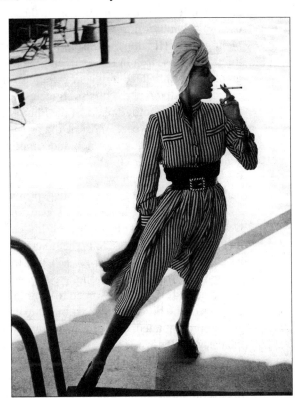

Figure 3.1 Louise Dahl-Wolfe.
Suzy Brewster. Miami, Florida, 1941.
Gelatin-silver print.
Louise Dahl-Wolfe, Courtesy
Staley-Wise Gallery, New York.

are photojournalists and fashion photographers, although a growing number of academic photographers who studied, and later taught, in institutions such as the Illinois Institute of Design and other universities also make their presence felt. Many of the photographers prominent during this era received their photography training during the war, either as armed forces personnel or as civilian journalists prior to, and after, its outbreak. Another group, epitomized by Moholy Nagy, who taught photography at Germany's Bauhaus before he was forced to leave, was part of the European experimental avant-garde. Many European artists and journalists immigrated to the United States to escape the war in Europe. As a result, European approaches to photojournalism, the photographic layout, and the avant-garde had become integrated into American culture at a time when the United States emerged as the dominant international power. Not coincidentally, in these same years, America produced its first international art movement, known as Abstract Expressionism.

The impact this cultural milieu had upon photography can best be traced by looking at a specific institution in the new postwar international art center of New York City—The Museum of Modern Art (MOMA). In March of 1937, an exhibit titled *Photography 1839–1937* opened there. The catalogue of the same name that accompanied the exhibit was written by the exhibit's curator, Beaumont Newhall, who was to become the first permanent curator of the museum's photography collection. Newhall used this exhibition to construct a model of what, in his opinion, constituted fine art photography. His illustrations and text demonstrated the cultural norms of the period, the state of research in the field, and the theory that the essential qualities of a photograph were embedded in the so-called "straight" or unmanipulated photograph.

Newhall tempered this straight aesthetic or "documentary" style by the inclusion of some major photographers of the Photo-Secession, such as Edward Steichen and Alfred Stieglitz. However, most of the artists he exhibited were nineteenth-century and early twentieth-century French and American men, whose work was documentary in style. Because of political divisions between Nazi Germany and other European nations and because time was short, Newhall did not visit Germany in the six-week trip he and his wife Nancy took to locate prints for the upcoming exhibit.

Early British photographers were perhaps underrepresented as well, because Newhall traveled first to France on his collecting tour and preferred the more documentary style of the French in the nineteenth and early twentieth centuries. In England he also was able to collect some work from avant-garde photographers such as the Hungarian born Laszlo Moholy Nagy, who had fled Germany when the Bauhaus, where he had taught, was forced to close by the Nazis. Yet even in the four subsequent editions of the book, derived from the exhibition's famous catalog, the straight photograph predominated, as it did in Newhall's first selections. In the common parlance of the early 1950s, work such as Moholy's was "experimental," hence, tentative and unfinished in comparison to the dominant documentary tradition.

Both the book and the exhibition influenced subsequent collecting and exhibiting in several ways. Beaumont Newhall's book provided its readers with the first struc-

tured and condensed look at the vast field of photography. It integrated photography's technical development with its documentary lineage and enabled the reader to understand the relationship between the two. The book also emphasized the importance of the subject and its treatment as a way of tracing the aesthetic development of a given genre, such as portraiture. Chapters were devoted to the development of such topics as portraiture or the news photograph. This first comprehensive synthesis of the field not only introduced the museum-going public to an overview of photography, but also influenced the collecting policies of the MOMA and the prints it chose to exhibit for decades to come.

During the period from 1940 to1960, most of the images exhibited at the MOMA were produced by photographers who earned livings as portraitists, photojournalists, or documentary photographers. In fact, the museum's exhibition policies not only reflected the rise of modernism and the documentary photograph evident from 1920 to 1940, but they also reflected the dominance of the picture press in the most famous exhibit of the 1940–1960 period, the *Family of Man.*

The *Family of Man* opened at the MOMA in 1955. Billed as the greatest photographic exhibition of all time, it featured 503 pictures from sixty-eight countries, reduced from an original two million submissions. It was described in the book of the same name as being "created" rather than curated by Edward Steichen. Steichen had followed Beaumont Newhall as curator of photography in 1947, when the latter left the museum to direct the International Museum of Photography at George Eastman House. As the readings that follow indicate, the *Family of Man* has been written about by authors as diverse as Roland Barthes and Christopher Philips, largely because the exhibit itself reflected both cultural and photographic trends in the postwar period.

The exhibit is a paradigm for photography's role in the culture in several ways. Although the photographs appeared first in the context of a museum, their selection and presentation had all of the hallmarks of a prolonged magazine photographic essay. Indeed, this may be why Steichen stated that he created rather than curated the exhibition. The exhibit featured groups of related pictures that moved the viewer from images of lovers meeting, to pictures of marriage, birth, raising children, and finally to universal communal concerns such as food and shelter. The photographs were also treated as if they were part of a magazine layout, and the museum as if it were a three-dimensional magazine. Rather than hanging framed and matted original prints by individual photographers, Steichen obtained the negatives and had them custom printed in a great variety of sizes that hung in space at different levels throughout the exhibition, rather than merely being lined up on the museum walls. He even had some prints mounted horizontally on the floor and ceiling. To state this baldly makes the *Family of Man* sound stranger than contemporary viewers actually found it. But it cannot be stated too strongly that the example of the picture magazines conditioned the public to accept quite extreme presentations and juxtapositions of photographs as a matter of course. And Steichen had sufficient editing talent and experience to carry off such a radical extension of magazine layout into the third dimension.

If enlarged to the same size, many of the pictures would have been similar in impact. By enlarging some pictures and reducing others, Steichen created a visual experience that mimicked the ebb and flow of written narrative or of photographs in a feature magazine story. The exhibit also was photojournalistic in that its themes were more important than the style or importance of the individual artist. In fact, Steichen did a very unusual thing: he included images by himself in the exhibit as well as many images made by Wayne Miller, his assistant. Normally curators do not participate in exhibitions they are curating, but it is clear from the images Steichen and Miller contributed that they were attempting to develop the exhibition's themes equally. To provide even greater thematic unity, the merry figure of a South American piper appeared intermittently throughout.

Many pictures in the *Family of Man* were from Farm Security Administration archives, lending the exhibition the imprimatur of the largest government documentary project of the 1930s. Most of the names included in the exhibition read like a who's who among contemporary journalists and magazine photographers. Ansel Adams, Dorothea Lange, Alfred Eisenstaedt, Robert Capa, W. Eugene Smith, Henri Cartier-Bresson, Margaret Bourke-White, and Robert Frank are among the many included. Many photographs carried bylines such as Magnum (an agency for photographers), *Look, Life, Time,* and the German magazine *Du.*

It should be noted that Edward Steichen reproduced a number of photographs from the United Nations and its organizations, as well as quoting from its charter, among other texts. This interpenetration of photographs and text was not only designed to produce the rich overlay of meaning created by combining a magazine's imagery and text, but to convey a simple and acceptable political message of world unity. Coming as it did at the height of the anti-communist feelings in the United States, it toured widely with government sponsorship, spreading its overt message of the human community and its implicit message of the American and capitalist point of view toward that community. This must be remembered when encountering the hostile criticism of the exhibition from a European critic such as Roland Barthes, whose political views were distinctly out of harmony with official American attitudes. More than any other exhibit or event, the *Family of Man* showed the dominance of American photographic journalism over the period as a whole.

The dominance of the "straight" and "documentary" photograph did not necessarily imply an overt anti-communism, even in the America of the late 1940s. Both the supporters and detractors of capitalism here were attracted to the power of mass media dissemination of the photographic document. However, in America, dissenting voices were silenced during the late 1940s and 1950s by a coordinated campaign of government harassment and economic privation. The Film and Photo League, an organization of generally politically left-leaning documentary photographers, which was founded in 1930, collapsed in 1951 as many of its members were blacklisted, accused of being members of the Communist party. They were not the sole victims of such blacklisting, and, historically, the period has come to be known as the McCarthy Era, after Senator

Joseph McCarthy of Wisconsin, who used his power as chair of a senatorial investigative committee to make himself the most virulent and best-known of the "red-baiters."

As a result, there occurred a distinct avoidance of overt political themes in the work of many photographers of the 1950s. Because of the influence of abstraction, modernism, and the immigration of the European avant-garde to the United States, a number of photographers, such as Aaron Siskind, who had been a member of the Film and Photo League, turned away from documentary photographs and produced abstractions resembling in spirit the gestural painting of the Abstract Expressionist painters who were emerging in New York during the late 1940s and early 1950s. These photographers would often photograph found objects or markings made by humans or the forces of nature. They were concerned with visual notations left on the landscape through the passage of time. Such subjects as graffiti, eroded rocks, or the passage of light over a surface were exposed to produce a photograph in which there was often little sense of scale but rather a sense of accidental or spontaneous beauty created by humans, the natural world, or their interaction.

Other photographers treated the social and natural landscape with the apolitical purism of an Ansel Adams, or they pursued rigorous formalism as practiced by Harry Callahan. All of these photographers—Siskind, Callahan, and Adams—had several things in common: they used photography as a vehicle for personal expression, their work was overtly formal, the way they exposed and printed their prints was essential to conveying their feelings about a subject, and they were all college teachers at some point in their careers. In the 1950s, Siskind and Callahan taught at the New Bauhaus, as the Illinois Institute of Design was called after Moholy Nagy, a former Bauhaus teacher, founded it in 1938, just prior to World War II. Later, postwar prosperity and the G. I. Education Bill combined to create an educational demand for photography at the same time it was being recognized and popularized in museums.

Of these three men, Ansel Adams is probably the best-known photographer and teacher. His pictures are one of the most significant achievements in landscape photography in the twentieth century, conveying an almost miraculous sense of pristine natural beauty and a romantic view of "wilderness as paradise"—the Great Good Place with little or no presence of industrial urban life or contemporary humanity. This was not merely an aesthetic, it was also a moral and political view, albeit an understated one, and its implications are still significant (Fig. 3.2).

From 1934 to 1971, Adams was on the board of directors of the Sierra Club, a foundation dedicated to the preservation and enjoyment of the environment. The club was one of the earliest environmental activist groups, and most importantly, it was rather conservative in political tone. Its focus on "wilderness" and its consequent romantic and anti-twentieth-century bias did not leave it easily open to the charge that it was "communist." Consequently, throughout the period from 1940 to 1960, the Sierra Club was politically effective, where a more radical organization such as the Photo League was not. During his tenure in the Sierra Club, Adams produced landscape portfolios for the club and was a highly visible spokesman on its behalf. Because he was

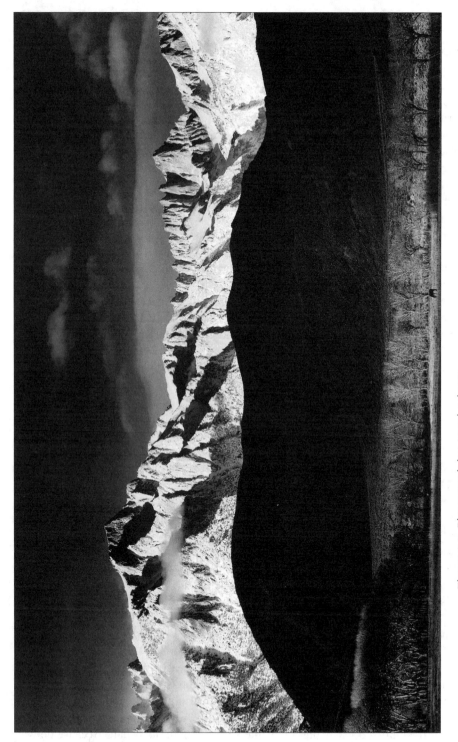

Figure 3.2 Photograph by Ansel Adams.
Winter Sunrise, the Sierra Nevada from Lone Pine, California, 1944.
Gelatin-silver print.

so successful at creating the vision of wilderness as the Great Good Place, Adams and his pictures are still the ground for much of the critical and political discussion of late twentieth-century photography, which largely centers around the radical critique of the conservative romanticism that Adams's vision embodies.

Moreover, Adams was in contact with Alfred Steiglitz from 1933 to the time of Stieglitz's death in 1946, and he became an art world arbiter himself when Beaumont Newhall sought his advice for Newhall's 1937 survey of photography at the Museum of Modern Art. As one of the founding members of the f 64 group, Adams had been a force for purism and the straight print since 1932. He was firmly committed to the notion of the "straight" photograph and was an ardent, almost moralistic, propagandist for its aesthetic virtues. Consequently, Adams was a strong influence on Newhall and his curatorial work.

Additionally, Adams was a successful commercial artist, photography teacher, and author of many important technical articles and books. His work in photography, teaching, and writing exemplifies the interrelationships among commercial photography, art photography, teaching, the museum, and public awareness of the field. At the same time he enjoyed a reputation as a fine artist, a successful magazine and commercial photographer, and an exceptional craftsman. In 1946, Adams founded the photography department at the California School of Fine Arts in San Francisco. In 1948, he started writing what he called the Basic Photo series. This series consisted of small, clearly written books each of which examined one aspect of photography in a thorough and systematic manner. The books, with titles such as *The Negative, The Print,* and *Natural Light Photography,* presented technical knowledge as a path to aesthetic control. Particularly important in this regard is his development of what he called the Zone System of exposure and development of photographic negatives, which has strongly dominated the academic education of photographers during the late twentieth century.

The particulars of the zone system are more complicated than a book of this type can fully explore, but what made it important was its ability to introduce the user to the controls needed to take advantage of the characteristics of the black-and-white negative and the print. These characteristics had been controlled in a rough and ready empirical fashion by most photographers since the invention of photography, but, until Adams, there was little effort to approach the craft of photography in an objective, systematic, and reliable way. With the advent of the Zone System, photographers suddenly had a reliable, repeatable, and teachable method whereby they could vary their exposure and development depending upon the lighting conditions and the print desired. The system helped control lighting contrast, particularly in landscape photography. Over the years, Adams taught many workshops, becoming especially famous for teaching the technical and visual aspects of large format landscape photography. In 1967, he founded the Friends of Photography in Carmel, California, and then helped found the Center for Creative Photography at the University of Arizona.

Adams's career is unusual because of his high popular visibility and great success. However, his combination of commercial and artistic work, teaching, writing and

contributions to photographic history describes the careers of a number of photographers during this period. Berenice Abbott, for example, was a successful commercial photographer who illustrated artistic and technical books. She was a well-known teacher and rediscovered and saved the work of Eugene Atget, bringing it to the attention of The Museum of Modern Art. Barbara Morgan and Lloyd Morgan were successful photographers, prominent technicians, and writers on photography, as well as the owners of Morgan and Morgan, a photographic press that is still in existence.

In 1940, this press (then Morgan and Lester), published an overview of large format camera technique. The book demonstrates that photography of the period was structured like the lives of its practitioners. Titled *Graphic Graflex Photography,* it featured articles on advertising, artificial and flash lighting, aerial photography, dance photography, the document, and photographic technique and composition. Its thirty-seven contributors included Ansel Adams, Willard Morgan, Barbara Morgan, Berenice Abott, and Laura Gilpin, among others. Art photography, portrait photography, documentary photography, and magazine photography are treated as integrated in this book, just as they appear integrated in the lives of Adams and others in this period.

The photography world of the day was quite small and interdependent. Photographers and historians of photography were still defining the different areas of the medium, and a scientific but coherent and accessible overview of techniques in the field was just emerging. As a result, people who were only teachers of photography or who made photographs only as a method of personal expression were much less common than from 1960 to 1980. This later period was one in which teaching in the field expanded at the same time that the picture magazine trade shrank.

One of the figures during the 1940–1960 period who epitomized this growing interest in the personally expressive photograph and in photography as an academic subject was Minor White. White provided an alternative vision to photojournalism and to seeing photographs in museums. Beginning in 1946, he taught with Ansel Adams at the California School of Fine Arts, which later became the San Francisco Art Institute. In 1952, aided by Adams, Beaumont, Nancy Newhall, and others, he founded a quarterly periodical called *Aperture.* It was and is a richly printed magazine that mirrored the high quality of Stieglitz's quarterly *Camera Work.* White published many emerging photographers, and like his predecessor Stieglitz in *Camera Work,* he published articles by photographers and others who helped illuminate the act of taking and experiencing a photograph.

Minor White saw photography as part of a spiritual quest in which the subject of a photograph became the visual "equivalent" of an emotional and spiritual experience. These words are highly abstract and often are thrown around without much understanding. It must be emphasized that for White they represented a view of life as much as they represented a photographic aesthetic. Such a view of life assumed that an *active* and *deliberate* search for spiritual experience is the highest and most profound calling for any human being, which should be undertaken at the expense of all else in life, if need be. As noble as this assumption sounds, it is not the only possible attitude

toward these matters. For it represents the furthest extreme of a deliberate rejection of politics as a part of photography and as a part of life. It must be kept clearly in mind that many believed White's view to be nonsense then, and many believe it to be non-sense now, because, beneath its overt quietism, it embodies a covert anti-political polemic. The historian has no business taking sides on this question, but it is our duty to stress that there *are* different sides to it, for both the partisans of a "spiritual" pho-tography and those of a "social" photography quickly lose sight of each other's point of view.

As far as the photographic aesthetic White's views implied is concerned, this viewpoint had as its antecedent the pictorialist belief that a meaningful photograph should show the viewer what the photographer had experienced in the presence of the subject, as well as the mere literal experience of the subject matter itself. This philos-ophy is explained by readings from Charles Caffin in the first section of this text. In the 1920s, Alfred Stieglitz defined this viewpoint more precisely, by asserting that it was primarily the handling of the formal elements in a photograph that would elicit this re-sponse. To test his theory, he produced a series of photographs that he termed "equiv-alents," meaning that the images were equivalent to an experience such as music in their emotional and spiritual impact on the viewer. Minor White took this theory fur-ther, arguing that there were several levels of equivalence: the formal qualities of the photograph, the viewer's experience, and finally the memory of the viewer's experi-ence.

The link of both White and Adams to pictorialism through Stieglitz is of the high-est importance. The polemics of "straight" photography have tended to illegitimately set the photography of the middle to late twentieth century at odds with the photogra-phy of the early twentieth century and overemphasize photographic "means" at the ex-pense of understanding aesthetic ends. There is, in fact, a strong continuity of these ends from the Photo-Secession forward, through Edward Weston, Adams, and White. All treated photography as if it were primarily an aesthetic experience and only secondarily as if it were a social or political experience. The true and significant oppo-sition of twentieth-century photography is between the proponents of this point of view, however "straight" or "experimental" their pictures may have been, and the pro-ponents of the view that photography is about the public, social, and political world—photographers such as Lewis Hine, August Sander, Dorothea Lange, Eugene Smith, John Heartfield, or Walker Evans. In many ways the paradigm for this opposition is the transformation of photographer Aaron Siskind from one point of view to another, as a result of the stresses of political controversy in the Film and Photo League.

Beyond the problem of equivalence, White believed that by using carefully con-structed *groups* of photographs—in the form of sequences with text—the images would interact in such a way that the sum total of their effect on the viewer would be greater than the effect of any individual image. A sequence also permitted multidi-mensional meanings and connections to develop as they would in a good magazine feature essay. This is not to suggest that White's work had the immediate impact and

accessibility of an article in a magazine such as *Life,* for White was influenced by Zen Buddhism and gestalt psychology as well as the mystic G. I. Gurdjieff, movements and names of which the general viewing public had heard little and understood even less. Rather, White's work expanded our definition of the photographic series while it contributed, as did the photographic magazine essay, toward defining this era in photography as one dominated by the concept of the series.

Here, too, however, it is important to stress the overwhelming unity and continuity of photography as an enterprise, beyond the partisan points of view among its practitioners. Photography in the 1940s and 1950s was a common language with a higher degree of sophistication and higher degree of viewer appreciation than it had ever had before or would ever have again. *Aperture* magazine, *Life* magazine, and the *Family of Man* exhibition were variant dialects of this common language, and they were more or less accessible to the entire viewing public, with very little real effort on that public's part. This common language was essentially a product of the spectacular growth of photojournalism, and even those photographers whose viewpoint was opposed to the assumptions of photojournalism benefited from it.

In 1923, the Hungarian Moholy-Nagy stated that one of the intrinsic and hence "natural" characteristics of photography was the series. In the period 1940 through 1960, there occurs a widespread use of the photographic series and an evolving understanding of sequencing and editing in both commercial and personal work. White transformed and developed the idea of the series in relationship to the equivalent and introduced these beliefs into the pages of *Aperture* and into the workshops he taught. Like Stieglitz, White was concerned with the relationship between technique and aesthetics, but unlike Stieglitz, White could rely upon a much broader visual literacy in the general public to expand these concepts into narrative forms of the picture series.

As stated before, Ansel Adams codified exposure and development controls into the Zone System so a photographer could visualize how the final print might appear. In his teaching, and in subsequent publications such as his 1965 *Zone System Manual,* White combined Stieglitz's idea of the equivalent with Adams's technical control to produce an approach to photography that he termed "previsualization." According to White, by following the Zone System's method of exposure and development controls, the photographer could predict not only how the final print would physically look, but also how it would affect the viewer and convey the photographer's experience. This combination of intuition and technique, coupled with the formal controls of a large format camera, became the hallmark of White's technique and aesthetic and of the many students who studied with him.

The notion of previsualization and the technique of the Zone System may be used to contrast American and European aesthetics of the period. Not all American photographers used either, and only a very small handful used both, but the preoccupation with photographic formal values that the combination implies is paradigmatic of American photography in general and American art photography in particular. American art photographers were very interested in building upon photography's mod-

ernist heritage as exemplified in the work of such photographers as Paul Strand, Alfred Stieglitz, and Edward Weston. This implied, above all other things, a conscious control of formal values, the dominance of the photographer's intentions over the subject matter, and a suspicion of the social and political dimensions of photographic content. Even the publication photography of American magazines embraced similar values. The perfect lighting and posing of an Avedon or the "corporate style" of *Life* served the same ends of intentional control over form and content in the sphere of fashion illustration and news coverage as the Zone System and previsualization served in the sphere dominated by *Aperture*. In other words, for the American photographer, the cardinal sin was to let either the medium or its expression take you by surprise.

As we have seen in the previous chapter, spontaneity, surprise, and a certain flexibility in the face of the social and political dimensions of the subject matter had been characteristic of European photography since World War I. This attitude did not change in the period after World War II. Although many Europeans made unmanipulated prints, they were more concerned with capturing subject matter using mobile and unobtrusive small-format cameras. They emphasized the documentary and unmanipulated print less as an object and more as a window into a new, usually urban, reality. Europeans emphasized the reproductive, social, and constructed properties of photography. Americans were more interested in making photographs in which an exterior subject mirrored the photographer's formal intentions, philosophical opinions, or feelings.

The most important European photographer to challenge the dominant American photographic aesthetic was the Swiss Robert Frank. Frank came to America in 1948 and supported himself by freelancing as a photographer for major periodicals such as *Fortune, Life, Look,* and *McCall's.* In 1955, he received a Guggenheim Grant in photography and spent a year traveling across the United States, using a 35mm camera to photograph in bars, cafeterias, and other public places, as well as on the streets of the cities he visited. His vision of America concentrated on the vernacular and, in 1957, his book *Les Americans* was published in France. It was a mordant and alienated criticism of American culture during a period when the United States was particularly sensitive to its international image in Europe and the Soviet Union. Consequently, it aroused much hostility in the established American photographic community. The book itself is so pivotal in the history of twentieth-century photography that we must examine the American reaction to it in detail—for the book burned itself into the consciousness of a generation of photographers and curators slightly younger than Beaumont Newhall, Ansel Adams, or Aaron Siskind, and much younger than Alfred Stieglitz or Edward Steichen—and this generation has dominated the last quarter of the American twentieth century.

First, the pictures in *The Americans* (the title the publication bore in America) are rough, casual, and offhand. Frank used the journalist's trick of "pushing" high-speed film by developing it in very active developer formulas. This allowed the film to be shot with a handheld 35mm camera under much lower lighting conditions than normal,

without flash. The resulting prints contain a great deal of information about content but are extremely coarse and grainy in appearance—they are the antithesis, in fact, of the American tradition of beautiful photographic printmaking, which stems from the Photo-Secession and was carried forth by Strand, Weston, Stieglitz, and Adams. Frank also used "pushed" film to press the camera unobtrusively into places such as dingy bars, bus station cafeterias, or low-lit elevators—places where American photographers were largely unaccustomed to taking a camera at all, and certainly not without a very obtrusive flashgun. Frank's photographs also are shot offhandedly, very rapidly, and sometimes without the photographer even looking through the camera—objects appear in odd and "unaesthetic" places within the frame, people blur when they are moving, and their facial expressions often have a slack "in-between" look of isolation and boredom. In short, the pictures do not appear to be "under control" in the obsessive way the American aesthetic demanded of "good photography," and, particularly, of "straight photography."

This apparent casualness and lack of control on Frank's part was an illusion, as a closer examination of *The Americans* reveals. The book itself is an extended picture essay as subtle as any that had been produced up until then. The device Frank used to exercise control was the repetition of content, themes, and motifs across many pictures rather than integrating them into a single photograph or a five- or six-picture magazine spread. Indeed, though it relied on the visually literate audience created by magazines, *The Americans* deliberately undermines the editorial manipulativeness of the picture magazine. Each left page of the book contains a terse label of location—Butte, Montana; New York City; U. S. Highway 286; and so on—followed on the right by a single picture. Upon first examination, one is well into the book before even noticing the repeating themes of the American flag, automobiles, jukeboxes, bored children, alienated adults, and, above all, African-American faces.

The status of African Americans was the most potent political content in America between 1940 and 1960, and well into the decade that followed. Legal racial segregation was a reality throughout the period, and to suggest that African Americans were treated even as well as second-class citizens would have been generous. In fact, the stark reality was that all people of color had little, if any, genuine legal protection all American citizens were nominally supposed to enjoy. The ravages of McCarthyism had left most American photographers gun-shy of any political content, and as a result African Americans were simply not present in much of the photography by European Americans during this period. This had not been the case, for example, with the FSA photographers of a decade earlier, nor of the famous Harlem Document of the Photo League, to which Aaron Siskind contributed before turning completely away from social and political photography in the late 1940s. By 1958, Frank's casual inclusion of so many African Americans in his pictures was a rude shock to a segregated United States.

Frank's pictures in *The Americans* make the deadpan observation that the black race and the white race are segregated, and they imply the same political corollary as

the famous court decision of Brown vs. The Little Rock Arkansas Board of Education (which began the American Civil Rights movement)—that separate MEANS unequal. The force of this corollary was an unanswerable rebuke to an America pretending to stand for "liberty and justice for all"—in the face of communism—around the world, in the picture magazines, and, most tellingly, in the *Family of Man.* The American photographic press was quick to take the hint, and Frank was frequently vilified.

Above and beyond the issue of race, Frank presented America as it appeared from the perspective of an alien stranger who is just passing through, rather than a resident with a vested interest in thinking well of the place. Like the poets and writers who were his contemporaries during the Beat Generation, he was concerned with transmitting his experiences as raw data using an apparently neutral viewpoint. And like those same poets, he found that experience both exhilarating and alienating at the same time. In the introduction to the 1959 American version of *The Americans,* Jack Kerouac, author of *On The Road,* the book which defined the Beat Generation, exclaims, speaking of Robert Frank: "You Got Eyes." This direct and ungrammatical praise mirrors the experiential and antiaesthetic stance of the Beats that Robert Frank shared.

Frank accurately captured the pace and style of fifties America by concentrating on roadside and urban scenes. His is an America of jukeboxes, chrome, cars, gasoline stations, drive-in movies, highways, public rallies, funerals, store fronts, and any place else public access is possible. In short, Frank captures the impermanence, insularity, and alienation that is part of American culture. As a European, he was especially sensitive to the vast spaces in this country as well as its peculiarly American institutions such as segregation, political campaigning, or the American love affair with the automobile. Frank used images showing profound aspects of American consciousness, along with the more frivolous aspects of American society. A Jim Crow or segregated trolley in New Orleans exists in the same book with a Hollywood opening and a drive-in movie. Each image is seen descriptively from the point of view of an outsider who witnesses significant gesture or detail with an unerring eye. Unlike the Frenchman Cartier-Bresson, whose photographs reflect the decisive moment, Frank was more interested in the instants between peaks of action and composition. Quoting the French author Andre Malraux, Frank stated that his photographs were intended to "transform destiny into awareness."

His major influence in this regard was a group of photographs taken by Walker Evans between 1938 and 1941. Titled *Many Are Called,* it was a series of images made surreptitiously with a 35mm camera on the New York subway. This group of images constituted an early version of what Frank and later photographers developed as "street photography" and the "snapshot aesthetic." The "snapshot aesthetic" means the photographer consciously uses the visual conventions of amateur snapshot. This aesthetic represents a stylization of the vernacular that is designed to convince the viewer that the photographer is an ordinary person and that the events depicted in the photograph are accessible to all, as they would be in a family album. By using this aesthetic, the

photographer not only photographs "everyman," he or she also appears to see with the eyes of the average person.

Frank and others of the period, such as the American expatriate William Klein, developed these characteristics along with a deliberate graininess and an uneven print quality to produce for the viewer a sense of participating in a gritty and spiritually impoverished, modern urban existence. This street photography differed from earlier depictions of urban life in that it was neither posed nor systematic, as were the earlier photographs of Atget, for example. Furthermore, in the work of Atget and others who documented Paris earlier in the century, such as Brassaï, there is a sense of a community and culture being photographed. As street photographers developed during the Beat Generation, most emphasized the marginalizing aspects of urban existence and its alienation and randomness. Their unposed subjects rarely appear to be willing or even aware participants in the photographs.

Despite their initial impression of haphazardness, Frank's work and the photographs of others working in this mode are carefully composed. Repetitive forms and gestures abound, while light is a constant and aggressive presence that often obliterates objects through reflection or shadow, or defines them as outline and surface. This use of the characteristics of the medium to undercut image quality also was an implicit rejection of the overtly beautiful print quality of the large-format photograph, such as those of Stieglitz, Weston, or Adams. Because these 35mm photographs are subtle, despite their apparent casualness, they require a second look. Unlike the contemplative photographs of nature produced by purists such as Adams, these images reveal a fragmented world devoid of natural beauty. Finally, the emphasis of Frank and others in photographing what happens *between* discrete actions was a rejection of the commercial photograph's clear message. These characteristics influenced the next generation of photographers, who portrayed modern urban realities in a manner that became known as social landscape photography.

These practices were not the only technical influences on photography during the 1940–1960 period. Flashbulbs had been available since 1930, but it was not until the mid-1930s that photographers such as Barbara Morgan and Margaret Bourke-White used synchronized flashes to light their subjects from different angles, which became another tool widely used by magazine feature photographers as well as studio photographers during the postwar period. Although in 1940 color photography was not yet frequently used in art or advertising, *Life* magazine began using it regularly in 1953, and by 1960 professional color photography was the norm. The first widely available color was developed by Eastman Kodak in 1937, but it was not until the 1940s that photographers were first able to process color negatives and slides on their own. It is during this period that photographers such as Harry Callahan begin to experiment with color in their work, and we shall see that this experimentation will lead to an unqualified acceptance of color in art photography from the 1960s on. The period 1940–1960 is the last time in which black-and-white photography will dominate the commercial aspects of the field.

The most important and astonishing invention of the period was the development of the Polaroid-Land Camera and developing process in 1947. This camera was designed to produce a negative or print in a matter of minutes. The camera's film or negative packs contained the chemicals needed for developing and fixing exposures. Edwin H. Land's invention revolutionized amateur photography, since instant records were now available at any number of family outings and celebrations. Much like the video camera used by so many people today, the Polaroid process permitted the photographer instant visual feedback about how subjects appeared. A kind of dialogue could develop between the subject and photographer as each participated in recording an event. Land Cameras also were used later to sharpen photographers' framing and exposure skills. Ansel Adams would sometimes have his students use Polaroid cameras to get a closer sense of how they should frame and expose their subjects, before they made exposures with a large-format camera. Polaroid Land cameras and the development of the Xerox machine in 1950 made both photographic and text reproduction essentially instantaneous.

Despite these developments, most working photographic newspaper journalists in the 1950s still used the 4" × 5" speed graphic, although many magazine and fashion photographers used the two and one-quarter inch square format as well. Film speed was still slow, by later twentieth-century standards, and it was difficult to control grain in the image when prints were made from the smaller 35mm negatives. However, in Europe, beginning with Cartier-Bresson and Brassaï in Paris in the 1930s, the 35mm camera was used by these and other unobtrusive observers. Unlike the American photographers, Europeans were not as concerned with eliminating grain, and they used the effect of grain and contrast produced by their smaller negatives to create a sense of gritty reality and of the photograph as a surface. As you can see, the issue of negative and image size and quality affects more than the photograph's style—it affects our interpretation of the image as well.

During the period 1940 to 1960, two separate large-format genres emerged. The first was the commercial photograph, which was exposed and printed to be reproduced in varying sizes and contexts. The large-format camera negative helped the commercial photographer maintain the clear outline and detail needed if the photograph was to survive the size and scale changes accompanying most magazine and book production. Since most if not all of these images were intended to illustrate something, they needed to resolve themselves quickly in the viewer's mind. The simple bold shapes and direct expressions found in the documentary style of photography in America in the 1930s are now modified by the dramatic angles and lighting of the news magazine photograph. In short, large-format commercial photography of this period was elegant, focused in its message, and visually persuasive.

The second major large-format genre was the personally expressive art photograph. In the work of Ansel Adams and others, it was epitomized by the full-scale, full-substance print of a landscape vista. In the work of Minor White or Harry Callahan, print quality was tailored to the individual print. The message in these images was

more open-ended and complex than in commercial work, but a common respect for the beautifully crafted, nearly grainless print as an object of contemplation unites most of the large-format art photographers of the period.

This dominance of the large-format photograph is undercut in the 1950s by younger European-influenced photographers, who use the 35mm camera to reject the values traditionally associated with both commercial illustration and the purism of such artists as Adams and White. They use the mobility of the small-format camera to create grainy images reflecting their own alienation and disaffection from a postwar society that appeared to show little concern for people, such as minorities and women, who might not be sharing equally in the prosperity and opportunity of the postwar period.

EXCERPTS FROM THE PERIOD 1940–1960

"The Judgment Seat of Photography." (1982)
Christopher Phillips*

"Photography, at least from the inception of Fox Talbot's negative/positive technique, would seem the very type of what Jean Baudrillard has recently called the "industrial simulacrum"—his designation for all of those products of modern industrial processes that can be said to issue in potentially endless chains of identical, equivalent objects. . . . This perspective, needless to say, is considerably at odds with the institutional trends that have, in recent years, borne photography triumphantly into the museum, the auction house, and the corporate boardroom. A curious denial—or strategic avoidance—of the fact of photography's sheer multiplicity informs much of today's authoritative discussion of the medium. . . .

"I speak, of course, of the MOMA Department of Photography, which for nearly half a century, through its influential exhibitions and publications, has with increasing authority set our general "horizon of expectation" with respect to photography. MOMA's assimilation of photography has indeed proceeded, on the one hand, through an investing of photography with what Walter Benjamin called the "aura" of traditional art—accomplished, in this case, by revamping older notions of print connoisseurship, transposing the ordering categories of art history to a new register, and confirming the workaday photographer as creative artist. . . .

"From the time of MOMA's opening in 1929, photography received the museum's nodding recognition as one branch of modernist practice, doubtless spurred by

*October #22, (Fall 1982) pp. 27–63. Copyright © 1982 by the Institute for Architecture and Urban Studies and the Massachusetts Institute of Technology.

MOMA director Alfred H. Barr Jr.'s awareness of the photographic activity of the European avant-garde. The first showings of photography at the museum resulted, however, from the intermittent enthusiasms of Lincoln Kirstein, then one of the most active members of the MOMA Junior Advisory Committee. . . . Until 1935, however, the date of Beaumont Newhall's arrival as librarian (replacing Iris Barry, who now headed the new Film Department), no MOMA staff member spoke with authority for photography's interests.

"Newhall's exhibition, "Photography 1839–1937," is usually cited as a crucial step in the acceptance of photography as a full-fledged museum art. It also emerges as an important link in the series of four great didactic exhibitions staged at MOMA during 1936–38; the others were Barr's "Cubism and Abstract Art" (1936) and "Fantastic Art, Dada, and Surrealism" (1936), and the retrospective "Bauhaus: 1919–1928" (1938). Together, these exhibitions demonstrated MOMA's influential modernization of what had come to be known among museum professionals as the "aesthetic theory of museum management." The central tenets had at first been spelled out in the dramatic reorientation of the Boston Museum of Fine Arts three decades earlier. At that time, the educational role of art museums had been sharply distinguished from that of history or science museums. Rather than provide useful information or technical instruction . . . it became a treasure house of "eternal" monuments of art, the guarantor of art's continuous tradition. . . .

"Newhall's exhibition is frankly uninterested in the old question of photography's status among the fine arts . . . [it] clearly seems guided more by Moholy-Nagy's expansive notion of *fotokunst* than by Stieglitz's *kunstphotographie*. Moholy was, indeed, one of Newhall's principal advisers and "teachers" before the exhibition. Stieglitz, on the other hand, who still insisted on the utter opposition of fine-art and applied photography, not only declined to cooperate with Newhall, but refused to allow his later photographs to be represented. . . .

"In Newhall's long essay (the seed of his subsequent *History of Photography*), we find an explicitly articulated program for the isolation and expert judging of the "aesthetic merit" of photographs—virtually any photograph, regardless of derivation . . . Newhall outlined photography's history primarily as a succession of technical innovations—independent, for all intents and purposes, of developments in the neighboring graphic arts or painting—that were to be assessed above all for their aesthetic consequences. . . . How were these aesthetic factors to be isolated? Newhall found the key in the purist/formalist appeal to those qualities somehow judged to be irreducibly intrinsic to a given medium. . . . Newhall opened the door to a connoisseurship of photographs that might easily range beyond the confines of art photography, yet still avoid the nettlesome intermediary questions raised by the photographic medium's entanglement in the larger workings of the world.

"Newhall never fully explored the implications of such a method; by 1940, when he was named the museum's curator of photography (the first time any museum had created such a post), he had already redirected his interest to what he conceived as pho-

tography's creative, rather than practical or applied, side. . . . In practice, this involved a new dependence on the connoisseur's cultivated, discriminating taste; on the singling out of the monuments of photography's past; on the elaboration of a canon of "masters of photography"; and on a historical approach that started from the supposition of creative expression—in short, an art history of photography. . . .

"Newhall's new alignment with such a transcendent claim of modernist photography, rather than with the more openly functionalist claims of the "new vision," can be seen as one means of attracting the support necessary to establish a full department at MOMA. The key step was the involvement—thanks to Newhall's friend Ansel Adams—of David Hunter McAlpin, a wealthy stockbroker related to the Rockefeller family, whom Stieglitz had groomed as a collector of photographs. It was McAlpin who initially agreed to provide funds for the museum to purchase photographs, and who was subsequently invited to join the MOMA board as the founding chairman of the Committee on Photography. In 1940, it was McAlpin who arranged to bring Ansel Adams to New York as vice-chairman of the new department, to join Newhall in organizing its first exhibitions. . . .

"Not surprisingly, Adams undertook a modernist rereading of the work of the nineteenth-century wet-plate photographers of the American West in the light of the post-Stieglitz "straight" aesthetic. Just before his move to New York in 1940, Adams (with Newhall's help) organized a large exhibition in San Francisco that highlighted such early Western photographers as Timothy O'Sullivan, William Henry Jackson, Jack Hillers, and Carleton Watkins. By confining his attention to questions of photographic technique and the stylistics of landscape (and pushing to the margins the very different circumstances that had called these photographs into being), Adams was able to see in them "supreme examples of creative photography," belonging to one of the medium's "great traditions"—needless to say, his own. . . .

"To a remarkable degree, the program of nearly thirty exhibitions mounted by the MOMA Department of Photography from 1940 to 1947 anticipates what has emerged only in the last decade as the standard practice of other American museums. . . . One may clearly wonder, then, seeing that Newhall's curatorial policies so clearly anticipate today's uncontested norm, why, in the summer of 1947, did MOMA's trustees cancel their support for these policies, name sixty-eight-year-old Edward Steichen as director of the photography department, and accept Newhall's sudden resignation?

"Simply put, it seems clear that Newhall's exhibition program failed equally to retrieve photography from its marginal status among the fine arts and to attract what the museum could consider a substantial public following. . . . Steichen's ambitions had carried him far beyond the confines of art photography . . . rather than contest the peripheral status of art photography, he was to capitalize on photography's demonstrably central role as a mass medium that dramatically "interpreted" the world for a national (and international) audience. That the museum harbored such an interest seems peculiar only if one ignores MOMA's extensive wartime program . . . after carrying out a number of wartime cultural missions for Nelson Rockefeller's Office of Inter-

American Affairs, MOMA emerged as one of the principal actors in the cultural Cold War. . . . [In Steichen's exhibitons] one can also see in their enthusiastic reception that familiar mass-cultural phenomenon whereby very real social and political anxieties are initially conjured up, only to be quickly transformed and furnished with positive (imaginary) resolutions . . . the global patriarchal family proposed as utopia in "The Family of Man" (1955) stands to gain considerably when set as the only opposing term to the nightmare image of atomic destruction. . . .

"To prize photographs from their original contexts, to discard or alter their captions, to recrop their borders in the enforcement of a unitary meaning, to reprint them for dramatic impact, to redistribute them in new narrative chains consistent with a predetermined thesis—thus one might roughly summarize Steichen's operating procedure. . . . Such exhibitions never raised the question of the artistic status on any branch of photography. Rather, they demonstrated that all photography, if properly packaged, could be efficiently channeled into the currents of the mass media. . . .

"Photographers who chose to explore what were defined as peripheral areas—whether of a social or an aesthetic nature—quickly faced loss of access to what had become (thanks in part to Steichen's proselytizing) a mass audience for photography. [Harry] Callahan and [Robert] Frank were typical of the ambitious younger photographers whose reputations benefited from their regular inclusion in MOMA exhibitions, but who nonetheless eventually chafed at the constraints of the mass-media model imposed on all of the work presented there. Callahan's rigorous formalist side was never shown to advantage. . . . (Fig. 3.3). In the same way, the poignant, romantic Robert Frank, whose work appeared at MOMA, resembled only slightly the photographer whose corrosive social vision informed *The Americans*, a book that defined itself in opposition to the reigning norms of *Life* magazine and professionally "committed" photojournalism.

"In dissolving the categories by means of which Newhall had sought to separate fine-art photography from the medium's other applications, Steichen undermined the whole notion of the "cult value" of the fine print. In the process, he attracted a wide popular following for photography as a medium, and won for it (and for himself) the regular attention of the mass press. The price exacted at MOMA was the eclipse of the individual photographer and the subordination of his or her work to the more or less overtly instrumental demands of illustration. This was the situation inherited by Steichen's successor in 1962. . . .

"What Szarkowski sought, rather than a repetition of Newhall's attempt to cordon off a "high" art photography more or less independent of the medium's everyday uses, was the theoretical salvaging of photography in its entirety from the encroachments of mass culture. . . . Szarkowski turned to quick advantage the presumption (inherited from Steichen) that the MOMA Department of Photography might address any of the medium's multiple facets. From this institutional salient, he was able to set about reconstructing a resolutely modernist aesthetic for photography and remapping a "main tradition" in order to legitimize it. . . .

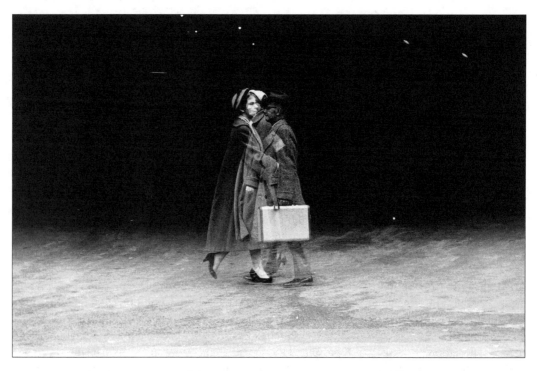

Figure 3.3 Harry Callahan.
Randolph Street Chicago, 1956.
Gelatin-silver print, 8½" x 12½".
Copyright © Harry Callahan. Courtesy PaceWildensteinMacgill, New
York. Photograph courtesy of The Hallmark Photographic Collection,
Hallmark Cards, Inc., Kansas City, Missouri.

"Szarkowski's ambitious program for establishing photography in its own aesthetic realm has been set forth explicitly in no single work, but arrived at piecemeal in a series of slender essays over the last twenty years. His project has followed, I think, three main lines. These include: **(1)** the introduction of a formalist vocabulary theoretically capable of comprehending the visual structure (the "carpentry") of any existing photograph; **(2)** the isolation of a modernist visual "poetics" supposedly inherent to the photographic image; and **(3)** the routing of photography's "main tradition" away from the (exhausted) Stieglitz/Weston line of high modernism and toward sources formerly seen as peripheral to art photography. . . .

"Interestingly, Szarkowski's concern with locating photography's formal properties signaled no incipient move toward abstraction. The formal characteristics he acknowledged were all modes of photographic *description:* instead of stressing (as had Clement Greenberg in his formalist essays on painting) the necessary role of the mate-

rial support in determining the essential nature of a medium, Szarkowski wished to re-serve unexamined for photography that classical system of representation that depends on the assumed transparency of the picture surface. Thus the delimitation of formal el-ements could prove no end in itself, but only set the stage for a move to the icono-graphic level. . . .

"Szarkowski's distribution of emphases—falling, as I have indicated, on the transparency of photography's representational apparatus, the formal/stylistic ele-ments peculiar to its descriptive system, and its ready-made modernist pictorial syn-tax—finally prepares the ground for the emergence of an aestheticized authorial "voice" proper to photography . . . it provides at the same time a powerful rationale for the systematic rereading, along precisely the same lines, of the photographs of the past. Unfortunately, since photography has never been simply, or even pirmarily, an art medium—since it has operated both within and at the intersections of a variety of in-stitutional discourses—when one projects a present-day art-critical method across the entire range of the photography of the past, the consequences are not inconsiderable. Nor, given the prevailing winds of today's art market, are they likely to be disinter-ested. . . .

"Reaching for a suitable analogy, he likens his search for photography's main tradition to "that line which makes a job of curator rather similar to the job of taxono-mist in a natural history museum." Can one say, then, that Szarkowski conceives of photography as endowed with an essential nature, determined by its origins and evi-dent in what he calls an "evolutionary line of being"?

"Such would appear to be the case, at least on the basis of MOMA curator Peter Galassi's 1981 exhibition "Before Photography," which sought to give substance to Szarkowski's conjecture that photography was "like an organism . . . born whole." Galassi's slim but ambitious catalogue had two aims: to portray photography as the le-gitimate (albeit eccentric) offspring of the Western pictorial tradition and to demon-strate that it was born with an inherent "pictorial syntax" that forced originality (and modernism) upon it. In stressing photography's claims as the heir to the system of one-point linear perspective, Galassi argued that the advent of photography in 1839 issued not from the juncture of multiple scientific, cultural, and economic determinations but from a minor tendency in late eighteenth-century painting. . . . The larger point of this peculiar argument is that while photography incorporated what has been called here the classical paradigm of representation, the new medium was incapable of taking over painting's conventional pictorial language. . . . Incarnated in the work of "primitives" (Szarkowski's term) like Brady and O'Sullivan, this "new pictorial language" awaited its recognition and appropriation by self-conscious artist-photographers like Walker Evans, Lee Friedlander, or Robert Adams.

"Thus endowed with a privileged origin—in painting—and an inherent nature that is modernist *avant la lettre,* photography is removed to its own aesthetic realm, free to get on with its vocation of producing "millions of profoundly radical pictures." As should be apparent, this version of photographic history is, in truth, a flight from

history, from history's reversals, repudiations, and multiple determinations. The dual sentence spelled out here—the formal isolation and cultural legitimation of the "great undifferentiated whole" of photography—is the disquieting message handed down from the museum's judgement seat."

"Of Mother Nature and Marlboro Men: An Inquiry into the Cultural Meanings of Landscape Photography." (1989)
Deborah Bright*

"Landscape photography has been enjoying a spectacular resurgence in the coffee table/art book press. . . . Why landscape now? A few conjectures come to mind: it is certainly true that among educated middle-class audiences, landscape is generally conceived of as an upbeat and "wholesome" sort of subject which, like Mom and apple pie, stands indisputably beyond politics and ideology and appeals to "timeless" values. This would sit well in our current conservative cultural climate, where images of the land (conceptual, historical, or literary) from Lake Tahoe to Wobegon are being used to evoke the universal constancy of a geological and mythic America seemingly beyond present vicissitudes.

"But this is too simple an explanation—images of landscape cannot be perceived simply as an antidote to politics, as a pastoral salve to lull us back to some primordial sense of our own insignificance. Nor should they be regarded as simply the loci of our modernist pleasure in arrangements of material objects in ironic constellations—found "happenings" for the lens whose references to the worlds beyond the frame rivet all attention of the sensibility of the artist. . . .

"Whether noble, picturesque, sublime, or mundane, the landscape image bears the imprint of its cultural pedigree. It is a selected and constructed text, and while the formal choices of what has been included and excluded have been the focus of most art-historical criticism to date, the historical and social significance of those choices has rarely been addressed and even intentionally avoided. . . .

"Thus, whatever its artistic merits, every representation of landscape is also a record of human values and actions imposed on the land over time. What stake do landscape photographers have in constructing such representations? A large one, I believe. Whatever the photographer's claims, landscapes as subject matter in photography can be analyzed as documents extending beyond the formally aesthetic or personally ex-

*Bolton, Richard, ed. *The Contest of Meaning: Critical Histories of Photography.* Cambridge: MIT Press, 1989, pp. 125–144.

pressive. Even formal and personal choices do not emerge *sui generis,* but instead reflect collective interests and influences, whether philosophical, political, economic or otherwise. While most art historical/curatorial scholarship has concentrated on the artistic genius of a select few (and the stake in doing so is obvious), it is time to look afresh at the cultural meanings of landscapes in order to confront issues lying beyond individual intuition and/or technical virtuosity. The sorts of questions we might ask concern what ideologies landscape photographs perpetuate; in whose interests they were conceived; why we still desire to make and consume them; and why the art of landscape photography remains so singularly identified with a masculine eye.

"In the late-nineteenth-century United States, after the "Indian problem" had been brutally solved and the frontier had ceased to exist, a veritable Cult of Wild Nature flourished, having undergone several evolutionary phases since the continent's discovery by white Europeans. This was characterized by a nostalgia for the red-blooded rigors of a pioneer life that had become obsolete. As with many significant movements in American cultural life, this one emerged from a pragmatic alliance of liberal reform and commercial interests: the first epitomized in the Progressive Movement's precept that the "nature experience" was a desirable antidote to the unhealthy urban life, and the second in the creation of a middle-class tourist market, first by the railroads and later by the automobile interests. . . .

"In the American consciousness, then, the western landscape has become a complex construct. It is the locus of the visually spectacular, culled from the total sum of geographic possibilities and marketed for tourist consumption. For liberal conservationists, it represents a romantic dream of a pure, unsullied wilderness where communion with Nature can transpire without technological mediation, a dream that has been effectively engineered out of most modern experience. . . . Nature has become commodified; its benefits can be bought and sold in the form of camping fees, trail passes, and vacation packages at wilderness resorts. . . . For others, the western landscape is the repository of the vestiges of the Frontier, with its mythical freedom from the rules and strictures of urban social contracts—a place where social Darwinism and free enterprise can still operate untrammeled, where tract houses can sprout in the waterless desert. . . .

"Repressed or unexpressed among these mythical landscapes that conventional photography and Hollywood cinema have served so well is a landscape that cannot be defined strictly by aesthetic or geographical categories. . . . A landscape, in other words whose construction by culture is made explicit—indeed, whose construction is made the very subject of of photographic investigation. Beauty, preservation, development, exploitation, regulation: these are historical matters in flux, not essential conditions of landscape. The political interest that landscape organization reveals are subjects that the practice of landscape photography has not clearly addressed. . . .

"The dominant landscape aesthetic in museum/gallery photography was self-consciously established as an offshoot of the American purist/precisionist movement in art during the late 1920s and 1930s. A second, West Coast landscape school,

founded by Edward Weston and continued more popularly by Ansel Adams and Eliot Porter, represented the continued taste for the picturesque sublime from nineteenth-century European and American painting. This aesthetic was premised on an identification between a mythical Eden and the American landscape and was well suited to the conservative social climate of a post-World War II United States basking in its reborn Manifest Destiny as a world superpower. . . .

"The publication of *Aperture* (begun in 1952) and Minor White's eclectic re-working of Stieglitz's Equivalent provided artistic landscape photography with something resembling a theoretical base. . . . For Minor White, Ansel Adams, and their generation of art photographers, intuition and expression were the central issues, not visual form. Thus *Aperture* could routinely publish portfolios as stylistically diverse as those of Robert Frank and Frederick Sommer. . . . It was on this slippery beachhead that the *Aperture* forces were eventually challenged and overwhelmed by John Szarkowski's curatorial juggernaut in the 1960s and 1970s.

"As a landscape photographer and as modernist photography's most influential tastemaker, Szarkowski used landscape photographs extensively to shape and bolster his assertions about photography's essential "nature." Employing a formalist vocabulary peculiar to his reading of photography ("vantage point," "detail," and "frame"), Szarkowski invoked the work of selected nineteenth-century landscape photographers as evidence for his theory of form. In keeping with his notion of photography as a medium with its own irrepressible forms, he proffered these photographers as "naifs" . . . as the sires of a bloodline of artistic photographers legitimized by a powerful American cultural institution, The Museum of Modern Art, and its provincial satellites: the Art Institute of Chicago, the Corcoran, the Walker, and now the Getty. . . .

"In the area of landscape photography in particular, Szarkowski's influence seems to have been particularly crippling. As recently as 1981, he published *American Landscapes,* a slender *catalogue raisonée* of photographs from the museum's permanent collection. . . . In some ways, this publication makes far more explicit the limitations of Szarkowski's vision of photography than other, more ambitious catalogues and exhibitions. There is, for example, the question of sexism in dominant curatorial practice: of the forty photographers included in *American Landscapes*, only two are women—Laura Gilpin and Dorthea Lange—both of whom are dead. Each is represented by a single image, while male counterparts such as Harry Callahan and Edward Weston are represented by three and four pictures, respectively. . . .

"Where are the women? As my comments on Szarkowski hint, their work has been systematically excluded from surveys of landscape photography at major museums. . . . And the beat goes on: the Spring 1985 *Aperture* survey of Western landscape photography featured the portfolios of eleven men, NASA (which may as well count as a twelfth!), and one women Marilyn Bridges (Fig. 3.4). In April of 1985 a major landscape exhibition tellingly titled *A Vision of Nature* was mounted by the Photography Department of The Art Institute of Chicago. . . . No less than Marlboro Country, American landscape photography remains a reified masculine outpost—a wilderness of the mind. . . .

"Rather than accepting established art-historical models of landscape photography or looking for alternative but equally universalized "norms" to replace them, it seems worthwhile to examine instead other disciplines such as urban planning, landscape architecture, and geography. In these disciplines, the environment is approached analytically; photographic evidence is used to make focused cultural statements. . . . Art photographers fear that in such "analytical" approaches the photograph might lose its primacy of place to a written text, should the two ever be joined. It seems as though part of the Faustian bargain to elevate photography to status of "art" has exacted a decree that written texts be forever banished from the vicinity of the visual image—that photographs present themselves in the same contentless depoliticized way as modernist paintings have embraced since the 1930s. Ironically, such concessions were instituted in the name of preserving "the integrity of the image," the price being the integrity of history! . . .

Figure 3.4 Marilyn Bridges.
Great Menhir, Carnac, Brittany, France, 1985.
Gelatin-silver print. Courtesy of Felicia C. Murray.
Copyright © 1985, Marilyn Bridges.

"If we are to make photographs that raise questions or make assertions about what is *in* and *around* the picture, we must first be aware of what the ideological premises are that underlie our chosen mode(s) of representation. Such awareness will structure the aesthetic, editorial, and technical decisions that are made with the goal of communicating ideas in a provocative (and yes, creative!) way. As part of this program, a reassessment of the museum/gallery system is in order. Many artists have found it necessary to seek other venues for their work. Should the rare fate of "art fashionability" befall the photographer engaged in socially committed work, s/he must be vigilant about protecting the work from being removed from its own history—from having its captions removed, its tape recorder unplugged, or its sequence jumbled. It goes without saying that any issue-oriented work becomes transformed by history and loses its immediacy with time, but this is no justification for abandoning the work's current cultural task to the first (or highest) bidder."

"A Personal Credo." (1943)
*Ansel Adams**

"I have often thought that if photography were *difficult* in the true sense of the term—meaning that the creation of a simple photograph would entail as much time and effort as the production of a good watercolor or etching—there would be a vast improvement in total output. The sheer ease with which we can produce a superficial image often leads to creative disaster. We must remember that a photograph can hold just as much as we put into it, and no one has ever approached the full possibilities of the medium. Without desire for self-flagellation, I often wish we were limited to processes as difficult as the old wet-plate and sun-print methods. We would then be as efficient, and would not have time or energy to make photographs of casual quality or content. The requirements of care and precision would result inevitably in a superior and more intense expression. I have seen many of the old photographs of Hill, Cameron, Brady, O'Sullivan, Emerson, Atget, and others of earlier days, and I always marvel at their intensity, economy, and basic emotional quality. I am aware of the fact that most of these early photographs were made for *factual* purposes; there is little evidence of self-conscious art intention. I believe a great statement in any medium remains a great statement for all time; and, while I do not favor the imitation of other men or of other times, I feel we should recognize the spirit of the earlier photographers, through the best examples of their work, and strengthen our own thereby. For more than one hundred years, photography, through the work of relatively few men, has maintained a magnificent spiritual resonance, as moving and profound as great music. Of course,

*From *American Annual of Photography,* Vol. 58, pp. 7–16.

great photographs are being made today, and it is our hope that the creative work of the future will achieve heights undreamed of heretofore. It is up to us—the photographers of today—to make this hope a reality.

"I have been asked many times, "What is a great photograph?" I can answer best by showing a great photograph, not by talking about one. However, as word definitions are required more often than not, I would say this: "A great photograph is a full expression of what one feels about what is being photographed in the deepest sense, and is, thereby, a true expression of what one feels should be set forth in terms of simple devotion to the medium—a statement of the utmost clarity and perfection possible under the conditions of creation and production." That will explain why I have no patience with unnecessary complications of technique or presentation. I prefer a fine lens because it gives me the best possible optical image, a fine camera because it complements the function of the lens, fine materials because they convey the qualities of the image to the highest degree. I use smooth papers because I know they reveal the utmost of image clarity and brilliance, and I mount my prints on simple cards because I believe any "fussiness" only distracts from and weakens the print. I do not retouch or manipulate my prints because I believe in the importance of the direct optical and chemical image. I use the legitimate controls of the medium only to augment the photographic effect. Purism, in the sense of rigid abstention from any control, is ridiculous; the logical controls of exposure, development and printing are essential in the revelation of photographic qualities. . . .

"Precision and patience, and devotion to the capacities of the craft, are of supreme importance. The sheer perfection of the lens-image implies an attitude of perfection in every phase of the process and every aspect of the result. The relative importance of the craft and its expressive aspects must be clarified; we would not go to a concert to hear scales performed—even with consummate skill—nor would we enjoy the sloppy rendition of great music. In photography, technique is frequently exalted for its own sake; the unfortunate complement of this is when a serious and potentially important statement is rendered impotent by inferior mechanics of production.

"Of course, "seeing," or visualization is the fundamentally important element. A photograph is not an accident—it is a concept. It exists at, or before, the moment of exposure of the negative. From that moment on to the final print, the process is chiefly one of *craft;* the pre-visualized photograph is rendered in terms of the final print by a series of processes peculiar to the medium. True, changes and augmentations can be effected during these processes, but the fundamental thing which was "seen" is not altered in basic concept.

"The "machine gun" approach to photography—by which many negatives are made with the hope that one will be good—is fatal to serious results. However, it should be realized that the element of "seeing" is not limited to the classic stand-camera technique. The phases of photography which are concerned with immediate and rapid perception of the world—news, reportage, forms of documentary work (which may not admit contemplation of *each* picture made) are, nevertheless, depen-

dent upon a basic attitude and experience. The instant awareness of what is significant in a rapidly changing elusive subject presupposes an adequate visualization more general in type than that required for carefully considered static subjects such as landscape and architecture. The accidental contact with the subject and the required immediacy of exposure in no way refutes the principles of the basic photographic concept. Truly "accidental" photography is practically non-existent; with preconditioned attitudes we *recognize* and are arrested by the significant moment. The awareness of the *right moment* is as vital as the perception of values, form, and other qualities. . . .

"Not only does the making of a photograph imply an acute perception of detail in the subject, but a fine print deserves far more than superficial scrutiny. A photograph is usually looked *at*—seldom looked *into*. The experience of a truly fine print may be related to the experience of a symphony—appreciation of the broad melodic line, while important, is by no means all. The wealth of detail, forms, values—the minute but vital significances revealed so exquisitely by the lens—deserve exploration and appreciation. It takes *time* to really see a fine print, to feel the almost endless revelation of poignant reality which, in our preoccupied haste, we have sadly neglected. . . .

"My approach to photography is based on my belief in the vigor and values of the world of nature—in the aspects of grandeur and of the minutiae all about us. I believe in growing things, and in the things which have grown and died magnificently. I believe in people and in the simple aspects of human life, and in the relation of man to nature. I believe man must be free, both in spirit and society, that he must build strength into himself, affirming the "enormous beauty of the world" and acquiring the confidence to see and to express his vision. And I believe in photography as one means of expressing this affirmation, and of achieving an ultimate happiness and faith."

Introduction to *Places: Aaron Siskind Photographs*. (1976)
*Thomas B. Hess**

"The "dirty little secret." . . . In the fine arts, that is to say among painters, sculptors, plus a few printmakers, it's been photography—the mixture of photography with art, the claims of photography to art. And it only recently has come out of the darkroom. It only recently has become common knowledge that artists began to incorporate photography into painting and drawing shortly after Daguerre's discovery in 1837, in spite of denunciations by aestheticians and poets, who excluded the camera from Parnassus. . . . Far from being independent mediums, each with its ineluctable manners

**New York: Light Gallery and Farrar Strauss and Giroux, 1976.*

and ineffable prerequisites, painting and photography have co-existed in (usually secret) mishmashes of borrowings and ripoffs, penetrations and misinterpretations for over a century. The tacit embrace in mutual symbiosis has become more apparent in the past few years as painters have begun to work directly with photographic materials and as photographers engage in painting, until no one can tell with any conviction what is what. One issue is clear—a rigid conception of Art, High or Low, is useless to the discussion. . . .

"Aaron Siskind is a key figure to the development of modern photography. . . . He was born on December 4, 1903, to a family of Ukrainian immigrants. They were poor. His father was an independent-minded tailor who found the monotony of the shop difficult, and so became the proprietor of a succession of neighborhood shops. His mother kept house for him and their five children. His parents were, he recalls, "non-intellectual." They spoke Yiddish together. . . . He matriculated at C. C. N. Y., probably the lushest hothouse for intellectuals of the time. . . . In 1926, he graduated from C. C. N. Y. He taught in the elementary schools of New York until 1949, when he secured the first of three appointments at the college level as a professor of photography. . . .

"If school work was exhausting and distracting from Siskind's major interests, it saw him through the Depression. His wife also taught and together they could afford a pleasant apartment, part-time help, and what started out as a hobby for Siskind—photography. In 1932, he joined the Film and Photo League, a club of professionals and amateurs, most of whom were oriented firmly to official Communism—a typical, 1930s, intellectual's approach to radicalism. The Communist Party, at one time or another, attracted almost every important artist, writer, and musician in Depression New York (the painters ranged in style from Stuart Davis to Rockwell Kent). At the Photo League, members called one another "comrade." One of Siskind's earliest memories of its sessions was the "trial" of one Izzie Lerner, accused of speaking ill of the "Worker's Homeland" (the U. S. S. R.). Izzie was found guilty, expelled from membership, and, in solemn judgement, the workers of the world were warned to have no further commerce with him . . . the League was one of the few places in New York where you could meet photographers . . . and where you could look at photographs. . . .

"In 1935, Siskind found the bigotry and authoritarianism at the League intolerable, from both a political and an aesthetic viewpoint. He left it in disgust. In 1936, he was invited back and formed what became known as the "Feature Group." . . . Working together for over three years, the group produced a number of studies of New York life, and with a black writer, the larger "Harlem Document." Working independently during those years, Siskind completed a study of an austere Protestant retreat in Martha's Vineyard ("Tabernacle City"). It was more architectural than humanist in feeling, and was attacked as "formalist" at the Photo League, which he quit in 1940. . . . Siskind hit his stride again in 1943–44, with the so-called "abstract" photographs that characterize his mature style. Still, the documentary experience was never forgotten and it remains near the core of his sensibility.

"Consider the abstract works as documentaries—including the recent photographs in this book. They are in what could be called an "interrupted serial" form. Siskind will find, and then return to a motif over and over again: a certain tree, seaweed dried into the most automatic of drawings on a Martha's Vineyard beach, a favorite stone wall. Years may intervene between one image and the next, between visits to a site. . . . The serial drama concerns small changes, critical shifts. Each version informs the next one. Shapes become luminous with meaning. . . . Siskind's later, abstract photographs convince you of the authenticity of his vision through a multiplicity of signs—in space and across time. You understand his tree; you seem to have known it for as long as you've known the palm of your hand. . . .

"There is little of the hot flash of photo-journalism in these icy prints or of the theatrical heavings common to most photographers of nature—even to the best of them (Ansel Adams comes to mind, with the Ferde Grofé Grand Canyons) . . . Siskind returns to old themes because, when he's thoroughly familiar with a hypothesis, he then can let his imagination soar at liberty. By fully accepting the *donnée* of a motif, he's free to concentrate on his art. . . .

"Siskind, of course, keeps himself open to fresh experiences; indeed, he has perfected certain disciplines to keep in contact with the unfamiliar. Once, for example, he set himself the assignment of walking from his studio at 47 East Ninth Street down to the corner, with the goal of discovering six new subjects. Usually, however, new subject matter evolves from previous insights. In 1973, in Villahermosa, Mexico, in an outdoor museum of Pre-Columbian sculpture, Siskind took a photograph of a monumental stone Olmec head (Fig. 3.5). Sunlight, falling across the convex features, camouflages a nose, lips, eyes, under shimmering spots of shadow. The following summer, at Martha's Vineyard, Siskind had a model take a series of poses, naked, in the woods. Her body, beneath the leaves, reminded him of his vision of the Olmec head. . . . Almost all of Siskind's photographs evolve from earlier photographs—just as art comes out of art. The Olmec head informs the nude. They become two glimpses of a perhaps unattainable synthesis. Pre-Columbian art quickened Siskind's vision in an even more crucial way. In the summer of 1943, in Gloucester, Massachusetts, he and his friends used to sun themselves and stroll on the Bass Rocks, a strand of rugged, granite boulders. The following winter, Barnett Newman was organizing an exhibition of Pre-Columbian sculpture for Betty Parsons at the Wakefield Gallery, and he asked Siskind to photograph some of the objects. . . . The following summer he returned to Gloucester, walked along the Bass Rocks, and suddenly, he recalls, the stones assumed something of the magic of the Pre-Columbian sculpture. He glimpsed a common, basic substructure. And he made some of his first "abstract" photographs. . . .

"Beneath any cosmetic likeness to the Abstract-Expressionist surface lies Siskind's dedication to the ambiguous, the allusive, the extended metaphors implied by chains of association. It is as if the glassy skin of the photographic print—as against the roiled textures of Franz Kline's oils—defined a locus for fantasy and dreams.

Figure 3.5 Aaron Siskind.
Villahermosa (Olmec) 5, 1973.
Gelatin-silver print. (36.1 x 35.8 cm)
Center for Creative Photography, University of Arizona, Tucson.
Copyright © Aaron Siskind. Courtesy Robert Mann Gallery.

Siskind shares with the Abstract-Expressionist painters a tough, dialectical approach (honed, of course, in the hard-knocks school of radical politics). He emphasizes the polar tensions in almost all his images. . . . Twigs of dried broom twitch against a blank sky, suggesting the flames into which they might burst at midsummer when the fields are burned. The crisp vegetable coils are opposed to the tight, straight, emphatic rectangle of the framing edge. Such are some of the cunningly plotted dialogs that can start free associations. Supporting them is a straightforward methodology, and in this, Siskind's approach differs sharply from that of the painters who formulated the grand style of Abstract-Expressionism. . . . It's hard to tell how a classic Pollock drip painting was created, or how de Kooning achieved certain jumpy passages, or Newman, var-

ious pulsing edges. In Siskind's photographs, on the other hand, all methods are open, frank; techniques are, in his words, "normal" and "usual." They articulate the image and the subject matter, just as, in International Style architecture, the inside of a building is articulated by the facade. In this important sense, Siskind's image is architectural rather than painterly, and has more to do with Mies than with Kline. . . .

"The scale in his pictures usually is . . . something you can hold in your hand, read like a poem. Siskind's shapes are basically legible. Often they refer to type or to scrawled letters or fragments of letters. Details of architecture or trees or sculpture cleave to that module. Like the noble arts of Islam, Siskind's basic unit isn't the body in a noble athletic gesture (as it was for the Greeks), but a hand holding a pen or a brush and marking out letters under the attentive supervision of a fine eye for curves. It's a lyric scale, for a poetry to be seen. . . .

"The emphatic flatness of the picture plane in most of Siskind's pictures, usually achieved by photographing a flat subject with the camera aimed perpendicular to it (a wall, the beach sand, a piece of paper, the white sky), sometimes conceals unsuspected vistas. Holes in an olive tree open to a view beyond, even though the holes are so consistent in texture and scale with other details of the bark that they look like gray material added to the surface—cement perhaps, or atmospheric chewing gum. They are different from wood; they don't look like air. Siskind likes to suck background elements forward to the picture plane by multiplying details and by judicious placement and variations of contrast. . . . About ninety percent of a Siskind photograph—of all photographs for that matter—concerns shapes, values, disposition of perspective, warping of volume, articulation of edges, translations from three to two dimensions, sense of emulsion, feel of paper, emergence of darks and lights from chemical deposits in developing and printing. . . . The finished prints should be considered as pure phenomena, matters of inter-relationships, or parts to a whole, the whole to the medium, the medium to its particular state of technological and philosophical self-awareness at the moment in art-historical time. This is what art is about."

"The Great Family of Man." (1957)
*Roland Barthes**

"A big exhibition of photographs has been held in Paris, the aim of which was to show the universality of human actions in daily life of all the countries of the world: birth, death, work, knowledge, play, always impose the same types of behavior; there is a family of Man.

"*The Family of Man,* such at any rate, was the original title of the exhibition

*Roland Barthes, *Mythologies.* Selected and trans. by Annette Lavens (Jonathan Cape, publisher). New York: Hill and Wang, 1972, pp. 100–102.

which came here from the United States. The French have translated it as: *The Great Family of Man.* So what could originally pass for a phrase belonging to zoology, keeping only the similarity in behaviour, the unity of a species, is here amply moralized and sentimentalized. We are at the outset directed to the ambiguous myth of the human 'community,' which serves as an alibi to a large part of our humanism.

"This myth functions in two stages: First the difference between human morphologies is asserted, exoticism is insistently stressed, the infinite variations of the species, the diversity in skins, skulls and customs are made manifest, the image of Babel is complacently projected over that of the world. Then, from this pluralism, a type of unity is magically produced: man is born, works, laughs and dies everywhere in the same way; and if there still remains in these actions some ethnic peculiarity, at least one hints that there is underlying each one an identical "nature," that their diversity is only formal and does not belie the existence of a common mould. Of course this means postulating a human essence, and here is God re-introduced into our Exhibition: the diversity of men proclaims his power, his richness; the unity of their gestures demonstrates his will. This is what the introductory leaflet confides to us when it states, by the pen of M. André Chamson, that *'this look over the human condition must somewhat resemble the benevolent gaze of God on our absurd and sublime ant-hill.'* The pietistic intention is underlined by the quotations which accompany each chapter of the Exhibition: these quotations often are 'primitive' proverbs or verses from the Old Testament. They all define eternal wisdom, a class of assertions which escape History: "The Earth is a Mother who never dies, Eat bread and salt and speak the truth, etc." This is the reign of gnomic truths, the meeting of all the ages of humanity at the most neutral point of their nature, the point where the obviousness of the truism no longer has any value except in a realm of purely poetic language. Everything here, the content and appeal of the pictures, the discourse which justifies them, aims to suppress the determining weight of History: we are held back at the surface of an identity, prevented precisely by sentimentality from penetrating into this ulterior zone of human behaviour where historical alienation introduces some 'differences' which we shall here quite simply call 'injustices.'

"This myth of the human 'condition' rests on a very old mystification, which always consists in placing Nature at the bottom of History. Any classic humanism postulates that in scratching the history of men a little, the relativity of their institutions or the superficial diversity of their skins (but why not ask the parents of Emmet Till, the young Negro assassinated by the Whites what *they* think of *The Great Family of Man?*), one very quickly reaches the solid rock of a universal human nature. Progressive humanism, on the contrary, must always remember to reverse the terms of this very old imposture, constantly to scour nature, its 'laws' and its 'limits' in order to discover History there, and at last to establish Nature itself as historical.

"Examples? Here they are: those of our Exhibition. Birth, death? Yes, these are facts of nature, universal facts. But if one removes History from them, there is nothing more to be said about them; any comment about them becomes purely tautological. The failure of photography seems to me to be flagrant in this connection: to reproduce

death or birth tells us, literally, nothing. For these natural facts to gain access to a true language, they must be inserted into a category of knowledge which means postulating that one can transform them, and precisely subject their naturalness to our human criticism. For however universal, they are the signs of an historical writing. True, children are *always* born: but in the whole mass of the human problem, what does the 'essence' of this process matter to us compared to its modes which, as for them, are perfectly historical? Whether or not the child is born with ease or difficulty, whether or not his birth causes suffering to his mother, whether or not he is threatened by a high mortality rate, whether or not such and such a type of future is open to him: this is what your Exhibitions should be telling people, instead of an eternal lyricism of birth. The same goes for death: must we really celebrate its essence once more, and thus risk forgetting that there is still so much we can do to fight it? It is this very young, far too young power that we must exalt, and not the sterile identity of 'natural' death.

"And what can be said about work, which the Exhibition places among great universal facts, putting it on the same plane as birth and death, as if it was quite evident that it belongs to the same order of fate? That work is an age-old fact does not in the least prevent it from remaining a perfectly historical fact. Firstly, and evidently, because of its modes, its motivations, its ends and its benefits, which matter to such an extent that it will never be fair to confuse in a purely general identity the colonial and the Western worker (let us also ask the North African workers of the Goutte d'Or district in Paris what they think of *The Great Family of Man*). Secondly, because of the very differences in its inevitability: we know very well that work is 'natural' just as long as it is 'profitable,' and that in modifying the inevitability of the profit we shall perhaps one day modify the inevitability of the labor. It is this entirely historified work which we should be told about, instead of an eternal aesthetics of laborious gestures.

"So that I rather fear that the final justification of all this Adamism is to give the immobility of the world the alibi of a 'wisdom' and a 'lyricism' which only make the gestures of man look eternal the better to defuse them."

"The American Way of Life at Home and Abroad." (1991)
*James Guimond**

"As documentary photography declined in significance, particularly in the popular media, a different kind of photography flourished and became influential during the 1940s and 1950s. During that period, millions of Americans learned about their own

*Reprinted from *AMERICAN PHOTOGRAPHY AND THE AMERICAN DREAM,* by James Guimond. Copyright © 1991 by the University of North Carolina Press. Used by permission of the publisher.

country and foreign nations through the eyes and minds of editors, photographers, and journalists employed by a few news agencies and magazines such as *Life, Look,* the *Saturday Evening Post,* and *Colliers.* . . . Photojournalism became, to use phrases from the 1950s, a "mirror" and a "showcase" for middle-class Americans because it enabled them to see their virtues reflected in magazines like *Life* and *Look* and also to exhibit the same virtues to others abroad. In fact, in some cases the same images were used both at home and in foreign countries. Eugene Smith's pictures of a hard-working country doctor, for example, appeared in *Life* magazine, where they demonstrated the virtues of volunteerism and the American medial profession, and also in *Amerika,* the illustrated magazine the USIA sent to Russia. . . .

"There were a few moderately significant differences between the two picture magazines. *Life's* images and photoessays often were more showy and visually assertive than *Look's.* "A great picture is not merely seen," one of *Life's* editors claimed, "It demands an emotional response." Virtually every issue of the magazine contained one or more big, glossy pictures meant to surprise, awe, shock, or delight readers. Some of *Life's* photoessays are also notable for their heavy use of innuendo—a tendency that might have been encouraged by the magazine's proximity to *Time,* whose writers often resorted to this device. *Life's* editorial comments were brash and assertive, and when they discussed subjects like the American way of life they were often chauvinistic and rather defensive. . . .

"*Look* was a calmer magazine and considerably more liberal than *Life* . . . its editors and writers were more inclined to acknowledge that there were problems in the United States, particularly among its minorities, and to offer brisk, constructive solutions. The layout of *Look's* photoessays were less showy than *Life's* and its editors liked to use smaller, more subtle pictures instead of the "big picture" (impressively staged, full- or double-page spreads) favored by *Life.* By American standards of the time, *Look* had considerably more "class" than *Life* did. The USIA publications were, if anything, even more optimistic than the magazines. They tended to imply that the United States had already solved (or was about to solve) the social problems that occasionally troubled the editors of *Look* or, more rarely, the editors of *Life.*

"Despite these differences, both the magazines and the USIA publications expressed essentially the same message, which is summarized by the term that Michael Schudson applied to American advertising, "Capitalist Realism." . . . Perhaps the apogee of their optimism was the 1959 special issue [of *Life*] on leisure, in which they acknowledged that, though America had not yet lived up to its full potential, it had the "unprecedented" opportunity to create a civilization that "ought to be freer and bolder than the Greek, more just and powerful than the Roman, wiser than the Confucian, richer in invention and talent than the Florentine or Elizabethan, more resplendent than the Mogul, prouder than the Spanish, saner than the French, more responsible than the Victorian, and happier than all of them together. . . .

"Despite all this optimism and idealistic rhetoric, which caused editors and photojournalists to work hard at "showcasing" and idealizing the nation's virtues, photo-

journalism itself (including much of that which appeared in *Life* and *Look*) was a visual genre with some rather humble antecedents and a number of ambivalent—almost schizophrenic—qualities. . . . This dual nature of photojournalism was summed up by German philosopher Erich Kahler's comments on the format of *Life* magazine in the 1940s. After quoting Ernst Junger's description of photography as "an unfeeling and invulnerable eye," Kahler criticized the "callousness" of the mass media, which mixed advertising with atrocities, and added that the worst examples of this attitude were popular magazines like *Life*. . . .

"Both sensationalism and the more respectable kinds of photojournalism started to become popular in the late nineteenth and early twentieth century, when newspapers and magazines began to be illustrated by mechanically reproduced photographs. . . . They all, through the use of new technologies, gave their audiences a strong sense of immediacy—or at least the illusion of immediacy—that increased the power of their emotional effects. . . . But even if seeing these images made ordinary people feel included in a larger world, what they saw was usually quite selective. First, because of their formulaic quality, certain kinds of realities were invariably featured more than others because there was a better "market" for them. Celebrities, for example, were always "newsworthy" and often had their pictures in magazines, whereas factory workers were almost never "news"—except when they were on strike and fighting with police. Sometimes these magazines showed ordinary people in [a] feature story that superficially resembled documentary studies; however, unlike documentary work, these images of ordinary Americans were almost invariably reassuring, and they were presented to illustrate popular stereotypes about patriotism, progress, gender roles, and the joys of consumerism. Moreover, the editors of some magazines (like *Life* in the 1930s and much of the 1940s) usually avoided news and feature stories about controversial issues. . . .

"The most successful new publishing ventures packaged their "products" most briefly and simply: this was evident in the United States by the mid-1930s and was another reason that the print mass media were selective and superficial. The most profitable magazines and newspapers made smaller and smaller demands upon the reader's attention span, intellect, and literacy. . . . The public, it seemed, did not want much thinking or complexity; it wanted short, snappy, entertaining news items rather than "long columns of type." The popularity of *Life* and *Look* showed that it also wanted plenty of vivid, exciting pictures.

"Another influence on magazine editors and publishers was their need to please advertisers. The best way to do this was to have large circulation numbers. This meant, particularly in the late 1930s when *Look* and *Life* were getting started, not only that the editors avoided "heavy-weight, important public problems" but also that they were extremely partial to what one critic called "old stuff, tried and proven": photojournalistic genres like sports, violence, sex, animals, and cute babies. Two of these genres, violence ("sensationalism") and sex ("cheesecake"), are especially revealing about the values of magazine editors and audiences.

"The portrayals of "national character" so popular in American magazines and books during the 1940s and 1950s often emphasized that Americans were a "friendly" people who loved "decency" and "fair play," and that they were "aggressive" only in self-defense. . . . When *Life* magazine's violent pictures are analyzed from this perspective . . . it seems clear that a kind of protocol was followed, presumably by both the photo agencies and editors. In addition to pictures of accidents and disasters, there were many pictures of violence to foreigners, people from "darker races," and/or members of American minority groups. In late December 1936, for example, *Life* published one of the more extreme examples of callous bad taste. Following immediately after a reverent article on the "Life of Jesus Christ" published for the Christmas season, the editors presented two pages showing Chinese Communists being beheaded or shot by Chiang Kai-shek's police. "Here (left) is the executioner, marching out with 'sword of justice' to decapitate a Red," said one caption. "Note the horror on the spectator's face as he looks down at the severed head, and the cruel smile on the executioner's [face]." And in February 1938, *Life* showed a picture of the corpse of a Kansas City black man, photographed so readers could see his face ("Negro killed in row over $10"). . . .

"This protocol governed not only who could be seen as victims of violence but also how they could be seen. Readers looked directly at the face of the dead black man in Kansas and saw the Spanish Republican soldier in Robert Capa's famous picture as he was falling backward at the instant the bullet struck him, but the three dead American soldiers in an equally famous *Life* World War II picture are all lying quietly on a New Guinea beach. They are photographed from an angle, no wounds or blood are visible, and their faces are obscured by their helmets. A similar protocol seems also to have governed the magazine's captions. It might have been unpleasant for *Life's* readers, or its editors, to acknowledge openly that they enjoyed looking at dead or dying people, and therefore the captions often have a deliberate numbness or pseudo-objectivity—as if they were comments by a lecturer describing a laboratory experiment. . . .

"Just as violence was implicitly controlled through the selection and editing of pictures, so was sexuality; an equally careful protocol governed *Life's* "cheesecake" pictures. Naturally, like most editors during the 1930s and afterward, *Life's* editors never allowed pictures that hinted that women possessed pubic hair or nipples—thanks to the efforts of the photographic retouchers. . . . Even the mildly erotic "How to Undress in Front of Your Husband," an early photoessay Luce published over the objections of his editors, caused such a commotion that nothing like it was ever repeated. Instead, *Life* specialized very frequently in pictures of nubile young acrobats, movie starlets, cheerleaders, and ice skaters who always managed to be leaping or jumping, so that *Life's* readers could get an excellent view of their thighs and panties. . . .

"These photojournalism genres, still popular with tabloid newspapers, reveal the extent to which editors changed photography not only into what Ernst Junger called "an unfeeling and invulnerable eye" but also into a pseudo-innocent eye that enabled readers to enjoy the pleasures of voyeurism without considering themselves voyeurs.

However, *Life's* "cheesecake" pictures also raise an issue relevant to certain other, more "respectable" kinds of photoessays. . . . The women pretend to be amusing themselves, not posing for a photographer. This same complicity, on a larger scale, also existed in many photoessays about how ordinary, middle-class Americans lived and behaved. In order to photograph people in their own homes, in restaurants, or at parties, photographers had to use large amounts of flashbulbs and floodlights. They could be extremely demanding in pursuit of the "perfect" picture. . . . Nevertheless, the picture magazines resolutely maintained the illusion that their photographs were not "staged"; presumably the subjects themselves understood that they had to look natural if they wanted to appear in the magazine. It seems that this principle was so well-established by 1938 that, when one *Life* photographer went through a steel mill, he noticed that as soon as "steelworkers noticed his camera, they'd assume highly dramatic poses." Another photographer, taking pictures at a San Antonio high school, was amazed at the students' sophisticated cooperation. "They didn't pose; they didn't look at the camera; they behave naturally." In other words, people already knew, from seeing picture magazines, how they were supposed to look when they were "on camera."

"Aperture in the Fifties: The Word and the Way." (1984)
*Jonathan Green**

"The *Aperture* quarterly of the fifties was a quiet manifesto for the work of the metaphorical and the expressionist photographer. Though it was thoroughly dominated by White's sensibility, it did introduce, through carefully chosen essays and photographs, alternatives to the popular photographic aesthetic. *Aperture's* audience was small, but the quarterly became the first significant critical forum of photography since Stieglitz's *Camera Work. Aperture* lacked *Camera Work's* urbanity, cosmopolitanism, sophistication, and cultural breadth, yet it did have a curious, at times adolescent, eloquent vitality.

"*Aperture*'s personality was the personality of Minor White. Where else could one find all rolled into one publication the finest possible photographic reproduction; White's eclecticism and gawky humor and Henry Holmes Smith's hard intellectual analysis; the historical perspective of the Newhalls and the aphorisms of White's alter ego, Sam Tung Wu; Lyle Bonge's photographs made and viewed under the influence of mescaline; portfolios by Adams, Bravo, Bullock, Caponigro, Cunningham, Eisenstaedt, Hyde, Jones, Lange, Weston, Stieglitz, Siskind, Sommer, and Charles Wong;

*From *American Photography: A Critical History 1945 to the Present.* Harry N. Abrams, New York, 1984 (reprinted 1996). Excerpts © 1998, Jonathan Green.

serious essays on photographic styles and schools and on the photographic conscious-ness; reviews of photographic books as well as Boleslavsky's *Acting: The First Six Lessons* and Herrigel's *Zen and the Art of Archery* . . . (Fig. 3.6)

"White was committed to the advancement of photography both as an art and as a medium of personal growth and expression. He was determined by trial and error, philosophical exchange, discussion, and debate to develop a theory of photography that was relevant to his own time. The theory he developed would not be one of style and form, but would be centered, as it had been for his mentor, Stieglitz, around the central issues of expression. The final form of the image was of less importance than its evocative meaning. White set out to define the nature of photography's emotional content and to discover methods by which that content could be perceived. *Aperture* moved ahead quickly to crystallize White's maturing ideas about the intentions of the photographer and the function of photography. Two major ideas emerged. The first was that photographs could be "read." The second was that photography could serve as a

Figure 3.6 Manuel Alvarez Bravo.
Obrero en Huelga, Asesinado, (Striking Worker, Assassinated), 1934.
Gelatin-silver print. Courtesy of the Gallery of Contemporary
Photography, Santa Monica, CA.
Copyright © 1988, Manuel Alvarez Bravo.

fitting medium for psychological and spiritual contemplation. . . . White . . . using analytical methods drawn from the New Criticism . . . as well as from romantic theory, Gestalt psychology, Wölfflinian terminology, Zen meditation techniques, and any other method or trick he happened to hit upon, began to put together a philosophy—one that insisted on the intrinsic value of the photograph, focusing attention on the individual image or sequence of images as an independent unit of meaning unrelated to biography, camera technique, or precedents of photographic history. . . . White shared the poet's belief that words could make one see more clearly. It was on this premise that the possibility of "reading" photographs rested. Though White had a mystical turn of mind, he never patronized the ineffable. A translation of some sort could always be found. Even the most extreme and unusual experiences could be communicated. . . .

"Yet for White "reading" was only one way toward the more important goal of spiritual perception. Over and over again, embedded in *Aperture's* responses to photographs were references to the contemplative and the otherworldly. The notion of photography as a spiritual endeavor is most dramatically indicated in the central *Aperture* issue of the period, issue 7:2 (1959). . . . When that issue appeared, it was entitled *The Way Through Camera Work.* The mystical beliefs that had been quietly flowing beneath the surface of all of *Aperture's* work now became explicit. The issue used as its frontispiece the Chinese calligraphic character *ch'i,* which relates to the first canon of Mai-Mai Sze's *Tao of Painting* and means "the breath of heaven," "spirit," and "vital force." In the issue White goes beyond the "reading" of photographs and begins to describe photography in terms of the extraphotographic rituals and philosophies he had begun to study in depth during the fifties. . . .

"*The Way Through Camera Work* was White's first major theme publication. It may be seen as his esoteric, internalized, sacred answer to the popular aesthetic of *The Family of Man.* Although the basic photo-essay technique was used, White employed extended quotations, not just aphorisms, and he allowed the photographs to be as dreamlike, luminescent, evocative, psychological, and enigmatic as possible. This was the spiritual center largely obscured in *The Family of Man.* Beyond the rush and loudness of Steichen's grand show, *Aperture* was the still, small voice crying for—and perhaps achieving—a measure of quiet revelation. . . .

"To many of *Aperture's* own readers and certainly to the popular photographer who wholeheartedly accepted the ethos of *The Family of Man,* the direction that White and the quarterly were taking—particularly in *The Way Through Camera Work*—must have seemed strangely obtuse, cultic, and antiestablishment. For *The Way Through Camera Work* was not only intellectually shocking to the conservative high culture of the fifties, it was also a distinct departure from the styles and manners sanctioned by complacent popular opinion. Though *Aperture* always stayed to the right of that thin line between respectable culture and the underground, between comprehension and obscurity, its roots go back to the same sources that spawned the alternative cultures of the fifties, particularly the Beat movement.

"White's relationship to Stieglitz is always rightly emphasized. Yet his closest

contemporary spiritual allies in the fifties were the same as Robert Frank's: the major Beat poets—Kerouac, Ginsberg, and Snyder—and the older members of the San Francisco and West Coast intellectual community—Kenneth Rexroth, Alan Watts, Gerald Heard, Christopher Isherwood, Aldous Huxley, Mark Tobey, and Morris Graves—who for years had been interested in Oriental religions and had been continually pursuing the contemplative life. Though *The Way Through Camera Work* appeared after White had left San Francisco for Rochester, its origins stem from the Oriental teachings that had long established themselves in California. California culture nurtured the seeds of White's polyglot, eclectic gathering of beliefs and teachings. It was by way of California that White ultimately incorporated Gestalt therapy, sensitivity training, the preliterate relationship between artists and audience, and, above all, the Japanese, Chinese, and Indian religions into his notions of photography.

"*Aperture* itself was just as surely a product of the San Francisco renaissance and bohemian ambiance as Ferlinghetti's City Lights publications. *Aperture* was one of the little magazines of the fifties, which, together with *Big Table, Chicago Review, San Francisco Review, Contact, Origin, Choice, Yugen, Black Mountain Review, The Jargon Society, Neon,* and *Evergreen Review,* gave America its first indication that something radical and thought and action was occurring beneath the surface of respectable culture.

"The Beats, seen through the exaggerations of the movements and people they inspired—the beatniks, Norman Mailer, the hippies, the yippies—have become popularly associated with violence, sexuality, drugs, and insane adolescent foolishness. Although these charges cannot be totally denied, there was much more to the major Beat writers. They are closely tied to the underground mystical and romantic tradition that has permeated American thought and imagery, clearly appearing first in the work of the Transcendentalists and Whitman, then in the work of Stieglitz's circle, and again with Hart Crane and Agee. This is the tradition that has shunned popular mentality and searched for direct, mystical, religious contact and experience. The Beats used the rough experience of life itself as the confessional medium for a new vision; Aperture used photography as the medium that could seek out the truths and essences that lay behind the accepted culture of the fifties. . . .

"The paths of the major members of the new tumultuous literary generation, the avant-garde painters, and the major photographers crossed with startling frequency. . . . It is Siskind, Callahan, and Sommer who make the personal ties. The painter Hugo Weber during the fifties was a close friend to both Kerouac and Callahan. The old Cedar Bar in New York became the hangout for Siskind and the Abstract Expressionists as well as for Ginsberg, Corso, Seymour Krim, and occasionally Kerouac. And some of these men might also have been found at Helen Gee's *Limelight* coffeehouse, the first and most important New York photographic gallery in the fifties. One of the leading sympathetic critics of Abstract Expressionism, Harold Rosenberg, wrote the introduction to Siskind's first monograph. And the Six Gallery, one of the initial homes of Abstract Expressionism in San Francisco, became the place where Ginsberg first read

Howl and launched the Beat movement. Black Mountain College hosted or published Siskind, Callahan, Jonathan Williams, Kerouac, Ginsberg, Burroughs, Snyder, and many more of the major poets, musicians, and painters of the vanguard.

"It was these personal connections and the trading of ideas, images, thoughts, and meeting places that, for the first time since *Camera Work* and Stieglitz's circle, put avant-garde photography in the same context as the avant-garde in the other arts. Siskind, Callahan, and eventually Sommer, Frank, and other anti-establishment photographers soon found their portraits of the author or even their abstract photographs appearing as cover illustrations for some of the most radical books of the day. Indeed, in the fifties and early sixties, it was these new, crisp black-and-white photographic jackets that gave the New Directions Paperbooks, the Grove Press Evergreen paperback series, and some of the Jargon Society and City Lights paperbacks their distinctive, contemporary look. The move from the more conservative, four-color artwork to the harder graphics of the photograph signaled all that was fresh, experimental, and remarkable in a literature that was in revolt against conventional styles and euphemistic speech. (This hard-edged, direct graphic presentation would become the hallmark of the modern photography book as well.). . . .

"It is the Tao that becomes the primary word and symbol for the major efforts of Frank, Kerouac, and *Aperture* in the fifties: *The Americans, On the Road,* and *The Way Through Camera Work. The Road* and *The Way* became central images in the search for new directions. The Tao symbolizes all the energies, traditions, heresies, and goals for which the prevailing culture had no use, especially the visionary and evangelical, the unconscious and the automatic. . . . Through *Aperture,* White was looking for the Tao of photography: the way to see clearly beyond the superficial, the intellectual, the pictorial."

From the Journal "Memorable Fancies," 15 April 1964. From *Mirrors Messages Manifestations*. (1968)
*Minor White**

"Four modes. I seem to have photographed in four branches of awareness; while the branches appeared in succession, all four continue to live.

"The first branch is a possessive one, a greed for all visible; and the famous recording power of the medium wondrously satisfies this demand for everything on the other side of barbed wire fences. With a camera I can "possess" all the objects in a

*New York: Aperture, 1968, pp. 194–195. Reprinted courtesy of the Mirror White Archive, Princeton University.

hardware store without destroying or altering the original . . . this bit of magic remains mystifying. The prominent danger is to keep from assuming that the silver shadow was a deed to the original. . . . In 1940 I would write, "*Straight photography,* tight as sonnet-form, is all the scope I need. *Experimental photography* could also be sufficient scope, but I do not lean in that direction at this time."

"The second branch has to do with a memory of things passed and the present invisible. I am still unable to understand a dream until I have either a diagram or a photograph of it. I became aware of this during World War II when my camera was taken away from me. I stopped seeing. Consequently, impressions and experiences by the thousands piled up . . . they had to be materialized before I could move on to seeing anything else. Verse was not enough. When camera was available again, Stieglitz's concept of the Equivalent opened the way to materialize those impressions and thus "release" myself from their tight grasp. For the long term effort the *metamorphosing* power of the camera was ideal. I would write in 1953, "For the purposes of Vision one medium is as inadequate as the next."

"The third branch pertains to the simple matter of creativity in respect to things, person, or Spirit. I always honor and obey the shock of a moment of revelation; the creative part of which is summed up in a quick Yes to a subject . . . or an image anywhere, seen or *remembered.* In picture editing, when a chance juxtaposition shocks a new Yes! out of me, it is as if I *see* an invisible third picture in a space between two images. Working with color slides, I find that by swinging two projectors so that their images overlap, whenever a pair *clicks,* an audience, as well as I, immediately experience what it feels like to say Yes to an image. In 1962 I would write, "What are more uniquely photographic than the negative print, the multiple exposure, the chance encounter, the found object, the anonymous medium?"

"Creativity with portraits involves the invocation of a state of rapport when only a camera stands between two people . . . mutual vulnerability and mutual trust. A portrait may be a record of an experience between two people, but the *photographing* may also be the creative foundation of the experience itself. During the period of making exposures, I can give or cause or "create" an atmosphere in which a person can blossom. I can bring about a feeling of resonance and well-being, or, if I choose, one of fear and discomfort or the feeling of being loved so ideally that the person loves himself. Thus to the power of camera to record and to transform was added the power of the photographer to extend his influence to those in the presence of his camera. This at first seemed more like what I associated with the word "creative." No longer! Not any more; not I, but a third force, "taking over."

"A fourth branch appears . . . the last? The formulation goes, "Camerawork in the pursuit of consciousness." Awareness of IT—I, and I—IT? I wonder whether the recording and transforming power, plus the power of influence through the camera are being integrated, transcended, or brightly burned up? Of the various illusions that abound in photography become conscious that *communicating* is limited to those factual matters that the reason can grasp visually; that evocation of feeling-stages requires

a willing audience; that *equivalence* is only for the metaphor-minded who can cope with the abstract level of any image; *self-expression* is for the young and must be worked through to "expression of Self," or degenerate into pure egotism; *creativeness* in photography relates to the realization that the ultimate medium of any artist is the mind and the psyche of those eating his images; *creativeness* also stands for the introduction of small changes in other people; and finally that making such changes in turn *might* lead the conscious photographer to *conscience.*

"Without going into reasons, I draw these conclusions to date (1968): I cannot give; I cannot teach, though I can learn; I cannot create, I cannot photograph. But I persist. Admitting what I can*not* do, when the shutter is released I catch the sound of stillness. I feel I AM release the shutter. It is like sitting so still that something realizes that my body is being breathed.

"Trends, modes, periods, unique photography, graphic photography, the finding of the "gem-like flame," all these and more are the shells on a necklace. The string? What is that? Merely what holds these shells in line that are so entrancing. In Heaven what matters is the string!

"Confronted with camera images that simple *Arc,* made by one who *Is,* an open heart will be wounded with joy."

Rochester, 15 April 1964

PHOTOGRAPHERS FROM THE PERIOD 1940–1960

1940–1960

Arnold, Eve (1913–), American
Avedon, Richard (1923–), American
Bernhard, Ruth (1905–), b. Germany, American
Bischof, Werner (1916–1954), Swiss
Blumenfeld, Erwin (1897–1969), German
Boubat, Edouard (1923–), French
Bravo, Manuel Alvarez (1902–), Mexican
Bristol, Horace (1909–1997), American
Burrows, Larry (1926–1971), American
Callahan, Harry M. (1912–), American
Capa, Cornell (1918–), b. Hungary, American
Chim, David Seymour (1911–1956), Polish
Clergue, Lucien G. (1934–), French
Corpron, Carlotta (1901–), American
Corsini, Harold (1919–), American
Danow, Ken (1909–), Japanese

*Davis, Griffith (1923–), American
*DeCarava, Roy (1919–), American
Doisneau, Robert (1912–), French
Duncan, David Douglas (1916–), American
Eliosofon, Eliot (1911–1973), American
Faurer, Louis (active 1940s–1950s), American
Feininger, Andreas B. L. (1906–), German
Frank, Robert (1924–), b. Switzerland
Frissell, Toni (1907–1988), American
Garnett, William (1916–), American
Gill, Leslie (1908–1958), American
Halsman, Philip (1901–1979), b. Latvia, American
Ishimoto, Yasuhiro (1921–), Japanese
Karsh, Youssef (1908–), Canadian
Klein, William (1928–), American
*Lachatenere, Romulo (1906–1952), b. Cuba, American
Laughlin, Clarence John (1905–), American
Lerner, Nathan (1913–), American
*Levitt, Helen (1918–), American
Licbling, Jerome (1924–), American
List, Herbert (1907–1975), German
Manning, Jack (active 1940s–1970s), American
Masao, Hovino (active 1940s), Japanese
McCullin, Donald (1935–), British
Miller, Lee (1906–1977), American
Model, Lisette (1906–1983), b. Austria, American
Morris, Wright (1910–), American
Najima, Kozo (active 1940s), Japanese
Newman, Arnold (1918–), American
Orkin, Ruth (1921–1985), American
Penn, Irving (1917–), American
Rodger, George (1908–), British
Ronis, Willy (1910–), French
*Rosenblum, Walter (1919–), American
Ruohomaa, Kosti S. (1914–1961), American
*Saunders, Richard (1922–1987), Bermudan
Siegel, Arthur (1913–1978), American
*Siskind, Aaron (1903–), American
Smith, Henry Holmes (1909–), American
Smith, W. Eugene (1918–1978), American
Stackpole, Peter (1913–), American

Steinert, Otto (1915–1978), German
Stern, Bert (1929–), American
Stouman, Lou (1917–1991), American
Sudre, Jean-Pierre (1921–), French
Teske, Edmund (1911–), American
Vachon, John (1914–1975), American
Vishniac, Roman (1897–), Russian
Weiner, Dan (1919–1959), American
Weston, Brett (1911–1993), American
White, Minor Martin (1908–1976), American

*Photographers whose work is significant for the study of cultural diversity. Many, but not all, of these photographs were taken by minority photographers.

4

The Period 1960–1980

OVERVIEW OF THE PERIOD
1960–1980

Topics Addressed

The Academization of Photography and the Rhetoric of the Self-Contained and Self-Referential Image • The Snapshot Aesthetic: The Informal Formalist • Documenting the Marginal as Mainstream • Revolt from Purism and the Development of the Manipulated Image • The Artist Who Uses Photographs.

From 1960 to 1980 the Cold War continued, accompanied by massive military buildups in the United States, the Soviet Union, and their close allies. In 1960, the year after the communist Fidel Castro ascended to power in nearby Cuba, the American military absorbed nearly 50 percent of the national budget. Ten years later, in 1970, the budget rose to $80 billion, up from $49.7 billion in the previous decade. The Soviet Union displayed a similar spending pattern throughout the period.

Relations between these great powers remained generally difficult and confrontational, but the Cuban Missile Crisis of late 1962 markedly altered the attitudes both of the major powers toward one another and of the rest of the world toward them. In that crisis, which was the closest the world has come so far to a nuclear war, the overwhelming military advantage in nuclear firepower that the United States possessed over the Soviet Union forced the Soviets to remove nuclear weapons they had established in Cuba. This had three long-term consequences: first, it encouraged both powers to engage in a twenty-five year arms race to establish or maintain nuclear superiority—a race that would severely erode the economic health of both countries;

second, it also encouraged a more conciliatory negotiating stance between the United States and the Soviet Union, on issues such as the avoidance of accidental nuclear war—an "agreement to disagree" politically without affecting issues of genuinely common interest; and third, it accelerated the process of the development of a "third world" independent of the superpowers—a process that consisted of the development of divergent political stances from the superpowers.

The single most important world event of the period was the Vietnam War, which began shortly after World War II and in which America became involved in the early 1960s, lasting until 1975. This war is important to our study of the period and its photographic history in several ways. It was the first major war that was consistently broadcast on television and one in which censorship was unsuccessful because of the dissemination of cameras among the troops and the presence of the press from many nations not engaged in the conflict. Consequently, neither side could successfully hide its difficulties from the world. It was a war that epitomized the period, for it pitted the North Vietnamese Communists successively against French colonial power, the South Vietnamese government, and America, its ally. It was one of many such wars fought by colonies against their rulers when geopolitical realignments took place after World War II and, as such, it was a crucial component of the development of the "third world." Finally, it was the event that toppled the United States from the twenty-year pinnacle of world economic dominance it had occupied since the end of World War II. This prosperous dominance had profoundly altered the quality of American life in general and the role of photography in particular during the preceeding decades, and the eclipse of it profoundly altered the role photography played in American society.

To understand this, one must first examine what the incredible stability of wealth and economic dominance from 1945 to 1965 meant to United States society in general. It produced what has been called a "revolution of rising expectations." This is most important for our study in one specific area: the education of the "baby boom" generation, born immediately after World War II. This generation was the first in American history in which virtually all of even moderate intellectual talent had the opportunity to undertake study at a college or university. In the years between 1945 and 1965, a college education changed from a luxury enjoyed by a wealthy or talented few to an economic necessity demanded by the average many. As pointed out in the previous chapter, this period saw the beginning of the "academization" of photography—the creation of an entire class of independent, college-educated, "photographic artists" alongside the structure of working professional photography. In the period from 1960 to 1980, working professional photography went into a decline, particularly the form known as magazine photojournalism, and, by 1980, the academic photographic artist was the dominant force in the field.

The reason for this can be stated in one simple economic word: "Inflation." The entry of the United States into the Vietnam conflict occurred at the height of American prosperity. The government of the United States attempted to pursue that war without the economic curbs it had imposed upon the public during, for example, World War II.

The result was an explosion of cost inflation of all wages and prices. The economic problems this created persisted into the 1980s and, in fact, the United States did not see anything resembling general prosperity with stable prices, comparable to the early 1960s, until after 1992. Particularly important for our story was the galloping inflation of the price of paper and price of postage. The combination of both of these costs destroyed the major weekly picture magazines *Life* and *Look,* both of which folded in the early 1970s. These magazines had never been intended to turn a profit based on their subscriptions—the newstand price of both was kept low to attain maximum circulation. The profits were made on advertising revenue. The inflation of the late 1960s and early 1970s caused production costs to exceed all possiblity of advertising profits, hence the magazines collapsed. With the demise of *Life* and *Look,* the major American markets for photojounalism evaporated, leaving only the photographic artists.

The uncensored images of the Southeast Asian conflict also had a profound effect on Western culture, in particular, creating a climate of mistrust between the government and the people of the United States, which at the time of this writing, has yet to be fully overcome. It also was in some part responsible for the rise of liberalism in the media in this country. Political controversy over the Vietnam War became part of the internal social movements that characterized Western Europe and the United States during these years. In the United States, the Civil Rights movement, feminism, gay rights, Native American rights, Latino rights movements, the hippies, the environmentalists, student unrest, and the war protesters all gained widespread popular media attention and ultimately changed American society during this twenty-year period, as well as the face of American art and photography. To a great degree, these movements emerged as civil rights movements or ones that questioned civil authority. Such unrest was not exclusively confined to the United States. From 1960 to 1980 in the West, a general revolt against repressive social institutions existed. In Europe and France, particularly in 1968, university students revolted against what they considered an educational system designed for the wealthy. There, they briefly allied themselves with the French working class and nearly succeeded in toppling the French government.

Throughout the industrialized world, various countercultures such as these developed to address the perceived failure of modern industrialized society to recognize the need for human health and dignity, personal freedom, and community. In response to these social movements, the governments of Europe, the United States, and Japan set up the Trilateral Commission in 1973. This organization was dedicated toward fostering international economic bonds and, as such, sought social and economic stability, at times at the expense of popular rights movements. During this same decade of the 1970s, the multinational corporation began to develop. In the industrialized world, television became the chief way government communicated with its people. It also became an important way for people to discover more about the world in which they lived. As a result, popular and academic literature began to address the essential nature of the media arts, particularly film and photography, as never before. Artists also examined the nature of the media arts as they became institutionalized through courses

and departments in universities and museums. This institutionalization of the media, especially photography, gave many people the opportunity to think critically about the medium and its history. The central question addressed during this period in intellectual and artistic circles became a vigorous debate over what constituted reality in film and photography and how this reality both replicated and influenced industrialized cultures. The period from 1960 to 1980 produced an ever-larger group of academically trained photographic historians and photographers in both the United States and Europe. This also was a period in which traditional schooling was reexamined in both Europe and the United States. To many, both film and still photography represented contemporary art forms that met the period's demand for relevance and accessibility in the art classroom. As a result, there was a great expansion of photographic education in schools and through museums, archives, and journals. In the United States, as art schools expanded and picture magazines declined, an academic photographic culture arose, and many of these new art photographers taught or worked in other noncommercial jobs. Because there was less call for daily and weekly news photography, emerging documentary photographers often worked on long-term projects that investigated marginal elements in society.

The period from 1960 to 1980 was noteworthy in that there were no small groups of photographers like the Photo-Secession or the F64 group who espoused a common style; rather, archives, educational institutions, and the marketplace encouraged both the collection and production of a wide range of photographs. When examining the timeline in this text, note the large number of institutions and organizations that were founded and rose to prominence during these years. It is during this period that the institutional structures that will influence photography until the end of the twentieth century are being erected. In 1962, the Society of Photographic Education was formed to promote education in photography at a university level. Although primarily American in membership, the society is the largest of its kind devoted to photographic education, and its journal *Exposure,* started in 1968, offers the reader glimpses into the changing concerns of its members. In 1963, Richard Rudishill becomes the first full-time photographic historian to teach in the art department of the University of New Mexico. In 1969, Nathan Lyons founded the Visual Studies Workshop in Rochester, New York. The workshop format proved popular during this period as an alternative to conventional university studies. Few survived, but the Visual Studies Workshop did, and it developed an M. F. A. program in conjunction with the State University of New York, giving rise in 1972 to *Afterimage,* the first periodical devoted to film, photography, and videography. This same year, Princeton University received an endowed chair in photographic history, whose first occupant is Peter C. Bunnell. In Europe and Japan, the university system rarely has photography classes. These classes are generally taught in art or technical institutes. Therefore, magazines and journals become one of the primary ways in which ideas about art photography are exchanged in these countries. In 1970, the British magazine *Album,* which was published for one year by Bill Jay, be-

came one of the first European magazines to publish both contemporary photography and its earlier history.

Multifunctional organizations that target a larger photographic community also developed during this period. The International Fund for Concerned Photography, founded by Cornell Capa in 1966, has become an archive, a museum, a gallery, an educational institution, and a publisher of photographic books. The Friends of Photography, established in California in 1967, performs similar functions. It was during the 1960s that the development of these foundations and others like them signaled the acceptance of the medium into the mainstream art market. The American government's acceptance of photography as an art form is shown in 1968, when the first National Endowment for the Arts grant in photography was awarded to Bruce Davidson for his documentation of East 100th Street in Harlem. It was not until 1971 that a separate category for photography was established by the Endowment.

Institutional acceptance and distribution of photography altered the photographic market in several ways. Galleries, dealers, and collectors proliferated, as the market for both contemporary and historic photographs rose sharply until the late 1970s. By 1979, the Association of International Photography Art Dealers was formed. Dealers such as Lee Witkin in New York acquired an international reputation not only by selling photographs but by educating the collecting public in connoisseurship. As a result of this new interest in acquiring photographs, photographic conservation became more important to photographers. In 1972, the Smithsonian Institution gave its first seminar on the topic, basing much of its information on the pioneering work of Henry Wilhelm, a photographer turned conservator.

For those who could not afford original prints, the artist's book and the richly printed book of photographs became available. The artist's book or portfolio might be a limited-edition object created individually by the artist, or it could be the product of a press, particularly a fine arts photography press such as Delpire or Schirmer-Mosel in Europe or Aperture and David R. Godine in the United States. Some academic institutions, notably the Nova Scotia College of Art and Design in Canada or the Tamerind Workshop at the University of New Mexico, worked with artists to produce limited-edition portfolios that included photographic printmaking techniques. Photogravure, a continuous tone etching process, which creates a print from a photographic negative, or photosilkscreen, which uses a photographic halftone screen, were some of the processes these presses used.

This interest in collecting, conservation, and printing sparked a renewed interest in nineteenth-century and early twentieth-century techniques and processes. The period 1960 to 1980 was one in which many nineteenth-century technical manuals were reprinted, along with articles about nineteenth- and early twentieth-century photographic aesthetics. An example of this phenomenon is included in this text. The selections by Charles Caffin in the first section of this book are from a photographic history written in 1901, which was reprinted by Morgan and Morgan in 1971. A revival of

sorts of earlier photographic aesthetics as well as processes even occurred. The book *Diana and Nikon* by critic Janet Malcolm, which appears as an excerpt in this section, is an oblique reference to the renewed investigation of the soft-focus aesthetic popular at the turn of the century. The "Diana" she refers to in the title is a plastic 120mm working toy camera ($1.50 c. 1971) whose imprecise lens created wide-angled dream-like effects. First used at Ohio University, this camera trained college level classes in basic photography during the late 1960s through the early 1970s. Like many other late twentieth-century technologies, 35mm camera technology was less affordable, compared to the last decade of the twentieth century. During the 1960s, civil rights efforts, low inflation, the postwar baby boom, and a growing middle class of postwar prosperity parents combined to produce a large and diverse university population. The low price of the camera enabled students with limited resources to learn photographic seeing and basic black-and-white printing technique. The camera was low-tech, with no real controls except a film advance, therefore students were left to concentrate on seeing. Since the average person, it was reasoned, had little contact with photography except for photojournalism and photography, students who used the Diana Camera for their first study of the medium would create different definitions of what a photograph looked like and what its uses were.

This curricular change had its origins in a kind of critical crisis regarding what constituted a photograph. Judging from the literature of the period, four major parts existed to this question: What constitutes reality in photography? What does a photograph look like? Exactly when does something cease to be a photograph, or conversely begin to be one? What does a photograph represent in our culture? Although photography at this time was being recognized institutionally, there were still few academically trained historians of the medium. As a result, the intellectual culture surrounding photography consisted mostly of people trained primarily as studio artists, people trained in film analysis and criticism, and philosophers and cultural critics. Marxist critics such as the German Walter Benjamin, who emphasized the economic and ideological underpinning of photography, became important. Film's explicit narrative qualities lend itself to the linguistic literary analysis known as *semiotics*. Soon, this form of analysis was being applied to photography as well, as evidenced by the writings of Stanley Cavell and Roland Barthes. At the same time, cultural critics like Susan Sontag discussed photography as a vehicle for shaping our modern perceptions of the world.

Photographers during this period often approached these aesthetic debates from two different vantage points: the manipulated print and the snapshot aesthetic. The manipulated print took two major forms: camera and darkroom manipulation of the silver print or the use of alternative non-silver processes, many of which first developed in the nineteenth century. With the rise of the modernist aesthetic and the hegemony of the straight print from 1940 to 1960, few artists at mid-century used combination printing (i.e., the printing of several negatives on one print) unless they were continuing the tradition of photographic Surrealism started in the late 1920s in Europe. But by the early 1960s, photographers trained in art schools and conversant with the history of

photography began to use combination printing to create surreal dreamlike images, often using subjects from the photographer's environment and personal life to create a personal symbolism. This development seems to be an extension of the personally expressive photograph found in the equivalents of Minor White and others. The montage technique also demonstrates an awareness of photographic history, for it acknowledges a debt to nineteenth-century European photography.

One important reinvestigation of printing with multiple negatives occurred in the photographs of Jerry Uelsmann, whose work is described in this section in the article by Peter C. Bunnell. Uelsmann acknowledged a debt to nineteenth-century photographers Oscar J. Rejlander (1814–1875) and Henry Peach Robinson (1830–1901), both of whom created elaborate combination prints, often with an implicit narrative. Rejlander's most famous print *Two Ways Of Life,* 1957, used thirty different negatives to illustrate the tale of a young man choosing between good and evil. Robinson's equally famous *Fading Away,* 1858, used five negatives to create the illusion of a young woman dying of consumption while flanked by helpless caregivers. Uelsmann's images have the same seamless quality as the work of his nineteenth-century predecessors, but his pictures allude to states of consciousness rather than presenting the viewer with a clear-cut depiction about what constitutes good and evil or sadness versus joy, as was common in nineteenth-century genre photographs and paintings. Because of the visually brilliant quality of his printing, we are aware of Uelsmann's photographs as objects.

This resurgence of a turn-of-the-century photographic aesthetic is seen more clearly during this period in the revival of early nineteenth-century processes that were still popular at the turn of the century and widely used by members of the Photo-Secession and their contemporaries. These were processes such as the gum bichromate print and cyanotype (blueprint), which were sometimes used with each other or in combination with platinum printing or another process. Soon modern counterparts of these earlier processes began to be used, known variously as Kwik Print, photolithography, and silkscreen printing. What these and many nineteenth-century revival processes have in common is the use of a negative the same size as the image and the ability to selectively color or build up or alter images on the print. Beginning in the 1970s, color xerox was available and artists such as Sonia Landy Sheridan began to experiment with what became known as color generative systems. Because of these old and new technologies, the boundaries of what was considered photography began to change. A photographic print no longer necessarily consisted of a moment in time, and it was as likely to document a private reality as a public one. Beginning around 1970, it was as likely to be a nonsilver color print or a combination silver print as it was to be a black-and-white silver print that was documentary in style. Because of their historical sophistication in terms of both technique and photographic aesthetics, the artists of this era made prints that were self-consciously manipulated, that is to say the photographers knew which implicit rules they were breaking, just as the Mannerists of the Renaissance did. The intellectual and physical deconstruction of the photographic image

that heralds the 1980s begins with this earlier investigation into what are called alternative processes (i.e., processes that present an alternative to the silver print). Indeed, a book titled *Breaking the Rules: A Photo Media Cookbook* was published by photographer Bea Nettles in 1977. It was one of many publications from the late 1960s until about 1980 that resurrected older nonsilver processes and explored modern printing technologies such as Kwik Print. This historical awareness added to an artistic debate that began in the nineteenth century. The central questions in this debate included: How did the characteristics of photography as an art form interact with other traditional arts such as painting and printmaking? When did an object cease to be a photograph and become an object that uses photographs? The influence of the manipulated photograph and conceptual art in the 1960s developed into a breakdown of distinctions between different media. As a result, in the 1970s, the artist who used photographs, but was not necessarily considered a photographer, emerged.

Since many photographers of this period held teaching positions, they often found themselves in art departments where they came into contact with traditional art forms. As a result, photography began to be seen as part of a continuum with a variety of other non-media arts such as printmaking, painting, and sculpture. At the same time, more artists from other fields were appropriating photographic imagery. The pop artist Andy Warhol made enlarged silk screened images of celebrities, while the photorealist painter Chuck Close meticulously reproduced photographs by painting them on canvas using a grid. Artists from other media not only used photographs, but their images appeared as though they were made from negatives. For many during the period from 1960 to 1980, the photographic negative and print were a point of departure, not ends in themselves.

From 1920 to 1940, Dada and Surrealist photographers recombined images cut from magazines into focused statements that frequently had political or sexual overtones. The juxtaposition of the images was the product of the artist's choice. By the period 1960 to 1980, another use of magazine images is seen. Photographer Robert Heinicken, a professor at the University of California, Los Angeles, began to make photographs by using pages from magazines and printing through them, so both sides of the page were visible at once. In his work, images of the Vietnam War might be superimposed over a fashion or beauty advertisement. This body of Heinicken's work asserts that magazines and television move the viewer abruptly and irrationally from one emotional state to another. "The medium is the message," a widely repeated pronouncement by cultural commentator Marshall McLuhan, was realized in these images. Heinicken's art and that of others in this period became an ironic commentary on the disjunctive nature of reality and the emotions it engendered. The works also incorporated words and images.

This use of words with photographs became widespread in the field during the early 1970s. By 1976, an exhibit and book titled *Photography and Language,* assembled and edited by Lew Thomas, included thirty artists who used photographs and text together. Undoubtedly, one primary influence on such artists was conceptual art, which

often juxtaposed images with text. The second was the resurgence of the photographic book. And the third was the use of alternative photographic processes, particularly those derived from printmaking. Finally, the emergence of the snapshot aesthetic during this period meant that images often displayed part of a narrative as do family snapshots when they depict scenes from a birthday or other family event. Instead of the narrative provided by a family member as an album was viewed, the photographer using the snapshot aesthetic might provide a handwritten or other explanation for the prints, as in the work of photographer Duane Michals, for example. This personalized the almost anonymous quality that such otherwise unmanipulated photographs had. The snapshot aesthetic was a reaction in part to the large format and formal qualities of much photography created between 1940 and 1960.

The snapshot aesthetic as it was practiced by many emerging photographers of the 1960–1980 period was influenced by the work of Robert Frank and others like him, who rose to prominence in the late 1950s. It was a reaction in part to the large format and formal qualities of much photography made between 1940 and 1960, but "snapshot aesthetic" has a rich definition and lineage in the history of twentieth-century photography. The word "snap-shot" was a British hunting term used to describe a quick unaimed shot in response to animal movement. In 1860, this term was first used to refer to photographs by Sir John Herschel (1792–1871), an astronomer, scientist, and photographic inventor. When Herschel first referred to the photographic "snap-shot," he used the word to refer to an exposure that captured the briefest instant of time. At the turn of the century, photographer Alfred Stieglitz criticized the carelessness with which the average amateur photographer made exposures. At the same time, he believed in the importance of the hand camera as a photographic tool and referred to spontaneous-looking, but carefully conceived photographs made with the hand camera, as "well-considered snapshots." By the 1930s, photographer Henri Cartier-Bresson attempted to "trap" life as he saw it on the streets of Marseilles. In 1952, he published a book of photographs titled *The Decisive Moment*. In the introduction, he defined this moment as an instant of exposure in which the composition and the event's unfolding narrative simultaneously reach a climax.

By the late 1950s, Robert Frank and others began to subvert Cartier-Bresson's definition of the decisive moment by framing and composing the subject in a way that made the photograph appear almost accidental. Deliberate strategies to echo the qualities of the amateur snapshot were used. The images were sometimes blurred, taken at a skewed angle, or featured poses that seemed accidental and awkward. Most important, Frank's human subjects often appeared to be between motions or emotions, rather than being captured on film at a climatic moment. In this way, Frank and other photographers of his generation sought to make the invisible visible by deliberately recording moments of visual and emotional awkwardness that the amateur photographer often accidentally records. The images resembled that of the French new-wave cinema during the late 1950s, and it comes as no surprise to learn that Robert Frank later abandoned still photography to work in film. At that time, French directors such

as Louis Malle, Jean Luc Godard, and Francois Truffaut developed a style known as *cinema verité.* This style was the product of the *camera stylo,* which literally means the camera used as a pen. It refers to a way of filming in which the handheld movie camera echoes the movements of the cinematographer, so we are conscious of seeing through that person's eyes, much in the same way we sense an individual's personality and viewpoint in a handwritten note. Like handwriting, where pen leaves paper at seemingly random moments, the camera stylo and snapshot aesthetic provided the viewer with a disjunctive but personal view of reality. The intrusive style of the photographer drew attention to the act of photography that became more visible as the importance of its subject matter diminished.

This effect was enhanced in the 1960s, when photographers such as Lee Friedlander began to use reflections, shadows, or parts of themselves in their work. Others, like Gary Winogrand, used a 35mm camera with a slightly wide-angle lens to self-consciously mimic the form of the snapshot by shooting from a skewed angle and emphasizing happenchance in photographs. These photographers and other street photographers continued to develop the vernacular subject matter that had always been central to the snapshot aesthetic. Its subjects were of no traditional artistic importance: suburban streets in the Midwest, motel rooms featuring a view of the television, animals and people at the zoo. Like the cinema verité of this period, photographers were presenting what became known as the new social landscape, a landscape where the marginalized style of the snapshot and the marginalized subject met.

The marginalized subject gained importance from 1960 to 1980 as the photography of the period reflected advances in feminism, civil rights, and a growing recognition of social diversity within nations. In industrialized peacetime nations, feminism was perhaps the most widespread and institutionalized. By 1974, in the United States alone, women's studies were taught at seventy eight post-secondary institutions. Nationwide, there were some 2,000 courses about women at approximately 900 campuses. In photography, feminism meant not only increased inclusion in photographic history, it meant both stylistic and subject matter changes in the photographs themselves. Photographers began to examine a number of gender issues. Women photographers, in particular, began to use the photograph as a chronicle of their intimate lives. One form this chronicle took was to record the daily lives of families or friends. A self-conscious examination of what photographers considered stereotypical women's environments also began. Traditionally female crafts such as quilting, china painting, and embroidery were being integrated into the arts by artists such as Judy Chicago in her collective ceramic work "The Dinner Party" (1979) or in the work of painter and printmaker Mariam Shapiro. Symbolic and actual references to these craft traditions also occurred in photography. Photographers like Betty Hahn and Bea Nettles used gum bichromate, Kwik Print, or blueprint and other photographic printing techniques to produce prints on a variety of fabric surfaces. These prints often were collages. The images were multicolored and their individual components were often snapshot-like photographs, culled from different vernacular sources: family albums, contemporary

family and travel snapshots, and posterlike images of figures in popular culture. At times, these photographs also were stitched on as well.

This reexamination of women's roles and appearances also affected photography of the nude. Minor White solicited photographs internationally for an Aperture monograph "Being without Clothes." Published in 1970, its title suggested its countercultural stance. Rather than focusing on the traditionally posed female nude, derived from painting, this book explored nudity in a variety of situations. The family, sexuality, and the natural world were some of the areas explored. A number of the nudes were male, many of the photographs created by women. In 1978, the Marcuse Pfeifer Gallery in New York had an exhibit on male nudes, as interest in the history of the male nude began to emerge. In 1915, photographer Imogene Cunningham had created a stir with an exhibition in Seattle by exhibiting nude photographs of her husband, and although there was no frontal nudity in the images, audiences in the second decade of the twentieth century found the idea of a woman photographing a nude man disturbing. Now in the 1970s such restrictions on subject matter began to erode for a large number of women photographers. Women not only began to explore the male and female nude in larger numbers, but increasing numbers of significant women artists began to emerge in areas such as large-format landscape photography, an area that has traditionally seen fewer women practitioners. In the 1940–1960 section of this text, critic Deborah Bright examines the way in which the photographic landscape is a cultural and visual construct that often slights the contributions of women. In the 1970s, more women landscape photographers begin to emerge, such as Fay Godwin in Britain and Marilyn Bridges in the United States.

There also was a renewed interest in women as photographic subjects. In 1975, Judy Dater and Jack Welpott collaborated on a book titled *Women and Other Visions.* Portraits of women and men were made with the subject's complicity, and objects and environment and dress conspired in these photographs to create for viewers a series of pictures they can literally read as signs that inform about the subject. Such images demonstrated that some of the developments taking place in photography during this period were almost visual demonstrations of the increasing influence of linguistic studies known as semiotics. From the early 1970s on, monographs and surveys of important women photographers began to appear. As the social movements of the 1960s changed the curricula of universities, feminist theorists emerged in the arts and humanities. Commentators and critics like Catherine Lord, Deborah Bright, and Jan Zita Groover emerged, as did photographic historians such as Ann Tucker, who has authored, among other publications, a book and catalog titled *The Women's Eye.* This book and others published during the same era gave readers increasing access to the contributions women had made and were making to photography. This richness in photographic literature by and about women was part of the growing body of work about photography history and criticism.

The civil rights movement also influenced photography, as growing numbers of both African-American and other photographers recorded civil rights struggles. By

1970, a number of photographers had started to reinvestigate what it was like to be black in a white-dominated culture. From the perspective of emerging African-American photographers, Roy De Carava was perhaps the most important influence. A recognized photographer and supporter of photography from the 1950s on, he served as a mentor to many young black photographers from 1963 to 1966 through his Kamoinge Workshops, which were dedicated to developing a black consciousness in photography. His work was part of a new renaissance in African-American art which, like the Harlem Renaissance of the 1920s to 1940s, was primarily literary during the 1960s. Writers like Richard Wright, James Baldwin, Eldridge Cleaver, and Lorraine Hansberry emerged into the mainstream during this period. In 1968, a multimedia presentation at the Metropolitan Museum of Art in New York titled "Harlem on my Mind" introduced many viewers to the richness of black culture. Its most important contribution to photographic history was the rediscovery of James Van der Zee, who worked as a portrait photographer in Harlem from the 1920s to the 1960s. His work showed a prosperous and middle-class Harlem that was at the same time aware of its African-American identity. Van der Zee not only created portraits of the living, he created a remarkable series of funeral portraits that are discussed in the 1920–1940 section of this text. He also was the photographer for Marcus Garvey and the Garveyites, who formed part of the back-to-Africa movement. Van der Zee's work formed part of the rediscovery and expansion of the visual archive of African-American culture. Like the contemporary women's movement, much examination of African-American culture is rooted the early 1970s, when a growing number of academics began to write about the black experience as historians, sociologists, and other observers. This period of the early 1970s also saw the beginnings of the *Black Photographers Annual,* published in 1973. In 1970, *East One Hundredth Street* was published by photographer Bruce Davidson, who made sensitive, but somewhat guarded, large-format images of the people who lived on one block of Spanish Harlem's East 100th Street. This work was not Davidson's only recording of black and Hispanic culture. In 1962, he was awarded a Guggenheim to photograph the civil rights movement, and in 1966 he received the first photography award from the National Endowment of the Arts. These grants demonstrated that the recording of minority culture was now becoming accepted by major art foundations. This acceptance was not without controversy, however. As a white man with a degree in philosophy from Yale, Bruce Davidson was an outsider to the culture he recorded. This positioning of the photographer as an outsider, although more common than not during this era, was increasingly being questioned. A major consideration that emerged out of the dialogue between the marginal and the mainstream in photography and photographic criticism of the period was the position of the photographer in relationship to the subject.

In 1971, Larry Clark's *Tulsa* was published, in which the snapshot aesthetic was used to produce an exceptional gritty look at amphetamine users in Tulsa, Oklahoma, over a period of years. The grim photographs reveal an obsessed and circumscribed world. Using shadows without details, out-of-focus foregrounds, casual framing, and

an intimate connection to his subjects, Clark creates understated images whose stylistic banality throws the desperate quality of the addicts' lives into higher relief. The pointlessness and human cost of the addiction is painfully evident when a photograph of a pregnant women shooting up is followed by a photograph of an infant's funeral. Although the subject is traditionally documentary, the narrative is implicit rather than explicit, and the photographer's vantage point, which also is ours, is that of a man who participates in the compulsion he documents.

At times the photographer was positioned as an outsider documenting an outsider. Joseph Koudelka's photographs of Gypsies, the Romany people, published in 1975, illustrated this concept. A Czechoslovakian, Koudelka photographed Gypsies in the British Isles, Romania, Spain, and France. His subject matter reveals the timelessness of Romany culture, while his style, with its occasional blurs and angled viewpoints, reflects a contemporary aesthetic. His evident empathy for his nomadic subjects can be seen within the larger context of the social progressivism and ethnic diversity that was emerging in European culture at the time. In major cities across Western Europe, former colonial peoples began to immigrate to Europe in search of economic well-being. Guest workers from Eastern and Southern Europe emigrated to Northern Europe in search of jobs. Koudelka's work may be seen as a plea for tolerance for a people that has traditionally experienced discrimination in many parts of Europe.

Changes also were taking place in postwar Japan as a new generation of photographers arose. Prior to World War II, the style of Japanese photographers could be characterized as reflecting the influence of Japanese prints as well as the influence of the Pictorialists and Photo-Secessionists of Europe and the United States. These two influences are intertwined, since the Pictorialists at the turn of the century were themselves influenced by Japanese prints, as were the Impressionist painters before them. The Japanese needed some time to rebuild their society after World War II, and they did so with a U.S. military presence. As the Japanese economy was rebuilt, it became a major economic power whose impact in photography was part of an early Japanese dominance in the field of electronics in general. Therefore, the camera culture in Japan was tied to American and European consumption of Japanese technology. By 1963, Japan had outstripped Germany as the world's top producer of cameras. A growing interest in photography throughout Japan coincided with a rapidly changing culture. The emerging Japanese photographers worked primarily as photographic journalists or they freelanced. Postwar Japanese photography was most often reproduced in magazines and books, also common in Europe. As a result, in both of these cultures, the print was primarily seen in reproduction and the fine print aesthetic was less important than capturing an instant of reality. In Japan, this work had such an immediacy that one often got the sense of participating in the photographer's reality at the moment of exposure. From the 1960s to the early 1970s, Japanese photography appeared to deal with three separate but related issues: (1) Japanese traditions in the face of westernization and modernization; (2) a concern for their small island environment; and (3) their vision of Western culture, primarily that of the United States. American culture also

found its way into Japanese photography in the form of contemporary photographic criticism. *Camera Mainichi,* a widely distributed camera magazine, often reprinted articles from American periodicals about subjects of interest to a Japanese audience. Numerous reprinted articles appeared in *Camera Mainichi* in the early 1970s on photographer Diane Arbus's work. In 1973, five articles appeared on her work alone. This interest in American photography was reciprocal. In 1974, the Museum of Modern Art exhibited the work of many established Japanese photographers. Americans were exposed to the work of photographers like Ken Domon, who photographed details of traditional Buddhist statuary. Shomei Tomatsu photographed the survivors of the atomic bomb blasts, the aftermath of a typhoon, and the pollution of the environment. The photographer Ikko traveled to the United States where he recorded moments of coincidental juxtapositions such as two ladies wearing the same Jackie Kennedy mask in New York City in 1970. Ambiguous pictures by Masahia Fukase and Eikoh Hosoe showed a concern with the changing relationships between the sexes in the midst of a changing culture (Fig. 4.1). By 1979, another major exhibit of Japanese photography was held at the Institute for Contemporary Arts in London.

It is evident that Japanese photography addresses the mainstreaming of the marginal in several ways. The artistic, cultural, and technological interchanges Japan shared with both Europe and the United States from the 1960s on, demonstrate the interconnectedness and mutual influences that were emerging in the industrialized

Figure 4.1 Eikoh Hosoe.
Man and Woman #24, 1960.
Gelatin-silver print.
Courtesy: Howard Greenberg Gallery. Copyright © Eikoh Hosoe.

world. At the same time Japan was becoming increasingly important to the development of photographic technology, it was being influenced by American and European photographic culture as well as achieving a distinctly Japanese sensibility. North Americans and Europeans were becomingly more and more interested in Japanese photography at the same time the Japanese were documenting their own changing culture with an awareness of the photographer as witness. Photographers such as Shomei Tomatsu documented traditional lifestyles and people who had been marginalized by suffering and deformity in a homogenous culture. The work of Fukase and Eikoh Hosoe shows a changing treatment of female subjects and an understanding of the grotesque as the marriage of incompatibles. These characteristics in the work of these three Japanese photographers perhaps help explain the popularity and importance of the work of American photographer Diane Arbus in Japan.

If it can be said that one photographer dominated the era from 1960 to 1980, it is Arbus, who most reflected industrialized society's preoccupation with sex and sex roles. Her work also reflected contemporary society's sense of the randomness of fate, the irony of destiny, and the alienation produced by constant change. The development of her work took place from the late 1950s, when she first started to photograph, until 1971, the year of her death. At the age of eighteen, Diane married Allan Arbus, and they became a well-known fashion photography team, with Allan exposing the film and Diane working on concept. This exposure to fashion photography, which Diane continued to work at throughout her career, gave Arbus an eye for telling detail. By the early 1960's, after Diane Arbus had studied with Lisette Model, she began to emerge as a magazine photographer. In 1967, after winning two Guggenheim grants to document American culture, she was featured with Gary Winogrand and Lee Friedlander in the "New Documents" exhibit in the Museum of Modern Art. In 1972, a year after her untimely death, she became the first American photographer to be exhibited at the Venice Bienniale.

The reason for her notoriety was her choice of subject matter and its treatment. She photographed giants, dwarfs, contest kings and queens, and transvestites, as well as nominally ordinary people. Human identity in her work is explored as a series of often contradictory roles, such as child or adult or male and female that exist within one individual. These opposing social roles describe a society where human appearance and character have become changeable and confused. When she said at the beginning of her photographic career that she wished to photograph "evil," she was not referring to sinful thoughts or actions, but rather she wished to photograph the alien and the mythic within the context of the familiar. She also wished to show how social alienation and disintegration could exist within the individual.

In *A Jewish Giant at Home With His Parents in the Bronx* (New York, 1970), a fairytale figure becomes accessible through the ordinariness of his parents and his Bronx environment. The giant is positioned in the corner of the room, while flash-lighting enlarges the outline of his body. An adult who is rendered childlike by the continuous growth characteristic of giantism, he dwarfs his parents who look up to him

with ingenuous surprise in return. The giant's cane, however, reminds us of his disability, which will hasten his death and contrasts with his status as young man and child.

The awkwardness of the giant's body, which is caused by his continued growth, was a characteristic Arbus worked on making visible. She first met her subject, Eddie Carmel, ten years prior to this final image, when Carmel was a fresh-faced, young man working at Hubert's Freak Show and Flea Circus, a now-defunct establishment on 42nd Street in New York City. When she first began creating pictures of him, she would capture individual characteristics, such as his awkwardness or his childlikeness, in separate images. Because her subject continued to grow over the years, his ungainliness became increasingly evident. Although prior photographs contained some of the characteristics she sought, Arbus also was compelled to work through time with the medical reality of giantism to achieve her final exposure. This final print not only contains all of these individually seen qualities, but it interweaves, contrasts, and juxtaposes them. Images such as this one, which took her years to achieve, suggest that Arbus worked toward solutions that pulled together a subject's multiple characteristics, while making them visible in a kind of uneasy tension. In this image there is the sense of intruding upon a tragedy, for Arbus knew what was happening to Eddie Carmel. Her image of the giant is a brief telling segment of her interaction with him. Arbus seeks to make not only the giant visible as a person, but also as a process.

There also is an inherent contradiction in this exploration of the ordinary and extraordinary. Although the giant is traditionally a scary fairytale character, as adults we no longer fear him. In fact, his cramped Bronx surroundings make us wryly aware of his very ordinary existence, and his inherent powerlessness. However, we are frightened by the crippling he endures. Our fear is immediate and personal, as well historic. Throughout Western culture, spiritual disease has traditionally been associated with manifestations of physical deformity. The grotesque human body may be seen as an individualized symbol for a disintegrating social structure. Thus, Arbus manages to both confuse our emotional expectations and forge an uneasy link between the viewer and subject.

Her work mirrors the turbulence of the period from 1960 to 1980, which was characterized in many industrialized nations as an era of the personal odyssey. First, Arbus participated in a personal odyssey in making her photographs. It is rare that a person can grow up in a culture, yet still manage to see it anew, as though through foreign eyes, while seeing and recording telling details whose significance only a native could discern. Her photographs also depicted a society consisting of autonomous individuals. A 1960s image of a pro-war demonstrator shows an isolated individual whose only apparent connections to mass protest are the protest buttons he wears. Arbus's world is one in which each individual seeks a personal solution, rather than identifies with a larger group. In this manner, Diane Arbus is a dissector of society, whose photographs show the viewer that American culture of the 1960s could be construed as having no center beyond the self.

It is not surprising then to note that the self-portrait also enjoys a renaissance from the late 1960s on. Many of the artists who make them seek an alternate way of examining who they may be. Some well-known practitioners of the form, such as Lucas Samaras, are, in reality, artists who use photographs rather than photographers per se. The Greek-born Samaras in 1969 began to make color Polaroid photographs whose surfaces he manipulated in the 1970s to create self-portraits of himself as a monster. Finnish-born photographer Arno Minkkinen produced a series of self-portrait nudes in which he exposed his body to emphasize both its abstract and vulnerable qualities in an often cold or distant landscape. The American photographer Anne Noggle took self-portraits before and after a facelift. Lee Friedlander, who was included with Diane Arbus in the New Documents Exhibit at the Museum of Modern Art, often photographs himself in the form of a shadow or reflection in his urban landscapes.

The self-portrait at this time in photographic history often is a prolonged examination that is ironically self-aware and intimate at once. What many aspects of photography have in common during this period is an examination of the relationship of the photographer to the subject. The photographer's eye (i.e., the vision of a specific photographer, whether as a documentator, montage artist, or an artist who uses photographs) is acknowledged during this time. This subjectivity on the part of the artist occurs when interest in photographic collecting is at its peak, and a variety of new and old materials and processes are making their way into photographs and, hence, into collections. The standards for quality in the silver print become quite high, and because of collecting there is an increased interest among photographers as well as curators in photographic conservation.

As color materials became more stable and commonly used in photojournalism, color photography began being produced more frequently by artists like Joel Meyerowitz, Harry Callahan, and William Eggleston, all of whom produced photographs of urban landscapes during the late 1970s. Amateur photographers also benefitted from an increased access to instant color, as polacolor film was developed in 1962. Yet it is not the technical developments that dominate this period, but rather the spread and institutionalization of photography as an art form at the same time that it documents a more subjective vision of culture.

By the mid-1970s, self-conscious references to photographic history and the use of appropriated imagery resulted in photographs that made consistent references to the process and nature of photography. Between 1974 and 1978, for example, American artist Tom Barrow created a series titled "Cancellations," in which the negative was deliberately scratched with a large "X" before printing. John Pfahl, another American, created witty visual references of nineteenth-century landscape photographs. In Germany, Ernst and Hilla Becher used photographs to document typologies, or types of vernacular architecture, as they photographed subjects such as blast furnaces that they then displayed in a grid pattern so the objects could be compared (Fig. 4.5). This quasi-objective recording also devalues the photograph as an object, an objective also achieved by Thomas Barrow when he scratched his negatives. As photography be-

comes accepted as an art form, its reproducibility and worth as an object becomes the center of vigorous debate, evidenced by the renewed interested in Walter Benjamin's 1936 article "The Work of Art in the Age of Mechanical Reproduction," which is excerpted in the 1960–1980 writings of this text. The Becher's photographic enumeration also had roots in nineteenth-century photography. When individuals like the nineteenth-century photographer Julia Margaret Cameron (fl 1863–71) made portraits of individuals, these individuals also represented types who thus became part of a system of types or typology constructed by the photographer.

Anonymous nineteenth-century documentary photography also was used to create typologies. The French were the first photographers to produce criminal mug shots, which they used not only for purposes of identification but to see if they could find common features that were present in a criminal "type." Thus, understanding the Becher's work fully requires some knowledge of photographic history, as does the work of Barrow and Pfahl. With the rise of the academic photographer comes the rise of the photograph that refers to photographic history. In the beginning of this chapter, Jerry Uelsmann's work in the 1960s was discussed as a revival of nineteenth-century technique. By the mid-1970s, photography was being used as a vehicle to demonstrate that photography operates within a cultural and historical belief system, the knowledge of which dictates the viewer's response to the print. Just as the 1960s generated an interest in historical technique, the 1970s lead to self-conscious examination or "deconstruction" of how we have been taught to make and see photographs. By the mid-1970s, this trend emerges as "Postmodernism," which becomes a dominant trend from 1980 to the end of the twentieth century.

EXCERPTS FROM THE PERIOD 1960–1980

"The Work of Art in the Age of Mechanical Reproduction." (1936)
*Walter Benjamin**

"In principle, a work of art has always been reproducible. Man-made artifacts could always be imitated by men. Replicas were made by pupils in [the] practice of their craft, by masters for diffusing their works, and, finally, by third parties in the pursuit of gain. Mechanical reproduction of a work of art, however, represents something

new. Historically, it advanced intermittently and in leaps at long intervals, but with accelerated intensity. The Greeks knew only two procedures of technically reproducing works of art: founding and stamping. Bronzes, terra cottas, and coins were the only works of art which they could produce in quantity. All others were unique and could not be mechanically reproduced. With the woodcut, graphic art became mechanically reproducible for the first time, long before script became reproducible by print. The enormous changes which printing, the mechanical reproduction of writing, has brought about in literature are a familiar story. However, within the phenomenon which we are here examining from the perspective of world history, print is merely a special, though particularly important, case. During the Middle Ages engraving and etching were added to the woodcut; at the beginning of the nineteenth century lithography made its appearance.

"With lithography the technique of reproduction reached an essentially new stage. This much more direct process was distinguished by the tracing of the design on a stone rather than its incision on a block of wood or its etching on a copperplate and permitted graphic art for the first time to put its products on the market, not only in large numbers as hitherto, but also in daily changing forms. Lithography enabled graphic art to illustrate everyday life, and it began to keep pace with printing. But only a few decades after its invention, lithography was surpassed by photography. For the first time in the process of pictorial reproduction, photography freed the hand of the most important artistic functions which henceforth devolved only upon the eye looking into a lens. Since the eye perceives more swiftly than the hand can draw, the process of pictorial reproduction was accelerated so enormously that it could keep pace with speech. A film operator shooting a scene in the studio captures the images at the speed of an actor's speech. Just as lithography virtually implied the illustrated newspaper, so did photography foreshadow the sound film. The technical reproduction of sound was tackled at the end of the last century. . . . Around 1900, technical reproduction had reached a standard that not only permitted it to reproduce all transmitted works of art and thus to cause the most profound change in their impact upon the public; it also had captured a place of its own among the artistic processes. For the study of this standard nothing is more revealing than the nature of the repercussions that these two different manifestations—the reproduction of works of art and the art of film—have had on art in its traditional form.

"Even the most perfect reproduction of a work of art is lacking in one element: its presence in time and space, its unique existence at the place where it happens to be. This unique existence of the work of art determined the history to which it was subject throughout the time of its existence. This includes the changes which it may have suffered in physical condition over the years as well as the various changes in its ownership. . . . One might subsume the eliminated element in the term "aura" and go on to say: that which withers in the age of mechanical reproduction in the aura of the work of art. This is a symptomatic process whose significance points beyond the realm of art. One might generalize by saying: the technique of reproduction detaches the repro-

duced object from the domain of tradition. By making many reproductions it substitutes a plurality of copies for a unique existence. And in permitting the reproduction to meet the beholder or listener in his own particular situation, it reactivates the object reproduced. These two processes lead to a tremendous shattering of tradition which is the obverse of the contemporary crisis and renewal of mankind. Both processes are intimately connected with the contemporary mass movements. Their most powerful agent is the film. Its social significance, particularly in its most positive form, is inconceivable without its destructive, cathartic aspect, that is, the liquidation of the traditional value of the cultural heritage. . . .

"The concept of aura which was proposed above with reference to historical objects may be usefully illustrated with reference to the aura of natural ones. We define the aura of the latter as the unique phenomenon of a distance, however close it may be. If, while resting on a summer afternoon, you follow with your eyes a mountain range on the horizon of a branch which casts its shadow over you, you experience the aura of those mountains, of that branch. This image makes it easy to comprehend the social bases of the contemporary decay of the aura. It rests on two circumstances. . . . Every day the urge grows stronger to get hold of an object at very close range by way of its likeness, its reproduction. Unmistakably, reproduction as offered by picture magazines and newsreels differs from the image seen by the unarmed eye. Uniqueness and permanence are as closely linked in the latter as are transitoriness and reproducibility in the former. To pry an object from its shell, to destroy its aura, is the mark of a perception whose "sense of the universal equality of things" has increased to such a degree that it extracts it even from a unique object by means of reproduction. Thus is manifested in the field of perception what in the theoretical sphere is noticeable in the increasing importance of statistics. . . .

"The uniqueness of a work of art is inseparable from its being imbedded in the fabric of tradition. This tradition itself is thoroughly alive and extremely changeable. An ancient statue of Venus, for example, stood in a different traditional context with the Greeks, who made it an object of veneration, than with the clerics of the Middle Ages, who viewed it as an ominous idol. Both of them, however, were equally confronted with its uniqueness, that is, its aura. Originally the contextual integration of art in tradition found its expression in the cult. We know that the earliest art works originated in the service of a ritual—first the magical, then the religious kind. It is significant that the existence of the work of art with reference to its aura is never entirely separated from its ritual function. In other words, the unique value of the "authentic" work of art has its basis in ritual, the location of its original use value. This ritualistic basis, however remote, is still recognizable as secularized ritual even in its most profane forms of the cult of beauty. The secular cult of beauty, developed during the Renaissance and prevailing for three centuries, clearly showed that ritualistic basis in its decline and the first deep crisis which befell it. With the advent of the first truly revolutionary means of reproduction, photography, simultaneously with the rise of social-

ism, art sensed the approaching crisis which has become evident a century later. At the time, art reacted with the doctrine *l'art pour l'art,* that is, with a theology of art. This gave rise to what might be called a negative theology in the form of the idea of "pure" art, which not only denied any social function of art but also any categorizing by subject matter. (In poetry, Mallarmé was the first to take this position.)

"An analysis of art in the age of mechanical reproduction must do justice to these relationships, for they lead us to an all-important insight: for the first time in world history, mechanical reproduction emancipates the work of art from its parasitical dependence on ritual. To an ever greater degree the work of art reproduced becomes the work of art designed for reproducibility. From a photographic negative, for example, one can make any number of prints; to ask for the "authentic" print makes no sense. But the instant the criterion of authenticity ceases to be applicable to artistic production, the total function of art is reversed. Instead of being based on ritual, it begins to be based on another practice—politics. . . .

"In photography, exhibition value begins to displace cult value all along the line. But cult value does not give way without resistance. It retires into an ultimate retrenchment: the human countenance. It is no accident that the portrait was the focal point of early photography. The cult of remembrance of loves ones, absent or dead, offers a last refuge for the cult value of the picture. For the last time the aura emanates from the early photographs in the fleeting expression of a human face. This is what constitutes their melancholy, incomparable beauty. But as man withdraws from the photographic image, the exhibition value for the first time shows its superiority to the ritual value. To have pinpointed this new stage constitutes the incomparable significance of Atget, who, around 1900, took photographs of deserted Paris streets. It has quite justly been said of him that he photographed them like scenes of crime. The scene of a crime, too, is deserted; it is photographed for the purpose of establishing evidence. With Atget, photographs become standard evidence for historical occurrences, and acquire a hidden political significance. They demand a specific kind of approach; free-floating contemplation is not appropriate to them. They stir the viewer; he feels challenged by them in a new way. At the same time picture magazines begin to put up signposts for him, right ones or wrong ones, no matter. For the first time captions have become obligatory. And it is clear that they have an altogether different character than the title of a painting. The directives which the captions give to those looking at pictures in illustrated magazines soon become even more explicit and more imperative in the film where the meaning of each single picture appears to be prescribed by the sequence of all the preceding ones.

"The nineteenth-century dispute as to the artistic value of painting versus photography today seems devious and confused. This does not diminish its importance, however, if anything, it underlines it. The dispute was in fact the symptom of a historical transformation the universal impact of which was not realized by either of the rivals. When the age of mechanical reproduction separated art from its basis in cult, the

semblance of its autonomy disappeared forever. The resulting change in the function of art transcended the perspective of the century; for a long time it even escaped that of the twentieth century, which experienced the development of the film.

"Earlier much futile thought had been devoted to the question of whether photography is an art. The primary question—whether the very invention of photography had not transformed the entire nature of art—was not raised. Soon the film theoreticians asked the same ill-considered question with regard to the film. But the difficulties which photography caused traditional aesthetics were mere child's play as compared to those raised by the film. . . . Far more paradoxical cases can easily be construed. Let us assume that an actor is supposed to be startled by a knock at the door. If his reaction is not satisfactory, the director can resort to an expedient: when the actor happens to be at the studio again he has a shot fired behind him without his being forewarned of it. The frightened reaction can be shot now and be cut into the screen version. Nothing more strikingly shows that art has left the realm of "beautiful semblance" which, so far, had been taken to be the only sphere where art could thrive. . . .

"How does the cameraman compare with the painter? To answer this we take recourse to an analogy with a surgical operation. The surgeon represents the polar opposite of the magician. . . . Magician and surgeon compare to painter and cameraman. The painter maintains in his work a natural distance from reality, the cameraman penetrates deeply into its web. There is a tremendous difference between the pictures they obtain. That of the painter is a total one, that of the cameraman consists of multiple fragments which are assembled under a new law. Thus, for contemporary man the representation of reality by the film is incomparably more significant, since it offers, precisely because of the thoroughgoing permeation of reality with mechanical equipment, an aspect of reality which is free of all equipment. And that is what one is entitled to ask from a work of art."

"The Photographic Message." (1961)
*Roland Barthes**

"The press photograph is a message. Considered overall this message is formed by a source of emission, a channel of transmission, and a point of reception. The source of emission is the staff of the newspaper, the group of technicians certain of whom take the photo, some of whom choose, compose and treat it, while others, finally, give it a title, a caption, and a commentary. The point of reception is the public which reads the paper. As for the channel of transmission, this is the newspaper itself, or, more pre-

*"The Photographic Message" from IMAGE/MUSIC/TEXT by Roland Barthes, translated by Stephen Heath. Translation copyright © 1977 by Stephen Heath. Reprinted by permission of Hill and Wang, a division of Farrar, Straus & Giroux, Inc.

cisely, a complex of concurrent messages with the photograph as centre and surrounds constituted by the text, the title, the caption, and the lay-out and, in a more abstract but no less "informative" way, but the very name of the paper (this name represents a knowledge that can heavily orientate the reading of the message strictly speaking: a photograph can change its meaning as it passes from the very conservative *L'Aurore* to the communist *L'Humanité*). These observations are not without their importance, for it can readily be seen that in the case of the press photograph the three traditional parts of the message do not call for the same method of investigation. The emission and the reception of the message both lie within the field of sociology: it is a matter of studying human groups, of defining motives and attitudes, and of trying to link the behavior of these groups to the social totality of which they are a part. For the message itself, however, the method is inevitably different: whatever the origin and the destination of the message, the photograph is not simply a product or a channel but also an object endowed with a structural autonomy. Without in any way intending to divorce this object from its use, it is necessary to provide for a specific method prior to sociological analysis and which can only be the immanent analysis of the unique structure that a photograph constitutes.

"Naturally, even from the perspective of a purely immanent analysis, the structure of the photograph is not an isolated structure; it is in communication with at least one other structure, namely the text—title, caption, or article—accompanying every press photograph. The totality of the information is thus carried by two different structures (one of which is linguistic). These two structures are cooperative but, since their units are heterogeneous, necessarily remain separate from one another: here (in the text) the substance of the message is made up of words; there (in the photograph) of lines, surfaces, shades. Moreover, the two structures of the message each occupy their own defined spaces, these being contiguous but not "homogenized," as they are for example in the rebus which fuses words and images in a single line of reading. Hence, although a press photograph is never without a written commentary, the analysis must first of all bear on each separate structure; it is only when the study of each structure has been exhaused that it will be possible to understand the manner in which they complement one another. Of the two structures, one is already familiar, that of language (but not, it is true, that of the "literature" formed by the language-use of the newspaper; an enormous amount of work is still to be done in this connection), while almost nothing is known about the other, that of the photograph. What follows will be limited to the definition of the initial difficulties in providing a structural analysis of the photographic message.

The Photographic Paradox

"What is the content of the photographic message? What does the photograph transmit? By definition, the scene itself, the literal reality. From the object to its image there is of course a reduction—in proportion, perspective, color—but at no time is this

reduction a *transformation* (in the mathematical sense of the term). In order to move from the reality to its photograph it is in no way necessary to divide up this reality into units and to constitute these units as signs, substantially different from the object they communicate; there is no necessity to set up a relay, that is to say a code, between the object and its image. Certainly the image is not the reality but at least it is its perfect *analogon* and it is exactly this analogical perfection which, to common sense, defines the photograph. Thus can be seen the special status of the photographic image: *it is a message without a code,* from which proposition an important corollary must immediately be drawn: the photographic message is a continuous message.

"Are there other messages without a code? At first sight, yes: precisely the whole range of analogical reproductions of reality—drawings, paintings, cinema, theater. In fact, however, each of those messages develops in an immediate and obvious way a supplementary message, in addition to the analogical content itself (scene, object, landscape), which is what is commonly called the *style* of the reproduction; second meaning, whose signifier is a certain "treatment" of the image (result of the action of the creator) and whose signified, whether aesthetic or ideological, refers to a certain "culture" of the society receiving the message. In short, all these "imitative" arts comprise two messages: a *denoted* message, which is the *analogon* itself, and a *connoted* message, which is the manner in which the society to a certain extent communicates what it thinks of it. This duality of messages is evident in all reproductions other than photographic ones: there is no drawing, no matter how exact, whose very exactitude is not turned into a style (the style of "verism"); no filmed scene whose objectivity is not finally read as the very sign of objectivity. Here again, the study of those connoted messages has still to be carried out (in particular it has to be decided whether what is called a work of art can be reduced to a system of significations); one can only anticipate that for all these imitative arts—when common—the code of the connoted system is very likely constituted either by a universal symbolic order or by a period rhetoric; in short by a stock of stereotypes (schemes, colours, graphisms, gestures, expressions, arrangements of elements).

"When we come to the photograph, however, we find in principle nothing of the kind, at any rate as regards the press photograph (which is never an "artistic" photograph). The photograph professing to be a mechanical analogue of reality, its first-order message in some sort completely fills its substance and leaves no place for the development of a second-order message. Of all the structures of information[1], the photograph appears as the only one that is exclusively constituted and occupied by a "denoted" message, a message which totally exhausts its mode of existence. In front of a photograph, the feeling of "denotation," or, if one prefers, of analogical plenitude, is so

1. It is a question, of course, of "cultural" or culturalized structures, not of operational structures. Mathematics, for example, constitutes a denoted structure without any connotation at all; should mass society seize on it, however, setting out for instance an algebraic formula in an article on Einstein, this originally purely mathematical message now takes on a very heavy connotation, since it *signifies* science.

great that the description of a photograph is literally impossible; *to describe* consists precisely in joining to the denoted message a relay or second-order message derived from a code which is that of language and constituting in relation to the photographic analogue, however much care one takes to be exact, a connotation: to describe is thus not simply to be imprecise or incomplete, it is to change structures, to signify something different from what is shown.[2]

"This purely "denotative" status of the photograph, the perfection and plenitude of its analogy, in short its "objectivity," has every chance of being mythical. (these are the characteristics that common sense attributes to the photograph). In actual fact, there is a strong probability (and this will be a working hypothesis) that the photographic message too—at least in the press—is connoted. Connotation is not necessarily immediately graspable at the level of the message itself (it is, one could say, at once invisible and active, clear and implicit) but it can already be inferred from certain phenomena which occur at the levels of the production and reception of the message: on the one hand, the press photograph is an object that has been worked on, chosen, composed, constructed, treated according to professional, aesthetic or ideological norms which are so many factors of connotation; while on the other, this same photograph is not only perceived, received, it is *read,* connected more or less consciously by the public that consumes it to a traditional stock of signs. Since every sign supposes a code, it is this code (of connotation) that one should try to establish. The photographic paradox can then be seen as the co-existence of two messages, the one without a code (the photographic analogue), the other with a code (the "art," or the treatment, or the "writing," or the rhetoric, of the photograph); structurally, the paradox is clearly not the collusion of a denoted message and a connoted message (which is the—probably inevitable—status of all the forms of mass communication), it is that here the connoted (or coded) message develops on the basis of a message *without a code.* This structural paradox coincides with an ethical paradox: when one wants to be "neutral," "objective," one strives to copy reality meticulously, as though the analogical were a factor of resistance against the investment of values (such at least is the definition of aesthetic "realism"); how then can the photograph be at once "objective" and "invested," natural and cultural? It is through an understanding of the mode of imbrication of denoted and connoted messages that it may one day be possible to reply to that question."

2. The description of a drawing is easier, involving, finally, the description of a structure that is already connoted, fashioned with a *coded* signification in view. It is for this reason, perhaps that psychological texts use a great many drawings and very few photographs.

From "A Series of Proposals." (1978)
*Janet Malcolm**

"Fashion photography can be likened to some of the more inflexibly formal poetic modes, such as the villanelle and the sestina. The fashion photographer's givens of dress, model, and magazine format are comparable to the villanelle's procrustean rhymes, the sestina's ineluctable endings. The task is do it correctly but not show the strain; rare masterpieces do not even reveal the form at first reading or first viewing. [Richard] Avedon's earliest fashion pictures reflect the tension and joy of the gifted beginner in love with the form and not yet sure, deep down, that he can do it. Consequently, each early picture has about it a kind of shimmer of extraness, like that of an A paper crying out for an A-plus because so much more was done than required. When Avedon entered fashion photography, after the Second World War (he had learned the rudiments of photography in the merchant marine), it had just passed through a Great Period, whose masters Dahl-Wolfe, Hoynigen-Huené, Munkacsi, Steichen, Beaton—have yet to be surpassed. The pictures that Avedon took in Paris for *Harper's Bazaar* between 1947 and 1957 are at once a serene celebration of the conventions of the master fashion photographs of the thirties and an anxious quest for new metaphors. His shrewd recognition of the fact that to join the ranks of the masters he must do more than imitate them drove him to lengths of artifice that fashion photography had hitherto not seen. . . .

"The culminating photograph of this first decade of Avedon's career (which occupies the first two rooms of the exhibition and breaks up loosely into the initial we-try-harder period and an easier and more assured later period) is of the delicately beautiful model Dovima in a long black evening dress, her head in uptilted profile, one hip thrust to the side, a small satin-slippered foot pointing forward, and one hand gently resting on the upward-coiling trunk of an elephant that is walking toward the viewer, while the other hand is held out in an imperious, straight-armed gesture of dismissal, which a second elephant seems to be heeding as he walks out of the picture. . . . Although you "know" that the elephant picture is a posed fashion photograph, on another level you don't know. You simply accept. . . .

"The third room, representing work of the early sixties, is joltingly different from the previous ones. . . . He is no longer valiantly tussling with the confines of the medium, using them (as poets use regular rhyme and meter) to plumb his unconscious and shape his invention. In fact, he is no longer playing the game. Having won it, he petulantly pushes over the pieces. Having mastered the art of fashion photography, he proceeds to savage it. . . . They are stylized, strident, brutal, bitter. There are no more backgrounds. The models who exuberantly ran down the Champs-Éleysées now

prance and leer in the white void of Avedon's studio and don't even pretend to be doing anything but making money or, in the case of the celebrities who then began lending themselves to fashion pictures, getting free publicity. . . . One of the most chilling of them looks like a triple-mirror image of a running, gesticulating, falsely smiling woman dressed in a plaid suit and a turban; it turns out to be a picture of three *different* women, wearing the same dress and turban and smile. Avedon has taken the fabled awful moment when you come to a party and someone is wearing your dress, and contemptuously shrugged: "What's the difference? The clothes are all alike. The women are all alike. It simply isn't interesting". . . . An even more misanthropic note is struck in the pictures where Avedon has brought crowds of "real" people to the studio to serve as background for fashion models . . . these supers (the personnel of the house of Dior, members of the French press, for example) are of unvarying unattractiveness—fatness or scrawniness, slack-jawed dullness, pitiful agedness . . . the idea is not to bring the models' beauty into relief but to point up its artificiality and vapid unreality. The idea works so well it's a wonder that the "real" people didn't sue Avedon, and that his employers didn't fire him. . . .

"In the late sixties, evidently refreshed by his bout of bad temper and caddishness, Avedon sets up the pieces again, and commences to play the game with a brilliance and an inventiveness that surpass even his own early achievement. The dazzling motion studies of this period bring to mind the distortion nudes of André Kertesz. Avedon takes the materials of a fashion assignment—model, dress, hairdo, shoes—and creates abstractions from them that bring something new to photography. Neither the illusion of the first period not the disillusion of the second period is present in these photographs: they are "about" nothing but themselves. . . . Avedon's years of putting clothes on models and observing what happens when they move—his long enforced preoccupation with the relationship of body and garment—were a preparation for these eloquent studies of flesh and bone and muscle and fabric in motion. They are a kind of dance photography, and, perhaps precisely because they are not pictures of real dancers doing real dances, they come closer than any other photographs have come to solving the impossible, *koan*-like problem of the genre: how to show movement in a *still* medium, how to describe motion by arresting it. . . .

"In addition to the motion studies and some Westonesque still abstractions (a foot encased in an archaic gold slipper with a wool tassel; a torso in an unbuttoned black beach garment showing a gleaming upturned breast), the fourth room offers a number of large, handsome portraits of young countercultural celebrities like Joan Baez and Janis Joplin. These idealized blowups—a reversion to the romanticism of Avedon's earliest period—cast light on the idolatry of youth which middle-aged liberals were seized by during the Vietnam years. They are social documents of a sort: a hundred years from now, someone many want to know what the term "radical chic" meant, and these pictures will tell him.

"Entering the final room, one feels the kind of abrupt hush that a cathedral imposes on the person entering its awesome vaulted vastness from the small-scale bustle

of the street. The room is hung with seven colossal portraits of women, nine feet high and six feet across, which flap loose from the walls, too large to fit a frame. The subjects are of varying ages and physical types, and—with one exception, the writer Renata Adler—are unknown. They are photographed in the "straight," direct, daylit, passport-photo style that Avedon exhibited at the Marlborough Gallery in 1975 and published the following year in his book *Portraits*. . . . What are they doing in a show of fashion photographs? Is Avedon once again recoiling from the meretriciousness of fashion, meanly contrasting the vacuousness of fashion-model attractiveness with the deep human beauty of "real" women? Yes, of course he is doing that—but he is doing something else as well. The anonymity of the portraits offers a clue to their fuller meaning. . . . The size of these portraits is not incidental but intrinsic—an essential stylistic property. The portrait of Loulou de la Falaise illustrates with special lucidity the significance of scale in Avedon's recent portraits (Fig. 4.2). The subject looks like an escapee from the Warhol Factory, with her punk outfit of gleaming black leather jacket, baggy trousers and shirt, rhinestone earrings, dark makeup, and mordant Marlene Dietrich smile. One is not altogether sure that this person is a woman. What "she" may be smiling about may be the success of "her" impersonation. What the picture itself mocks is the labor and pretensions of Photo-Realist painting. . . . This whole late style of portraiture, with its built-in intention of gallery exhibition, represents Avedon's flight from the confines of fashion-magazine photography to the larger spaces and ambitions of the art world—Photo-Realism having provided both the sanction and a satiric occasion. . . .

"Avedon strips away photography's pretension to being an art and a craft, saying that it is nothing but an idea, a series of proposals about picture taking. The show at the Met illustrates this idea of photography as a *mental* medium, more like math and chess than like painting and drawing, and triumphantly "proves" it. . . . With the Met portraits, Avedon continues the work that commenced with the great, unbearable studies of his dying father (shown at MOMA in 1974), about which there is "nothing personal" (to borrow the telling title of Avedon's second collection of photographs), and in whose implacable objectivity lies a description of photography as well as our common fate."

"Sights and Sounds." (1971)
Stanley Cavell*

"... Erwin Panofsky puts it this way: The medium of the movies is physical reality as such." André Bazin emphasizes essentially this idea many times in many ways: at one point he says, "Cinema is committed to communicate only by way of

*Stanley Cavell. *The World Viewed.* New York: The Viking Press, 1971, pp. 16–22.

Figure 4.2 Photograph by Richard Avedon.
Loulou de la Falaise, fashion consultant. Paris, December 1977.
Gelatin-silver print. © 1978 Richard Avedon. All rights reserved.

what is real". . . . What Panofsky and Bazin have in mind is that the basis of the medium of movies is photographic, and that a photograph is *of* reality or nature. If to this we add that the medium is one in which the photographic image is projected and gathered on a screen, our question becomes: What happens to reality when it is projected and screened?

"That it is reality that we have to deal with, or some mode of depicting it, finds surprising confirmation in the ways movies are remembered, and misremembered. It is tempting to suppose that movies are hard to remember the way dreams are, and that is not a bad analogy. . . . But, unlike dreams, other people can help you remember, indeed are often indispensable to the enterprise of remembering. . . .

"It may seem that this starting point—the projection of reality—begs the question of the medium of film, because movies, and writing about movies, have from their beginnings also recognized that film can depict the fantastic as readily as the natural. What is true about that idea is not denied in speaking of movies as "communicating by way of what is real": the displacement of objects and persons from their natural sequences and locales is itself any acknowledgement of the physicality of their existence. It is as if, for all their insistence on the the newness of the medium, the antirealist theorists could not shake the idea that it was essentially a form of painting, for it was painting which had visually repudiated—anyway, foregone—the representation of reality. This would have helped them neglect the differences between representation and projection. But an immediate fact about the medium of the photograph (still or in motion) is that it is not painting. (An immediate fact about the *history* of photography is that this was not at first obvious.)

"What does this mean—not painting? A photograph does not present us with "likenesses" of things; it presents us, we want to say, with the things themselves. But wanting to say that may well make us ontologically restless . . . [it] sounds, and ought to sound, false or paradoxical. Obviously a photograph of an earthquake, or of Garbo, is not an earthquake happening (fortunately), or Garbo in the flesh (unfortunately). But this is not very informative. And, moreover, it is no less paradoxical or false to hold up a photograph of Garbo and say, "That is not Garbo," if all you mean is that the object you are holding up is not a human creature. Such troubles in notating so obvious a fact suggest that we do not know what a photograph is. . . . We might say that we don't know how to think of the *connection* between a photograph and what it is a photograph of. The image is not a likeness; it is not exactly a replica, or a relic, or a shadow, or an apparition either, though all of these natural candidates share a striking feature with photographs—an aura or history of magic surrounding them.

". . . The problem is not that photographs are not visual copies of objects, or that objects can't be visually copied. The problem is that even if a photograph were a copy of an object, so to speak, it would not bear the relation to its object that a recording bears to the sound it copies. We said that the record reproduces its sound, but we cannot say that the photograph reproduces a sight (or a look, or an appearance). It can seem that language is missing a word at this place. Well, you can always invent a word.

But one doesn't know what to pin the word *on* here. . . . Nor will the epistemologist's "sense-data" or "surfaces" provide correct descriptions here. For we are not going to say that photographs provide us with the sense-data of the objects they contain, because if the sense-data of photographs were the same as the sense-data of the objects they contain, we couldn't tell a photograph of an object from the object itself. To say that a photograph is of the surfaces of objects suggests that it emphasizes texture. What is missing is not a word, but, so to speak, something in nature—the fact that objects don't *make* sights or *have* sights [in the way in which they can make or have sounds]. . . .

"Photographs are not *hand*-made; they are manufactured. And what is manufactured is an image of the world. The inescapable fact of mechanism or automatism in the making of the images is the feature Bazin points to as "(satisfying), once and for all and in its very essence, our obsession with realism."

"It is essential to get to the right depth of this fact of automatism. It is, for example, misleading to say, as Bazin does, that "photography has freed the plastic arts from their obsession with likeness," for this makes it seem (and it often does look) as if photography and painting were in competition, or that painting had wanted something that photography broke in and satisfied. So far as photography satisfied a wish, it satisfied a wish not confined to painters, but the human wish, intensifying in the West since the Reformation, to escape subjectivity and metaphysical isolation—a wish for power to reach this world, having for so long tried, at last hopelessly, to manifest fidelity to another. And painting was not "freed"—and not by photography—from its obsession with likeness. . . .

"And if what is meant is that photography freed painting from the idea that a painting had to be a picture (that is, *of* or *about* something else), that is also not true. Painting did not free itself, did not force itself to maintain itself apart, from *all* objective reference until long after the establishment of photography; and then not because it finally dawned on painters that paintings were not pictures. . . .

"Photography overcame subjectivity in a way undreamed of by painting, a way that could not satisfy painting, one which does not so much defeat the act of painting as escape it altogether: by *automatism,* by removing the human agent from the task of reproduction.

"One could accordingly say that photography was never in competition with painting. What happened was that at some point the quest for visual reality, or the "memory of the present" (as Baudelaire put it), split apart. To maintain conviction in our connection with reality, to maintain our presentness, painting accepts the recession of the world. Photography maintains the presentness of the world by accepting our absence from it. The reality in a photograph is present to me while I am not present to it; and a world I know, and see, but to which I am nevertheless not present (through no fault of my subjectivity), is a world past."

"Photograph and Screen." (1971)
*Stanley Cavell**

"Let us notice the specific sense in which photographs are of the world, of reality as a whole. You can always ask, pointing to an object in a photograph—a building, say—what lies behind it, totally obscured by it. This only accidentally makes sense when asked of an object in a painting. You can always ask, of an area photographed, what lies adjacent to that area, beyond the frame. This generally makes no sense asked of a painting. You can ask these questions of objects in photographs because they have answers in reality. . . . We might say: A painting *is* a world; a photograph is *of* the world. What happens in a photograph is that *it* comes to an end. A photograph is cropped, not necessarily by a paper cutter or by masking, but by the camera itself. The camera crops it by predetermining the amount of view it will accept; cutting, masking, enlarging, predetermine the amount after the fact. . . . The camera, being finite, crops a portion from an indefinitely larger field . . . in principle, it could all be taken. Hence objects in photographs that run past the edge do not feel cut; they are aimed at, shot, stopped live. When a photograph is cropped, the rest of the world is cut *out*. The implied presence of the rest of the world, and its explicit rejection, are as essential in the experience of a photograph as what it explicitly presents. A camera is an opening in a box: that is the best emblem of the fact that a camera holding on an object is holding the rest of the world away. The camera has been praised for extending the senses; it may, as the world goes, deserve more praise for confining them, leaving room for thought. . . ."

"Two Roads, One Destination." (1980)
*Janet Malcolm***

"Photography went modernist not, as has been supposed, when it began to imitate modern abstract art but when it began to study snapshots. . . . In the artless relics of picnics past—in the images of squinting children, of faces distorted by eating or hollering, of badly fitting clothes, improbable gestures, impossible movements—the avant-garde photographer finds ready-made the self-reflexive style that the modernist painter had to invent. Robert Frank, the Manet of the New Photography, scrupulously shed all the pictorial values of his predecessors—composition, design, tonal balance,

*Stanley Cavell. *The World Viewed*. New York: The Viking Press, 1971, pp. 23–24.

**From *Diana and Nikon* by Janet Malcolm. Boston: David R. Godine. 1980, pp. 113–130. Copyright © 1980 by Janet Malcolm. Reprinted by permission of The Wylie Agency, Inc.

print quality—and produced pictures that look as if a kid had taken them while eating a Popsicle and then had them developed and printed at the drugstore. In *The Americans,* Frank showed photography at its most nakedly photographic. Permitting the camera what no art photographer had ever hitherto let it get away with—all the accidents of light, the messy conjunctions of shape, the randomness of the framing, the disorderliness of the composition, the arbitrariness of gesture and expression, the blurriness and graininess of the printing—he showed America at its most depressing and pathetic. However, Frank has been overvalued as a social critic and undervalued as a photographic innovator, for what he revealed was something not about America but about photography. Taking his cue from the snapshot, he grasped that the camera is equipped as no other medium is to show us things in their worst possible aspect. . . . Frank was hardly the first person to point out that our consumer society is vacuous and chaotic, but he was the first photographer to make a virtue out of—indeed, erect a style on—the fundamentally vacuous and chaotic appearance of photography.

"Followers of Frank continued the movement away from the meretriciously "beautiful" photographs of the past. Simply by going with the camera instead of against it, they produced a body of work that looked as different from the photography of the past as Action Painting did from its predecessors. That this photography emerged shortly after the emergence of Action Painting is itself yet another indication of the close (if often secret) watch that photography keeps on developments in painting. . . . Thus [Garry] Winogrand, Lee Friedlander, Emmet Gowin, Henry Wessel Jr., Mark Cohen, Bill Owens, and other "action" photographers followed people on the street, peered into suburban living rooms, hung around fast-food chains, and—with nothing in mind, with none of the elaborate previsualizations of traditional art photography—repeatedly clicked the shutters of their small cameras. . . . The emergence of this school of photography just at the time when the medium was entering a period of unprecedented critical attention and commercial exploitation created a complicated situation. It drove certain photographers, critics, publishers, and collectors, who had hitherto serenely considered themselves aesthetically advanced, into an uncomfortably retrograde position. These were the people who had worked for the acceptance of photography as an artistic medium, denying its mechanical nature and stressing its affinities with traditional art. From their point of view, the messy pictures of Winogrand and the others were an affront: photography had finally proved itself—was in its highest efflorescence of art and craftsmanship—and along came these guys to call the whole game off. What was even more galling to the traditionalists was that these radicals, these impudent prickers of photography's pretensions, became overnight stars of the art establishment. John Szarkowski's photography department at the Museum of Modern Art fawned over them, the Guggenheim Foundation showered grants on them like confetti, universities hired them, the Light Gallery provided a permanent *salon des acceptés.* The recognition that modernist painters and sculptors (not to say photographers) had had to fight for was picked up like a welfare check by the post-modernist photographer. At the same time, the traditional pictorial photograph (boring though it

was to Szarkowski) became one of the hottest commodities on the art market. . . . Never in the history of photography have photographs sold as they have sold in the past decade—photographs of the past, that is, and of the Stieglitz—Strand—Weston derived present. Pictures but the Winogrand school never sold, or even became known outside the academy. . . .

"Something unexpected is beginning to emerge from this polarization. As each side digs out its position—the avant-garde going deeper and deeper into its examination of the photographic, the old guard into the making of medium-transcending beautiful forms—the gap between them seems to be *narrowing* rather than widening. Two exhibitions in New York illustrated this paradox with special lucidity. One was a show of color photographs by the young avant-gardist Eve Sonneman, as Castelli Uptown, and the other was a show, also of color work, by the renowned master formalist Harry Callahan, at the Light Gallery. Sonneman takes one of the most radical and mordant attitudes toward photography on record. By the simple device of showing pictures in pairs—two slightly different or vastly different views of the same subject, set in a single frame—she attacks what even the most belligerent of the Winogrand school accepted as a core concept; namely, that there is such a thing as *the* picture of something. With her pairings, Sonneman argues that there is only *a* picture—that any photograph taken is inevitably arbitrary. . . .

"The sense of paradox within the Sonneman pairs is accompanied by an external paradox: each member of the pair devaluates and discredits photographic values of the other, but together the two become something more that a critique of photography—they form *an object.* Singly, Sonneman's pictures are without interest; conjointly, they are respectable works of avant-garde art. . . . They follow what seems to be an invariable principle of avant-garde art: if a critique of art (or even a statement of anti-art) is made honestly, fiercely, disinterestedly, and cleverly enough, it begins to partake of the appearance of art. Duchamp's found objects first established this peculiar principle. An equally peculiar corollary is that when imitators come along and cynically and mindlessly copy the original—sometimes without even grasping its intellectual point—the result still looks like art. Harry Callahan has produced some of the purest and most austere abstract photography of our time. His career is one of those monuments to dedication and work and care and belief in self that command respect even where they do not induce love. His spare abstractions . . . all have established his reputation in modern-art circles and reflect his connection with the painterly tradition of photography. . . . Callahan's photographs are stylistically of a piece, marked by a kind of exquisite dryness, a quietness and evenness of tone, and a quality of muted restraint, almost grudgingness. He is a sort of harpsichordist of the camera; with a few exceptions . . . his pictures do not leap out at the viewer and demand attention. His work is hard to respond to, the way a quiet, drab-looking person at a party is hard to go up and talk to. . . .

"Callahan's show at Light Gallery, of photographs of frame houses in Providence (houses that he had already photographed in 1963), was marked by a characteristic for-

malism, deliberation, and single-mindeness, and by a typical continuing obsession with a subject. But, uncharacteristically, the pictures were in color. I think it was this "vulgar" touch, this concession to the childish (human) craving for pleasure, that broke down my resistance to Callahan and permitted me to experience one of those rare moments of aesthetic joy (akin to the well-being one actively feels on recovering from an illness) that arrive when one is suddenly able to appreciate, understand, and enjoy what has hitherto been thwarting, boring, off-putting.

"The pictures are portraits. . . . They exude a [Edward] Hopper-like sense of the loneliness and emptiness of such places . . . of the small-town willingness to accept the wistfulness and unfulfillment that underlie provincial peace and security. . . . Another element must be considered in accounting for the immense power and presence of these pictures of Callahan's. It is that they were taken with a wide-angle lens, which has great depth of field and produces a profound distortion . . . their perspective is strange, and the houses loom and threaten, as if they had been taken from the vantage of a recumbent drunk. . . . Callahan uses a mechanical limitation as a stylistic expression: what Hopper achieved with drawing, Callahan achieves with optical laws. . . . And in this he is doing conspicuously what other painterly photographers—Weston, Strand, Evans, Kertész—have done more covertly. For if you scratch a great photograph you find two things: a painting *and* a photograph. It is the photographic means with which photography imitates painting that produce a photograph's uniqueness and aliveness."

"Introduction to *The New Topographics*." (1975)
*William Jenkins**

"There is little doubt that the problem at the center of this exhibition is one of style. It should therefore be stated at the outset that while this introduction will concern itself with the exhibition as a stylistic event, the actual photographs are far richer in meaning and scope than the simple making of an esthetic point. . . .

"This point is made first because the stylistic context within which all of the work in the exhibition has been made is so coherent and so apparent that it appears to be the most significant aspect of the photographs. It would seem logical to regard these pictures as the current manifestations of a picture-making attitude that began in the early nineteen sixties with Edward Ruscha. His books of photographs (*Twentysix Gasoline*

*From *Introduction to The New Topographics*. George Eastman House, 1975. Reprinted in *Reading Into Photography,* ed. Thomas F. Barrow et al. Albuquerque: University of New Mexico Press, 1982, pp 51–56. © Bill Jenkins.

Stations [1962], *Some Los Angeles Apartments* [1965], and others) possessed at once the qualities of rigorous purity, deadpan humor, and a casual disregard for the importance of the images which even permitted the use of photographs not made by Ruscha himself. The pictures were stripped of any artistic frills and reduced to an essentially topographic state, conveying substantial amounts of visual information but eschewing entirely the aspects of beauty, emotion, and opinion. . . .

"There is an obvious visual link between Ruscha's work and the pictures shown here. Both function with a minimum of inflection in the sense that the photographers' influence on the look of the subject is minimal. . . . That is, rather than the picture having been created by the frame, there is a sense of the frame having been laid on an existing scene without interpreting it very much . . . picturing, almost without exception, man-made structures with larger contexts such as landscapes.

"Yet there remains an essential and significant difference between Ruscha's *Twentysix Gasoline Stations* and, as an example, John Schott's undetermined number of motels along Route 66. The nature of this difference is found in an understanding of the difference between what a picture is *of* and what it is *about*. . . . I have deliberately chosen to belabor the Ruscha issue because the distinction, though elusive, is fundamental to photography. The two distinct and often separate entities of actual, physical subject matter and conceptual of referential subject matter can be made to coincide. It is this coincidence—the making of a photograph which is primarily *about* that which is in front of the lens—that is the central factor in the making of a document. . . .

"The word topography is in general use today in connection with the making of maps or with land as described by maps and it does not unduly stretch the imagination to see all photographs as maps of a sort. But for the sake of clarity a return to the original meaning may be helpful: "The detailed and accurate description of a particular place, city, town district, state, parish or tract of land." The important word is *description* for although photography is thought to do many things to and for its subjects, what it does first and best is describe them.

"Unfortunately, the simple descriptive function of the photographic image is linked to other, more complex issues. . . . Such concerns stemmed from a recognition that it is precisely photography's pretense of truthfulness, its assertion of accuracy that gives it the ability to mislead so effectively. The issue was not that photographs are inherently untruthful, but that the relationship between a subject and a picture of that subject is extremely fragile. The simple task of describing something photographically requires that this delicate coherence be preserved. . . .

"If then, as Lewis Baltz suggests, the photograph needs to appear without author in order to function well and maintain veracity, what has become of style? When Timothy O'Sullivan photographed the American West he was working without precedent. Many of this subjects had never been photographed and he was working in a medium which had virtually no past. It would therefore be possible to conclude that O'Sullivan and other photographers of the early and mid-nineteenth century neither embraced nor rejected any existing photographic style or esthetic: that they had no style. (Even this is questionable since they were subject to varying degrees of visual prescription from

painting.) It is, however, impossible to imagine the photographers in this exhibition working in a critical and historical vacuum. To recognize one's antecedents (as Robert Adams has done) and to elect to make pictures that look a certain way is a stylistic decision, even if the effort is to subdue the intrusion of style in the picture. . . .

"It must be made clear that "New Topographics" is not an attempt to validate one category of pictures to the exclusion of others. As individuals the photographers take great pains to prevent the slightest trace of judgement or opinion from entering their work. . . . This viewpoint, which extends throughout the exhibition, is anthropological rather than critical, scientific rather than artistic. The exhibition, as an entity separate from the photographers, will hopefully carry the same non-judgemental connotation as the pictures which comprise it. If "New Topographics" has a central purpose it is simply to postulate, at least for the time being, what it means to make a documentary photograph."

"Lee Friedlander's Guarded Strategies." (1975)
*Martha Rosler**

"Lee Friedlander's photos are in a sense exemplary. Their cool, gentle disdain places them at a crossing point between photography and high art, where meaning can be made to shift and vanish before our eyes. In 1967, when The Museum of Modern Art showed photos of Diane Arbus, Garry Winogrand, and Friedlander, the exhibit was called "New Documents"; at the recent MOMA exhibit of 50 of Friedlander's photos curator John Szarkowski termed the photos "false documents." Szarkowski's rhetoric about Friedlander has undergone the corresponding shift from asserting that the work represents a kind of device for improving our vision of the commonplace to asserting that it represents the outcome of personal "hedonism" while stemming nonetheless from "an uncompromisingly aesthetic commitment." The overriding assertion now is that Friedlander's concern is both "disinterested" and "artistic," and the corollary disclaimer is about instrumentality. That is, the work is firmly claimed as part of art tradition and distinguished by the documentary photography of the '30s and earlier, which was meant to "change the world" . . .

"Friedlander's work provides some of the first and best examples of what has become a widespread approach to photography. It was part of the general reorientation of American Art during the '60s. Within photography his work violated the dominant formal canons not by inattention but by systematic negation. High-art photography had had a tradition of being directed, by and large, toward some "universal" message. It

**Artforum*, vol. 13: no. 8. (April 1975), pp. 46–53.

had aimed to signify a "transcendental" statement through subtraction or rationalized arrangement of elements within the photographed space, dramatic lighting, expressive intensity of glance or gesture, exotic or culturally loaded subjects, and so on. If Friedlander uses these devices, only to subvert them, to expose their arbitrariness. But in shifting the direction of art photography, Friedlander has not rejected a transcendental aim—nor has he specifically embraced one. Instead his attention is on the continuum whose poles are formalist photography at one end and transparent, or information-carrying, photography at the other. Imagine a mapping system for photographic messages: the continuum formal versus transparent is at right angles to the continuum transcendent versus literal. . . . Without insisting on this device we can observe that even if an artist locates his work near the formal end of the one continuum, his messages no matter how commonplace or vernacular, are still free to wander anywhere along the other, from literalness to transcendence.

"In moving toward "vernacular" photo images, photography has had to confront some of the issues behind Realism, such as whether a photograph is in any sense a document and, if so, what kind. Is it "about" what it shows concretely, metaphorically, representatively, allegorically? Does it refer to a moment alone? If so, how long a moment? Does it reveal only that moment, or does it indicate past and future as well? Or, is a photo a record of sensibility, or is it most specifically about photography itself? These are metacritical questions about the range of messages a photo can convey as well as about how it signals what it signals. These questions are both contentual and formal, and they are all at issue in Friedlander's work.

"The meaning of a photographed instant is pivotal, though the problem is not flamboyantly explored. Among the reasons why it is unwise to compare Friedlander's photos to "snapshots" the most telling may be that they are not commemorations of a moment; once you have seen more than one, his critical concerns clearly emerge. His conscious presence assaults the notion of transparency, breaking our experience of the moment photographed while at the same time alluding to it. Whereas the photos display the look and the subjects of literal and transparent photography, Friedlander's use of these commonplace features shifts their meaning to another place. . . .

"The locus of desired readings is, then, formalist modernism, where the art endeavor explores the specific boundaries and capabilities of the medium, and the iconography, while privately meaningful, is wholly subordinate. Whatever meaning resides in Friedlander's photographs, and it is more than the image management at the Modern has let show, this set of claims allows Friedlander, and the hundreds of young photographers following the same lines, to put forward playfulness and pseudopropositions as their strategy while identifying some set of formal maneuvers as the essential meaning of their work. The transiency or mysteriousness of the relations in their photos suggest the privatization of the photographic act. The result is an idiosyncratic estheticizing of formerly public and instrumental moves.

"Yet the ambiguity of presenting a set of familiar images while simultaneously denying both their exoteric reference and their commonly understood symbolic meaning is problematical in such work, as in Pop Art in general. Friedlander shares with Pop

the habit of converting instrumental uses of a medium into formal and metacritical ones using the techniques and images of naive photography where Pop might use those of graphic art. "Composition," control of pictorial elements, isn't really enough to distinguish work that quotes naive imagery from what is being quoted, especially in photography, where the format and the framing of art and nonart are basically the same. . . . What is required in such work is aggressively conscious, critical intelligence (as opposed to sensibility or expressiveness), signaled by esthetic distancing.

"Friedlander's presentation is exhaustive yet cool, the effect markedly distanced. The voraciousness of a view that yields, in good focus and wide tonal range, every detail in what passes for a perfectly ordinary scene, the often kitschy subject handled in a low-key way, the complete absence of glamour, and the little jokes, these put intelligence and humor where sentiment or anger might have been. Distancing is everywhere evident in the palimpsests of shadow, reflection, and solidity, in the fully detailed, small-town-scapes empty of incident, in the juxtapositions and the carefully composed spatial compressions and sliced reflections that are significant only in a photo (Fig. 4.3). Art-making here entails a removal from temporal events, even though the act of recording requires a physical presence, often duly noted. Friedlander records himself

Figure 4.3 Lee Friedlander.
Kyoto, Japan, 1981.
Gelatin-silver print.
Courtesy Fraenkel Gallery, San
Francisco.

passing through in a car, standing with eye to camera, and so on, in widely separated locations, always a nonparticipant.

"Control is evidenced by Friedlander's hard-headed, patiently systematic formal moves. Most of the issues of painterly "design" within a rectangular format turn up in his photos. There are echoes of analytical Cubism in the deconstruction, crenellation, fragmentation, and other deformations of space and image, and in the look of collage—the (apparent) joining of disparate elements and image fragments—filtered through the attitude toward stylistics, and even in the homeyness of the subjects. When Friedlander breaks the rules of "good" photography, his doing so amounts to an insistence on photography as photography. He accomplishes this by applying a broader set of pictorial conventions. Take the compression of foreground and background fairly common in Friedlander's photos. It violates the tacit rule that a representational photo should suggest space as we perceive it in the world, with any deformations being easily decodable. Friedlander's deformations rarely result from the optics of lenses, which we have learned to cope with. Rather, he arrays the pictorial elements so that they may connect as conceptual units, against our learned habit of decoding the flat image into rationalized space.

"More importantly, spatial compression is a possibility peculiarly inherent in photography, where such junctures can happen accidentally. Friedlander characteristically locates the issue in the domain of control, which he equates with insisted-on consciousness. . . . Friedlander's work may make us think of naive photos that incorporate unwanted elements until we inspect a body of his work, when his habitual choice becomes evident, and chance and accident can be seen to diverge.

"Chance imagery figures in the wider strategy of juxtaposition and collage. Collaging in Friedlander's photos, no matter how it is accomplished, once again points out the nature of photography, its impartial mapping of light-dependent images at a single instant in time. All types of visual phenomena have essentially the same "weight" in a photo, formally speaking—but conceptually that is obviously not true. Friedlander's collages involve not just spatially disjunct imagery but a conceptually based welding of elements of different time scales into a unitary image. He tends to go for the dryly humorous juncture, as in *Knoxville, Tennessee, 1971,* a rather typical naturalistic collage: a perky little cloud seems to sit like cartoon ice cream atop the back side of a leaning "yield" sign whose shadow angles down the unremarkable street. The sign is a long-term, weighty, manufactured element, the shadow is a natural, regularly recurring light-produced image that moves only gradually, and the cloud is a natural, randomly appearing visual element not as substantial as the sign but much more so than the shadow. Clouds, shadows, and signs feature fairly often in Friedlander's iconography, along with clumsy statues and telephone poles, as types of phenomena marked for duration, solidity, provenance, and iconicity. Reflections and mirror images, like shadows, also appear often, and all are, in a sense, proto-photographs. All raise questions about the immediacy and the validity of the photographic document.

". . . In a regionally marked photo, *Los Angeles, 1965* photo cutouts of two im-

placably smiling TV stars, conspicuously taped on a storefront window, are the only clear elements, against ripply reflections of palms, clouds, and cars. It is only the simulacra of people that we see without obstruction and must, on some level, respond to as though they were photos of people, unmediated.

"A photo of a mirror image, like one of a photo, provides no superimposition and so is like a direct photo of the thing mirrored. The importance of the instant is subordinate to the cognitive tension about what is seen and which side of the camera it's on. In some photos, large car-mirror reflections disrupt the unity of the image, turning the photos into diptychs or triptychs. Whether they form part of the ostensible subject, modify it, or subvert it, these images box in the space and provide a "fourth wall." Such closure is accomplished in other photos by an obstructing foreground element. Like the oblivious passerby who ruins a snapshot, these elements obtrude between camera and ostensible subject. The fronted barrier provides a cognitive, not a formal, tension like the annoyance you feel when your theater seat is behind a pole or your view out the car window is blocked by a passing truck. Friedlander's famous shadow or reflection, in virtually every photo in *Self Portrait,* also is a closing element. It is not a stand-in for our presence in the real-world moment referred to by the photo but an appropriation of it. . . .

"Portraiture is extensively undercut; people are opaque. We are kept mostly at arm's length or further. The closer shots at the Modern were party photos in which several people pressed together across the picture plane or formed a shallow concavity. They seem to be ordinary youngish middle-class urban or suburban people—the kind of people who look at photos. Their expressions, although sometimes bizarrely distorted, say more about the effects of flash lighting than about personality or emotion, except the most conventionalized kind. The close-up is a form suggesting psychological encounter, and Friedlander uses it to negate its possibilities. People shown interacting with things often look unwittingly funny, or sometimes peculiarly theatrical, bringing a suggestion of seriousness to the irony of their situation. . . .

". . . It is the photographer, with his prevision of a flat representation, who can present the people as transient self-absorbed entities enclosed in a humanly created space. . . . We assume the photo is synecdochic, intended to convey, if anything, something about people in general, or about some class of people, or about some class of images, or most attenuatedly, about some class of images of images.

"The particular conjoinedness of images can be taken as a witticism rather than as a serious assertion about the real world. Interpretation, if it occurs, is a private task of the viewer's. . . . It is likely that Friedlander doesn't care to decide at what level his photos are to be read. He presents tokens of the type that might be called "significant pseudojunctures"; his images function like the mention rather than the use of a word, noninstrumentally. . . . This metamessage applies as well to photos of people with people, as is fairly clear in the party photos.

"We can't know from a single image what relation the people in it have to one another, let alone whether they communicate or what they did before or after. . . . The

general lack of such personal markers as foreignness, poverty, age, and disability allows Friedlander an unbounded irresponsibility toward the people he photographs. His refusal to play psychologizing voyeur by suggesting that a photo can reveal some inner or essential truth about an individual or a stereotyped Other is admirable. . . . Friedlander has laid vigorous claim to control over his camerawork but has omitted any active claim to control over reading. His work can be taken by casual viewers as value-free sociology and, because of his denial of photographic transparency, as artful construction for photography buffs.

"Friedlander's work has antecedents in the small-camera photography and street photography of such people as Eugène Atget and Walker Evans, to mention only two, but both Atget and Evans appear serious where Friedlander may seem clever, light, or even sophomoric. Atget and Evans photographed people of various classes, in their work, and out. They cannot be accused of making their subjects the butt of jokes, whereas Friedlander does so almost always, though not the savagely involved ones of Arbus or Robert Frank. For both Atget and Evans, photography's ability to convey hard information was not much in doubt.

". . . Evans, like Friedlander, is not psychologistic, but his photos are seated much more firmly in their social context; even his captions are more informative: *Coal Dock Worker, 1932* and *Birmingham Steel Mill and Workers' Houses, 1936* are more than the bare bones of place and year. Evans, too, used collage, including in a photo both "positive" and "negative" cultural elements: heroic statues and clean streets meeting up with prosaic power lines, icons denoting beauty or sleek commercial messages embedded in degraded human environments, people in rags lying in front of stores. Like Evans's collages, Friedlander's may preserve the impression of simple recording and mass-produced iconography at the same time as exquisite awareness of both formal niceties and telling juxtapositions. But Friedlander's collages, hung on chance and ephemera, are not consciously invested with social meaning and may or may not aspire to universal import. . . . In Evans's photos the directed message of the haves imposed on the have-nots is solidified and naturalized in Friedlander's. The have-nots have disappeared.

"In Friedlander's books Friedlander comes across as a have-not himself—significantly, though, one psychosocially rather than socioeconomically defined—a solitary guy who slipped around with a camera in a crazy-clockwork world, fantasizing with mock voyeurism about sleazily sexual targets while never forgetting the meaning of a photo. . . . Friedlander has shown us a sanitized if unglamorous but uniformly middle-class world. His human presence has been submerged under his professionalism, and nothing is serious but the photographic surface—he is approaching the status of classic in his genre. Minute detail in these photos does not add up to a definitive grasp of a situation or event; it would be an ironically false presumption to suppose we can infer from the photo something important about the part of the world depicted in it. Yet making connections is an ineradicable human habit, and the metamessage of framing is that a significant incident is portrayed within. Looking at his photos, we are in the same sit-

uation as Little Red Riding Hood when she saw dear old Grandma but noticed some wolflike features and became confused. Our pleasant little visit has some suggestion of a more significant encounter, but we don't have enough information to check. The level of import of Friedlander's work is open to question and can be read anywhere from photo funnies to metaphysical dismay."

"Photography: The Coming to Age of Color." (1975)
Max Kozloff*

"Can anyone remember the first time he or she walked into a movie theater and did not expect to see a black-and-white film? That event might date from as early as the Cinerama '50s, or it could have occurred as recently as the last decade, depending on one's frequency of attendance in those dark palaces. But, as a happening, it most likely passed unnoticed. Multigray films, like radio and monophonic recording, were outgrown very gradually when the economic and technical investments necessary to supplant them found their market over a period of time. More important than that—psychologically—the satisfaction of a craving, for the world reproduced cinematically in color, had become such a normal state of affairs, so uneventfully standard, that one no longer remembers very well having grown accustomed to it.

". . . On these terms alone, black-and-white imagery for a movie audience (or, for that matter, a TV audience), lingers on as a primitive situation or a historical phenomenon. Yet, who enters a current show of photographs and anticipates that they shall be in color?

". . . Viewed from the perspective of all the other full-blooded camera media, serious still photography in black-and-white offers a very archaic spectacle. How fascinating and peculiar that it has dominated its field even to such a far-fetched moment as today.

"Were there no social appetite for color or no imaginable realization of accurate hues in photography, we would understand this dominance quite well. Actually, it would not appear to us as proscriptive at all because we would not have any conception that a prohibition is involved. There has simply never been a theory of black-and-white photography any more than there has been a *theory* of English. Everyone assumed a common language, and then went on to specifics. But the intense desire to ground photography in color stems right from its beginnings in the 1820s, when Niepce invented the medium. Time and again, 19th-century researchers were frustrated

Artforum, vol. 13, no. 5 (January 1975), pp. 30–35.

in their inability to find and program a permanent color-sensitive constituent into the photographic emulsion. Practitioners often took to hand-tinting their prints, in emulation of painting only insofar as its chroma remained the sole element that was more informing of the world than what was already available in photography. That color was manually added to an already developed black-and-white base (though in practice, it was sepia or ochre toned) paralleled experiments that led to exposures through colored screens or filters. . . .

"The point remained, though, that as long as they lacked hues, photos reneged on their major premise of recording the world in all its sensory magnitude. Each advance in this area, illusory as it might have been, or faltering and cumbersome as it was, incited delirious hope. When Ducos du Hauron revealed a handsome color view of the French town Angoulême in 1877, when the Lumière brothers brought out their Autochromes in 1907, they were applauded. The introduction of dye transfers onto the plate or film, though they required multiple exposures for multiple negatives to produce one, completed color image finally led to composite, layered (dye coupler) emulsions, responsive to the different major light rays simultaneously (Kodachrome, 1935). From that date, any number of positive prints could be made from the reverse color negative, a development that reduced the cost, heightened the ease, improved the fidelity, and expanded the presence of color photographs so as to make them in our day, the premier mode of the camera. In every application of photography to public social use, and for the sheer domestic pleasure they afford, color photographs overmaster our visual sensibility.

"Far from discovering any philosophical impediment to the condition, the great masters of photography wished it well, when they hadn't actually enthused over it. A scholar would have to look far on the horizon to uncover even casual animus against color in the literature. Steichen, Stieglitz, and Weston are on record as having endorsed, and for a while, tried out color. Yet it is as if they and many others whose work has become indelible for us, were artists who knew about the existence of oil, watercolor and acrylic pigments—but they themselves drew. For the length of time, let us say 35 years, that it would have been possible to color imprint the art and the visual history they gave us, that option was not taken. Why was this?

"At best, one lists contributing factors and constructs hypothetical answers. The picture that emerges seems a kind of stew in which laboratory difficulties and working attitudes jostle with the psychology of folklore and the restrictions of the market. In 1938, when Giselle Freund pioneeringly conceived the idea of portraying the notables of her day—Gide, Valéry, Joyce—in color, she was enchanted by the possibilities even as she was aggrieved by the results. Subjects had to wear clothes light in tonality to avoid chronically murky registrations. Romain Rolland's piercing blue eyes, the only specks of chroma in a pasty complexion, turned nondescriptly dark when reproduced in print. With black-and-white photos, the main *structural* problems were of tone and contrast. Color added to them the question of chromatic balance—a whole new domain of often treacherous recessions, weights, and advances that conditioned the thermal environment and deformed the space of the field. These factors, ungratefully hard to con-

trol, produced queasy anticipation of images. Early Kodachromes would show the scarlet bathing suit wearing the woman instead of the other way around. For, some printing dyes had an absorbency that defied modulation by light, while others had hardly enough to declare themselves through light.

"If one looks at the volumes of *U. S. Camera* during the '30s, color makes a desultory, brightening appearance, though it was confined, as black-and-white never was, to very specific subjects. Still-lifes, upper-class interiors, sports, theatrical portraits and stage scenes make up the usual repertoire. In other words, a specifically make-believe world, associated with fashion and entertainment, was reserved for expensive color reproduction. Even the color cover of a 1934 folio of Man Ray photographs is an exotic, precious still-life. It was apparently assumed that color did not have any graphic value or artistic potential at all. It may have been dramaturgically rich, but it was perfectly unsound as a reliable witness of real events. . . .

"By 1940, there appeared Ivan Dimitri's *Kodachrome and How to Use It,* an influential book that propounded, as its title indicates, helpful clues to more animated and effective color photography. Though it displayed advances in the medium, it provoked a most negative view of the state of the art. The book could not have been better calculated to let its readers associate color photography with postcards, *National Geographic,* commercial assignments, calendars, fashion, tourism and snapshots (many of which, today, have ripened rather charmingly). . . .

"With the rise of *Vogue* and *Harper's Bazaar,* the *haut monde* could be shown forth with a truly peacock splendor. This tendency continued, of course, through the affluent '50s, kicked off more or less officially by a book called *The Art and Technique of Color Photography* edited and introduced by Aline Saarinen, 1951. Here was a volume of glossy work by such practiced cameramen as Arthur Penn and John Rawlings. They would flood their elegantly caparisoned *grandes dames* with one luxurious hue, azure perhaps, or rose, to bring out the most cosmetic moods. At the same time, however, color prints were increasingly collected in family albums and were most familiar in that homey context. (The color testimony of *significant* events was, for all practical purposes, confined to a documentation of the war. And on both sides, military photographers did a credible job.)

"But for the free-lance professionals, those who were making the artistic history of the medium, both of these intents, technicolor stylishness and amateur insouciance, were cautionary. Without much reflection, but with evident accuracy, they concluded that the contexts of images reproduced increasingly in color provided that the new palette in photography, with its bogus lushness, had become the captive of the most vulgar visual lusts of the mass audience. . . . Slides, of course, when they came, did not mollify this impression. Hobbyists, with their spontaneous desire for the glamour of color, could get their glib efforts industrially developed and processed. A maestro like Walker Evans might have to earn his living by doing corporate color assignments for *Fortune,* but that would only reinforce his belief, along with that of his peers, that the important, because nonmercantile, work, was in black-and-white. . . .

"But the great shortcoming of color output, as viewed by independents, was that

it was physically materialized by agencies other than the makers themselves. . . . Every practitioner of ambition developed his or her own work: toning, filtering, altering . . . cropping, printing, etc. . . . Nor did the uncertain permanence of color prints gladden those who had every right to take permanence for granted.

"On the other hand, a school of important photographers, not at all concerned with the nuances of craft, but the acuteness of the observing eye, would have no use for color film because it was not fast enough to crystallize instantaneous behavior in public places, or within historical events. I refer to the photo-journalists of well-deserved fame and import grouped together by the Magnum agency: Robert Capa, Chim, Bischof, etc. Both the Adams and the Magnum attitudes (I use them only as convenient stereotypes), however different their impulses, were aristocratic, perhaps of necessity, but also through choice, when it came to the color alternative. The subject with which they were concerned demanded a sobriety, even a certain starkness, which defined their respective notions of photographic naturalism. Upon their deftness in bringing about this naturalism, their reputations hinged. The more easy, lurid, and plebian graces of color were inevitably equated with *anti-realism.*

"This was a situation very much the reverse of the prior history of the contrasts between exclusive and mass tastes in the pre-modern arts. But it cannot be said that the memorable black-and-whites of the last three decades were less accessible to the public than work in color. . . . On the contrary, it had been spontaneously established in our consciousness that *news* of the real world was given to us by photographs in black-and-white. . . .

"Much of this began to change in the '60s, the era of Pop Art, standard color movies, and color television. The media transformations that concern us here, however, evolved from the flourishing of magazine journalism—the opulent, color-fat issues of *Life, Look, Paris-Match,* and *Stern.* Many of the older trademarked professionals saw no reason to accommodate themselves to the chromatic lavishness that was now possible through bigger circulations and more advertising. Besides, they would have to adjust very uncomfortably to seeing through the view finder what their eyes actually saw, and not some tonal abstraction whose perverse schematism betokened their occupational skill. Until now, it would not have occurred to any of these people that they had made any choice in doing black-and-white, or that they might be considered conservative in refusing color spreads. Eisenstadt, Arnold Newman, Eliot Elisofon, and Philippe Halsman were seasoned professionals who adapted themselves to color assignments on demand, though without appreciable gains. But it fell to younger men, of whom, in 1965, there was a shortage, to make their mark in this area.

". . . For it was inconceivable that the graphic consciousness of photography, even on its own terms, should ever resist the blandishments of the full spectrum of hues. When we speak of the richness of the darks in Adams' prints, say the sky, we are looking at something literally very inky, though it conjures up an absent blue of the deepest saturation. The intensity of its profile against lighted ground images functions as a coloristic, not a modeling element in his work. No one will deny Adams this metaphoric license, so intrinsic to the medium and so cannily used by him. But it is

clear, nonetheless, that actual color would not make any advance upon our sensibilities until it satisfied the hard demands black-and-white photographers put upon themselves to record the fine gamut of volume-defining tones that existed in nature.

"Though perhaps he would not then, nor even today be discussed in such fashion, this task was accomplished by Eliot Porter. We are unlikely to see again the dazzling, jewel-like printing that distinguished the Sierra Club books of 1961–62: *In Wildness Is The Preservation Of The World,* and *The Place No One Knew,* both illustrated by Porter with a fanatic care that every lovely ripple of water or streak of desert varnish take its chromatic place in the surface articulation of the natural firmament. Without sacrificing a delicacy of color nuance that seems infinite to us, he grips his motif with a clear, hard precision of contour and imparts to it a tactile denseness that roots his palette deep into matter. Overnight, the gauzy memories of Kodachrome in countless books were burned away, and with them, the myth that only black-and-white was capable of high resolution. None of this looked "easy," nor could it have been at all casual in the performance. . . .

"Here, then, was an aristocratic program, an aristocracy of craft rather than of style or subject in color. If one is to think only of the expenses of such undertakings— always exceeding more than in black-and-white—nothing can equal the devastating costs gone into the Gemini photos of the earth taken for NASA. Capitalized far more than any blockbuster movie, with cruel social sacrifices, they are also images of such splendor and fascination that they renew, at each encounter, the job of being able to see.

"Yet, they are in a tradition that by the late '60s did not have to be self-conscious about its advantages. These were always plainly visible in the ordinary information they furnished about seasonal changes or time of day (often independent of permanent shapes), facial complexions, the health or age of persons established more by color than features, the temperature of the moment, and the symbolic aura of signs of every description, that lack meaning without hue. To show this happening when the means chosen are chromatic, let me now consider three young artists working today.

"Neal Slavin travels on his own around the United States, taking group portraits of organizations or clubs, like Camp Fire girls, circuses, Elk members, mummers, and firemen, eventually to be gathered in a book of large color prints. He quotes de Tocqueville:

> The Americans of all ages, all conditions, and all dispositions constantly form associations. They have not only commercial and manufacturing companies in which all take part but associations of a thousand other kinds, religious, moral, serious, futile, restricted, enormous, or diminutive. . . .

". . . There may be something perplexing, uplifting, strained, or finally touching about the sight of these thousands in mufti, losing themselves in their role, at least for this one formal moment, to a stranger. Some appear very conscious of the decorative spectacle they are making, and all seem pleased to be an object of interest. More than

to any specific activity, these gorgeous prints dedicate themselves to the gesture of commemoration itself. But they are neither commissioned nor off-hand, as with the endless images in the group portrait genre from which they stem. On the other hand, like many photographers we recognize as strong independents, Slavin is a proficient commercial artist. Much of the supercharged lighting and posing skills displayed by the professional are at work here, minus the advertising motive. He upholds, yet displaces, both references, and puts them at the disposal of his cardinal interests—color.

". . . The curious pomp of Slavin's subjects is always discovered in its appropriate setting, whether this be a chamber for Buddhist worship in Los Angeles, or a football stadium. Park Service rangers station themselves against the backdrop of the Grand Canyon, with a brilliant sky overhead, so diminishing them that one can say of this, as well as many other prints, that they are landscapes or interiors as much as they are portraits. When the place is a theater or stage, the colored filter light—cyan, orange, or cerise—becomes an oomphy subject in its own right, to which the sitters respond. They may mug or be perfectly serious, whatever; the photographer is always straight with his models. He engages them in a spontaneously contracted presentation, to whose abrupt flair or sobriety both parties are instinctively alive. This is social picture-making of novel distinction, leavened, sometimes, with subtle humor. . . .

"Stephen Shore has very little in common with Slavin, other than youth, the fact of being a highly urbanized New Yorker constantly on the move through rural or small town America, and the mutual decision to use the view camera's color prints as expressive vehicle. There is an unsettling current of aggression and passivity in Shore's pictures of indigenous buildings and their settings. By any of the usual criteria of architectural interest or civic grace, they are grossly undistinguished vistas. Yet, though accepted in their very banality, they are often transfigured by a suavity of color or beauty of light that can be extremely assertive. Even more, this contrast does not seem forced in the least. . . .

". . . To this end, the individual prints, which are color corrected by machine, function in a special way. They are highly endowed and privileged artifacts that bestow upon the sensations they frame a physical dignity and refinement that would not have been arrested in a more modest format. No one I know has gotten hues as *precious* from car painting reflections or the stone or stucco of a building hit by long light. The imagery sits there, warmed by a fugitive glow, but resistant to any passage of time, ultimately quiet and unpeopled.

". . . What he (Shore) singles out for attention in Kanab, Utah, or Durango, Colorado, is not a local curiosity, found there and no place else, but something much rarer: the complexion of a scene we fail to notice because the objects within it are too familiar. . . . The younger man takes his place in a much less heroic and monumentalizing culture, whose highbrow tastes and lowbrow motifs coexist very well. . . .

". . . In the end, if his art *illustrates* anything, it is the theme of being *alone* in color, a solitary in a lavishly rendered brick, grassroots, and plastic America. Change

the setting, but keep the impetus of that solitary mind, and one may very well recall that Atget to whom Shore offers up his deepest homage.

"The last photographer whose work I describe is Joel Meyerowitz, also a New Yorker, who does *slides* in the Leica tradition of Cartier-Bresson, and more recently, Garry Winogrand. It had been an acutely rapid, expression grabbing form of urban photography. But Meyerowitz, especially in the last year, transposes it into color with Kodachrome II, occasionally aided by a strobe flash.

"In his hands, that extraluminous boost neither bleaches saturations nor even startles the unsuspecting. But it does emblemize the split-second decisions he makes, and much of the apparently casual mystery and complexity he gets. A flash heightens values and separates blurred or moving contours. Through these actions, though, it virtually creates a new scene that had not been there before. At first sight, these slides, exactly because they are slides, mislead by their varied foci, and swarming information; you take them to be the lucky images of an amateur—certainly very honorable things to be. But they yield up their dense contents in a slow way, each and every successive image, and they are unlocked only by a visual input that must recognize the consistent rigor with which they have been structured. This penetrating behavior of the photographer comes about through a lubricated vigilance, able to cut in on action at point-blank distances as short as three feet.

"... The shock of color here, as well as with much recent, serious chromatic work, is to make the usual mode look by contrast harsh, thin, and abstract. And what a revealing challenge it must be to the photographer who now not only juggles the dynamic ratios of space and time in terms of values, but also must clock the escaping and impinging energies of color as well. . . ."

Some Final Remarks

"Of the expressive realism of these new color efforts, there can be little doubt. But they are cued by the black-and-white traditions as well as the chromatic background I have already mentioned. Even the most original artists demonstrate a vital continuity with their past, and the methods of it here, with all their variety and visual wealth, are rehabilitated by a conviction that the earlier hierarchical judgments of photographic content and form are very much open to the recreating mind. This certainly applies to slides, their role in our visual culture. . . . I shall admit immediately that the majority of them are not concerned with the canons or limits of photographic genres. They will not necessarily exhibit the purposefulness nor concision of artists whose cumulative and individual patterns of perceiving implant themselves in our consciousness. Yet, they were never subject to the prejudices that made the onset of ambitious color photography so belated. Surely the random color excitement snapped by hobbyists, without pretension, makes up a genre of its own. It takes for granted the fidelity of the means and the dazzling malleability of hues as a birth-right from which there evolves a furthered grasp of the visual world."

"Roy DeCarava: 'Thru Black Eyes.'" (1970)
*A. D. Coleman**

"In a peculiarly American perversion, our society delights in taking credit for the success of artists who manage to overcome the endless obstacles we place in their path. It may be gratifying to think of ourselves as an aesthetic boot-camp, and in some instances not entirely inaccurate; most often, though, all that is accomplished by this enforced handling of nonsensical barriers is the dissipation of creative energy, the frustration of wasted time. For black artists, needless to say, these problems are so compounded that superhuman efforts are required merely to retain enough sanity to go on.

"I state this deliberately and bluntly, to forestall anyone (myself, white as I am, included) from rationalizing himself into the mistaken belief that the triumph of this exhibit belongs to anyone save the man who made it—Roy DeCarava. This is his show, his alone; and, quiet as it may be kept, I do not think that Edward Sprigs—executive director of the Studio Museum in Harlem, where "Thru Black Eyes" was mounted— exaggerated too much when he called it "one of the most important photo shows of our time". . . .

"In collaboration with a renowned American writer, [DeCarava] produced a book that won two awards, received critical plaudits from the *New York Times Book Review,* and sold out its first edition. Additionally, as his superb one-man show proved, he is capable of sustaining an exhibit almost 200 prints long—which, in my book at least, places him in the ranks of the master photographers.

"Yet Roy DeCarava is almost as unknown to the outside world as are the men who push racks of clothing through the streets below his windows. His name is hardly recommended for dropping; it rings no bells with most people. While it is tempting to call him a "photographer's photographer," that would be evading the issue, since only a small number of photographers are aware of his work.

"Most of those who recognize his name do so with raised eyebrows and a strange expression—as though the photographic world were a frontier town, and they had just heard tell of some trouble-making lawman hellbent on a showdown with the local gunslingers. Not only do such words as "difficult" and "intransigent" crop up continually in the ensuing discussions; at times, incredibly, there is even a faint aura of danger, much like that which hangs over the marked man in a gangster flick.

"All this is curious indeed, because Roy DeCarava does little more than tell the truth as he sees it and insist on his rights as an artist and a man. It would be even curiouser—incomprehensible, in fact—were he not black. . . .

*A. D. Coleman, "Roy DeCarava: Thru Black Eyes," *Popular Photography,* Vol. 66, no. 4, April 1970. Subsequently reprinted in: Coleman, *Light Readings: A Photography Critic's Writings, 1968–1978* (New York: Oxford University Press, 1979; second edition, University of New Mexico Press, forthcoming 1997). © 1970, 1998 by A. D. Coleman. All rights reserved. By permission of the author and Image/World Syndication Services. P.O.B. 040078, Staten Island, New York 10304-0002 U.S.A.

"DeCarava's contribution to modern photography is twofold and both facets merit consideration in depth. First, he is—as photographer James Hinton wrote in the exhibit brochure—"the first black man who chose by intent to document the black and human experience in America, and he has never wavered from that commitment. He was the first to devote serious attention to the black aesthetic as it relates to photography and the black experience in America."

"Consequently, DeCarava's body of work, taken as a whole, provides what is undoubtedly the most thorough and profound record we have of black life over the last two decades, invaluable precisely because it was made from within the black culture rather than from without. His unswerving dedication to this task has made him the spiritual father of all black photographers. . . . Much of that influence can be traced back to the Kamoinge Workshop, which DeCarava founded and ran from 1963 to 1966 . . . organized by him at the request of numerous black photographers. . . . To quote Hinton, "The younger black photographers have been influenced by Roy without knowing it, through the few black photographers who do know his work. Black photographers—and black subjects—used to be afraid to be black. Roy broke that down, and he was doing that in the late forties and early fifties—twenty years ahead of his time."

"The second part of his contribution, inherent in his work, is an approach to the medium, to the act of photography, which makes his images extraordinarily compelling.

"We are accustomed to defining maturity in a photographer as the ability to confront honestly and express clearly his own deepest feelings. . . . Beyond the self-knowledge which introspection brings, however, there is an even higher level of photographic maturity: the ability to use that self-knowledge for the purpose of confronting honestly and expressing the deepest emotions of others.

"For any photographer whose primary subject is people, this is treacherous ground to tread. Pitfalls abound: sentimentality is one, formlessness another—and, even if these are avoided, success is never guaranteed. Yet, eschewing sentiment, and without in the least sacrificing formal considerations, Roy DeCarava has charged all his images with the emotional *Gestalt* of the moment in which the camera seized them. . . . Because it is purely visual, this effect is difficult to describe (though such words as love, soul, and compassion—especially compassion—come to mind), but it results in unutterably moving photographs.

"Given all this, it is hardly surprising that DeCarava should have elected to work within the boundaries of the realistic tradition, unquestionably the ideal framework for his vision. However, it is not only surprising but grimly ironic to hear the curator of a leading photographic collection dismiss him—regretfully, it should be noted in all fairness—as being, "after all, rather old-fashioned." That DeCarava has remained true to his vision, even at the price of being bypassed by the waves of fashion, is one of his greatest victories. . . .

"Portraits of him—even one he took himself—fail to capture the controlled intensity of his presence. In them, his eyes seem vaguely troubled, and there is a guarded

quality, as though he did not entirely trust the instrument to which he has devoted his life. In person, what appears at first to be an impossibility—the absence of bitterness—is in fact something more dynamic, the presence of an internalized anger that must daily be reconquered.

"I am bitter," he said quietly, "but that's a safety valve, a self-indulgence. Either you believe that life in all its manifold horrors is basically and essentially good, or you don't." A pause. "What I try to say in my work is that I believe in life. I can't create out of bitterness. It undermines my creativity". . . .

"He started to photograph seriously in the late forties, and received his Guggenheim [fellowship]—the first ever awarded to a black artist—in 1952. The pictures that he took on his Guggenheim—all studies of life in Harlem at that period—became *The Sweet Flypaper of Life,* to date the only collection of his work in book form. This slim volume . . . was the brainchild of Langston Hughes, author of the tender, lyrical text.

"Nobody wanted the pictures," DeCarava remembers, "so I took them to Langston. I never said a word to him about the photographs; I just handed them over to him." Hughes assembled DeCarava's images into a visual narrative, a counterpoint to the bittersweet story he wrote to accompany them. . . .

"[In "Thru Black Eyes"] Rather than a self-glorifying virtuoso display, DeCarava chose instead to offer a carefully planned, thematically structured exploration of black life. Sections were devoted to such subjects as family life, music, civil rights demonstrations, work, and the white world; the exhibit probed the ghetto's subsurface far more exhaustively than the Metropolitan Museum of Art's "Harlem On My Mind."

"Thru Black Eyes" more than justifies DeCarava's "intransigent" insistence on an entire room for himself as the price for his participation in the Met's fiasco. No one, black or white, has photographed New York's black ghetto more truthfully or in greater detail over the past two decades, so it hardly seems out of line for him to have asked for one room—which, not altogether coincidentally, is exactly the space "Thru Black Eyes" occupied.

"But his conditions were not accepted, and—unlike Bruce Davidson, who at first made the same demand—DeCarava refused to compromise. . . . Obviously, this sort of frankness has not endeared him to the photographic establishment, and he has ended up in a semi-exile which is only partially self-imposed. . . . "No, I'm not loved by the white photographic community," he says wryly, "but I *am* loved by the black photographic community, and that's what really matters to me."

"He recounts these and countless similar incidents reluctantly, though with calm objectivity; he would obviously much prefer to discuss his work. Yet his struggles are so intertwined with his imagery that it would be hypocritical of him to avoid mentioning them. . . .

"It is little short of tragic that our prejudices should have deprived Roy DeCarava of the wide audience he deserves, and deprived that audience of an artist with so much to reveal that they desperately need to know. . . . It is high time for Roy DeCarava, black photographer, to begin receiving the recognition rightfully due him."

"Introduction to *Jerry Uelsmann, Silver Meditations*. (1975)
*Peter C. Bunnell**

"Creators of Jerry Uelsmann's stature may be seen to have altered the language, the substance and the direction of their art. He personally has been the recipient of considerable critical praise, though the general field of synthetic photography remains only cautiously embraced. Critics have been transfixed by the rational and the realistic in photography while the irrational and the imaginary have remained foreign to most. Present-day thinking about the medium is dominated by a naturalistic aesthetic and only a few individuals have encouraged the possibilities of separating and manipulating the syntactical structure of the *language* of photography. Most people still tend to think that when photographers make pictures they must depict objects and scenes that could, in principle, also be described in words. Photographs which appear to lack the assertive handiwork by which the artist has traditionally pointed to his invention are understood to be truly photographic, while artists in photography who employ varied and fundamental approaches to the synthesis of the medium are shunned. Uelsmann is, of course, of this latter rebellious breed and in his approach he strives for his senses to reveal, for his mind to re-create, a quintessential structure reflective of how he views the photographic process itself. In one sense his art may be considered conceptual; however, this is not wholly accurate for the otherness of the outside world is affirmed, not mitigated, by the intrusion of this artist's mind and hand.

"The metamorphosis of ideas in photography is one of the most difficult aspects of the medium to understand. How a photographer such as Uelsmann searches for a significant image, first from the selection of the motif, then to the organization of forms, and finally to the combination of each in a picture in which the content is other than pure data is a kind of process magic-theatrical magic if the essence is the least bit irrational. This is no different from the process of creation in other media but it seems that photography has been dominated, in fact handicapped, by the failure of persons to recognize this conception of expression in the medium. So permeating has been the belief that photographs must be a form of vicarious experience of the subject itself that exceptions to this interpretation are rejected. A picture, properly appreciated, stands away from us as an object on its own—independent and complete. A division of the medium may be seen in which, on the one hand, images provide an imaginative and on the other hand a rational basis of experience.

"Uelsmann's adherence to what he terms in-process discovery places him firmly in support of intuition. He affirms that there is no doubt that an important connection

*Introduction to *Jerry Uelsmann, Silver Meditations*. Dobbs Ferry N.Y.: Morgan and Morgan, 1975. Copyright © 1975. By Peter C. Bunnell. All rights reserved.

exists between his creative activity and dreaming. As the dream is an involuntary act of poetry, so the fortuitous selection and combination of negatives is the reflection of the imagination's independence of the will. In this sense Uelsmann's photographs, like dreams, have either no meaning or several meanings. Photographs freed from the scientific bias can, and indeed usually do, have double meanings, implied meanings, unintended meanings, can hint and insinuate, and may even mean the opposite of what they apparently mean.

"Photographs have tended to be treated scientifically as a factual statement: "this is a person," "this is a shell," "this is a building." Contemplation in the face of such concrete things demands a great deal of the mind and the senses. Once one has recognized that photographs have meaning, they become open to interpretation and characteristically several not mutually exclusive interpretations can be made of them. One has to add that most photographs are, usually, incomplete acts of visualization. Something still must be added to them before they can be transferred from the private sector of experience to the public, before they can acquire universality. This something-still-to-be-added must, I think, be more than just the translation of visual, nondiscursive imagery into coherant discursive photographic language; in other words, the transformation of a dream or unconscious fantasy into a work of visual imagination cannot be analogous to the process of interpretation as practiced, for instance, by psychoanalysts. It must rather comprise the casting of the central meaning in symbols which are part of the shared iconography of the culture of which the artist is a member, and which, therefore, carry a heavy charge of shared, public associations and resonances. It is not that the artist actively masters the iconography of his times in order to be able to universalize his private emotions, but that one aspect of his capability is an exceptional sensitivity and receptivity to the iconograhical network that constitutes the culture of his time that makes it natural for him to express his private emotions in universal terms, or perhaps not to distinguish between the individual and the universal, between the microcosm and the macrocosm at all. In this vein many persons superficially acquainted with Jerry Uelsmann and with his work have difficulty recognizing in him the ability to articulate the complex symbolism, which a number of writers, especially William E. Parker, have identified in his photographs. What I am suggesting is that while Uelsmann does have an inquiring, searching, and aware mind he is moreover exceptionally sensitive to the iconography of public expression. It is a fact that in photography there is a strong anti-literate sentiment which is most generally brought to bear against any photographer who is the least bit learned in his work. Such is clearly the case with Uelsmann and in his public appearance he often does little to challenge this notion. He is one of the few photographers to talk about his work with commitment and to have articulated a stylistic analysis of his own photographs, but I believe he stops short of verbalizing his awareness of iconology because he fears this very sentiment among his peers. No additional evidence of his ability to use his knowledge need be cited than the considerable body of photographs made over the last fifteen years which are indicative of his overall expressive achievement.

"A necessary precondition of all imaginative activity seems to be what Keats called "negative capability," the ability to allow oneself to be "in uncertainties, mysteries, doubts, without any irritable reaching after fact and reason." In other words the ability to abandon the ideal of rational action and stop trying to master reality in favor of letting oneself happen. And, at least for such artists as Uelsmann, the execution as well as the conception of a work of art may also be largely independent of the will. In this it must be seen that all images reveal a psychic state.

"In his approach Uelsmann has affinities to several artists in a variety of media. Like Joyce, for example, as he chooses to let his subjects dictate his methods rather than to impose a method upon his subjects. Uelsmann's description of this working procedures is similar to Jackson Pollock's well-known comment, "When I'm in my painting, I'm not aware of what I am doing." Like action painters Uelsmann sees the aim of art to be discovery, not the solving of formal problems. At work he proceeds until intuition informs him that a culmination has been reached which is the way abstract expressionist painters recognize that a painting is finished. One discovers what he has done afterwards. Art has to do with finding out something one did not know. This illustrates the fact that the imagination is autonomous of the will, of the self-conscious ego, and it is presumably the reason why poets and artists before the rise of psychology could believe literally in their inspiring Muse.

"Uelsmann's process of self-revealment lies in the imaginative articulation of fragments. These fragments are the components of his existence experienced first, and particularly, through the camera but it is as if he has not lived them until he sees them combined in pictorial form. Indeed he may also be seen to have now reached the state in his life where he projects these completed visions back on reality itself. His self-confidence rests in his ability to synthesize knowledge outside of actual experience and his affirmation of in-process discovery is another way of saying that he values the revealment of autobiography. His pictures reflect a formal order, but their meaning is outside the logic which confronts the rest of us in our everyday life. He is one of the very few to have depicted the Apocalypse. His work has been determined, in part, out of painful adolescent experience and tempered by the acceptance of the premise that the practice of art is rooted in life and that the felicity of art lies in its sustaining power. Humor, or perhaps more pointedly a kind of wit, has been one of Uelsmann's most characteristic qualities. On the surface it might be seen that this is reflective of this doing what he likes, but it is also reflective of a lingering suspicion that life is positioned by the potential of tragedy.

"Minor White, whose aesthetic derives from Stieglitz's equivalent form, gave Uelsmann the realization of the poetic reality when he was a student at the Rochester Institute of Technology. Significantly, however, White by that time had extended Steiglitz's concept of equivalency through his own development of the corporate sequence of non-similar images. White draws freely from all fragments of his personal experience and recombines them into controlled autobiographical statements. This sense of control, through the combining of single photographs, and the interest in autobio-

graphical expression, are key elements in White's contribution to the medium and in Uelsmann's subsequent extension of it through his own work. Autobiography is not necessarily in accord with fact and it may be seen to possess an immense potential for fiction and passion.

"While Stieglitz organized his cloud photographs—images so photographic that they were true pictorial abstractions—into sequences or groups, the effect he sought was not so much to recreate experience as it was to allegorize his emotions. White, on the other hand, takes images which are more obvious or rational than abstract, and combines them in a kind of cinematic presentation heavily reliant on a varied repertoire of symbols which he believes can be "read" in photographs. The goal as White sees it is one of freeing the photographic experience from chronological time and making it into the totality of a life experience which has a cumulative meaning and identification greater than any individual picture. Because of this method his pictures are frequently fragmentary in themselves and incomplete as allegory.

"Uelsmann grasped this concept and has significantly modified it by adopting manipulative techniques which allow him to construct a non-linear sequence of images within a single picture. White, it must be pointed out, has always adhered to the stylistic purity of the straight photograph and his images reflect his strong and continuing solidarity with the group of Stieglitz, Weston, and Adams. Uelsmann, who by 1959 was now building on the encouragement of Henry Holmes Smith, who placed a liberal emphasis on subjective creativity within the photographic process itself, sought to re-invent the process of picture making in photography by considering each camera negative as only *part* of a single photograph. I use the word re-invent very particularly, because this is precisely the contribution made by Rejlander a hundred years before but which unfortunately has been lost today because of our inability to see his extraordinary invention beneath the sentiment of subject for which it was placed in service. Photographers like Uelsmann, Rejlander, White, and Stieglitz extended the concept of photographic time by replacing the finality of exposure time with a construct of conceptualized time as the basis for the experience of photographic reality (Fig. 4.4).

"The thought of incongruous juxtaposition was not, at first, an issue with Uelsmann and his early images are as pictorial in motif and motivation as are the photographs by the other three photographers mentioned above. Interestingly Uelsmann's observation on Rejlander's "Two Ways of Life" is that it is "an amazing image in that it is so intricately complex yet so infinitely resolved." Only gradually has he developed the ambiguous and more psychologically related experience where the expression of the irrationality of thinking and feeling is seen in both content and form. In recent years Uelsmann has admitted to not knowing what some of his pictures are about. I believe this is due to the fact that he has used single images within these photographs that come about through unrealized experience as early as the time of photographing when the continuum of recognition and reaction was incomplete and when his subconscious did not absorb and catagorize even the observable sensation. It is very much to the point in analyzing Uelsmann's working method that he does not consider using other

Figure 4.4 Jerry Uelsmann.
Untitled, 1968.
Gelatin-silver print.
Copyright © 1997 Jerry Uelsmann.

persons's negatives. He will not borrow from the consciousness of others their visual fragments which are vividly different from what I have described as his life fragments in visual form. This methodology also relates to, and I believe clarifies, the issue of the symbolic construct of his pictures as discussed earlier. His sensitivity to the iconography of culture is manifested in the gesture of identifying his fragments in the field when photographing, and not only in the selecting of parts for a picture once in the darkroom. It is in this respect that he, like Manet, a counterpart in painting, may be seen to create after nature and it is why, after all the arguments about synthetic photography are said and done, Uelsmann is a photographer dependent upon the real world of primary observation.

"Nevertheless Uelsmann also loves fantasy, and he uses it to carry a distinct moral. Literary art for him does not mean the mere teaching of moral truths, because whatever is honestly worth seeing seems to him also capable of moral implication. His repititions of various images and themes is an emotional rhythm of testing propostions by refutations, as with bringing witnesses forward and cross-examining them. Like artists everywhere it is his aim not to find wisdom but to put it to work. He believes reality has room for such models.

"In contrast to his earlier pictures, Uelsmann's work in recent years has become less graphically dominating in terms of what may be seen as the relatively simple and harmonious counterpoint of objects and forms. Since about 1972 the picture space in his images has been filled in a more total and stressing fashion reflecting his own more complex psychic nature. He has reached the point where the work has turned in upon itself, where the mastery of craft has moved outside of illusion and conscious showmanship to a more introspective state of affairs where one can no longer tell so easily what is going on. I do not believe this is a matter of his technique becoming simply virtuosic, but rather that a fundamental change has occurred in the work where the desire to exert any control over the artistic invention has been relinquished for the sake of creating images which exert control over his own life process in the hope of realizing something he feels is confused or incomprehensible. It is as if he is allowing the dream/image process to stabilize his own existence. Even today I do not believe we are at a point where this change has been concluded, though I sense a returning to his accustomed security which in the past has made his pictures more pictorial.

"The dominating character and participant in Uelsmann's visual world is man. He is a humanist concerned with man's achievements and interests, with his actions and, as I have stated, with the moral implication of these actions. In many cases his pictures are singularly expressive of the sexuality of human interaction and he has mastered the presentation of erotic tension without yielding to pornography or resorting to non-objective symbolism. He uses the clothed or nude figure almost interchangably. This is true nor only with the female but we see it even more with his depiction of the male figure which does not appear naked but is almost always used as an expression of the anxiety and the primitive power of male sexuality. His rendering of the human figure is analogous to how one contrasts masks with illusion in the theater and it is clear that Uelsmann prefers the mask because it is frank; the figure in the mask is clearly an actor, not someone who is half-persuading you with grease paint and a wig that he is Othello.

"Many persons, including myself, have been photographed by him and it is difficult to characterize these pictures. Portraiture is an easy label to assign to a large number of them, but it is not wholly satisfactory because Uelsmann's own dominating presence is never far below the surface of our own projection. When viewing our likenesses our composure is shaken by the realization that he has exempted us from the crowd and that we now must contemplate ourselves in a landscape which was not of our own choosing. The interpretation of these pictures will be largely individual when it is most clear that the emotive image is very particular, and when it is not the tendency is to take comfort and reach out for more universal interpretations.

"Uelsmann is one of the few photographers who is not afraid to place himself before the camera. I believe that this is to intervene in his fantasy life, thus to assure his physical presence there, as well as a gesture to record for posterity the life process of aging-cum-maturing. Technically, Uelsmann's self-portraits are no different from his other compositions but in conception they are significantly different. His identification

with his own being causes him to counter the independence of his will and to more fully conceptualize and control the image. In this way, his self-portraits are extraordinarily reminiscent of the self-portraits of the pioneer Frenchman Bayard or not unlike Stieglitz's shadow images of 1916 or Friedlander's recent photographs. These images are all compelling and rich because they are so dominated by a controlled psychological intensity. In portraiture we are always concerned with revealment, a quality which is frequently associated with perceptual truth. Uelsmann has admonished photographers to get out in front of the camera. Under his own terms yes, but when he is photographed by others he is noticeably reticent and inevitably a comic pose is assumed in gesture and expression. He is aware of what the camera can do. Not that any of us are not, but in his self-portraits, and likewise in his pictures of others, Uelsmann disarms us with the dark ambiguity between model and persona.

"This is Uelsmann's second book and it brings together images primarily of the last five years. These photographs reinforce his position in the field, and as I said at the beginning of this essay, he clearly prefigured the contemporary direction of his medium. In so doing he has restored a tradition and acquired a position which relatively few of his generation can match. He has done this through a sustained endeavor and in measuring his work his failure must be seen to matter as much as the successes. It has only been in recent years that the public dedicated to photography has been able to map the continuous growth of its artists. Through many exhibitions and publications we have been in a position to follow this artist's work in-depth as it has been created through incessant and thoughtful effort. In some respects this public awareness of him, which began at a very early point in his career, has had a profound effect on Uelsmann's own consciousness. There have been many public events as his chronology shows, but the slow evolution and tempering of a maturing personality occurs more through private agonies and obsessions. All of these pictures do not have the instant appeal of certain of his earlier images which, both by quality and familiarity, are considered masterworks. These more recent images are less simple, more substansive, and in some cases dangerously close to contrivance or *voulu*. Certainly they are much less apt to amuse the viewer, but to be a master is to be a master. Uelsmann's innovation as an artist is in keeping with the multiplicity of his vision. There are pictures of his as perfect as anything in photography and emotions as clearly expressed as any in any medium. It is precisely in making the accommodation between self-confidence and humanity that makes his pictorial life so pleasurable for him and, ultimately, so challenging for us."

"The Anti-Photographers." (1976)
*Nancy Foote**

"Though the post-modernist revolution has (as in many other disciplines) eradicated traditional boundaries and brought about a tremendous increase in "esthetic mobility," photography's status in the art world remains problematic. For every photographer who clamors to make it as an artist, there is an artist running a grave risk of turning into a photographer. . . .

"Oddly enough, conceptual art has never been plagued with accusations that it belongs on photography's side of the tracks, yet the condition in which much of it could or would exist without photography is open to question. Photographs are crucial to the exposure (if not to the making) of practically every manifestation of conceptual-type art—Earthworks, process and narrative, pieces, Body Art, etc. Their first function is, of course, documentation; but it can be argued that photography offers certain specific qualities and possibilities that have done much to inform and channel artistic strategies and to nurture the development of idea-oriented art. Despite its dependence on photography, however, conceptual art exhibits little *photographic* self-consciousness, setting itself apart from so-called serious photography by a snapshot-like amateurism and nonchalance that would raise the hackles of any earnest professional. In fact, many conceptual artists consider it irrelevant whether or not they take their own pictures. . . .

"The artistic success of these anonymous and technically unremarkable pictures provides, perhaps, a clue to the root of photography's difficulties. Over half a century ago, Alfred Stieglitz conducted a massive p. r. campaign for photography's acceptance as art within an emerging climate of modernism which he himself did much to foster. He translated the self-referentiality of the modernist position in painting into a self-consciousness about photography for photography's sake. Much was made of the importance of the unique photographic print. Abstract formal values were, as in painting, given a high priority, heavily influencing the photographer's choice of subject, as well as his compositional tactics. Ironically, a medium which started out as an image recorder and replicator came to look on itself as a producer of sacred objects. But the strength of photographs lies in their unique ability to gather, preserve and present outside information, not to "make art." Thus the contents of a photograph are inherently extra-photographic; a fact which, though not profitably reconcilable with modernism, offers considerable potential of its own. . . . Conceptual artists, however, in espousing photography for expedient recordmaking purposes, have begun to extend its ideological potential.

"Conceptual art's Duchampian underpinnings strip the photograph of its artistic pretensions, changing it from a mirror into a window. What it reveals becomes impor-

*From *Artforum*, Vol. 15 (Sept 1976), pp. 46–54.

tant, not what it is. It doesn't matter to conceptual art whether the photographic prints that testify to its occurrence come from a fancy darkroom or the drugstore; the view's the same. Nor does it matter if they're reproductions, thus opening up the whole area of publications as possible territory for art. . . .

"Photographers's photographs, of course, also become "secondary" information when reproduced in books. Conceptual artists's do not. In fact, the final form of the work may well be its publication. Robert Smithson's *Incidents of Mirror-Travel in the Yucatan,* for example, documents nine "Mirror Displacements" placed in various locations, photographed, then packed up and moved to the next place. Smithson published the photographs in *Artforum,* along with an extensive commentary, as the completed work. . . . Eleanor Antin's *100 Boots* series took the form of industrially printed postcard reproductions; certainly in this case the production and distribution of the cards was as integral a part of the work as the antics of the boots themselves.

"Art that does not depend . . . on its physical presence relies heavily on photography for its credibility. Though few make the pilgrimage necessary to see Earthworks firsthand, or preside over the machinations that comprise Body Art, photographic reports from the front tell it like it was to all the (art) world. And though the photographs started out as documentation, once the act is over, they acquire eyewitness status, becoming, in a sense, the art itself. A grayish close-up of the teeth-marks on Vito Acconici's arm (*Trademarks,* 1970) or the barely distinguishable figure of Chris Burden sitting in a dark boiler-room (*The Visitation,* 1974) is hardly the photographer's idea of a masterpiece. And yet, we may ask ourselves, how much of such art would continue to be made were it not for photography's flawless credibility record in swearing to the truth of such occurrences?

"Photos also allow artists to carry over Duchamp's Readymade esthetic into the realm of conceptual art. Richard Long and Hamish Fulton stake artistic claim to various sections of landscape by photographing it—Long according to predetermined systems ("walking a 10-mile line, filming every half mile out and back, 42 shots"), Fulton by isolating certain memorable moments, also on lengthy walks. With both artists, the act of photographing is as much a part of the work as the resulting images. In Long's case, it determines the conceptual structure of the piece; with Fulton, it enables him to "charge" the landscape esthetically. . . .

"If photography makes it possible to confer Readymade status, on otherwise untransportable places and deposit them in one's *oeuvre* (or gallery), it also expedites the collection of such material for later artification by juxtaposition, group presentations or serial publication. Bernd and Hilla Becher ignore the architectural or engineering achievements of the buildings that make up their work, photographing them so as to categorize types, compare similar formal elements, and arrange them in sequences (or pseudosequences) that suppress the structures' individual characteristics in favor of what they call "typologies" (Fig. 4.5). The conceptual precision of their enterprise would be impossible without photography because, as Carl Andre has pointed out, it allows them to equalize the proportions of buildings that are not the same size, for pur-

Figure 4.5 Bernd and Hilla Becher.
Blast Furnace Heads, Frontal Views, 1985.
12 black and white gelatin-silver prints, mounted, 61¾" x 66½"
Courtesy of Sonnabend Gallery, New York.
Copyright © Bernd and Hilla Becher.

poses of presentation. The Bechers claim not to care whether or not the resulting grids of images are works of art, nevertheless, their relevance to current art ideas is inescapable. . . .

"The idea of art through selection, harking back to Duchamp and vastly enlarged in scope through the use of photos, is gently parodied by Baldessari in his *Choosing* series. Here photographs of the artist's finger pointing to one of three similar items (green beans, chocolates, etc.) call attention to the process involved in making choices.

"In addition to being a means of gathering information, photography offers a number of structural strategies which play a greater part in the conception of many works than they are usually given credit for. An important, if obvious, difference between traditional photography and art comprised of or documented by photos is the use of several pictures rather than [a] single image. This immediately alters the sort of con-

tent possible within the overall work, offering the chance for a conceptual complexity rarely found in a single picture. The artist has a number of options—photos can be serial, sequential, in suites; they can be narrative, documentary, even components of abstractions. Usually any given group of photos serves several of these functions simultaneously.

"In documenting gestures and processes, the photograph allows the artist to eliminate the problem of duration, either by isolating a specific moment or by presenting a linear sequence without having to endure the possible monotony of a film or videotape of the actual event. . . . This emergence of the temporal in favor of the visual is possible only with still photograph. . . . Even . . . in large series of photographs when it is impossible to take the whole work at once, our sense of ongoing time remains negligible.

"If photography can eliminate the duration of process, it can also telescope distance, allowing one to relate isolated situations or events that derive their conceptual strength from juxtaposition and comparison. . . . In Dennis Oppenheim's *Parallel Stress* the artist positioned the body in a V-shaped pose that conformed to two different locations. The final form of this work becomes the juxtaposition of the two photographs. Much of Douglas Huebler's work also relies on juxtaposing isolated instances. *Variable Piece 1^A* relates the facial expressions of eight people in five different countries soon being told, as we learn in an accompanying statement, that they have beautiful/special/remarkable faces. . . .

"Photographs can constitute physical as well as conceptual structure, as in the work of Jan Dibbets and Jared Bark. Both use sequences of photos artificially juxtaposed to produce nature-defying fantasies. Dibbets' *Dutch Mountain* series, where photos of the horizon are successively tipped to give the illusion of a hill, comment on that country's characteristic flatness. Bark, who uses the most banal form of photography imaginable—the subway photo booth—collages pictures of various parts of his body in elaborate series to form trees, animals, etc. In one respect they are reminiscent of certain 17th-century portraits by Archimboldo—grotesqueries where faces are composed entirely of vegetables.

"If photography's widespread acceptance as the currency of conceptual art has had an effect on the structure of such art, it has also opened new possibilities for many who consider themselves primarily photographers. The sequence-serial-narrative issue deserves further consideration in this respect, for photographers have been drawing on its didactic capacities for the extra-photographic content which they are increasingly interested in incorporating into their work. Some manipulate the characteristics of narrative or sequence, juxtaposing presentational formats that are habitually read in certain ways (left to right, top to bottom) with photographed information that does not necessarily relate accordingly. . . .

"Sequences do not need to progress horizontally; Duane Michals reverses photography's usual method of showing an overall view and details of varying closeness, gradually dispensing additional information about his subject by moving farther and

farther away. Tableaux which at first appear to contain bizarre discrepancies in scale reveal their true identities as the camera recedes, clarifying by degrees the structure of the scene. . . .

"Collecting for conceptual purposes is also gaining appeal for photographers. Louis Baltz's photographs of industrial parks, for instance, though perhaps more closely related to Minimalism in their frontality and sparse geometry, converge with Ruscha's gas stations in their banal subject matter and with the Bechers in their structural comparisons. . . .

"Over the past few years, as photographers have experimented with conceptual tactics, artists have begun to be seduced by the technical capacities of the photographic process. Baldessari, for example, has concentrated increasingly on the professional quality of his photographs. What was once presented in standard-sized Polaroid snapshots has begun to appear in larger, much slicker form. A recent strobe series recording the motion of objects required a much higher degree of technical skill than the casualness of his earlier work. And Hamish Fulton's photographs, extremely large in size and meticulously framed and matted, exploit the graininess which photographers often rely upon for special effects; they also allude to the romanticism which Ansel Adams, for instance, seeks in his landscapes. . . .

"On the purely documentary side of things, perhaps the quintessential example of heightened attention to technical quality would be the elaborate photographic records and resulting coffee-table book that attest to Christo's *Valley Curtain*. It's ironic that an art whose generating impulse was the urge to break away from the collectible object (and hence the gallery/collector/artbook syndrome) might, through an obsession with the extent and quality of its documentation, have come full circle.

"Photography obviously cannot claim sole credit for the rise of the prevailing ephemeral art styles; nor is it fair to say that conceptual art is produced purely to be photographed. It isn't. But there can be little doubt that photography's role has extended far beyond its original archival function, entering into dialogue with artistic ideas in mutually reinforcing ways. Certainly the production of impermanent works is encouraged by the status accorded the photographic stand-in. Works don't have to locate themselves in remote places, self-destruct in five seconds, or cease to exist at the end of a gesture to benefit from a photographic afterlife. Even ephemeral gallery-installation exhibitions, a recent but ever more common phenomenon, owe the luxury of their three-week fling to the reassurance that there'll always be the photos. . . .

"If photography has encouraged such transitory indulgences, it has also, in many cases, helped shape their character. The extent to which the two have become inseparable was noted by Robert Morris in a conceptual/photographic/publication piece of his own, where he invented three artists and discussed their work . . . in *Artforum*. One of the "artists," Marvin Blaine, had dug an elaborate cave . . . he insisted was not art and would not allow to be photographed: . . . "The easiest way to remove the efforts of it being taken as art by others was to have no photographic memory exist."

PHOTOGRAPHERS FROM THE PERIOD 1960-1980

1960-1980

Adams, Eddie (1933–), American
Adams, Robert (1937–), American
*Allen, Vance (1939–), American
Andrejor, Claudia (1931–), Brazilian
Appelt, Dieter (1935–), German
Arbus, Diane (1923–1971), American
Bailey, David (1938–), British
Baltz, Lewis (1935–), American
Bar-Am, Micha (1930–), b. Germany, Israeli
*Barboza, Anthony (1944–), American
Barrow, Thomas (1938–), American
Becher, Bernd (1931–), German
Becher, Hilla (1934–), German
Berger, Paul (1948–), American
Bizilliat, Maureen (1931–), Brazilian
Blanco, Lazaro (1938–), Mexican
Blume, Bernhard, Johannes (1937–), German
*Blue, Caroll Parrott (1943–), American
Bostelmann, Enrique (1939–), Mexican
Bourdeau, Robert (1931–), Canadian
Bourdin, Guy (1935–), French
Branco, Miguel Rio (1946–), Brazilian
Bullock, Wynn (1902–1975), American
Burgin, Victor (1941–), British
Burrows, Larry (1926–1971), American
Callis, Jo Ann (1940–), American
Caponigro, Paul (1932–), American
Chappell, Walter (1925–), American
Christenberry, William (1936–), American
Clark, Larry (1943–), American
Clift, William (1944–), American
Cohen, Lynn (1944–), Canadian
Cohen, Mark (1943–), American
Connor, Linda (1944–), American
Cosindas, Marie (1925–), American

Crane, Barbara (1928–), American
Cumming, Robert H. (1943–), American
D'Amico, Alicia (1933–), Brazilian
Dater, Judy (1941–), American
*Davidson, Bruce (1933–), American
*Davis, Collis H. (active 1965 on), American
*Draper, Louis (1935–), American
Dutton, Allen A. (1922–), American
*Eda, Joan (active 1965 on), American
Edelson, Mary Beth (1933–), American
Eggleston, William (1939–), American
Eleta, Sandra (1942–), Panamanian
Faller, Marion (1941–), American
Faucon, Bernard (1950–), French
Faurer, Louis (1916–), American
Fellman, Sandi Lee (1952–), American
Fichter, Robert (1939–), American
Fink, Larry (1941–), American
Fontana, Franco (1933–), Italian
Fontcuberto, Joan (1955–), Spanish
*Freed, Leonard (1929–), American
Freedman, Jill (1939–), American
*Freeman, Roland (1952–), American
Friedlander, Lee (1934–), American
Fujiwara, Shinya (1944–), Japanese
Fulton, Hamish (1946–), British
Giacomelli, Mario (1925–), Italian
Gibson, Ralph (1939–), American
Gnisyuk, Mikola (1944–), Ukrainian
Godwin, Fay (1931–), b. Germany, British
Gohlke, Frank (1942–), American
Golden, Judith (1934–), American
Gossage, John (1946–), American
Gowin, Emmet (1941–), American
Griffiths, Philip James (1936–), British
Groeblie, Rene (1927–), Swiss
Groover, Jan (1943–), American
Hahn, Betty (1940–), American
Hamaya, Hiroshi (1915–), Japanese
Hassner, Rune (1928–), Swedish
Heinecken, Robert (1931–), American

Hellebrand, Nancy (1944–), American
*Higgins, Chester Jr. (1946–), American
Hill, Paul (1941–), British
Hiro (Yasuhiro Wakebayashi) (1930–), Chinese
Hockney, David (1937–), British
Hosoe, Eikoh (1933–), Japanese
Hujar, Peter (1934–1987), American
Hyde, Scott (1926–), American
Ikko (Ikko Narahara) (1931–), Japanese
*Jones, Brent (1945–), American
Jones, Tony Ray (1941–1972), British
Josephson, Kenneth (1932–), American
*Koga, Mary (1920–), American
Kossoy, Boris (1941–), Brazilian
Koudelka, Joseph (1938–), Czechoslovakian
Krause, George (1937–), American
Krims, Les (1943–), American
Labrot, Syl (1929–1977), American
Larsen, William (1942–), American
Leonard, Joanne (1940–), American
*Lewis, Jr., Matthew (1930–), American
Livingston, Jaqueline (1943–), American
Lotti, Giorgio (1937–), Italian
Lyon, Danny (1944–), American
Lyons, Joan (1937–), American
Lyons, Nathan (1930–), American
MacAdams, Cynthia (1939–), American
Macijaukas, Alexandras (1938–), Lithuanian
Mandel, Michael (1950–), American
Manos, Constantine (1934–), American
Mark, Mary Ellen (1940–), American
Martine, Franck (1938–), French
Mascaro, Christian (1944–), Brazilian
MaCallin, Donald (1935–), American
Meatyard, Ralph Eugene (1925–1972), American
Meiselas, Susan (1948–), American
Mendoza, Antonio (1941–), b. Cuba, American
Merlo, Lorenzo (1935–), Italian
Mertin, Roger (1942–), American
Metzker, Ray (1931–), American
Meyerowitz, Joel (1938–), American

Michals, Duane (1932–), American
Minkkinen, Arno Rafael (1945–), Finnish
Misrach, Richard (1949–), American
Moon, Sarah (1940–), French
Moriyama, Daidoh (1938–), Japanese
Mugubane, Peter (1932–), South African
*Muhammad, Ozier (1950–), American
Naitoh, Masatoshi (1938–), Japanese
Nettles, Bea (1946–), American
Newman, Arnold (1918–), American
Nilsson, Lennart (1922–), Scandinavian
Nixon, Nicholas (1947–), American
Nofhelfer, Gabriele and Helmut (both 1945–), German
Noggle, Anne (1922–), American
Nori, Claude (1949–), French
Ockenga, Starr (1938–), American
Okuhara, Tetsu (1940–), American
Owens, Bill (1938–), American
Papageorge, Todd (1940–), American
Parker, Olivia (1941–), American
Penone, Giuseppe (1947–), Italian
Peress, Gilles (1946–), French
Peterson, Anders (1944–), Swedish
Pfahl, John (1939–), American
Pistoletto, Michelangelo (1933–), Italian
Plossu, Bernard (1945–), French
Porter, Eliot (1901–), American
Pratt, Charles (1926–1976), American
Prince, Douglas (1943–), American
Purcell, Rosamond (1942–), American
Rauchenberg, Robert (1925–), American
Rexroth, Nancy Louise (1946–), American
Riboud, Marc (1923–), American
Riebesehl, Heinrich (1938–), German
Riefenstahl, Leni (1902–), German
Rinke, Klaus (1939–), German
Rubenstein, Eva (1933–), b. Argentina, American
Ruscha, Edward (1937–), American
Russo, Marialba (1947–), Italian
Samaras, Lucas (1936–), b. Greece, American
Savage, Naomi (1927–), American

Sheridan, Sonia Landy (1925–), American
Shinoyama, Kishin (1940–), Japanese
Shirakawa, Yohikazu (1935–), Japanese
Shore, Stephen (1947–), American
Sinsabaugh, Art (1924–1983), American
Slavin, Neal (1941–), American
*Sleet, Moneta Jr. (1926–), American
Sonneman, Eve (1946–), American
Steinert, Otto (1915–1983), German
Sternfeld, Joel (1944–), American
Stettner, Louis J. (1924–), French
Szilasi, Gabor (1928–), Hungarian
Thijssen, Andre (1948–), Dutch
Tice, George (1938–), American
Tomatsu, Shomei (1930–), Japanese
Tress, Arthur (1940–), American
Turbeville, Deborah (1938–), American
Uelsmann, Jerry (1934–), American
Vogt, Christian (1946–), Swiss
Walker, Todd (1917–), American
Warhol, Andy (1928–1987), American
Wegman, William (1942–), American
Welpott, Jack (1923–), American
*West, Edward (1949–), American
Winogrand, Garry (1928–1984), American
Witkin, Joel-Peter (1939–), American
Wu, Dazhen (1944–), Chinese
Yamanaka, Nobuo (1948–), Japanese

*Photographers whose work is significant for the study of cultural diversity. Many, but not all, of these photographs were taken by minority photographers.

5

The Period 1980–2000

OVERVIEW OF THE PERIOD 1980–2000

Topics Addressed

Photography and Post-Modernism • An Inclusive History of Photography • The Body as Battleground, Photography and the Construction of Race and Gender • Photography, Patronage and Censorship • Fabricating to be Photographed, Photography as Fiction • Photography as Autobiography • Analog Past, Digital Future.

As we examine the photography of the past twenty years, the difficulties of historical analysis grow greater and the choices and opinions of the authors must, candidly, be viewed with circumspection. Remember, this time period is "the present" for both the writers and readers of this book, and that fact presents historical problems. History shades more deeply into criticism and personal taste the closer one comes to the immediate moment. We all have a "vested interest" in the outcome of the history that is still being made, and the authors' vested interest may *not* be the same as the reader's. Everyone wants his or her favorite contemporary photographer to be the one who is regarded, in hindsight, as the most historically important. Moreover, it is impossible to separate oneself from the unconscious attitudes of one's time. The issues that seem greatly important now may not appear to be very signficant in the future. But, the issues are at least compelling in the present and can provide a vantage point for photography in our contemporary world.

The millennium is approaching, and with it we see its transformations in cultures all over the earth. Economic, political, and technological changes become intertwined in what often look like paradoxical relationships. As international boundaries are dis-

solved via satellites, computers, and the Internet, there also is an opposite rise in nationalism in the world and ethnocentrism within nations. We are at once more international and more tribal than our predecessors. This apparent contradiction can perhaps be resolved by remembering that the pressures of international economics, communication, and awareness are *not* culturally neutral. As we have repeatedly pointed out, the world of capitalist enterprise, scientific advances, and complicated technology has its historical roots in Europe, and moreover, it has, until recently, been largely dominated by European or Euro-American men. There is no real way of escaping the implicit European values that our internationalism embodies. But one can react to it from other standpoints. Indeed, the international and the European is so pervasive that it has the effect of marginalizing at once everything else and also of throwing it into high relief. Hence the growing tribalism of the world.

It is the authors' belief that the most significant photography of the past twenty years has been undertaken as an emotional counterpoint, in response to the pervasive economic, political, scientific, and technological internationalism of our time. It is essentially a critique of the homogenization of the world. But the very terms under which internationalism subsists, the European "rules of the game," mandate that our philosophical position be held with a certain forcefulness, much the same assertiveness that the significant photography since 1980 itself embodies. So having stated our position, we encourage the reader to once again maintain a certain independence of mind toward it.

Multinational corporations that were founded in the 1960–1980 period have now emerged as dominant forces in world trade. There has been increasing international pressure in favor of free trade relations without control or restrictions. While nations retain and in many cases gain their independence, international alliances are increasing. The European community, for example, is progressing toward economic and monetary system unity by means of such negotiations as the Maastricht Treaty, which took effect in 1993, or GATT, the General Agreement on Tariff and Trade, signed the same year, both of which are designed to enhance Europe's financial, political, and social cohesion. In 1971, the United States moved into a new economic relationship with the rest of the world when the value of the dollar was allowed to float free and world currencies were no longer pegged to its value. This economic interdependence now defines world relationships, and when, in 1986, the United States imposed trade sanctions against South Africa, this action aided in dismantling that nation's policy of segregation known as apartheid. Three years later, Gorbachev came to power in the Soviet Union and it was dismantled while the nations that were under Soviet rule or influence gained political and economic independence. The great symbol of the Cold War, the Berlin Wall, was torn down in a prolonged popular and bloodless demonstration, and a reunited Germany emerged. With the wane of the Cold War, which had dominated the post-war world, anti-nuclear movements gained in influence and some arms reduction on the part of the United States and the former Soviet Union ensued. Environmentalism was also brought to the forefront by the rise of multinational corpo-

rations, the reduction of trade barriers, and the emerging economies of newly independent and/or developing nations. The deforestation of large areas of the globe, as well as concerns over shrinking biodiversity and pollution, have lead to more public and government support of the environment. Rising prices and scarcity of some materials have made recycling more feasible.

Although these developments seem to be primarily political and social in nature, they influence both how photographs are made and their subject matter. Two major processing changes that impacted the environment were resin-coated paper and silver recovery. Introduced in 1972, resin-coated printing papers reduced a photograph's washing time by limiting the print's absorption of chemicals. In 1977, the Hunt Brothers, American millionaires, attempted to corner the world market in silver. This caused the price of silver to soar, albeit briefly. As a result, black-and-white photographic paper, whose image is formed by silver halides, experienced a fourfold increase in price. Although the price of silver decreased, the price of the paper did not, and silver recovery became much more widely practiced. Public pressure and new environmental standards have made industrial pollution less acceptable, which has changed photographic processing and chemistry.

The larger industry trend of converting from traditional film and print photography to digital imagery also is somewhat driven by the desire to reduce pollution and the use of new materials. Digital photography eliminates chemical, film, and paper processing. Since digital prints can be produced by direct scanning into a computer, the need for water-polluting chemicals and silver salts is eliminated.

Photographs are not only changing physically, their subject matter is changing as well. As developing nations emerge, instantaneous global communication, via the Internet, and interdependent economies make people more aware of each other, and there is a renewed interest on the part of the industrialized West in understanding developments in other cultures. Photography of or from these cultures becomes increasingly noticed and available. In multiethnic societies, such as those of the United States and in Latin American countries, there is a renewed interest in regional and ethnic self-awareness. As we shall see in this overview and in the readings that accompany this chapter, photographers of color are now imbuing the photographic subject with the resonance of personal and political history.

The art world atmosphere that contextualized these events for photography was the emergence of postmodernism. Overall, postmodernism can be defined as a breach with the modernist tenet of producing images and objects that were formally strong. "Art (used) to call attention to art," to quote the critic Clement Greenberg. In painting, primarily formal art movements such as Cubism and Abstract Expressionism demonstrate modernism's attention to the painting as a flat surface, upon which the artist created a design. In chapters 1 and 2, modernism in photography was defined as a conscious attempt on the part of the photographer to emphasize not only a strong composition but those elements of photography such as focus and framing that separate photography from painting and the other arts. In modernism, formal visual elements

are the prime definers of style. As a result, the boundaries and characteristics of each medium are clear. Painting and photography, for example, are talked about in terms of their differences rather than their similarities.

Hence, no medium, including photography, can embody a complete world view. By the end of the twentieth century, modernism's belief in photography as a formally coherent world view is undercut and replaced with a belief that the photography on its own is an incomplete statement. As a result, in postmodernism, media boundaries are crossed and recrossed. Postmodernism is not so much a style as it is a collection of ideas and attitudes toward art, primarily the product of ideas from Marxism, feminism, and texts that deconstruct our commonly held assumptions about the meanings that objects convey. It is a rejection of a belief in individual artistic genius and the uniqueness of the work of art. Content is more important than form, and rather than break from the past, postmodernism borrows from it. Photography is seen as part of a larger cultural and historical continuum, which includes painting and the graphic arts as well as film, television, video, and the computer. It also appropriates a variety of cultural stereotypes, and exaggeration and repetition replace subtlety and uniqueness. In postmodern art, objects often are not what they appear to be visually, rather their meanings must be discerned by trained connoisseurs.

As photography moves from modernism to postmodernism, it emerges into an art world that emphasizes photography's relationship to popular culture, while it challenges its claim to be a document. In doing so, it readdresses issues of race, class, gender, and the environment by fabricating realities in which the subject and photographer often collaborate. Sometimes the photographer is the subject and the works become personal cultural criticisms. In postmodernism in general, the arts have become reactive. Art is offered more as a commentary than as a defining statement about the world, as modernist photography often was. In the writings that follow, the photography of Jo Spence and Cindy Sherman, contemporary photographers who have participated as subjects in their own serial works, will be examined. Both have created identities for themselves by using their bodies and gestures. Both draw on widely understood female cultural stereotypes to critique the culture they depict. Spence evokes painful memories of her British working-class youth and adulthood. In the 1980s, in her first major work, the better-known Sherman presents us with a range of female characters culled from cinema and presented as movie stills. Sherman began her one-frame movies in 1978 by directing herself in front of her own still camera, as she portrayed female stereotypes appropriated from films, television shows, and commercials of the 1950s and 1960s. These black-and-white prints, called "Untitled Film Stills," are fabricated photographs in which Sherman is the actor, photographer, and art director. From these beginnings, she expanded her themes and photographs to include cibachrome color prints in six-foot formats, which portrayed scenes derived from horror films, fairy tales, and soft-core pornography. Sherman, as subject, was disguised with false noses, breasts, and other body parts. In a logical outgrowth of this substitution of the human for its inanimate replica, dummies were also given key roles by the photographer. In

her more recent work, she has fabricated "old master" photographs by posing as a subject in photographs that emulate the paintings of "old masters" such as Holbein, Goya, or Caravaggio. Sherman presents photography as a series of parodies of high art, thus breaking down traditional hierarchies in painting by using photography, that very democratic of mediums, to create a postmodern statement about the dissolution of media boundaries. Like Sherri Levine, who has rephotographed famous works by male photographers such as Weston, or like Barbara Kruger, who uses images appropriated from advertising, Sherman uses photography to question the importance of authorship, originality, and form. Sherman, Levine, and Kruger understand that to alter the context of an image is to alter its meaning in our culture. Like many artists who fabricate a work to photograph it, the deliberate artifice in Sherman's work reinforces the viewer's sense of a world described by culture rather than nature. The difference and the dialogue between nature and culture provokes much of the debate about sex and gender in late twentieth-century art.

Although the Stonewall riot which marked the beginnings of gay liberation occurred in 1969, photographs addressing gay culture became internationally important only in 1980. These photographs were made by Robert Mapplethorpe, who photographed flowers with the same crystalline and posed elegance that he photographed often phallic male nudes and men engaged in homosexual and sadomasochistic sex. Like Arbus, Mapplethorpe makes visible what was formerly unseen, but he presents it in a way that turns postmodernism on its head. In his sexually explicit pictures, Mapplethorpe strives for a composition and print quality that overrides content in its polished beauty. Form carries us to the content in his work, and all subjects are morally alike. Along with the sexually explicit content of Mapplethorpe's work, this moral equivalency caused a censorship debate that brought the issues of obscenity and homosexuality into the forefront of American popular culture. Because Mapplethorpe's 1988 exhibit *The Perfect Moment* was funded through the National Endowment for the Arts, it sparked a debate about the propriety of funding controversial art with public monies. This dialogue also was about censorship and the public's reaction toward a newly visible sexuality that had never until now appeared with such entitlement in such a public arena.

Sexual cultures are not the only cultures reconsidered from within. Photographic history enters prominently into the area of cultural studies from approximately 1980 on. One of the books published at the beginning of this period that exemplifies this interest is Judith Mara Gutman's 1982 book *Through Indian Eyes*. It is the story of what happened to photography when it first arrived in India in 1840. The book's pictures concentrate on portrait and documentary photography of the late nineteenth to the early twentieth century. It is the first book in the history of photography to explain the appearance of a non-western photograph using the aesthetic system of a non-European culture. *Through Indian Eyes* suggests that Indian visual conventions of patterning and space in painting are present in Indian photographs as well. Gutman offers textual and visual proof that photography is not a transparent medium that looks the same way in

all cultures. In India, its Europeaness was often transformed by painting on the picture using traditions borrowed from Indian miniature portrait painting. Even when the photographs were not overpainted, they show an Indian interpretation of space that gives them a "foreign" look to Western eyes. Through an international approach to cultural studies, Gutman questions, as do many postmodernists, photography's value as objective, neutral evidence. At the same time she suggests that the camera is a tool governed by shared cultural assumptions that may vary from culture to culture.

One may compare the photographs made by Indians in this work with the photographs of India made by an American photographer, Mary Ellen Mark. Her 1981 book *Falkland Road* shows photographs of Bombay prostitutes, their clients and their surroundings. The colors, space, and patterns revealed in these photographs sometimes resemble those of Indian miniature painting. Mary Ellen Mark can show her Western viewers that the world described by traditional Indian paintings is grounded in the visual reality of Indian life. Yet, Mark's own use of space and pattern in her photographs is distinctly European-American. She can depict another culture, but her own images, when contrasted with the photographs in Gutman's book, seem grounded in Western visual conventions.

These two books both clarify and echo postmodernism's debate within the framework of cultural studies, which was always a strong and now is a dominant form of photographic criticism. Both photographers and their critics no longer view photography as a transparent medium. Rather, each photograph made reveals the cultural constructions of the photographer, the subject, and the viewer. We see that photography cannot embody all of the world, rather it shows a point of view. In the postmodern world you must stand somewhere. There is no more pretense at objectivity. Unlike modernism in photography, which believed in the objectivity of the lens, the postmodern world believes in the subjectivity of the photographer.

This disjunction between the world view of the photographer and the relative objectivity of the lens is exploited by artists who have previously existed on the margins of the art world. From 1980 to the present, the focus and structure of institutionalized art photography moves from being dominated by North Americans and Europeans to a greater internationalism. For example, 1978 saw the first Latin American photography conference in Mexico City. In the readings that follow, the critic Max Kozloff comments on his perception of the photography he saw during the second colloquium a year later. Although it has been argued that Latin America is a compendium of diverse cultures rather a single continental culture, Kozloff notes some overarching similarities in Latin American photography. He sees lighting and tonality used as conveyers of meaning to document the lives of people under economic pressure. Although Kozloff does not use the term "magic realism" to characterize Latin American photography, it is clear that this is what he is describing. In Latin American art, we are most often exposed to magic realism in literature and painting. In these art forms, magic realism characteristically manifests as a combination of the European influences of Surrealism, combined with the symbols and world view of a people influenced by their in-

digenous Indian past. Latin America is seen as a continent where the surrealism of an intense and dreamlike world can intrude at will in the midst of daily reality.

There is ample evidence that Latin American photography is attracting attention on other continents as well. In 1991, a Latin American photography exhibition in Arles, France, which was held in the context of "International Encounters In Photography," was held. The following issue of *Camera International* magazine, published both in Europe and the United States, was devoted to presenting photographers from the Latin American exhibit, highlighting important individuals, while indicating once again that magic realism is Latin American photography's dominant characteristic.

Continental characterizations are being consistently eroded, however, by photographers who work internationally. The Mexican photographer Pedro Meyer is one example (Fig. 5.1). He moves between Mexico and the United States and has a website that shows his work. Like a number of other artists and arts institutions, Meyer is taking advantage of the cultural phenomenon of "one world" created by the Internet. His most recent work, *Truth or Fiction,* has been published as a book and compact disk. Meyer's internationalism and exposure in both in North and South America is the result of a process whose roots go back to the early twentieth century when modernism emerged in Latin America. In addition to Pedro Meyer, a number of Hispanic photog-

Figure 5.1 Pedro Meyer.
La dama del lunar y sus amigas, 1982.
Black and white ink-jet print.
Copyright © Pedro Meyer.

raphers have recently achieved international prominence. Flor Garduno lives in Switzerland and photographs Mexican folk traditions, and Sebastiao Salgado documents the difficult working conditions faced by day labor all over the world (Fig. 5.2).

More recently, grassroots art organizations that promote a close relationship between the arts and the Hispanic culture at a community level have emerged. In 1974, for example, En Foco, an organization to promote photography by photographers of color, was originally founded in the Bronx, New York, to serve a primarily Puerto Rican constituency. By the early 1990s, it emerged as an organization that now serves as a registry for all photographers of color. It also publishes announcements of grants and exhibits, while its journal *Nueva Luz* is the only journal in the United States that publishes portfolios by minority artists and artists of color from all parts of the world. Similarly, in 1984, the Border Arts Workshop, which promoted Mexican and Chicano artists and writers, was founded in Tijuana, Mexico, and San Diego, California. These events show the merging of the politics of internationalism, postmodernism, and cultural studies with photography, beginning in the late 1970s and the early 1980s.

Figure 5.2 Flor Garduno.
Dreaming Woman. Pinotepa Nacional, Mexico, 1991.
Gelatin-silver print.
Copyright © 1997 Flor Garduno.

In the United States, the Chicano art movement is an example and a case in point. Like postmodernism in photography, which has no particular style but often has a sociopolitical agenda, the Chicano art movement is not so much a style as it is a series of statements about Mexican, Mexican-American, and Indian identities. As politics and art merge, there is a merging of art into everyday life. Art does not exist for art's sake, rather it incorporates political perceptions. In the 1960s, the Chicano political movement grew out of the farmworkers' struggle to unionize in California and Texas. They were joined by dispossessed land grant owners in New Mexico and the urban working classes in the southwestern and midwestern United States. From approximately 1968 to 1975, Chicano visual art usually meant noncommercial posters and murals that influenced the life of the immediately surrounding community, with the idea of making art accessible to all. Founded in 1983, Self-Help Graphics, in East Los Angeles, is an example of this grassroots effort. Self-Help Graphics has encouraged the surrounding community to collect its silk screens and to encourage regional and community artists to print at their facility. At the same time, Self-Help Graphics is part of a larger, more internationally oriented aspect of the Chicano movement, which begins to emerge by 1975. From this time on, there is a closer alignment to international aspects of Latin American culture, including indigenist movements. The themes of Chicano arts and letters are working-class, Indian, spiritual, and revolutionary. Their symbols—the Mexican flag, the image of the Virgin of Guadalupe, the skeletons featured in Mexican Day of the Dead ceremonies—become symbols of contemporary struggle as well-shared international identity. Thus, the Chicano internalizes both the identity of the colonizer and the colonized. In photography, this influences the work of such photographers as Laura Aguilar, who produced a self-portrait showing herself bound and ambivalent toward the cultures of both the United States and Mexico. Other artists, such as Kathryn Vargas, create collaged still lifes that address such disparate subjects as political disappearances in Latin America and death as a symbol in Mexican art.

A different kind of cultural dualism is emerging in the work of Native American photographers. Although Native Americans in the United States created a Native American civil rights movement in the late 1960s, it was in 1990, in Quita, Ecuador, that the first intercontinental gathering of indigenous peoples of the Americas took place to mobilize against the 1992 sesquicentennial of Columbus's voyage of discovery. The year 1990 also saw the first major exhibition of Native American photography. Called "Language of the Lens, Contemporary Native American Photographs," the exhibit originated at the Heard Museum in Phoenix, Arizona, which has an international reputation for its collections and exhibitions of Native American culture. The exhibit featured ten Native American photographers, many of them women. A common thread in these images is the problem of maintaining one's native identity in the face of white culture. In this exhibit, two artists, Carm Littleturtle and Hulleah Tsinhnahjinnie, use hand-colored prints to comment on such issues as the relations between the sexes, Native American response to pending legislation, and the encroachment of industrial society on Native American culture.

During the postmodernist period, African-American photography starts to turn away from documenting the civil rights movement and the external side of black culture and begins to show how Americans as a culture internalize issues of race and gender. Lorna Simpson and Carrie Mae Weems are two artists who are recognized contributors to this dialogue. Both photographers use serial imagery and text to create situations where the viewer must confront his or her own attitudes toward race in North American culture. Both artists also exploit the slippage that exists between the mechanical qualities of the lens, with all of its connotations of European natural philosophy, science, and cultural colonialism, and their intensely personal vision of what it means to be black and female in the United States. In the late twentieth century, cultural diversity is both a fact of life as well as a part of an ongoing social debate. Varying cultures embody postmodernism's rejection of a universal text to describe all human experience. Postmodernism separates personal and subcultural experiences from the dominant culture. It sees knowledge as contextual, with a dialogue from differing positions taking priority over consensus. Multiculturalism in photography is an important expression of this postmodernist stance, just as the constructed or fabricated photograph or "piece" becomes an important postmodernist technique.

One can trace the lineage of the fabricated photograph from composite printing of the nineteenth century, through constructivism and surrealism in the 1920s and 1930s, to the multiple imagery that artists such as Uelsmann espoused during the 1960s. Beginning in the late 1970s, photographers start constructing scenarios that they then photograph. This world is both real, because it exists to be photographed, and fictitious, because it is essentially a set design including actors, a sort of tableau vivant, a set with living characters, similar to the Hollywood sets the photographers imitate. The prints the fabricators make often are the result of collaboration. One American photographer, Patrick Nagatani, creates pieces that center on the problems surrounding nuclear weapons. From 1983 to 1989, he collaborated with set designer Andree Tracy; now he works with a number of people, employing them as models, set assistants, and photographic assistants. His photographs often feature household objects or model airplanes hanging on filament to simulate action, the way objects used to be suspended on movie sets before the advent of computer-generated special effects. Nagatani is not the only photographer who is creating sets. Sandy Skogland, Joel Peter Witkin, and Cindy Sherman are among the contemporary artists who create pieces to be photographed.

Their work, like Nagatani's, addresses several practices pointing to a changing position for photography. While these fabricated works share in film and photography's illusionism, they also demonstrate a postmodernist concern with the dissolution of media boundaries and a decline in interest in the photograph as evidence. The postmodern photograph is not important because it is true, it is important because of its mimesis or its ability to imitate reality. Photography gained institutional acceptance as an art form during the period 1960–1980, when conceptual art began to erode media distinctions and the documentary became the province of news programs on television,

not news magazines such as *Life* and *Look*. Photographic mimesis is now in the service of personal visions that address social and political issues.

For Nagatani, an American of Japanese descent, nuclear war was especially important and his work deals with nuclear bombing of the Japanese cities of Hiroshima and Nagasaki by the United States in 1945. Nagatani also is concerned with the environmental impact of current nuclear military development sites in New Mexico, where he lives (Fig. 5.3). His work shows the impact that contemporary issues of cultural pluralism and environmentalism have on photographic subject matter. These constructed photographs are a species of stilled action shots in which the culmination of an entire piece is miraculously encapsulated in one image. The decisive moment described by Cartier-Bresson in 1952 becomes the constructed moment of the 1980s.

Postmodernism's acceptance of mimesis over the documentary also was shown in the growth of holography as an art form during the 1980s and 1990s. Although

Figure 5.3 Patrick Nagatani.
"Nike-Hercules Missile Monument, St. Augustine Pass, Highway 70, White Sands Missile Range, New Mexico," 1989.
Chromogenic color print, 17" x 22" (Ilfocolor RA).
Albuquerque Museum. Copyright © Patrick Nagatani.

holography, three-dimensional, laser-generated photography, was invented in 1960, it was not until the mid-1980s that a body of holography work began to emerge. Holograms can be made to appear in front of or behind a surface, and they change visually depending on the viewer's position. They often are compound images that reveal new ones as the viewer moves interactively around the exhibit. In holography, the three-dimensional illusionism of a two-dimensional surface is carried to its logical extreme. Holograms were photography's first venture into virtual reality and are often combined into multimedia displays. Their dependence on the personal perspective of the viewer and their illusionism visually links them to postmodernism and to the photographs of the future.

In 1996, Advanced Photosystems cameras were put on the market. These cameras are the result of a multinational collaboration between the world's largest film and camera companies: Kodak, Nikon, Minolta, Canon, and Fuji. As many as forty companies have licensed these innovations and are developing products for the consumer market. At a price consumers can afford, this multinational corporate effort provides the photographer with film that can be programmed to change format and can store magnetic information on the edges and surface of the film itself. The film cassette stores the negatives after printing, while the photographer can order any print from an index provided. The marketing information suggests to the consumer that the product can be easily scanned into a computer or onto a compact disk for subsequent printing, viewing, or alteration.

Digital cameras are now available, but technical and cost problems remain. These cameras still have difficulty stopping motion. Digital cameras that are capable of creating photographs that are more detailed than analog images from a conventional camera cost thousands of dollars and are still out of reach of the average consumer, therefore, their impact on the amateur photographer is still minimal. However, the new Advanced Photosystems cameras and film are paving the way for a growing acceptance of the digital still photograph. The system is being marketed as a product that is superior, thus because it can be manipulated to produce that perfect picture using a computer after the exposure. This marketing undercuts any belief held about photography being evidence. Although many consumers are perfectly aware that images they see on television or in magazines have been digitally altered for the last twelve or so years, participating as an amateur in these alterations is a new phenomenon and is meant to ensure public acceptance of digital cameras as they become affordable to photographers on this level. Consumers are now being asked to participate firsthand in photography as pseudo-documentary fiction.

Although personal computers have been available at an affordable price to the public since about 1988, it is only since the mid-1980s that the home computer has had the memory to make much use of images. Computers are now in a position to extend the individual's understanding of photography, whether through the professionally generated computer images or through home-based retrieval and manipulation. Computers also are changing the way we exhibit images that currently must be retrieved on

a screen or output to hardcopy. The digital photograph is now viewed as a matrix from which a variety of images or objects can be produced. Conversely, the photograph may be seen as a simple part of a complex whole that can include other graphics, type, and sound. Photography today is sold as media, to be altered and incorporated.

The search for an ever-more virtual reality has been part of photography since its inception in the nineteenth century, when stereo photographs produced the illusion of three-dimensional depth. Now it is possible to connect a virtual reality consisting of sight and sound directly to the nervous system by means of virtual reality helmets. This apparent imitation of the world presents new problems in the use and analysis of photographic images. Constructions or reconstructions of objects and sites can replace photographs of landscapes, buildings, and other people. Computers are changing the nature of scientific inquiry, just as photography has since 1839. Before the invention of photography, it was not possible to reproduce the individual characteristics of an object exactly, nor was it possible to make reproductions of an object that looked the same as the original. Current computer modeling technology enables the user to construct either a schematic vision of a subject or use the computer to actually model an object. An example of the first instance is a computer model of an atom or molecule, where the structure is schematized. To actually model an object, computers also can be programmed to guide machines to make a three-dimensional object that exists outside the computer. The computer is a flexible medium that can create a two-dimensional screen reality, a three-dimensional projection on the screen, or a precise three-dimensional generated model that actually has weight and takes up space. Like photography in the nineteenth century, computers are beginning to generate a new world view of which photography is only now a limited part.

We must learn the conventions of the computer's reconstructions of the world if we are to determine their accuracy (i.e., their real-world uses as a guide to three-dimensional reality). Computers, for example, have their own way of imaging color that has expanded our aesthetics of color. Techniques of superimposing images are currently influenced not only by techniques of montage, or scene cutting film, but by computer screen windows. We still need an interface other than a computer keyboard to experience these reconstructions and to be able to program them. We also need changes in copyright laws and electronic copyright protection to make the dissemination of images possible, while preserving their creators' rights.

This dissemination of images and their appropriation and alteration is rapidly increasing. Computers are not only a new media, they are making all images and objects into media. Photographs, writing, and drawings all appear routinely now, subordinate elements in a hypermedia whole. The seamlessness with which this media montage may be accomplished supersedes the hyperreality and montage of Surrealism in the first part of the twentieth century. This hyperrealism and hypermedia montage is as natural a method of image construction for the computer as is the series for the still photograph. Computers are an inherently more transparent and egalitarian instrument than the camera, for information can be presented in a variety of formats and changed

at will. The creators and receivers of this information can be invisible to each other and not be bound by considerations of age, sex, race, nationality, or class. Information also can be sent globally in a matter of minutes to and from a worldwide web. The cultural phenomenon of one world is now here on the Internet.

In contrast, the era of the unmanipulated silver print has passed. Conventional photography will probably be used for many years to come for specific scientific or artistic uses. However, its central position as a visual medium has been irrevocably changed. Collecting the works of major analog (non-digital) photographers is now more important than ever to preserve a history of the medium. Soon, only people who wish to make images where the quality of the silver print as image and object are important will be making black-and-white photographs. Valuing the photograph primarily for its quality as a print will put photography in the same position today as the more traditional print media, such as etching or lithography. Just as these processes and others were replaced by photography or photographic hybrids such as photogravure or photolithography, photography today is being replaced by computers or becoming part of hypermedia. The industrialized world is moving from a society that has a camera or television in most homes, to a society that has a computer and peripheral machines (such as a digital camera) in most homes

Computer information is rapidly becoming more accessible to the individual household, as well as to government and business. France and Singapore are among those nations in the forefront of civilian networking. In 1983, a national computer network was established in France to provide over 12,000 services to French home computers. Singapore's government has used its computer system to maintain giant electronic databases that store information about individual citizens, as well as store information about such things as buildings and businesses.

The ability to produce data is one of photography's prime functions. The history of creating this data has moved consistently toward four technical and social goals: (1) low cost; (2) ease of operation; (3) immediacy of result; and (4) an ever-increasing fidelity to the real world. It may be said that the digital photograph or pixelgraph is the logical outcome of photography's earliest mission Yet it cannot be denied that photography, as we know it, is rapidly being replaced with the visual equivalent of what Truman Capote called the non-fiction novel. At the end of the twentieth century, we have stepped into the age of the fictionalized and digitized photograph.

EXCERPTS FROM THE PERIOD 1980–2000

"The Self-Reflexive Camera." (1989)
*Estelle Jussim**

". . . Photographers in the postmodernist era are pressed to defend the very activity of image making. No longer trusted for its presumed objectivity and transparency, no longer the reliable guide to visual "truth," documentary photography has had its authority devastated by technologies like computer graphics (which can dismantle a photograph, remove some of its parts, and reconstitute it as if it were an original), and the mass media (which trivialize each event, hypnotize our children, and increase the likelihood of violence from terrorists and neighborhood punks).

"Yet it never seems to occur to many photographers to ask themselves certain painful questions: Why photograph? What is left to photograph? What does a photograph convey? Is photography, in the words of Susan Sontag, cannibalizing experience? Are we any longer able to see the world except as reified image?. . . . The contemporary photographer must ask what it means to have outlived modernism. . . .

"What does a postmodernist photographer do? Rejecting aestheticism as irrelevant to the production of images are four considered to be postmodernists: Sherrie Levine, Cindy Sherman, Barbara Kruger, and Martha Rosler.

"Levine, before turning recently to making watercolor copies of El Lissitzky paintings, would photograph a photograph by, say, Walker Evans, and sign her name to it. *Appropriation,* after all, is the key to postmodernism. If architects can appropriate Palladio, Alberti, and McKim-Mead-and-White, if Philip Johnson can mount the back of a Chippendale chair on top of a skyscraper, if post offices can sprout gothic revival towers, why should not a photographer appropriate the modern "masters" of photography? This is not simple plagiarism. . . .

"To adapt Linda André's useful paradigm, from "The Politics of Postmodern Photography" (*Afterimage,* October 1985), to looking at a Sherrie Levine copy of a Walker Evans, we are to imagine the experiences of three different gallery-goers. The first viewer, unfamiliar with Walker Evans, assumes that Levine is a documentarian. The second viewer recognizes the image as a famous one by Evans, and therefore notes that Levine's photograph is a copy, but is hazy about how to react. The third viewer, a sophisticate who has read Roland Barthes, instantly understands Levine's commentary on the strategy by which Walker Evans conventionalized and mythologized everyday scenes so that they can be considered "Truth." Thus Levine's appropriated images are to be considered coded messages, to be interpreted only by a knowledgeable audience.

"This characteristic of postmodernism—addressing elites with special knowledge—assumes an entirely different purpose in the photographs of Cindy Sherman. We see Sherman herself posing as a terrified starlet in a 1950s *film noir* encounter with an always unseen villain (the personification of female terror), as a vapid lingerie model, as a screeching opera diva, or as other manifestations of the stereotypes of women. All of these impersonations embody male fantasies about women and are directed against men who would like to create permanent and humiliating identities for women. But the notion of using stereotypes for commentary presupposes that we all maintain a thesaurus for common meanings, an iconography of popular culture. Unfortunately, there can be no assurance that a general audience, male or female, will recall the origins of Sherman's recreations or, that recalling these, will provide meaning beyond the fleeting pain or pleasure of recognition.

"While the ambiguities inherent in her program have confused critics who see her as engaging in narcissistic posturing, it seems clear that Cindy Sherman is attempting to frame stereotypes with Roland Barthes' notion of the "mythology" of socially distributed images. Why, she asks, do men enjoy gazing at women who are being terrified by men? How do stereotypes evolve and become models of communicative behavior while being incorporated on an unconscious level by individuals? How do they change into new models, and what is the role of photography in accomplishing such change? Since Sherman's images are fundamentally antiaesthetic and antiformalist, she belongs in the vanguard of photographic postmodernism. Not only does she appropriate images (or styles of images) and recreate them, but she comments on their status within the ideological structures of specific societies. Ultimately, her goals are political (Fig. 5.4).

"In the work of Barbara Kruger, we find photographs as large as the posters in New York subway stations, with words sutured onto the body of the photograph, creating a new kind of politicized poster. The basic operation of imposing words onto images elicits a variety of reactions. One of her best-known "posters" contains the upside-down head of an attractive woman, facing us as if she were resting on grass. Her eyes are covered with two eye-shaped leaves. The words that slash into the picture, set in boldface modern typography, are *We won't play nature to your culture* (an attack on the stereotype of Man = Intellect and Art; Woman = Body and Fecundity). In another montage, the scrambled fragments of what must have been the head of the Venus de Milo underlie the ferocity of *Your fictions become history*. On a nuclear mushroom cloud that fills the rectangle, we read *Your manias become science*. A group of men clasping, thumping, and pulling at another man, all the while grinning and laughing, are injected with *You construct intricate rituals which allow you to touch the skin of other men.*

"In a brilliant essay about Kruger, "The Medusa Effect, or the Spectacular Ruse," Craig Owens observed, "Many artists today work within the regime of the stereotype, manipulating mass-cultural imagery so that hidden ideological agendas are exposed—or so it is supposed. But most of these artists treat the stereotype as something arbi-

Figure 5.4 Cindy Sherman.
Untitled #146, 1985.
Chromogenic color print, 72½" x
49¾."
Courtesy Metro Pictures.
Copyright © Cindy Sherman.

trarily imposed upon the social field from without, and thus as something relatively easy to depose. Kruger, however, regards it as an integral part of social processes of incorporation, exclusion, incorporation and rule—that is, as a weapon, an instrument of power." Kruger is not attacking stereotypes for the purpose of raising consciousness in an intellectually or emotionally barren maneuver. She intends to stop us in our tracks, to make us reconsider, to force us to work at deciphering her messages.

"Martha Rosler, by contrast, has no faith in either words or images as transmitters of messages. In her sequence, *The Bowery in Two Inadequate Descriptive Systems* (1974–75), Rosler alternates photographs of Bowery buildings and storefronts with pages of scattered typewritten words that are slang or vernacular equivalents to "drunkenness." Unlike the captions in picture magazines, which are intended to clarify or "name" the contents of a picture (since no photograph names itself), these word clusters explain nothing in the picture and the picture explains nothing about the words." . . . In addition, she is convinced that photographing the victims of a society exploits them; it is a collaboration with the system responsible for their condition, and a serious misinterpretation of what is real.

"Along with many of her postmodernist colleagues, Rosler rejects photography as a reliable way of documenting reality. Strongly influenced by recent French theorists, she is an advocate of one of their fundamental propositions: since "reality" is always *represented* to us through symbol systems, it can never be known "as it is." Representation can never deliver reality. It follows, then, that the supposed realism of reform-minded photographers like Dorothea Lange, Margaret Bourke-White, and the Walker Evans of *Let Us Now Praise Famous Men,* is a hoax. . . . "The photographs are powerless to deal with the reality that is totally comprehended-in-advance by ideology. . . ." For Rosler, it is apparently insufficient that the Farm Security Administration photographs of Great Depression victims of the dust bowl aroused the American public and Washington legislators to some recognition of the disasters overwhelmingly poverty-stricken families. Using victims as the propagandistic content of photographs reveals only the smallest fraction of what their lives encompass.

"Extreme as Rosler's stance may seem, it calls into question aspects of documentary as a strategy for "truth" already under attack from many quarters. Given its history as the quintessential focus for arguments about theories of representation, photography has remained controversial. It is not only the purported realism of photography that is mistrusted, but art photography—which makes no pretense at representationalism—is also regarded with hostility by modernist, Marxist, and postmodernist critics alike.

". . . Demanding above all else originality and innovation, the embattled avant-garde of early modernism saw photography as an all-too-easy method of both capturing and duplicating images. Photography was therefore a distinct threat to the notion of the original genius who was expected to rise above politics, social concerns, and the "real world" itself in order to achieve eternal fame and metaphysical transcendence.

"To outraged postmodernist critics, such lack of political commitment was not the only moral failing of modernist photography. In the 1970s, there was a stupefying inflation of the prices of all art. . . .

"For Marxist critics like Lucy Lippard, the price inflation of photographs is not a sign of social utility but a symptom of the cooptation of a medium, once used to social advantage by the likes of Lewis Hine, into "commodity fetishism." To Lippard, photography has to serve the revolution, especially in the Third World. Also an ardent feminist, she declares that the vital contribution made by feminism to "the future of art" is precisely "its lack of contribution to modernism.". . . Modernism had not only rejected drama and anecdote in images (along with realistic photography), but, in Lippard's view, it also dismissed the rich heritage of women's "anonymous" works. . . . As she puts it in *Get the Message? A Decade of Art for Social Change* (1984), "The goal of feminism is to change *the character of art.*" Such change, she asserts, requires a sense of community among artists, a commitment to political action, a rejection of self-referential art, and, of course, the abolition of exclusive privilege for males in museums, galleries, and the academy.

"If Lippard argues for changing "the character of art," and therefore for a pho-

tography no longer aesthetic but revolutionary, it seems obvious that her concept of change does not challenge photography as a tool of propaganda. Photography can be trusted to relay messages. Sherrie Levine, Cindy Sherman, Barbara Kruger, and Martha Rosler do use photography for message making, but not naively. If persuasion and propaganda are their aims, they see photography as a coded system for cryptically attacking the methods and content of representation. But to attack representation *by means of* representation is a subtle and often difficult pursuit.

"Martin Heidegger once called this "The Age of the World Picture."...."Nothing in the world, he contended, *exists any longer* except in and through representation, that is, in images. . . . Our understanding of the world, our relationship to that world, our relationship to each other and to ourselves, therefore, depends entirely on who is representing the world to us. Each maker of images believes that he or she will decide on what is to be pictured, and how "it" will be pictured. . . .

"The postmodernist rejects such privileged creation. The stereotypes attacked by Kruger, Sherman, and Rosler are the products of image makers who demand the imposition of their exclusive "world picture" on the realities of others. Representation is not merely the imitation of nature, but includes *who and what are being represented, and by whom, for what purposes (conscious or unconscious), and with what effect on which viewers.* . . .

"Not everyone sees postmodernism as the healthy antithesis to modernism, no matter how needed were the attacks on representation. At least one critic, Charles Newman, in *The Post-Modern Aura* (1985), sees postmodernism as "an uneasy amalgam of high modernism and popular culture." Mocking modernism's high seriousness and its emphasis on art as a sanctuary "when the evidence suggests that it can be clearly a maze, a prison, a battlefield, a gladiola, or anything else one wants to make of it," Newman observes that post-modernists punctured the pretentiousness of modernism. Postmodernism does, indeed, amalgamate aspects of modernism with popular culture, but only to use a few strategies of assemblage or collage to invite a political attack on representation or to create multiple images that "read" like sentences. Unlike some modernists, who believed that the art object was an independent totality unto itself, the postmodernist demands the intellectual participation of the audience. The postmodernist working with photography insists the image is completed only in the viewer's mind, and the strategy is to force the viewer away from aesthetic contemplation toward an understanding, or at least an awareness, of a message.

"Photographers who have abandoned the photographic modernists' insistence on "straight photography" (the unmanipulated print), combining words with pictures, painting on prints, or fabricating situations and objects to be photographed, are not necessarily postmodernists. To certify as a postmodernist, a photographer must also challenge the photograph as a reliable, or even rational, system of representation, and deny its aesthetic intent. . . .

"Photography, despite its seemingly intrinsic bias toward realistic representation, had imitated the modernists, attempting both idealism and transcendence through a

pursuit of abstraction. So much abstraction was produced in all the visual media that the world seemed emptied of people, trees, rocks, and emotional realities. . . .

"To accept what Roland Barthes called "The Rhetoric of Images" is to submit to uncertainty, for if modernism lies dead, then formalist aesthetics, as a method of judging or responding to images, is also about to be buried. Yet, we must grant postmodernism its own heroic status; it has forced us to pluck ourselves out of a dream world of acquiescence and into a recognition of what images do to us."

"The Photographic Activity of Postmodernism." (1980)
Douglas Crimp*

It is a fetishistic, fundamentally antitechnical notion of art with which theorists of photography have tunneled for almost a century, without, of course, achieving the slightest result. For they sought nothing beyond acquiring credentials for the photographer from the judgment-seat which he had already overturned.

—Walter Benjamin, "A Short History of Photography"

"That photography had overturned the judgment-seat of art is a fact which the discourse of modernism found it necessary to repress, and so it seems that we may accurately say of postmodernism that it constitutes precisely the return of the repressed. Postmodernism can only be understood as a specific breach with modernism, with those institutions which are the preconditions for and which shape the discourse of modernism. These institutions can be named at the outset: first, the museum; then, art history; and finally, in a more complex sense, because modernism depends both upon its presence and upon its absence, photography. Postmodernism is about art's dispersal, its plurality, by which I certainly do not mean pluralism. Pluralism is, as we know, that fantasy that art is free, free of other discourses, institutions, free, above all, of history. And this fantasy of freedom can be maintained because every work of art is held to be absolutely unique and original. Against this pluralism of originals, I want to speak of the plurality of copies.

"Nearly two years ago in an essay called "Pictures," in which I first found it useful to employ the term *postmodernism,* I attempted to sketch in a background to the work of a group of younger artists who were just beginning to exhibit in New York. I traced the genesis of their concerns to what had pejoratively been labeled the theatricality of minimal sculpture and the extensions of that theatrical position into the art of

*This paper was first presented at the colloquium "Performance and Multidisciplinarity: Postmodernism" sponsored by *Parachute* in Montreal, October 9–11, 1980, and subsequently published in *October 15* (Winter 1980). Copyright © 1980 Massachusetts Institute of Technology and October Magazine Ltd.

the seventies. I wrote at that time that the aesthetic mode that was exemplary during the seventies was performance, all those works that were constituted in a specific situation and for a specific duration; works for which it could be said literally that you had to be there; works, that is, which assumed the presence of a spectator in front of the work as the work took place, thereby privileging the spectator instead of the artist.

"In my attempt to continue the logic of the development I was outlining, I came eventually to a stumbling block. What I wanted to explain was how to get from this condition of presence—the *being there* necessitated by performance—to that kind of presence that is possible only through the absence that we know to be the condition of representation. For what I was writing about was work which had taken on, after nearly a century of its repression, the question of representation. I effected that transition with a kind of fudge, an epigraph quotation suspended between two sections of the text. The quotation, taken from one of the ghost tales of Henry James, was a false tautology, which played on the double, indeed antithetical, meaning of the word *presence*: "The presence before him was a presence."

"What I just said was a fudge was perhaps not really that, but rather the hint of something really crucial about the work I was describing, which I would like now to elaborate. In order to do so, I want to add a third definition to the word *presence.* To that notion of presence which is about *being there,* being in front of and that notion of presence that Henry James uses in his ghost stories, the presence which is a ghost and therefore really an absence, the presence which is *not there,* I want to add the notion of presence as a kind of increment to being there, a ghostly aspect of presence that is its excess, its supplement. . . .

"This is precisely the kind of presence that I attributed to the performances of Jack Goldstein, such as *Two Fencers,* and to which I would now add the performances of Robert Longo, such as *Surrender.* These performances were little else than presences, performed tableaux that were there in the spectator's space but which appeared ethereal, absent. They had the odd quality of holograms, very vivid and detailed and present and at the same time ghostly, absent. Goldstein and Longo are artists whose work, together with that of a great number of their contemporaries, approaches the question of representation through photographic modes, particularly all those aspects of photography that have to do with reproduction, with copies, and copies of copies. The extraordinary presence of their work is effected through absence, through its unbridgeable distance from the original, from even the possibility of an original. Such presence is what I attribute to the kind of photographic activity I call postmodernist.

"This quality of presence would seem to be just the opposite of what Walter Benjamin had in mind when he introduced into the language of criticism the notion of the aura. For the aura has to do with the presence of the original, with authenticity, with the unique existence of the work of art in the place in which it happens to be. It is that aspect of the work that can be put to the test of chemical analysis or of connoisseurship, that aspect which the discipline of art history, at least in its guise as *Kunstwissenschaft,* is able to prove or disprove, and that aspect, therefore, which either admits the work of

art into, or banishes it from, the museum. For the museum has no truck with fakes or copies or reproductions. The presence of the artist in the work must be detectable; that is how the museum knows it has something authentic.

"But it is this very authenticity, Benjamin tells us, that is inevitably depreciated through mechanical reproduction, diminished through the proliferation of copies. "That which withers in the age of mechanical reproduction is the aura of the work of art," is the way Benjamin put it. But, of course, the aura is not a mechanistic concept as employed by Benjamin, but rather a historical one. It is not something a handmade work has that a mechanically made work does not have. In Benjamin's view, certain photographs had an aura, while even a painting by Rembrandt loses its aura in the age of mechanical reproduction. The withering away of the aura, the dissociation of the work from the fabric of tradition, is an *inevitable* outcome of mechanical reproduction. This is something we have all experienced. We know, for example, the impossibility of experiencing the aura of such a picture as the *Mona Lisa* as we stand before it at the Louvre. Its aura has been utterly depleted by the thousands of times we've seen its re- production, and no degree of concentration will restore its uniqueness for us.

"It would seem, though, that if the withering away of the aura is an inevitable fact of our time, then equally inevitable are all those projects to recuperate it, to pretend that the original and the unique are still possible and desirable. And this is nowhere more apparent than in the field of photography itself, the very culprit of mechanical re- production.

"Benjamin granted a presence or aura to only a very limited number of pho- tographs. These were photographs of the so-called primitive phase, the period prior to photography's commercialization after the 1850s. He said, for example, that the peo- ple in these early photographs "had an aura about them, a medium which mingled with their manner of looking and gave them a plenitude and security." This aura seemed to Benjamin to be a product of two things: the long exposure time during which the sub- jects grew, as it were, into the images; and the unique, unmediated relationship be- tween the photographer who was "a technician of the latest school," and his sitter, who was "a member of a class on the ascendant, replete with an aura which penetrated to the very folds of his bourgeois overcoat or bowtie." The aura in these photographs, then, is not to be found in the presence of the photographer in the photograph in the way that the aura of a painting is determined by the presence of the subject, of what is photographed, "the tiny spark of chance, of the here and now, with which reality has, as it were, seared the character of the picture." For Benjamin, then, the connoisseurship of photography is an activity diametrically opposed to the connoisseurship of painting: it means looking not for the hand of the artist but for the uncontrolled and uncontrol- lable intrusion of reality, the absolutely unique and even magical quality not of the artist but of his subject. And that is perhaps why it seemed to him so misguided that photographers began, after the commercialization of the medium, to simulate the lost aura through the application of techniques imitative of those of painting. His example was the gum bichromate process used in pictorial photography.

"Although it may at first seem that Benjamin lamented the loss of the aura, the contrary is in fact true. Reproduction's "social significance, particularly in its most positive form, is inconceivable," wrote Benjamin, "without its destructive, cathartic aspect, its liquidation of the traditional value of the cultural heritage." That was for him the greatness of Atget: "He initiated the liberation of the object from the aura, which is the most incontestable achievement of the recent school of photography." "The remarkable thing about [Atget's] picture . . . is their emptiness."

"This emptying operation, the depletion of the aura, the contestation of the uniqueness of the work of art, has been accelerated and intensified in the art of the past two decades. From the multiplication of silkscreened photographic images in the works of Rauschenberg and Warhol to the industrially manufactured, repetitively structured works of the minimal sculptors, everything in radical artistic practice seemed to conspire in that liquidation of traditional cultural values that Benjamin spoke of. And because the museum is that institution which was founded upon just those values, whose job it is to sustain those values, it has faced a crisis of considerable proportions. One symptom of that crisis is the way in which our museums, one after another, around 1970, abdicated their responsibility toward contemporary artistic practice and turned with nostalgia to the art that had previously been relegated to their storerooms. Revisionist art history soon began to be vindicated by "revelations" of the achievements of academic artists and minor figures of all kinds.

"By the mid-1970s another, more serious symptom of the museum's crisis appeared, the one I have already mentioned: the various attempts to recuperate the auratic. These attempts are manifest in two, contradictory phenomena: the resurgence of expressionist painting and the triumph of photography-as-art. The museum has embraced both of these phenomena with equal enthusiasm, not to say voraciousness. . . .

"That this kind of painting should so clearly see mechanical reproduction as the enemy is symptomatic of the profound threat to inherited ideas (the only ideas known to this painting) posed by the photographic activity of postmodernism. But in this case it is also symptomatic of a more limited and internecine threat; the one posed to painting when photography itself suddenly acquires an aura. Now it's not only a question of ideology; now it's a real competition for the acquisition budget and wall space of the museum.

"But how is it that photography has suddenly had conferred upon it an aura? How has the plenitude of copies been reduced to the scarcity of originals? And how do we know the authentic from its reproduction?

"Enter the connoisseur. But not the connoisseur of photography, of whom the type is Walter Benjamin, or, closer to us, Roland Barthes. Neither Benjamin's "spark of chance" nor Barthes's "third meaning" would guarantee photography's place in the museum. The connoisseur needed for this job is the old-fashioned art historian with his chemical analyses and, more importantly, his stylistic analyses. . . . To begin, there is, of course, the incontestable rarity of age, the vintage print. . . . But this kind of certifiable rarity is not what interests me, nor its parallel in contemporary photographic prac-

tice, the limited edition. What interests me is the subjectivization of photography, the ways in which the connoisseurship of the photograph's "spark of chance" is converted into a connoisseurship of the photograph's style. For now, it seems, we can detect the photographer's hand after all, except of course that it is his eye, his unique vision. (Although it can also be his hand; one need only listen to the partisans of photographic subjectivity describe the mystical ritual performed by the photographer in his darkroom.)

"I realize of course that in raising the question of subjectivity I am reviving the central debate in photography's aesthetic history, that between the straight and the manipulated print, or the many variations on that theme. But I do so here in order to point out that the recuperation of the aura for photography would in fact subsume under the banner of subjectivity *all* of photography, the photography whose source is the human mind and the photography whose source is the world around us, the most thoroughly manipulated photographic fictions and the most faithful transcriptions of the real, the directorial and the documentary, the mirrors and the windows, *Camera Work* in its infancy, *Life* in its heyday. But these are only the terms of style and mode of the agreed-upon spectrum of photography-as-art. The restoration of the aura, the consequent collecting and exhibiting, does not stop there. It is extended to the carte-de-visite, the fashion place, the advertising shot, the anonymous snap or Polaroid. At the origin of every one there is an Artist and therefore each can find its place on the spectrum of subjectivity. For it has long been a commonplace of art history that realism and expressionism are only matters of degree, matters, that is, of style.

"The photographic activity of postmodernism operates, as we might expect, in complicity with these modes of photography-as-art, but it does so only in order to subvert and exceed them. And it does so precisely in relation to the aura, not, however, to recuperate it, but to displace it, to show that it too is now only an aspect of the copy, not the original. A group of young artists working with photography have addressed photography's claims to originality, showing those claims for the fiction they are, showing photography to be always a *re*presentation, always-already-seen. Their images are purloined, confiscated, appropriated, *stolen.* In their work, the original cannot be located, is always deferred; even the self which might have generated an original is shown to be itself a copy. . . .

"At a recent exhibition, Sherrie Levine showed six photographs of a nude youth. They were simply rephotographed from the famous series by Edward Weston of his young son Neil, available to Levine as a poster published by the Witkin Gallery. According to the copyright law, the images belong to Weston, or now to the Weston estate. I think, to be fair, however, we might just as well give them to Praxiteles, for if it is the *image* that can be owned, then surely these belong to classical sculpture, which would put them in the public domain. Levine has said that, when she showed her photographs to a friend, he remarked that they only made him want to see the originals. "Of course," she replied, "and the originals make you want to see that little boy, but when you see the boy, the art is gone." For the desire that is initiated by that represen-

tation does not come to closure around that little boy, is not at all satisfied by him. The desire of representation exists only insofar as it never be fulfilled, insofar as the original always be deferred. It is only in the absence of the original that representation may take place. And representation takes place because it is always already there in the world as representation. It was, of course, Weston himself who said that "the photograph must be visualized in full before the exposure is made." Levine has taken the master at his word and in so doing has shown him what he really meant. The a priori Weston had in mind was not really in his mind at all; it was in the world, and Weston only copied it.

"This fact is perhaps even more crucial in those series by Levine where that a priori image is not so obviously confiscated from high culture—by which I intend both Weston and Praxiteles—but from the world itself, where nature poses as the antithesis of representation. Thus the images which Levine has cut out of books of photographs by Andreas Feininger and Elliot Porter show scenes of nature that are utterly familiar. They suggest that Roland Barthes's description of the tense of photography as the "having been there" be interpreted in a new way. The presence that such photographs have for us is the presence of déjà vu, nature as already having been seen, nature as representation.

"If Levine's photographs occupy a place on that spectrum of photography-as-art, it would be at the farthest reaches of straight photography, not only because the photographs she appropriates operate within that mode but because she does not manipulate her photographs in any way; she merely, and literally, *takes* photographs. At the opposite end of that spectrum is the photography which is self-consciously composed, manipulated, fictionalized, the so-called directorial mode, in which we find such *auteurs* of photography as Duane Michaels and Les Krims. The strategy of this mode is to use the apparent veracity of photography against itself, creating one's fictions through the appearance of a seamless reality into which has been woven a narrative dimension. Cindy Sherman's photographs function within this mode, but only in order to expose an unwanted dimension of that fiction, for the fiction Sherman discloses is the fiction of the self. Her photographs show that the supposed autonomous and unitary self out of which those other "directors" would create their fictions is itself nothing other than a discontinuous series of representations, copies, fakes.

"Sherman's photographs are all self-portraits in which she appears in disguise enacting a drama whose particulars are withheld. This ambiguity of narrative parallels the ambiguity of the self that is both actor in the narrative and creator of it. For though Sherman is literally self-created in these works, she is created in the image of already-known feminine stereotypes; her self is therefore understood as contingent upon the possibilities provided by the culture in which Sherman participates, not by some inner impulse. As such, her photographs reverse the terms of art and autobiography. They use art not to reveal the artist's true self, but to show the self as an imaginary construct. There is no real Cindy Sherman in these photographs; there are only the guises she assumes. And she does not create these guises; she simply chooses them in the way that

any of us do. The pose of authorship is dispensed with not only through the mechanical means of making the image, but through the effacement of any continuous, essential persona or even recognizable visage in the scenes depicted.

"That aspect of our culture which is most thoroughly manipulative of the roles we play is, of course, mass advertising, whose photographic strategy is to disguise the directorial mode as a form of documentary. Richard Prince steals the most frank and banal of these images, which register, in the context of photography-as-art, as a kind of shock. But ultimately their rather brutal familiarity gives way to strangeness, as an unintended and unwanted dimension of fiction reinvades them. By isolating, enlarging, and juxtaposing fragments of commercial images, Prince points to their invasion by these ghosts of fiction. Focusing directly on the commodity fetish, using the master tool of commodity fetishism of our time, Prince's rephotographed photographs take on a Hitchcockian dimension; the commodity becomes a clue. It has, we might say, acquired an aura, only now it is a function not of presence but of absence, severed from an origin, from an originator, from authenticity. In our time, the aura has become only a presence, which is to say, a ghost."

Updated Excerpt from:

"Art Technology and Postmodernism: Paradigms, Parallels, and Paradoxes." (1990)
*Margot Lovejoy**

". . . Electronic imaging capabilities such as digital simulation open up unprecedented critical challenges to the visual field. The computer can produce from mathematical formulas and algorithms completely artificial images which provide a logical model of visual experience and are indistinguishable in appearance from photographs.

A digital image is then a representation made through encoding information about the lights, darks, and colors of reality captured and digitized through any kind of lens or scanning procedure. The computer digitizes electronically scanned information about a scene and transforms it into numerical data which can be made visible as imagery. Once an image's structure of lights and darks— it's "information" has been digitized by the computer into its numerical data space, its picture elements or pixels can be controlled individually. They can be altered, manipulated, weighted, warped, or repositioned to create not only a simulation of a photograph, but also an artificial or parallel "virtual" reality.

Art Journal, Vol. 49, no. 3 (Fall 1990), pp. 259-265. Reprinted by permission of the College Art Association.

"It is thus capable of making invisible alterations to photographs, thereby undermining the accepted "truth," authority, and authenticity of the photograph through a seamless process of retouching and editing. Digital image production exists only as an immaterial image structure or accumulation of data, without physical substance, and does not lead necessarily to the production of a material art object unless the artist makes a conscious decision to translate it into one that can maintain a physical presence within a perceptual field.

"Today's electronic technologies provide possibilities for radically new conceptions of an art based on exchange and interactivity. One notable example is multimedia hypertext technology, which can involve the direct participation of viewers with diverse interests and from distant geographical locations via the Internet. Such innovative activities raise fundamental questions about the relationship between artist and society and about the function of art and the way it is communicated or disseminated. What is to be the role of the museum in an era where such new interactive and participatory forms of art are emerging and where the terms for creating and disseminating art have begun to change so radically? How can public institutions respond adequately to the expanded public need for art that has been created by the very electronic conditions of the postmodern era?

"It is vital to see technology as a form of dynamic leavening in society, a pragmatic agent of growth and change, some of which is positive and some of which is not. Artists in all eras have used whatever tools are at hand to make art and have learned how to adapt new technologies to their needs. The penchant for innovation often leads to further refinement of the tool or toward development of other tools. Because the new electronic ones are ever more complex, no longer innocent, but rather implicated with larger issues within society as a whole, their use is associated also with their inherent possibilities for good or evil, as is all technology. There is no such thing as neutral technology.

"The sixties' concept of an electronic "global village," of a world united through electronic communications, has come a long way. "All the world's a dish" is the current expression. But the shape of world culture growing out of this "dish" is completely different from the utopian one we had in mind in the sixties. Postmodernism represents a global "shift" toward a more pluralistic way of seeing with a broader perspective on political and cultural possibilities. Artists more diverse than ever before are participating in an unprecedented forum for art. They are part of a rapidly expanding cultural exchange of exhibitions, performances, and special projects, a response to the worldwide public need for communicated aesthetic experience created by the new, more democratic conditions of the electronic era."

"Digital Image, Digital Cinema. The Work of Art in the Age of Post Mechanical Production." (1990)

*Roger Malina**

". . . The computer is foremost a machine for creating interactions, for symbol manipulation and for processing information or sense data; it is not primarily a machine for making objects or fixed representations. . . . The unique computer tools available to the artist, such as those of image processing, visualization, simulation and network communication are tools for *changing, moving* and *transforming,* not for *fixing,* digital information. These processes are carried out by the computer under rules potentially controlled by the artist.

"There is a second well-understood feature about computer art. In traditional plastic art forms, the artwork is embedded in the material itself and is directly accessible to the human senses. In computer arts the artwork itself, embedded in digital data and software, is not directly accessible to the human senses. The computer artwork must be projected or transformed into a form apprehensible by the human senses. The choice of output device, whether cathode ray tube or film or sound, is in itself an artistic choice that can be exercised. In a trivial sense this is also true of photography and film, since the artwork cannot be seen until projected onto a reflective screen; however, the range of choices of output modes for a film negative is very narrow. This aspect of computer art connects it to the time-based and performing arts, where the creative work is in the score or text.

"These two facts—that digital, stored data and software are inherently malleable and that the software is the art—have a number of consequences. . . .

"We can notice two kinds of effects of the new computer technologies on art-making. First, new kinds of art forms are enabled by the unique capabilities of the computer. I have argued in a previous article that the only significant kind of computer art, within the context of the history of art, will be the type that could not have been made *without* the computer.

"Second, the introduction of the computer is affecting artmaking in preexisting or traditional art forms. Just as the introduction of the technology of photography had multiple and profound effects on painting, so the computer is affecting preexisting art forms. The computer is leading to change both in static art forms, such as painting, photography, sculpture, poetry and literature, and in time-based art forms, such as kinetic art, film, video, music, dance, and theater.

**Leonardo* 23 (Supplemental Issue 1990), pp. 33–38. © 1990 by the International Society for the Arts, Sciences and Technology (ISAST).

"The effect of the use of computers on preexisting art forms is twofold. First, computers are being used as labor-saving devices or cost-saving devices to achieve existing artistic goals of artists using preexisting art forms. . . . Second, the computer can be used as a 'sketch pad' for trying many variations of a composition or visual design very quickly. The artist then implements the final design in a traditional medium; . . . systems are now being widely used to generate simulated landscapes and scenes that are then displayed as photographs and judged as conventional photographic art.

". . . Computer artists using computer graphics images are already creating work that either is indistinguishable from that made using painting techniques or is equally successful artistically and aesthetically. Similarly, computer animation films are now competitive with films made by traditional film animation techniques; the recent winning of an Academy of Motion Picture Arts and Sciences Award by a computer animation short is an example. Although these kinds of artworks are still often classified, exhibited, and juried as computer artworks, it would be more appropriate to include them within more traditional art venues. . . .

"Film and television productions are beginning to exploit techniques such as the mixing of synthetic and real actors, the use of computer-generated scenery, and simultaneous display of multiple scenes on a split screen or in multiple windows. Digital television sets now available permit simultaneous viewing of two television stations on one television screen. We can anticipate new kinds of film scripts that exploit this capability by simultaneously presenting several linked film sequences. These kinds of technological developments represent the evolution of film technologies that has continued unabated since the introduction of cinema as an art form. . . .

"One of the problems facing the artist using computers in preexisting or traditional art forms is that the computer was not developed with the specific needs of artists in mind. The computer keyboard, mouse, digitizing tablet are all inferior tools for drawing compared to a piece of charcoal. The musician who is able to use two hands, two feet, breath and body motions, sometimes simultaneously, to control traditional musical instruments can be severely constrained if the only interface to the computer is a keyboard. State-of-the-art computer graphics systems still are not as flexible as a paintbrush and paints for producing realistic landscapes, and music-computer interfaces offer less control than a sliding trombone or violin bow. Development of computer-human interface technology is an area of key importance for computer artists.

"One result of the lack of artists' involvement in directing the technological development of the computer is that the impact of the computer on existing art forms, although significant, has been short of revolutionary. Award-winning computer animation films have done little to advance the art of animation beyond the achievements of the 1920s and 1930s. The creators of abstract film and abstract art explored in detail most of the artistic issues being studied, at great expense, by many computer artists using expensive computer graphics. Surrealistic and photorealist painters have already achieved the artistic goals addressed by software simulating realistic landscape and scenes. . . .

"Several lines of analysis are needed to elaborate the new kinds of art forms that are enabled by the computer. The first involves understanding the specific capabilities of the computer and creating art forms that exploit these. This approach, experimental and empirical, is being followed by many computer artists. As argued by John Berton the concept 'tool first, application after' changes the way artists approach a tool. Berton argues that the motion picture camera shares with the computer a similar history of assimilation into artistic practice. Many computer artists not interested in learning to program the computer live within the constraints of software developed for other purposes, just as a painter is happy to leave the chemical formulation of paints to the paint manufacturer. These artists are assuming that the computer is a mature artistic technology. . . . The proponents of the empirical approach argue that until the artist has access to the technology, its potential for artmaking cannot be fully understood. A larger context for this argument is that, since contemporary culture is being driven by contemporary science and technology, one of the roles of the artist is as 'colonizer' of the technology for artistic ends. Some technologies, and some capabilities of computers, will not however prove hospitable hosts to the arts. . . .

"If the computer is to be used as a starting point for artistic practice, it is wise to understand the change of world-view or paradigm that will ensue. The computer is of course not aesthetically neutral, since it enables certain kinds of artmaking in preference to others. Historians of science have documented in detail the impact of specific technologies on human affairs. . . .

"There is a growing literature discussing the way the computer is becoming a new metaphor for explanations of physical and human phenomena. Sally Prior has discussed the feminist analysis that questions the way in which the development of the computer is driven in the male-dominated computer industry; the dominance of war games in the computer-game industry is an obvious observation. Current metaphors based on the computers tend to connect to earlier metaphors of mind/body duality, rather than to emphasize the more holistic—and equally appropriate—metaphors of general systems theory. . . .

"In recent years there have been a number of fertile areas of research, including the algorithmic aesthetics of, for example, James Gips and George Stiny, the generative aesthetics of Mihai Nadin or of Herbert Franke, and the current work in shape grammars by Ray Lauzzana and by Russell and Joan Kirsch. These research directions can be viewed as contained in a larger discursive practice that seeks to develop artificial intelligence, more recently extended to the general study and development of artificial life (the synthesis and simulation of living systems). . . .

"This agenda, locating art-as-we-know-it within the larger picture of art-as-it-could-be, is of course the agenda of the art 'avant-garde' in every period; the computer artist, working the agenda of the new field of artificial life, is defining the new art avant-garde (as the term has been applied in this century).

"We can then identify one of the specific goals of the computer artist as that of developing an artistic or creative Other, an artistic Other that in turn elicits an aesthetic

experience in the artist; the computer artist of the future will seek ways to break the perceived alienation of the individual in contemporary society and to create new connections to society and the surrounding world. The computer is a technology that responds to this need and to the discursive practice arising from it. . . .

"There are a number of attributes that could allow the computer to become a *creative artmaking machine* rather than merely a significant artmaking tool. These attributes include the ability to have an in-built learning capability; the ability to connect to other computers or to people over short and large distances using various types of telecommunications technologies; the ability to collect information from the environment and to issue information through several sensory modes, many of them not directly available to the existing human senses; the ability to be used in real-time interactive display with humans or other devices; and the ability to create synaesthetic works.

"These attributes can in turn be viewed as the areas of key technological development that will allow the computer, as a component of an artificial life form, to carry out its own evolution and, through this intermediary, the evolution of the human organism. The technologies can be grouped into three areas, according to purpose. The first purpose is its use to extend or expand our information collecting systems; that is, our senses. Thus telescopes and microscopes extend the capability of our eyes to scales that our eyes cannot by themselves reach. These technologies also extend our visual range to include wavelengths of light to which our eyes are not sensitive . . . the development of computer networks has been in response to this need to extend the sensory apparatus. An important impact of the extension of the computer through computer networks is to give credence to the concept of 'mind at large.' As argued by Gregory Bateson, the human plus the computer plus the environment can be viewed as constituting a thinking system, which today can be considered planetary in dimension. The current awareness of global environmental issues is one consequence of this perspective. . . .

"Visualization tools—that is, computer-graphics tools—make up one of the most developed areas of computer technologies and are the fundamental technology usable to convert this expanded sensorium to a form that the human being can access. Virtual reality systems represent a major advance in providing new visualization environments. The development of new ways of connecting the environment directly to the human nervous system, bypassing the existing human senses, is one of the most important long-range agendas in this field. . . .

"The second kind of purpose for technology is to amplify innate capabilities and functions. Thus storage devices, from books to photography to computer disks, allow us to increase both the size of our memory and the time-scales over which information is collected. Machines extend the range and power of our limbs and our capability for locomotion and mechanical action. The development of robotic technologies and cybernetics is important for achieving future artistic goals; when viewed as an artistic Other, the computer needs to become mobile. Computer artists are working in a num-

ber of areas for this agenda. . . . Workers in artificial life such as Randall Beer have been developing artificial insects, such as miniature robots capable of maneuvering around computer circuit boards to carry out circuit repairs. . . .

"The third kind of purpose for technology is to create artifacts—that is, to change our environment by creating objects, events or processes that in turn affect us. . . . The ability of computers to create interactions between the artist and the artwork situates the new artworks in a non-traditional format. . . . It is very unlikely that the context of the commercial art marketplace, the gallery or the museum will be appropriate venues for this kind of art. These institutions derive from the needs of a prior, and exhausted, discursive practice. The computer artist is, by necessity, creating new exhibiting and displaying contexts and institutions appropriate to the new discursive practice. . . .

". . . The goal of mechanical reproduction is to produce copies that are indistinguishable from an original in as many ways as possible. . . .

"A different kind of reproduction is made possible by software—this is what I will call post-mechanical reproduction (although a more descriptive term such as 'generative reproduction' is needed). The goal of post-mechanical reproduction is to make copies that are as different as possible from each other, but constrained by a set of initial rules. The prototypical type of post-mechanical reproduction is of course sexual and biological reproduction.

"As noted by Marc Adrian, the reproductive capability of computers to produce copies of work is very different from that of photography. "The social consequences of the computer used in an artistic context lie rather in the fact that with each basic program . . . a practically inexhaustible number of dissimilar realizations is possible." . . .

". . . Not only is the software the art, but the behavior of that software constitutes the work of art in the age of post-mechanical reproduction."

"Sexual Difference: Both Sides of the Camera." (1987)
*Abigail Solomon-Godeau**

"The genesis of this essay and the exhibition that it accompanies was a conference in which I participated in the fall of 1986, entitled "Women in Photography: Making Connections." Within a short time after the conference began, some of the disaffected participants—myself included—had privately renamed it "Ladies with Cameras." It is the conceptual divide between these two titles with which I want to begin.

*Abigail Solomon-Godeau, *Photography at the Dock*. Minneapolis, Mn.: University of Minnesota Press, 1991, pp. 256–282. Originally published in the *CEPA Journal,* Spring, 1987.

". . . For the issue of women in photography—as is always the case when gender is mapped onto existing fields, discourses, and practices—profoundly alters their terms and provokes new and difficult questions.

"This is particularly striking in the case of photography, a medium which by virtue of its supposed transparency, truth, and naturalism has been an especially potent purveyor of cultural ideology—particularly the ideology of gender. Here we might start with one of the most basic questions that a gendering of photographic discourse suggests: what, if anything, changes when it is a woman who wields the camera? For the organizers and many of the participants in the "Women in Photography" conference, the answer to this question was taken to be largely self-evident. In other words, insofar as women in photography was understood to be a problem—a problem of unequal representation within the ranks of professional photographers—the practical solution was assumed to lie in overcoming those barriers that limit women's participation in the field. Furthermore, the implied corollary to this position—and one by no means limited to the conference organizers—was that photographs taken by women may in some fashion reflect or inscribe their gender in the photographs they take, whether that difference is understood to reside in their choice of form, content, or in their method of working. Moreover, where images of women in the culture at large were perceived as problematic—fetishizing, objectifying, sexist—the assumption was that bad or false images of women could, should, be countered by positive and true ones.

"That such facile and uncomplicated assumptions should have currency in the encounter of feminism and photography as recently as 1986 is disturbing. First, because they fly in the face of fifteen years of feminist theory which began with comparable assumptions and went on to reject them as theoretically and politically inadequate. Second, because such assumptions are grounded, variously, either in an unexamined essentialism or in a positivist model that is both limiting and ultimately deceptive.

"It was thus as a form of rejoinder that I conceived of the exhibition "Sexual Difference: Both Sides of the Camera," intending it to complicate any too easy conflation of the fact of sexual difference on one side of the camera with the representation of sexual difference on the other. In part, the nature of these complications follows from the conviction that sexual difference in photography must be addressed—insofar as it operates—in three different sites: on the level of biological gender of the photographer and his or her intentions, in the construction of masculine and feminine subject positions within photographic representation, and in the unstable and subjective nature of photographic representation as it is received by the sexed spectator—the site where photographic meanings are equally produced. It should be apparent that the act of mapping these three sites in which the operations of sexual difference may be understood to play a determining role in the production of meaning owes a great deal to the work of feminist film theorists. The exhibition title itself is an allusion to E. Ann Kaplan's *Women and Film: Both Sides of the Camera*. Further, a particularly profound debt is owed to the work of Laura Mulvey. Mulvey's discussion of the three looks in the cin-

ema—the look of the camera (the camera eye whose place is taken by the spectator), the look of the spectator, and the look of characters within the film itself—was formulated specifically in relation to the construction of sexual difference. But the difficulty for photographic critics, curators, or image-makers is how to draw upon the insights and analyses of film theory to develop an analogous system of analysis that is applicable to the specific nature of still photography.

"Thus, while many of the fundamental insights and formulations of feminist film theory are applicable to photography, many are not. For example, within film theory, explorations of fetishism, of the erotics of looking, of the production of subject positions, of ideological functioning, can all be adapted—more or less—to the specificity of the still camera image. On the other hand, issues of narrative and its crucial links to Oedipal structure, the operations of sound, indeed, the physical, material nature of the film-watching experience itself, cannot be transferred to photography. And between those elements that are germane to both media—say, the mechanisms of fetishism in the representation of women—and those that are not, there is a third category—here I am thinking of the concept of suture—that requires some modification and conceptual tinkering to be adequate as a critical tool for photography. . . .

"Most importantly, and harkening back to my criticism of the "Women in Photography" conference, I wanted to make clear that sexual difference in photography could not be equated with biological gender on either side of the camera. Accordingly, *Subject Position and the Erotics of Looking* (Part I of the exhibition) was intended to demonstrate that neither the biological gender of the photographer nor the biological gender of the model was necessarily congruent with the sexual and social implications of masculinity and femininity. . . .

"Successful or not—that is not, after all, for me to say—Part I of the exhibition was supposed to invoke the connections between sexuality and looking (looking at, being looked at) that conventional photographic discourse tends to elide. Where the question of femininity as a subject position arises, as well as the conventional forms in which it is expressed, this is a problem to the extent that the feminine position is hardly an equal pendant to the masculine one. In other words, as long as femininity, as a differential construction, is secondary, lesser, lacking, and other, its photographic incarnations cannot but ratify, reassert, and further naturalize social relations based on domination and subjugation. Such an analysis does not require a moralistic renunciation of photography, but, rather, a sensitivity and attentiveness to its signifying systems. It was thus in the second part of the exhibition, entitled *Critical Interventions,* that I sought work that, in one form or another, addressed aspects of the photographic medium that constituted its problematics for feminism.

"Diane Neumaier's twenty-part work entitled *Teach Yourself Photography: 50 Years of Hobby Manuals 1935–1985* could well be taken as an emblematic artwork for this section. What Neumaier has done is to scour back issues of *Popular Photography, U.S. Camera,* and the like, and rephotograph images and texts that demonstrate, over and over again, that the subject of photography is pre-eminently male, and the object

of photography (when it is a human figure) is almost always female. The exception to this rule—and is it really an exception or a subcategory of the feminine?—is provided by the occasional appearance of babies and children.

"That men are conventionally the subjects of photography and women its objects is manifestly not news. It is, however, one thing to acknowledge this as a conceptual and political insight and quite another to invent a form that graphically illustrates some of the implications following from the sexual positioning that photography interminably and ritualistically constructs and affirms. For example, Neumaier has selected images that represent men in their role as *homo faber,* represented in the act of possessing, learning, controlling, and manipulating the camera and its accessory instruments. It is not for nothing, after all, that the word "tool" can be used as a synonym for the penis. The camera and its mysteries of lighting, exposure, composition, and special effects are thus the purview of knowledge and power, while women (and children) are generally consigned to what Judith Williamson has described as a kind of nature preserve of sexuality, domesticity, leisure, or indeed "nature" itself.

"That these social constructions are underwritten by male fantasies of mastery and possession is made quite clear in Neumaier's work. One of her particularly funny devices consists of juxtaposing her found images of women with found images of men or photographic apparatuses which bear more or less obvious phallic connotations, thereby revealing the power relations inscribed in the male/photographer and female/model polarity.

"That those photographs most emphatically declaring their status as "art" are frequently those in which the woman is nude, supine, fragmented, or otherwise "worked over" (one especially grotesque example depicts a nude torso caged by lines incised in the negative with an x-acto knife) is significant. For while "art" photographs in hobby magazines are obviously not of the same aesthetic or intellectual caliber as those, say, produced by the surrealists, *Teach Yourself Photography* nonetheless prompts reflection on certain of the relations between the two.

"Neumaier's epigraph for the work—"She no longer wondered how she fit the picture"—is suggestive of the problem of women and photography both from the perspective of their historic exclusion from the medium and from the perspective of an analysis of the nature of dominant representations of the feminine. Neumaier's approach—consistent with the goals of critical practice in general—is to point out how ideology functions to naturalize the cultural. For example, Neumaier includes in the piece a blow-up of a film exposure diagram (the kind that comes inside every roll of film) which employs a stick figure schematization illustrating that once again, the man holds the camera and the woman holds the pose. Because we normally don't even perceive the myriad ways that photography is gendered, *Teach Yourself Photography* functions to elicit recognition of social facts that are at once completely visible and consequently—like the purloined letter—completely hidden. . . .

"In Jo Spence and Terry Dennett's *Remodelling Photo History,* the object of critique is an officially sanctioned notion of discrete photographic genres (e.g., the art

photograph, the ethnographic document, the crime photo, etc.). Deftly "remodelled" through the device of restaging them and labeling them, these various genres are made to yield new meanings, an operation that links them to the technique of photomontage. In the thirteen image/texts that comprise the work, Spence is herself the model (Dennett also appears in one sequence) . . . different correspondences, connections, relations are obliquely proposed: exploitation of land, exploitation of women, domination and capitalization of the environment, women as infinitely exploitable resource, and so forth. Finally, Spence's literal inscription of herself into the photographs suggests that she, as an individual, is subject to the same historical forces, determinations, and sexual and social relations that her photographs attempt to symbolize. This political symbolism is one which is generated from the particular and employs the image of the woman as a paradigm of all other forms of domination, a model to which Marx and Engels themselves subscribed. Thus, the two photographs captioned *Victimization* use the genre of the police scene-of-the-crime photograph (Spence sprawled out nude, under the wheels of a car, next to a sign warning trespassers off private property) with a close-up photography of Spence's hands doing laundry in a bowl, to set up an infinitely expanding network of meanings that encompass both domestic and property relations.

"The work of Sarah Charlesworth, Richard Prince, and Cindy Sherman, in contrast to that of the first group of artists, is usually situated within the range of contemporary production designated as postmodernist. As such, it evidences a shared preoccupation with the look of mass media, and a deliberate appropriation of that look ranging from strategies of direct confiscation (Prince) to elaborate reconstruction (Sherman). Of the three artists, Sherman is the one whose work is most germane—indeed central—to a feminist project. . . .

"In Sherman's endless tabulation of the category "woman," difference cuts in and across the work in a number of ways. While her format, *mise en scène,* and the nature of her implied narratives have constantly changed, Sherman has persevered in her practice of starring in those roles traditionally assigned to women, be they sexy ingenue, vulnerable victim, femme fatale, or wart-chinned witch. Always her and never her (for who could identify the real Sherman in the street?), Sherman's pictures undercut the notion of any fixed and stable feminine identity. For if such identities are a function of wardrobe and makeup, and if, further, they are given content and meaning by the viewer's capacity for projection and investiture, where and how is the "authentic" feminine identity to be located? Difference is here constellated along an axis of various feminine roles (revealed to be an empty category) and in terms of the cipher of femininity itself. Last, Sherman's pictures, particularly the ones that trade on the most stereotypical images of women—launch a certain challenge to the male spectator. For as Judith Williamson has argued, to the extent that one accepts the Sherman personae in the guise they are presented, the viewer is an accomplice in the construction of a femininity that has been already exposed as altogether fictitious. This suggests that Sherman's work is constructed to address male and female spectators in different ways. . . .

"Broadly speaking, the work of Milner, Spence, Charlesworth, and Sherman takes as its point of departure a preexisting and ubiquitous image world that deploys pictures of masculinity and femininity which function to establish a culturally sanctioned and delimited range of sex-role models. To the degree that the viewing subject can recognize, identify with, and project him- or herself into this image world, a particular construction of gender is effectively secured. Feminism, however, amply demonstrates that for all its power, ideology—sexual or otherwise—is never without its internal contradictions which allow for the various resistances and contestations that perpetually arise. Indeed, the very ability to recognize and postulate the operations of the ideological assumes a position at least somewhat outside it. The specular mechanics of photography bear more than a coincidental resemblance to those of ideology (as Marx recognized, by famously likening it in its avatar of false consciousness to the workings of the camera obscura). In this regard, one of the most suggestive analogies between the two is the congruence of the camera's point of view with the spectator's, effectively determining that the viewer's place is in every sense given in advance. For feminists for whom the question of women's place, in all its ramifications, is the central problem, the photographic point of view may be considered as a locus where issues of subject position, the interpellation of the subject, and subject/object relations all intersect. . . .

". . . While the history of the medium offers numerous examples of photographers who have played with the camera's capacity to "bare the device" (a range that would include practitioners from Rodchenko to Friedlander, as well as vernacular and anonymous photographers), it is a specifically feminist approach to take the camera's fixing of subject/object positions as a problem, rather than as a given. For women, whose position in the economy of looking conventionally resides with the surveyed rather than with the surveyors, the use of the camera to "expose" and capture the social and sexual transactions of others is particularly charged. . . .

"It is entirely appropriate that Louse Lawler's installation should be the last work discussed because Lawler's work functions as a kind of last word within any exhibition framework. . . . Lawler could fairly be described as the quintessentially Derridean artist, addressing herself to the margins, to what lies outside the mythic autonomy of the artwork. Consequently, Lawler's subtle installations operate to upset or complicate conventional dichotomies of inside/outside, original/copy, part/whole, supplement/essential, and last, but not least, male/female. Consistent with what we might term the ethics of deconstruction, Lawler's intent is not to substitute new truths for old, but to circulate and put into play questions that provoke an awareness of the institutional and discursive order of things.

"Lawler's contribution to the exhibition immediately prompts questions about what the nature and parameters of a "work" actually are. Allocated a wall, she has had a square painted on it in a contrasting color upon which she has positioned four identical black-and-white photographs of two statues, which are placed to create a cross-

like emblem formed by the two edges of each print. This ensemble, however, is clearly intended to relate to the large cibachrome print, also of two statues, and to the intervening photograph depicting an interior view of the Metropolitan Museum of Art. Further, while the large cibachrome bears a short text whose meanings extend to the other pictures—indeed, to the exhibition as a whole—the largest typeface is given over to a wall title that reads "Prominence Given/Authority Taken."

"From whence the prominence and to whom the authority? Both the large cibachrome print and the multiplied black-and-white print depict full-figure female statues in the foreground and severe-looking portrait busts of men behind them. In *Sister/Brother*—the photograph in the suite of four—the female figure, a type rather than an individual, is sculpted in an attitude of extreme abjection, seeming to cower beneath the stern and intimidating gaze of the portrait bust. Similarly, the neo-classic female figure in *Eve and Patriarch,* seen in profile, casts her look downward, likewise under the eye of a somber patriarch. Printed on the photograph's mat, Lawler poses the following questions: "Is it the location, the model, or the stereotype that is the institution?" Last, the photograph that spatially mediates between *Brother/Sister* [sic] and *Eve and Patriarch* features a statue of Perseus (he who slayed Medusa by stealing her gaze and then decapitating her), cropped just above the genitals and incorporating the sword that he wields. Written on the mat is the allusive title *Statue before Painting, Perseus with the Head of Medusa, Canova.* Behind the statue is the Metropolitan's central stairway leading to the arched entranceway marked "Paintings," one of which can be seen—a Tiepolo, as it happens, depicting the subjugation of an African queen by a Roman hero. As Rosalyn Deutsche has pointed out, both the title and the museum architecture Lawler has pictured not only implicate the current heroization of painting, but conjure a shade of another hierarchization—statue before painting, as in ladies before gentlemen.

"Prominence and authority in this multivalent work are thus fully dispersed over and through a range of physical and discursive sites. Prominence, which had spatial as well as a hierarchically designative sense, is meted out by the artist who gives prominence in her work to representations of feminine abjection. In controlling the photographic crop—what the viewer will see—she also gives prominence to the patriarchal values enshrined in the predominantly all-male preserve of the art museum. Finally, in giving prominence to Perseus's sex organ and sword, guardian of a painting collection that in many respects incarnates the masterful gaze of the male subject, Lawler gives prominence to the hidden liens between phallus, fetish, and painting (Freud, of course, used the Perseus and Medusa myth to theorize fetishism and its relation to the look).

"But prominence given is by no means exclusively the purview of the artist and her choices. For prominence is given to *her* by me, the curator, who requested the work, and by C. E. P. A., the institution which exhibits it, by the art world audience which assesses it, and so forth. Similarly, the patriarchal authority figured in the photographs is by no means confined there. In the same way that it is necessary to distin-

guish between patriarchy—as system, as structure, as institution—and male human be-ings, so too must the multiform and infinitely dispersed forms of authority be ac-knowledged, up to and including its manifestations—although frequently not even recognized as such—in one's own activities.

"If in curating an exhibition of this kind I have given prominence to a range of work, most of it explicitly feminist, it may be, as Lawler suggests, an inevitable con-sequence of the enterprise that authority is somehow taken. But as much of the exhib-ited work implies, the imbalanced world of sexual difference is not to be rectified by simple reversals. Or, as Audre Lorde has stated, "The master's tools will never dis-mantle the master's house." To the extent that photography has been a particularly ef-fective master's tool, it is incumbent upon feminist art practice to try to use it in different—critical—ways. As a feminist and a critic, wearing, in this instance, a cura-torial hat, I would less wish to assert a dubious authority than to affirm a collective sol-idarity with the project of claiming the camera for more humanly satisfying ends.""

"Barbara Kruger: Resisting Arrest." (1991)
David Deitcher*

> I'm interested in making art that displaces the powers that tell us who we can be and who we can't be.
>
> Barbara Kruger, 1989

"It sometimes seems as if curators, critics, and journalists alike are doing their best to eradicate "critical" post-Modernist art from the historical record. This can hap-pen even when the opposite effect is intended: the organizers of the "Image World" ex-hibition, for example, at New York's Whitney Museum of American Art in 1989–90, lavished upon works by Richard Prince, Sherrie Levine, Cindy Sherman, Barbara Kruger, All McCollum, and others such a heady blend of museum formalism and disco pyrotechnics that this art's social and discursive implications were all but obliterated. It was not surprising, then, that when the *New York Times* photography critic Andy Grundberg decided to issue a postmortem on post-Modernist photography, "Image World" served as his exhibit A. Many people seem eager to forget the relatively brief spell during which the term "post-Modernist art" meant something other than an ahis-torical traffic in once historically specific styles. This is due, no doubt, as much to the success as to the failures of the art that warranted that designation.

"In the early '80s, during the heyday of neo-Expressionist painting, it was

*Artforum, Vol. 29, no. 6 (January 1991), pp. 84–91.

hard to imagine that the unprepossessing, photo-based works of the "critical" post-Modernists would ever find a market. Yet since the late 1970s a handful of influential critics and art historians had argued for the significance of this radically antiexpressionist art. Interpreting it through ideas borrowed from Marxist, deconstructionist, and feminist texts, these writers theorized post-Modernist art as a reflexive challenge to Modernist esthetic tropes. Post-Modernist art proposed a radically pluralist conception of visual culture, one that helped to expose the hierarchical social structures inherent in modern systems of cultural classification.

"Few if any of the artists who benefited from the claims of these politically engaged critics would have wanted to be tagged "political artists." Aside from the marginality that such a denomination tends to impose, the majority of these artists were women, whose feminist concerns had for years been overlooked—or openly derided—by partisans not only of the political right but also of the left. Throughout the period of their obscurity, post-Modernist artists—both female and male—were not inclined to contradict supportive critics who associated their work with Marxist critiques. But with increased visibility and viability in the marketplace, many of these artists adjusted their practices to distance themselves from such an identification and to increase their sense of independence.

"Meanwhile, at the same time that some post-Modernists were moving away from the appearance of political commitment in their work, political activists concerned with AIDS, health care, housing, and abortion rights were beginning to deploy the devices of post-Modernist art in order to inform and provoke audiences that extended well beyond the limits of the art world. Also, certain post-Modernist artists were not content to limit their practices to art-world values and narrowly esthetic concerns. More than any other artist of her generation, Barbara Kruger has proven worthy of the term "crossover artist." Political and esthetic, high and low, cheap and dear, public and private, practical and theoretical—it is not surprising that her highly visible practice has proven as favorite a target for criticism as any.

"Never was so much said—and so vindictively—about the entry of politically engaged artists into the marketplace than when word got out, late in 1986, that Kruger had agreed to be represented by the Mary Boone Gallery, New York. Some objected to Boone's notoriety as a power broker in the international art market and to her association with such neo-Expressionists as Julian Schnabel. Others noted the apparent contradiction in Kruger-the-feminist's decision to join a gallery that for almost a decade had represented no women artists. She had alienated traditional humanists of both sexes, on both left and right, when, in 1981, she began to lift images from old advertising annuals and other such compendia of photographic clichés, which she enlarged, cropped, and then supplemented with bold slogans and crimson frames. This seductive form ensured that the works would circulate smoothly at every level in the late-capitalist economy of commodity signs. Moreover, though Kruger did her best to "welcome the female spectator into the audience of men," she made some men feel intensely unwelcome.

"Kruger is frank about her refusal to participate in the romance of marginality. She believes that the market economy is ubiquitous, though no more so than the presence of politics: in "every deal we make, every face we kiss." To this day, however, some commentators who find Kruger's work indistinguishable from "the methods and strategies of advertising" are more interested in dismissing it as art than in considering why this equation exists. Sandwiched between partisans eager to savage her work for selling out and a voracious marketplace just as eager to consume it and neutralize its politics, Kruger's situation has become emblematic of a predicament that confronts a handful of artists who achieved the improbable during the last decade when they developed politically engaged forms of art that were rewarded not with the customary neglect but with unprecedented success.

"Since 1981, Kruger's art has proceeded from the assumption that visual stereotypes and clichés play a significant role in our formation as social subjects. To demonstrate and to help impede the mechanism by which the stereotype achieves its result, she has deployed stock images that set in motion the processes of self-identification through which people interpolate themselves as constituents of the social order. Cutting across and otherwise littering these fields of self-identification, Kruger's slogans confound this process of involuntary subjection. As Kate Linker has written, the slogans "intercept the stereotype, to suspend the identification afforded by the gratifications of the image." In this way her photomontages have proven as empowering to some women as they have been intolerable to some men.

"Kruger has responded to the rapid success of her style by diversifying the forms of her practice. This has done little to quiet her critics, yet one could argue—as I intend to in this essay—that her refusal to limit her work to any single venue, and her identity to a single vocation, has acted in concert with her formidable inventiveness and wit to preserve the radical potential of her art.

"Among Kruger's most ambitiously "public" outlets are her billboards and poster designs, which generally take on the crisp design of sophisticated advertising in order to inject difference into homogenous urban situations, and to question publicly the authority of social and cultural hierarchies and of the categories that reinforce them. Sometimes the site and the scale militate against Kruger's radically antiauthoritarian message. On the occasion of the 1989 exhibition at the Frankfurter Kunstverein and Schirnkunsthalle, for example, she got permission to hang five huge images on a building facade above the town square, placing the spectator in the untenable position of having to look up to them. Three of them showed differently cropped versions of a photograph in which a police officer thrusts forward a huge, leather-gloved hand, as if to stop traffic, or in any case to enforce the law. The fourth featured a man's fist connecting with a woman's chin, while the fifth showed a hand outstretched to proffer one of the work's five slogans, which read, in German, "No Thought/No Doubt/No Goodness/No Pleasure/No Laughter." This systematic cancellation of what, in a better world, might be known as civic virtues combined with the disjunctive, filmic montage of harsh imagery to counter the authoritarianism in the project's mode of address.

"Kruger's billboards usually employ more playful means. The slogan that she has disseminated perhaps most widely appropriates a lyric from a Tina Turner song, "We Don't Need Another Hero," which she pairs with an image of a smug, chubby fellow about to take a bite from a banana; or with a Norman Rockwell-type illustration of a girl in pigtails attending to a little boy flexing a pathetic biceps. Public works such as these function precisely like the "hip" ads that intrude upon the urban environment; except that Kruger's don't quite conduct business as usual. Even such deceptively simple pieces work to diversify the increasingly limited messages that business and government are willing to put out.

"Among the few instances in which Kruger's work has functioned directly as agitprop was the poster she designed as an ad for "The Decade Show," New York, in 1990. Typical of ads she has designed for museum exhibitions, this one reserved the right to criticize what it promoted. The poster shows a face cropped between nose and hairline. Its dramatic horizontality echoes the shape of the white blindfold that covers the figure's eyes. In a wide red rectangle within the blindfold, white letters read, "The Decade Show starring Reagan/Bush presents 10 years of almost NO MONEY for Health Care, Housing, Education, the Environment, and almost ALL MONEY for Weapons, Covert Operations, Corporate Tax Breaks, and Savings and Loan Bail Outs."

"Kruger tries to use humor to get beyond the rhetorical flatness of so much agitprop. In a recent series of posters for Manhattan bus shelters, she moves beyond her own procedures to dramatize the struggle over women's reproductive rights (Fig. 5.5). Appropriation here has nothing to do with the reuse of photographs; it encompasses an entire advertising genre. Kruger has set up and photographed men of different ages, races, and classes in stereotypical situations. To those images she adds a text that imagines a world in which men as well as women can conceive and bear children.

Image: Man in mid forties wearing a hard hat and looking uncomfortable.
Text: We've finally sent the kids off to school. We're not getting any younger.
 I've got high blood pressure and arthritis. I just found out I'm pregnant.
 What should I do?

In works like these, Kruger has tried to foster a resistant public at the level of its receivership. There are risks, however, in attempting to intervene in urban space. For such space is not merely physical: it is invested—in every sense of that term—with social relations. . . .

". . . Given the nature of late-capitalist urban space and of art's susceptibility to the forces that shape it, there is nothing about the placement of art outside the commercial gallery that ensures its status as "public" art; any more than the situation of art in the "private" space of the gallery necessarily prevents it from maintaining a "public" purpose.

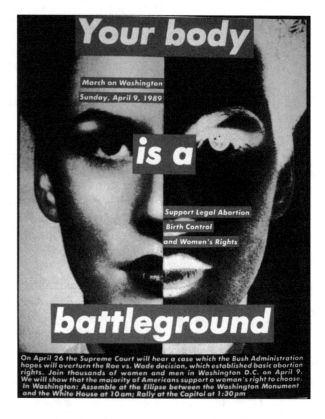

Figure 5.5 Barbara Kruger.
"Untitled" (Your Body is a Battle-ground), 1989.
Poster for March on Washington.
Copyright © 1998 Barbara Kruger.

"Until recently, Kruger used her commercial gallery shows for straightforward installations of discrete works of art that tried to consolidate a sense of (feminist) community. But in 1989 and 1990 she created installations in Santa Monica and Chicago that used the architecture of the gallery to generate the same results. (In doing so she furthered the logic of '60s and '70s artists who had worked to discredit the idea of the gallery as a neutral space for the disinterested contemplation of art objects.) As she handled them, the spaces were transformed into theaters of condescension. The bulk of both works remained beneath the visitor's feet: in bold white letters on the crimson-painted floor was inscribed, "All that seemed beneath you is speaking to you now. All that seemed deaf hears you. All that seemed dumb knows what's on your mind. All that seemed blind is following in your footsteps." That this text began at the most distant reaches of these rectangular galleries meant that visitors had to traverse the space to look down on it and to read it. Of course, looking down on it was precisely the point—looking down and having it talk back to you at the same time. . . .

"Works like these are not Kruger's first to interrogate the politics of space. As early as 1977, in the "Hospital Series," one of the earliest of her works to juxtapose pic-

tures and words, Kruger was ruminating upon the ways that architecture not only shapes our daily lives but assists in our formation as social subjects, . . .

". . . The "Hospital Series" scrutinized the trappings of hospital architecture and evoked the protests of its patients. Given the state of health care in America today, its deadpan enumerations of the effects of medical technologies have a disturbing prescience: "The technology of early death/ The providing of consumer goods to a dying populace/ the manufacture of plague/ The denial of epidemic." . . .

"Kruger's manipulation of the architecture of the gallery space relates to still another aspect of her recent practice: on three occasions Kruger has collaborated with a team of architects, the New York firm of Smith-Miller and Hawkinson. . . .

". . . The first of Kruger's collaborations with Smith-Miller and Hawkinson, aided by the landscape architect Nicholas Quennell, was in an open competition to design a 164-acre park around the North Carolina Museum of Art, in Raleigh. Their proposal, entitled "Imperfect Utopia," was approved by the museum board in September 1988. Although delays have abounded (this is state-owned property), work on the first of three phases intended to extend over ten years may soon begin in earnest.

"The "theory," or "guiding principals," of Kruger's architectural collaborations, as expressed in the team's proposal for the park, are as follows:

To disperse the univocality of a "Master Plan" into an aerosol of imaginary conversations and inclusionary tactics.
To bring in rather than leave out.
To make signs.
To re-naturalize.
To question the priorities of style and task.
To anticipate change and invite alteration.
To construct a cycle of repair and discovery.
To question the limitations of vocation.
To be brought down on earth.
To make the permanent temporary.
To see the forest for the trees.
To have no end in sight.

"If Kruger were to write a description of the goals of all her work, it might very well read like this. . . .

"In the list of theoretical goals that Kruger and her colleagues articulated for the North Carolina project, one stands out here: "To question the limitations of vocation." The diversity of Kruger's work—its materialization not only as unique art objects but as artists' books, postcards, T-shirts, posters, billboards, book covers and illustrations, shopping bags, film and TV criticism, and, most recently, architectural collaboration—has helped ensure that her practice will retain its critical edge. Speaking about the recuperative powers of myth today, Roland Barthes discussed the way in which

denomination can function as disavowal: through naming, "Otherness is reduced to sameness." Kruger's refusal to take comfort in a stable professional identity has done as much to protect her art from the hazards of her success as any other aspect of what she does. Is she just an artist? just a feminist? a writer? designer? critic? architect? Reduction of difference to sameness, reduction of difference to binary oppositions: Kruger's continuous refusal to make peace with such logic in a society that cannot live without it has ensured the continuing importance of her practice as a model of resistance to arrest."

"Robert Mapplethorpe: The Philadelphia Story." (1991)
*Judith Tannenbaum**

"It has been more than two years since the controversy surrounding the Robert Mapplethorpe exhibition arose. Organized by the Institute of Contemporary Art (ICA), University of Pennsylvania, in Philadelphia in 1988, what started out as a "normal" exhibition turned into something quite different—a national cause célèbre, the impetus for intense congressional debate about federal funding of the arts, and, ultimately, the focus of an obscenity trial in Cincinnati.

"Robert Mapplethorpe: The Perfect Moment" was designed as a retrospective exhibition, covering all aspects of the photographer's career over a twenty-year period, from the late 1960s to 1988, just shortly before Mapplethorpe died of AIDS in March 1989. It was organized as a traveling exhibition, to be seen at five other museums in various regions of the country during the next year and a half, after it closed at ICA. Curated by ICA's director, Janet Kardon, the exhibition of more than 150 images was presented in Philadelphia without incident (and to enthusiastic critical response) from December 1988 through January 1989. It subsequently traveled to the Museum of Contemporary Art in Chicago, again without generating any unusual public attention or raising legal questions about obscenity in relation to the content of the work (Fig. 5.6).

"It was not until June 1989, after the cancellation of the exhibition by the Corcoran Gallery of Art, in Washington, D. C., just two and one-half weeks before it was to open there, that ICA was unexpectedly thrust into the national spotlight. It then sud-

*This article was originally published in *Art Journal* Vol. 50, no. 4, (Winter 1991) pp. 71–76. Reprinted by permission of the College Art Association. Judith Tannenbaum is associate director and senior curator of the Institute of Contemporary Art, in which intense national controversy about public funding for the arts surrounded the Robert Mapplethorpe exhibition originated by the ICA. Janet Kardon, ICA's former director who had initiated the project, left the institution in April 1989 to become director of the American Craft Museum in New York.

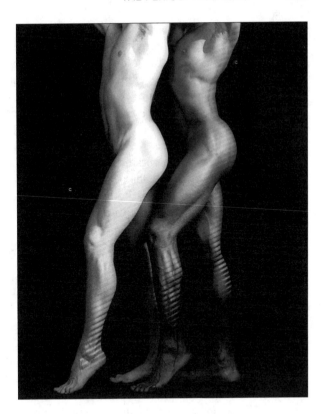

Figure 5.6 Robert Mapplethorpe.
Ken and Tyler, 1985.
Gelatin-silver print.
Copyright © 1985 The Estate of
Robert Mapplethorpe.

denly became a key player in the congressional debate over what taxpayers' dollars should and should not be spent on, and the related issues of censorship and artistic freedom. . . .

"I was acutely aware of the underlying legal principles, moral issues, and political ramifications as the drama developed. In my role as chief spokesperson for ICA, my priorities were to uphold the institution's integrity and identity in the face of serious scrutiny and possible financial losses and to evaluate how our situation related to the most basic values and tenets of American democracy.

"But how did we arrive at this point? The worst scenario we might have anticipated before the show opened was receiving letters and phone calls from disgruntled or offended viewers. Because of the explicit sexual content of a small number of images in the show, a notice with the wording "The Robert Mapplethorpe exhibition includes material that may be inappropriate for children" was placed at the gallery entrance and also appeared in the room containing Mapplethorpe's *X, Y,* and *Z* portfolios. (After the controversy arose, the wording and placement of such a cautionary statement was determined by each institution.) Now we were in the middle of a national political battle, subject to public criticism, as well as praise, and constant media attention.

"In 1988 a National Endowment for the Arts had awarded ICA a $30,000 grant under its museum program, to help support the organization of the Mapplethorpe retrospective and publication of its accompanying catalogue. The Corcoran's sudden withdrawal from the exhibition tour (and cancellation of its contract with ICA) was made in anticipation of controversy during Congress's consideration of a bill appropriating funds for the NEA during the next fiscal year, and was based on that museum's wish to remain "outside the political arena." (Debate over this legislation was expected to take place during the summer, when the Mapplethorpe exhibition would have been on view at the Corcoran.) In retrospect, it is clear that the Corcoran's decision backfired and drew it into the political realm rather than keeping it removed; it also intensified the debate waged both in the media and in Congress surrounding the NEA's funding of projects perceived by some individuals or organizations to be inappropriate for support.

"In late July, after the Senate had passed its version of the appropriations bill, with the eleventh-hour inclusion of the so-called Helms amendment, . . . controversy escalated even further. The proposed legislation not only restricted funding for "obscene or indecent materials" but included another clause prohibiting ICA and SECCA (the Southeastern Center for Contemporary Art in Winston-Salem, North Carolina) from receiving NEA funds for five years. SECCA was the organization responsible for awarding a subgrant to the photographer Andres Serrano and for including his now-infamous image, *Piss Christ,* in its Awards in the Visual Arts exhibition series. Such a punitive action would have been unprecedented—and unconstitutional.

"ICA had played by the rules and had, in fact, been rewarded by receiving an NEA grant in the museum program's highly competitive "special exhibitions" category, yet it was being singled out for punitive action by Congress, and the future of federal funding for the arts in America was placed in serious jeopardy. Although ICA found itself in an unenviably defensive position, it was clear that the institution was in no way at fault for organizing the Mapplethorpe exhibition and using public funds to help support it. . . . In contrast to the Corcoran, the Contemporary Art Center in Cincinnati (CAC) was not wrong to honor its contractual agreement (and, by implication, its commitment to Mapplethorpe's work) to present the exhibition in its complete form. This it did despite threats of legal action to shut down the museum or seize some of photographs; local law-enforcement agents deemed them inappropriate to be viewed by the citizens of Cincinnati, although they had been seen already by several hundred thousand citizens in Philadelphia, Chicago, Washington, D.C., Hartford, and Berkeley.*

"To delete works or to isolate particular images in response to political pressure would have been an act of censorship on our part. The intention of the exhibition was to represent the artist as fully as possible; it was our responsibility to be true to the

*After the Corcoran's cancellation, the Washington Project for the Arts (WPA) came forward immediately as an alternative venue. The exhibition was presented there, without incident, from July 21 to August 12, 1989.

spirit of the work and to ensure that it be shown in a secure and dignified manner. Altering the show would have seemed like an admission of guilt—that there was something wrong with exhibiting Mapplethorpe's photographs. We did not want to play into the hands of the conservative groups who believe they must protect the American people from material they deem unwholesome. In contrast, it was our position that the museum-going public is smart enough and discriminating enough to decide what it wants to see, and that no one was involuntarily being put in the position of looking at images that might make him or her uncomfortable.

"The experience of viewing an exhibition of photographs in a museum space is not the same as inadvertently encountering an artwork in a public space. As a contemporary art museum, our job is to expose the public to recent work with which it may be unfamiliar, not to limit or shield people from new experiences. The ultimate acquittal in court of the Contemporary Arts Center and its director, Dennis Barrie, in October 1990 vindicates the institutions that believed the exhibition should continue to be seen by the American public. It also underscores that the Mapplethorpe show could still receive government funding under existing NEA guidelines, because the work does have artistic merit. The prosecution was unsuccessful in attempting to pit community standards against the First Amendment right to freedom of expression. In this case, a jury of eight—four men and four women from the suburbs of Cincinnati, who had little or no interest in art or art museums—believed the museum professionals who testified that Mapplethorpe's photographs do indeed have artistic value, even if their content is explicitly sexual. The decision was perhaps even more remarkable because the seven photographs considered by the jury (five were images from Mapplethorpe's *X Portfolio,* two were portraits of children) had been taken out of the context of the exhibition as a whole and considered individually. . . .

"The dark cloud of punishment suddenly appeared again in May 1990, when the National Council for the Arts, which advises the chairman of the NEA, voted to reject grants for two upcoming ICA shows that had been recommended for funding by the peer-review panel. This action was based neither on the merits of the proposals nor on the content. . . . It is unwise to jeopardize everything the NEA has achieved in its twenty-five-year history by overreacting to criticism and changing the basic principles under which the agency has operated. The NEA's reluctance or inability to stand up for its very real achievements as an advocate for experiementation and cultural diversity in the arts has been a notable failing. Instead, it has responded defensively, internalizing the criticism generated by the Reverend Donald Wildmon of the American Family Association, Senator Jesse Helms, and other conservative factions. Most disturbing is that it now prematurely rejects grants in an effort to precensor the programs it will support.

"The greatest danger to the future of the NEA now rests within the NEA itself. It was through its own administrative procedures, established after the compromise legislation passed in October 1989, that the NEA chose to require all grant recipients to sign a pledge stating that they would not use the funds to support "obscene" work. The NEH, which was subject to the same legislation, chose not to add such a clause. After

the pledge was adopted, a number of artists and organizations refused to sign NEA grant awards and instead filed federal lawsuits, claiming that the pledge violates First Amendment free-speech guarantees. Although the National Council voted to remove the pledge, and the report issued in September 1990 by an independent commission (appointed by the President and leaders of Congress) to evaluate the NEA made a similar recommendation, the chairman of the NEA still refused. . . .

"The Mapplethorpe controversy also raised the question of how a museum defines its audience, and what may be seen as the responsibility of the curator and the museum to that audience. In the past (before the NEA was founded), when the museum-going public was considerably smaller and the audience for contemporary-art exhibitions in particular was limited, curators may have operated on the assumption that they were addressing a well-informed, educated, homogeneous audience only, and that the larger, more culturally diverse public, lacking specialized training in art or art history, had no interest in what they did. Or, if they operated on the premise that they had a broad public audience, its opinions and responses did not much matter. It is clear from the public response and media coverage over the past two years that museum professionals can no longer function under these outdated assumptions. A large, heterogeneous audience attends art exhibitions, either as a result of genuine interest or merely out of curiosity.

"When considering the issue of audience in relation to how an institution responds to external pressure, the first questions must be: Who is exerting that pressure and is it justified? In the Mapplethorpe case, it became clear that it was *not* the general public who demanded that the show be closed down or edited. Nor was it the public who questioned the legitimacy of spending tax dollars on a controversial venture. In marked contrast, once the controversy arose, attendance grew substantially every time the exhibition moved to a new city. In fact, in Cincinnati more than eighty thousand people saw the show, for which the CAC added a surcharge of four dollars per ticket. Further, the museum more than doubled its membership. The content of the show was not questioned by the citizens of Cincinnati as a result of any direct contact with particular photographs; rather, the court action was instigated through political and financial pressure exerted by a local organization called the Citizens for Community Values, in advance of the opening of the exhibition at the CAC.

"Similarly, in Washington there were no incidents of public protest, despite the enormous media attention and brouhaha that preceded the opening of the exhibition at the Washington Project for the Arts. It was the WPA's belief that because of the issues raised about the NEA in regard to the Mapplethorpe exhibition, it was even more important that the public (and the politicians) in Washington have the opportunity to see the works firsthand and not rely on reproductions and hearsay. The president of the WPA's board of directors stated, "We feel it's essential to maintain and preserve a climate that encourages individual and institutional artistic freedom of expression in our city. Artists and their work must be strongly supported in the face of any attempts towards censorship, either direct or subtle."

"Will recent political events change the way in which museums define their roles and responsibilities in the future so that, consequently, they alter their programs and operations in an effort to avoid controversy? Artists and art institutions now find themselves under constant scrutiny— from within as well as from outside their own ranks— having to defend their reputations and their eligibility to receive public funds. The current debate about censorship and public funding for the arts had forced us to reexamine our values and principles—as institutions and as individuals. Without a strong NEA, individual artists, artists' organizations, and art museums will have to serve as their own advocates and increase their activism in the public arena. If we truly believe in freedom of expression, if we feel that the arts should be valued in our society, then we must oppose any efforts that abridge that freedom or limit the public's access to all forms of artistic expression."

"Auteurs as Autobiographers: Jo Spence and Cindy Sherman." (1994)
James Guimond*

"From the 1930s through the 1970s, Weston-style nude studies were one of the staple products of both commercial and amateur photographers who had "artistic" intentions. . . ."

"Such images were also descended, historically, from oil paintings of female nudes in which, as John Berger points out, the female models were often seen as "passive" and "supine," sleeping, staring at mirrors, or coyly looking at viewers who were presumably the painting's spectator-owners. But what these spectator-owners saw was not only the passivity of the female model: they also saw the results of the male painter's activity and creativity, which were evident in every brush stroke, his technical skills and his achievement as an artist. Analogously, the photographic nude study creates a similar opposition of the male photographer as an active, creative agent who consciously selects the modernist technology and exhibits the skills which produce images, whereas the woman model becomes an object, passive, part of the pre-modern, natural world, so that she is seemingly innocent—or even unconscious—asleep on some pristine beach. Throughout the process, the "male gaze" of the painter/photographer is in control of the image and its production as he selects poses and colors, f-stops, and shutter speeds. To many late-twentieth-century viewers, such representations may seem to be fictions, but they are fictions whose generic, coded messages ex-

*From *Modern Fiction Studies,* Vol. 40, no. 3, Fall, 1994, pp. 573–592. Copyright © The Johns Hopkins University Press.

press attitudes about the positions and status of men and women in relation to creativity and control, activity and passivity.

"Cindy Sherman's *Untitled Film Stills,* made in the late 1970s, and Jo Spence's 1986 book, *Putting Myself in the Picture,* are photographic statements which attack the stereotype I've just described. Both destroy the distinction between the active photographer and the passive model so completely that it is appropriate to describe these women as being *auteurs* more than photographers, since—except for the fact that they use still photography—they function very much like movie directors. Both rebel against the "male gaze" by actively casting themselves as the subjects of their own stories. Both control the *mise-en-scènes* and select the format of the images in which their self-representations appear. Both de-emphasize the modernist concern with glossy technical expertise, which dominated mid-twentieth-century photography. Many of Spence's images are rather plain snapshots, and some of Sherman's *Film Stills* look like they are from B-movies made by mediocre cinematographers (Fig. 5.7). However, other qualities of Spence's and Sherman's images and the formats in which they appear are so drastically different that I will contrast them for most of the rest of this essay.

"Spence's *Putting Myself in the Picture* is an intensely personal and candid book about what she calls "my journey through life and photography." It is, in the words of the book's sub-title, *A Political, Personal and Photographic Autobiography.* Arranged in a roughly chronological narrative, it contains Spence's memories and explanation about herself, hundreds of pictures which Spence made herself or in which she appears, "A Family Album" of her life from 1939 to 1979, a letter about herself, articles she wrote with co-workers, conversations with colleagues in phototherapy sessions, and questions and answers with people who saw the exhibit which was the book's source. Other photographers stay out of their pictures as they claim to be presenting the truth about their subjects. In contrast, throughout *Putting Myself in the Picture,* Spence represents herself as struggling to discover and communicate the truth about herself. . . .

"As I mentioned earlier, Spence shows little interest in the glossy technological expertise which characterizes much modernist photography; however, by selecting this poem to introduce the book, she expresses allegiance to one of the fundamental tenets of modernity itself: the "belief that in principle the deep structure of reality is knowable, that it is intellectually and culturally penetrable," a belief which expresses itself in the "aspiration to reveal the essential truth" of existence which does "not reside on the surface of things." . . .

". . . Spence is an individual much concerned with creating and communicating an authentic, present self: one which has not been, like her past selves, imposed upon her by others. Thus it is significant, as she reveals in a letter at the end of the book, that she had a whole series of names given to her by her parents (Joan Patricia Clode), co-workers and friends (Jo), a husband (Joan Patricia Holland), a man she lived with in Ireland (Spence), and her own commercial ambitions (Joanna Spence Associates) before she finally "decided to stay with Jo Spence." For Spence, identity is a process of self-naming and re-naming, learning where her names or selves originated and decid-

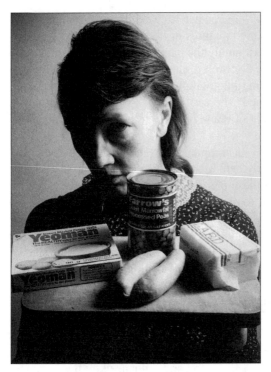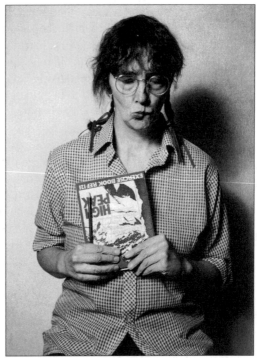

Figure 5.7 Jo Spence.
Jo Spence in collaboration with Rosey Martin from Double Exposure:
The Minefield of Memory, 1987. A Photographer's Gallery touring
exhibition.
Chromogenic color print.
Courtesy Jo Spence Memorial Archive.

ing which of them are more truthful than others, which of them must be accepted and
which must be rejected to reveal the process and the complexity of her being. . . . And,
since Spence is a photographer, this process involved selecting or making images and
arranging them in ways she thought would be truthful—even though, as she acknowl-
edged, many of these pictures originally were made to mask or conceal unpleasant
truths about herself. In particular, looking at pictures of herself made before the mid-
1970s when she became more politically aware, she realized that they contained:

> no record of my appalling health . . . no record of the pointless years, shunted
> around schools inside formal education (where I was downgraded for "unruly
> behavior," constantly evaluated and eventually crushed into the mould of "typ-
> ist"); no record of a broken marriage and the havoc this so-called failure caused
> me; no record of trying to please parents and other authority figures; no record
> of struggles. . . .

"To remedy these omissions, Spence created her 1979 exhibition, *The Family Album: 1939–1979* in which she accompanied pictures of herself—from baby to forty-year-old adult—with a prose narrative explaining the painful details the pictures were meant to conceal. As she did this, Spence discovered, she also changed her relationship to photography. "By tentatively examining photographs of myself . . . by taking control over how I wanted to be photographed" she wrote later, "I changed my role from being behind the camera to being in front of it and became at the same time an active rather than passive subject."

"Looking at the pictures she made as a commercial ("high street") photographer between 1967 and 1974, Spence subjected them to the same scrutiny. What sort of photographer, she asked herself, produced these pictures? Her answer often was: a photographer who was herself "constructed" to produce fictions for the market. "These are not real but imaginary children, conjured out of the skills of the photographer, in collusion with parents," she said of her commercial baby pictures; and when she looked at the "Madonna and child" pictures of mothers and children she had made before she became a feminist she was "so ashamed at what I'd done (ideologically speaking)" that she destroyed the negatives.

"When she had done this commercial work, twenty years before, Spence believed photography enabled her to express her individuality, but by the time she wrote *Putting Myself in the Picture* she had learned there was nothing "unique" about her pictures "because contrary to my belief that I was inventing my technique, I realize with hindsight that my work was totally of its period and influenced by the dominant trends in portrait photography. I had already internalized various ways of encoding photographs from watching others at work, from reading magazines and from the cinema." Nevertheless, in the narrative portion of *Putting Myself in the Picture,* Spence saves herself from complete self-contempt by remembering that there was a saving slice of subversion in even her most conformist commercial work. "I used to go and perform through a kind of split personality where I would do the expected romantic lovey-dovey stuff" at weddings, she recalled:

> But I was also influenced by Diane Arbus, I was a nasty, sneaky, little rat behind the camera who said: "I'll show you people what you are really like!" So at a wedding I would be oscillating across those two areas, and then I found that people really liked both types of pictures. Only it wasn't always the same people. So, the wedding couple might like the Diane Arbus shots . . . and all the mums and dads would pick out the lovey-dovey stuff.

"By combining her prose narrative with photographic images of herself (or with images she has made of other people), Spence transforms her practice of photography from a kind of social fiction into a form of personal self-revelation. Art photography critics had dismissed her *Family Album* exhibit as mere "therapy," but by the early 1980s Spence decided that the therapeutic uses of photography were those which were

most important to her. Politicized and enlightened by feminist, leftist, and psychoanalytic theories, she began to use images of herself to confront her own feelings—particularly the ones she found most painful or shameful. Her own sexuality, her childhood anger at her mother, her illness from breast cancer, which led to a lumpectomy, all became the subjects of her photography.

"The self which emerges from Spence's narrative and images is one which resists and asserts itself against authorities. Do doctors, nurses, and medical technicians try to "infantize" patients? Spence has herself photographed with the caption "Property of Jo Spence" written on her left breast, as if to remind herself that she was an adult who "owned" her own body; and she had herself photographed, after the lumpectomy, dressed like an infant and sucking her thumb to parody and thus relieve her feelings of having been treated like a baby during and after her operation. When she became an adult student in photography courses at the Central London Polytechnic, she resented the authority of teachers in much the same way that she resisted the authority of doctors in the hospital. For at the same time that she was learning radical theories assaulting "preconceived ideas about what constitutes a photograph," she also had to be "on the receiving end of interpenetrating theories of communication, culture, psychoanalysis, semiology, history, feminism, and social and political discourses." . . . So, at the conclusion of her book, Spence gives her own theories of photography, therapy, and the "female gaze," thus making herself the equal of the tutors who had angered her. She too, she asserts, has read Foucault, Althusser, and—by implication—Freud, Mulvey, and other theorists as well; and therefore she has the power to theorize and construct her own Jo Spence, the Jo Spence who has written *Putting Myself in the Picture.*

"She has transformed herself so that she has become an active participant in modern culture rather than a passive "female" object of that culture—a transformation which she symbolized forcefully in a diptych of two photographic images, entitled "Industrialism," which are reproduced on pages 122 and 123 of *Putting Myself in the Picture.* In the left (that is, the past) image she had herself photographed lying nude in a field with her back to the camera, a classic, modernist "pastoral" image of woman-as-nature. In the right-hand image of the diptych, which presumably indicates the present, she stands naked, one half of her back visible, confronting a series of electric power pylons. Modern technology and industry divide woman, since only half of her is visible, yet she still stands erect facing this power, asserting the presence of her body and her willingness to confront power instead of allowing images of her body to be used as parts of the pseudo-pastoral illusion, which is one of modernism's nostalgic myths.

"The very subtitle of Spence's book—*A Political Personal and Photographic Autobiography*—proclaims its autobiographical intentions. Sherman's *Untitled Film Stills* is more ambiguous. In a 1983 interview in *American Photographer,* which appeared shortly after the first publication of the *Film Stills,* Sherman insisted that her images were "not at all autobiographical." This statement may be true if one uses the term "autobiographical" in an unsophisticated way as referring to actual events from Sherman's personal past which she has re-staged or sought to represent in her photographic

images. But if one applies the word "autobiographical" in a more modern/postmodern sense to her *Stills,* if one considers them as self-constructions, then her images are autobiographical because they do create an identity for Sherman as a combination *auteur,* model, photographer, artist, and "film star."

"However, in contrast to *Putting Myself in the Picture,* which is a modernist quest to construct a more complex and authentic self, a personal version of a modernist's "grand narrative," Sherman's *Untitled Film Stills* are very much a postmodernist series of micronarratives and simulacra, a celebration of the artist's ability to create a multiplicity of inauthentic selves. Thus seen from a modernist perspective, Sherman's images of herself are profoundly evasive. Using wigs, costumes, and assorted *mise-en-scènes,* she defeats any efforts by others to put her in a "formulated phrase by casting herself in images which are ready-made, already-formulated cultural stereotypes: film noir vamps, plucky career girls, Hitchcock heroines, soap opera sophisticates, and New Wave or neorealist actresses. Thus Sherman's *Stills* exhibit that "chronic provisionality" and "plurality of perspectives" which are considered so characteristic of postmodernism, and postmodernist theoreticians have responded to her images by producing a "mountainous literature" lauding them as extremely significant cultural productions.

"A few of these critics have debated whether or not the *Stills* were intended to be representations of specific films. Sherman seemed to answer that question in a 1983 interview when she said her images were pastiches (or appropriations) made up of her memories of movies mixed with observations of actual people: "In the time that I spend in front of the camera," she said, "I think of all the movies and all of the people I've ever seen, and I just try to put the pieces together in a way that makes sense. I'll just sit there and ham it up, looking in the mirror to see what works. . . . [I]t all comes from watching movies and studying peoples' faces—even on the streets and in the subways." In contrast, when Spence criticized her own commercial photographs, she did so because, when she made them, she had internalized images from mass media like "magazines and the cinema" and encoded them into her own work.

"Behind this contrast, we can see one of the more salient differences between modernism and postmodernism. Spence, the modernist, distrusts the mass media because it is stereotypical and not genuinely original. Sherman has the postmodernist disdain for originality, and she revels in her ability to internalize and encode images and *mise-en-scènes* from media like the movies. . . .

"Nor do her *Stills* have any dominant, overall mood. Some of them seem to be intended as images from *noir* or suspense films because they have dark *mise-en-scènes,* because Sherman shows herself as tense or disturbed in them, or because they seem to imply suspicious or fearful narratives. As examples, one can cite Still #4 in which she is listening through a closed door in a dark corridor, Still #32 in which her face is partially in a shadow while she lights a cigarette, or Still #27 in which she seems to be sitting in a nightclub with tears or sweat streaking her face. In other images—such as Stills numbers 25 and 83—there is a milder sense of danger because Sherman has represented herself as a woman being observed from a distance by someone, perhaps in a

hostile way. . . . However, in contrast to these images, Sherman also made a considerable number of stills in which she appears as a strong personality, in which there is no particular sense of danger, or in which she seems to be interacting with someone outside the picture frame in a friendly or neutral way. These images generally have light *mise-en-scènes,* and in them Sherman looks forceful, calm, or relaxed. In Still #5, for example, she is holding a letter while looking out of the picture frame, apparently waiting for a comment from someone, and in Still #16 she is sitting in a chair and appears to be poised and sophisticated, gesturing with a cigarette as she listens to someone near her. She also made several stills—numbers 11, 34, 37, and 52—in which she portrays herself as brooding or enveloped in a reverie, apparently waiting for something to happen which will change her life. And, in a related category, there are what I would call her road movie or coming-of-age stills in which she posed herself as a traveler: Still #48 in which she stands in a road, waiting for a ride, with her suitcase beside her; and Still #44 where she posed by the Flagstaff railroad station waiting for a train.

"Such images may suggest many kinds of narratives, but because of the format Sherman has adopted for her *Stills,* she never develops or completes any of them. There is never any continuity between the images, and Sherman is costumed and appears so differently in her images that viewers cannot make any narrative connections between them. . . .

"Moreover, the stills also imply narratives of various kinds in which Sherman herself could have a variety of identities. The Cindy Sherman listening at the door in Still #4, for instance, could be a dangerous spy in a *noir* film, or a heroic counter-spy in a patriotic thriller, but of course viewers can never know which she is because the film, which would reveal that information, will never be made. . . . By simultaneously implying fragments of narratives and then refusing to develop those narratives, Sherman discovered a visual equivalent to the multiple endings, the problematic characterizations, and the indeterminate conclusions which are so characteristic of postmodernist prose fictions.

"Some of the political and ethical implications of Sherman's Untitled *Film Stills* are as problematical and ambiguous as the self she represents in them. On the one hand, as I suggested earlier, she attacks the traditional photographic division of males as active (photographers) and women as passive (models) by acting as her own photographer and *auteur* as well a model and "film star." On the other hand, as Arthur Danto has commented, film stills—because of their function—encourage voyeurism since they must "arouse enough purient curiosity in the passerby to justify spending money and time in seeing the film." . . . By adopting the film still as her visual medium, Sherman committed herself to producing "seductive, enticing" images, and she compounded these qualities—in a few images—by posing herself in ways which would appeal to voyeurs. In Stills 2 and 39 in particular she photographed herself wearing a towel as she stared back at a bathroom mirror (Still #2) and standing by a wash basin in her underwear (Still #39). The pictures are quite similar to the kind of amateur snapshots which a voyeur might make of his wife or girlfriend.

"However, thanks to the flexibility of postmodern theorizing, Sherman's defenders can argue that such images should be interpreted in ways that transform them into "deconstructions" or "denunciations" of the bad old advertising and mass-media attitudes toward women. . . . We thus encounter once again the unavoidable necessity of participating in the very activity that is being denounced *precisely in order to denounce it*" (emphasis in original, 235). On the other hand, Spence, who is much more overtly political than most photographers, makes her own direct denunciations of the media by producing words and images which explicitly attack media representations of women. Part of her *Picture of Health* exhibit, for example, consisted of a collage on a panel containing her photograph of doctors clustered around a patient, the covers of two paperbacks with pictures of nurses on them (*Love and Nurse Ava*) is one of the titles suggesting that the medical profession is sexy and romantic, and Spence's own caption, "love, or money?" to denounce the romantic illusion. Spence's "denunciation" is explicit: the mass media help to disguise the financial motivations of medical professionals by representing them as romantic lovers and sex objects. Or Spence expresses her attitude toward the "male gaze" by parodying it as she directs her own "female gaze" at the body of her companion/partner David Roberts and photographs him as he performed various activities—including urinating—while he was naked or wearing only an undershirt.

"This contrast is significant. Spence fends for herself as a theoretician as well as an artist. She feels she has an authentic self: therefore, she is willing to state and defend her own political viewpoints and have her own "gaze." Sherman, who represents herself as having a postmodernist plethora of selves—none of whom are accompanied by any comments from Sherman herself—has to be rescued from political and ethical "incorrectness" by postmodernist theorizing. . . . By learning theory and speaking to readers through a narrative, Spence has taken a considerable amount of control over her images and the self she represents in them. She has been able to interpret as well as to produce these images and incorporate them into the narrative structure of *Putting Myself in the Picture*. In contrast, though Sherman has been very active as a visual artist, she has remained verbally passive or "silent." She has produced no narratives—even postmodernist ones—explaining her *Film Stills* which remain, significantly, *Untitled*. Thus the various editions of her *Stills* have remained in the conventional artbook format of images accompanied by a verbal text provided by one or more critics or theoreticians. In the case of Sherman's *Stills*, critical texts have become increasingly long and theoretically complex. The 1993 Rizzoli *Cindy Sherman*—which contains many of the stills as well as her later work—has a particularly elaborate critical text by Rosalind Krauss. Instead of having any narratives by Sherman which might put her images in a context relevant to her as an artist and woman, the Rizzoli book contains Krauss's critical text which uses the *Stills* as illustrations of "formulated phrase[s]" from postmodern and post structuralist critical texts involving semiotics, myth, feminist theory, and psychoanalysis.

"In her critique of the "male gaze" in films, Mulvey argued not only that women

were "passive" in the sense that they were present in films mainly to be looked at, but also because male movie stars were presented as active, "main controlling figure[s]" who "can make things happen" and set narratives in motion. Sherman tacitly followed this convention in many of her *Stills* by representing herself as looking out of the picture frame as if she were waiting for someone—presumably a man—who would begin a narrative that would give meaning to the situation in the still. An analogous relationship between Sherman's images and Krauss's theories exists in the Rizzoli book. There, instead of being "silenced" by patriarchy, Sherman has been "silenced" by theory. To be sure, a great many artists, including many male ones, have been similarly "silenced" by the critical texts published with their images; but this kind of silence is (as postmodernists might say) particularly problematic with women artists since now they are supposed to be more articulate and assertive—a challenge which Spence confronted successfully by adding her own narrative and theorizing to *Putting Myself in the Picture.*

"Spence's and Sherman's respective works represent relatively extreme examples of the differences which can exist between late twentieth-century modernist and postmodernist visual and autobiographical practices. Both Spence and Sherman confront the issue of how women can represent themselves in a media—still photography—which was until very recently largely dominated by male artists and theoreticians. Neither of them has shown an interest in what Danto calls the "aristocratic format" of still photography which attempts to produce "elegant," arrogant, crystal-clear" images. Both of them did major work—the *Untitled Film Stills* and *Putting Myself in the Picture*—within the same decade, between the late 1970s and the mid-1980s; but in other respects their forms of discourse diverge.

"Like many modernist thinkers and writers (Freud, Beauvoir, Woolf, Sartre, for example), Spence tries to confront the complexity of the self and to give as complete a portrait of it as possible. Her *Putting Myself in the Picture* illustrates how this process can be achieved autobiographically through the use of images, particularly when those images are accompanied by a narrative which allows the individual to interpret his or her past and present visual selves. In contrast, Sherman's *Stills* demonstrate the postmodernist fascination with ready-made selves which can be encountered in and appropriated or consumed from the mass media. . . ."

"Carrie Mae Weems: Issues in Black, White and Color." (1993)

*Andrea Kirsh**

"Though others know her as an artist or photographer, Carrie Mae Weems describes herself as an "image maker." The term, with its baggage of popular and commercial connotations, is crucial to Weems's task. Since 1976, when a friend gave her a camera, she has generated a sequence of images reflecting her concern with the world around her—with the nature of "our humanity, our plight as human beings." She has focused on the ways in which images shape our perception of color, gender, and class. Surveying the development of her work, we can see her exploring the existing genres of photographic imagery. She has looked at their uses in artistic, commercial and popular contexts, the work of both amateurs and professionals. With great subtlety, complexity and wit, Weems has manipulated a variety of photographic conventions, playing with their abstractions and adapting them to her own use. . . .

"As a black woman photographing her own community, Weems found few precedents. The tradition of documentary photography within which she began her investigations is primarily one of describing the "other," whether nation, class, gender or race. The *Black Photographers Annual,* published intermittently from 1972 to 1980 by Joe Crawford in Brooklyn, would reveal a tradition of photography of blacks, by blacks. The tradition encompassed three generations of photographers who documented everyday life in Harlem, as well as younger photographers working in urban and rural communities across the country. The first issue of *Black Photographers Annual* featured the work of James Van Der Zee, a commercial photographer whose studio recorded images of Harlem's elite, including many figures from the Harlem Renaissance. Van Der Zee's work reached a wider audience, black and white, when the Metropolitan Museum of Art included it in its controversial exhibition *Harlem on My Mind* in 1969.

"A more immediate model for Weems was Roy DeCarava, a painter who turned to photography in 1947. . . . DeCarava's work would serve as a major inspiration to Carrie Mae Weems. She admired his commitment to portraying the life of his own neighborhood. She also was drawn to the formal poetry of his imagery, which reflects the beauty he sees in his subjects—his own people. DeCarava is certainly an honored forebear of much of the exquisite printing and formal rigor of Weems's work. . . .

"Weems's earliest body of work, the *Environmental Portraits,* came out of the mainstream of documentary photography. She began it in 1978 with shots taken in Portland, Oregon, her hometown, and in New York, where she lived intermittently. . . .

". . . The series *S. E. San Diego,* shot between 1983 and 1985, records sites of the

*From *Carrie Mae Weems*. Washington, D.C.: National Museum for Women in the Arts, 1993, pp. 9–17.

social rather than the personal life of the community, which Weems had portrayed in *Environmental Portraits*. It also explores the neighborhood's home-grown institutions, little frequented by outsiders. *S. E. San Diego* marks the beginning of a narrative emphasis that would recur in Weems's photographs and in her text (which she added later, after she had developed the use of images and text in *Family Pictures and Stories*).

"Weems was closer to her subjects in southeast San Diego, but still an outsider. As a student of folklore and anthropology, she was well aware of the inherent problem for the outsider, even a close outsider, in recording a culture. . . .

"If the *Environmental Portraits* and the *S. E. San Diego* series were attempts to explore the uses of straight documentary to tell a story, *Family Pictures and Stories* (1978–84) suggests the format of the family photo album. The personal is emphasized not only by the choice of subject—Weems's own family—but by the accompanying narratives, which take the form of written captions and two audiotapes. . . . We sense her involvement in the abandoned pose of her mother, arms thrown wide, and the intimacy of a kitchen scene in which the photographer is clearly a part of the family, standing just across the table from her sisters and nieces.

"Weems has said that the series was prompted, in part, by the Moynihan Report, which characterized the black family as being in crisis and suggested that a matriarchal system was partly responsible. Although the report was more than a decade old, these were still potent issues. In *Family Pictures and Stories,* Weems explores the means by which her family passes on its history. . . . We hear of four generations, displaced by poverty and racism, telling of family gatherings and domestic violence. We see a large, supportive clan, including a mother baffled by the teenage pregnancies of two daughters and brothers who are, themselves, affectionate young fathers. Weems's father tells stories of his rural, impoverished youth in response to his children's requests. He is close to his son, yet pulls a gun on him in the midst of a drunken fight. This is not a one-dimensional picture of family life, simplified and prettified in the name of black pride. Weems's exposure of her family's struggles and problems, along with their resilience and affection, develops a multi-dimensional portrait. She is confident enough to reveal the more complex truth.

"Carrie Mae Weems tells her own story as a consciously political act, defying inaccurate government sociology. The first-person perspective is crucial, since the personal narratives have a subversive power precisely when the "official" histories create distorted records or write a people out of existence. Weems uses the 35mm format, the informality of the "snapshots" and the first-personal viewpoint to construct an "alternative" history which implicitly questions the third-person "objectivity" of official portrayals. *Family Pictures and Stories* can also be seen as a response or reproach to documentaries of black America by white photographers; these include Photo League projects of the 1930s, such as Aaron Siskind's *Harlem Document,* and Bruce Davidson's *East 100th Street* of 1970. Their representations were clearly made from outside the community, and Weems thinks they present distorted views. . . .

"Up to this point Weems's work was produced with a 35mm camera, consistent

with its aesthetic of informality, temporality and mobility. In the work that followed she turned to the use of a larger format (2¼ × 2¼ in.) negative and explored its potential for carefully posed subjects and large, high-resolution prints. . . .

"While attempting to understand her own family through the series *Family Pictures and Stories,* Weems became increasingly interested in storytelling and folklore. . . . She was drawn to folklore's uncensored quality and particularly to the large collection of jokes in the archives of Berkeley's Folklore Program. Weems sees jokes as a social barometer and as a socially sanctioned way to discuss topics that, while of obvious current interest, would otherwise be considered unmentionable.

". . . The legacy of folklore to her artwork appears most clearly in the recurrence of themes drawn from folk sources, in her tendency to choose subjects on the margins of social acceptability and, more subtly, in her insistence on establishing an alternative, grass-roots history that counters the authority of official history.

"In 1987 she began to explore the implications of racist humor in the series of works titled *Ain't Jokin,* another series of captioned photographs. While the texts in *Family Pictures and Stories* allowed Weems to add more information to her visual imagery, here they become a powerful vehicle for ironic contrast, which she manipulates to challenge the viewers' stereotypes. . . .

"Some works in *Ain't Jokin* play with the conventions of educational books and toys, using the favored teaching device of compare and contrast (What's a cross between an ape and a nigger?), and force the viewer to come close, to get involved. The answer is concealed by a sliding panel which the viewer must move to reveal the text. The viewer must touch—violating art-world conventions. The discomfort of touching the artwork is made to parallel the discomfort of confronting our own racism.

"Although Weems pairs photos and captions throughout *Ain't Jokin,* she uses no formula. She plays words off images to varying purpose, evoking different responses. Some texts are literal descriptions (*Black Women with Chicken*), unsettling because of their association with racist stereotyping; some reflect internalized racism within the black community . . ., others are unabashedly violent, racist jokes (How do you get a nigger out of a tree?). One might say there is something here to offend everyone—everyone, that is, but the unregenerate racist. This work has a demonstrated capacity to upset both black and liberal white audiences. That discomfort is surely one measure of its importance. . . .

> Each of us carries around little packages of consumer racism in the form of neat little characteristics and qualities reserved for specific groups—unlike ourselves—we may encounter along this miserably short course in life. And the unfortunate part of the business is these stereotypes are not harmless expressions, but have real—devastatingly real—effects on the material well-being of those singled out as objects of these expressions.

"The *American Icons* series of 1988–89 is a counterpart to *Ain't Jokin* because of its treatment of racist imagery in our daily lives, as opposed to the mass media. Behind

this series one hears the feminist slogan of the 1960s: "The personal is political." The formats of the series are the still life and the domestic interior. These photographs, lushly lit, composed and beautiful, slyly project their subtext as they reveal caricatured blacks reduced to subservient, decorative objects. The photographs show *tsatskes* or curios in the form of cookie-jars, ashtrays and other minor household furnishings. They hold letters on the desk, peek from behind a porch thermometer, serve as objects of fun in the playroom ("everywhere but in the bedroom," the artist has remarked, where racist myths about black sexuality might upset the hierarchy). . . .

"In *Untitled* (Kitchen Table Series) of 1990, Carrie Mae Weems has created her masterpiece to date (Fig. 5.8). The photographs have a beauty that exploits the full potential of the large-format camera. Their formal subtlety and intricacy counterpoints the folksiness of the text. Their verbal and visual call-and-response draws on African American tradition as it engages us in complex and timely issues. This inter-play de-

Figure 5.8 Carrie Mae Weems.
Untitled, (Woman Brushing Hair), 1990.
Gelatin-silver print, 27¼" x 27¼."
Courtesy P.P.O.W. Inc., New York.
Copyright © Carrie Mae Weems.

velops the story in which a woman sorts out the conflicts between her political ideals and her emotional needs.

"The narrative proceeds through a space that is fixed rigidly in three dimensions by the immobile position of the camera/photographer/viewer, which defines the spatial breadth; by the receding table; and by the prominent verticality of the overhead light. The consistent illumination infusing the series recalls the bare bulbs of interrogation rooms, yet here the illumination becomes a metaphor for the artist's examination of the woman's life. The heroine interacts with her lover, daughter and friends. The characters sit and stand around a table—anchored to its central, domestic space. . . . These personal objects have the studied casualness of a 17th-century Dutch still life—the cigarettes, ashtrays, drinking glasses, playing cards become attributes of modern emotional life. The text for *Untitled* reveals a finely cocked ear for the vernacular. It combines a free-flowing association of folk sayings and lines from oft-heard songs, as familiar as the furnishings of one's home, to create a parable of contemporary life.

"The format of *Untitled* is related to a tradition of narrative photographic fictions and to the use of serial photography by conceptual artists. It is also clearly related to film, as if we were given a script and storyboards. Yet the intricate choreography of the figures, down to the subtlest detail of a glance or gesture, would be impossible on film—it would be more likely in dance or in history painting from an earlier period. The work is, in part, a conscious response to feminist film criticism, particularly Laura Mulvey's analysis of the problems inherent in female representation. The photographer is the model for the main protagonist of *Untitled*. This knowledge allows the viewer, in identifying with the photographer, to identify with her subject as well. The text always brings the viewer back to the narrative. Written in the third person, it is firmly anchored in the female voice, even when it opens up to allow her lover his say.

"Weems has discussed the fact that Mulvey's analysis of female representation in film entirely elides the issue of women of color. With her *Untitled* series, Weems challenges this omission, and looks back. Her protagonist not only functions independently of the white women who are her friends (upsetting the usual role assigned black women in white films), but several times within the sequence she stares directly at the viewer. Weems takes control of her own space, refusing to be the compliant object of "the gaze." . . .

"By 1990 Weems produced her first color work, when she was invited by Polaroid Corporation to use their 20 × 24 camera. . . .

"The Polaroid images became part of an installation titled *And 22 Million Very Tired and Very Angry People*. The installation consisted of thirteen still lifes, each of a single subject, plus single images of an armed man and a veiled woman. All fifteen photographs were captioned and arranged around the periphery of the space. Above the photographs Weems hung banners of text, evoking the voices of writers and theorists she admires: Fannie Lou Hamer, Antonio Gramsci, Ntozake Shange, Gabriel Garcia Marquez, Anton Chekhov, Malcolm X, and others. The photographs with suspended texts take the form of a primer, instructing the viewer about the role of the individual in the cause of political change. . . .

Deep Black, Ashy Black, Pale Black, Jet Black, Pitch Black, Dead Black, Blue Black, Purple Black, Chocolate-Brown, Coffee, Sealskin-Brown, Deep Brown, Honey Brown, Red Brown, Deep Yella Brown, Chocolate, High-Brown, Low-Brown, Velvet Brown, Bronze, Gingerbread, Light Brown, Tan, Olive, Copper, Pink, Banana, Cream, Orange, High Yalla, Lemon, Oh, and Yeah Caramel.

"From late 1989 to early 1990 Weems created a series which celebrated the range of skin color hidden behind the term "black." Its title, *Colored People,* recaptures the term American whites once used to describe blacks, and plays upon the fact that the prints themselves are "colored" (hand-dyed black and white prints). The triptychs and single images in the series portray the terms by which the African American community has created its own hierarchies of color. The preference for lighter or darker skin has reflected the changing politics of the community and, while such distinction by color is controversial, it is still operative.

"The format of the series harks back to the 19th-century use of photography in eugenics and criminology (by Francis Galton and Alphonse Bertillon), which led to the modern "mug shot." Yet in both photographs and captions, Weems converts demeaning systems of picturing and naming into a loving embrace of our polychrome humanity. With deft irony, she takes the names of the colors of caste literally, highlighting their artificiality: her *Magenta Colored Girl* is the synthetic color of aniline dye, far from anyone's skin tone. She adapts the mug shot's sequence of front and side view, the better to trap the miscreant (or, in its use in anthropology, to fix the "primitive other"), and turns it into a repetition of affirmation. The series' reference to Minimalist art adds another layer of subtlety: Weems overlays Minimalism's formal repetitions with those of the mug shot. This gives Minimalism's color sequences a purpose, generated not by aesthetic considerations but by the social implications of color.

"It is no accident that most of Weems's *Colored People* are, in fact, children and adolescents. *Golden Yella Girl* is a profile of a young girl with a broad gentle smile that reveals braces on her teeth. *Honey Colored Boy* is a bust portrait of a smooth-cheeked boy with an incipient mustache, his hair tied up in rubber bands. *Blue Black Boy* is younger still, staring directly at us, startling, darkly innocent. *Colored People,* growing out of black folklore, is addressed largely to its own young people—holding up a mirror to the beauty of their multiplicity.

"Carrie Mae Weems has forced a rereading of the history of photography in America, by insisting that we see black photographers as a distinct group with its own traditions. She has framed images of black Americans perpetuated through popular and media sources, and compelled us to examine their biases. She has furthermore adapted the repressive photographic techniques of Galton, as well as the documentary photography of both liberal social reformers and self-conscious art photographers. In so doing, Weems has brought a rare complexity, humor and beauty to an art dedicated to social change."

"Lorna Simpson." (1993)
*Andrew Wilkes**

"Lorna Simpson's photographs are documents of and testimonials to real-life situations, told through the use of symbolic figures and allegorical situations in order to create a narrative. Simpson demands active participation from her audience, offering hints of meaning without telling us what to think. Her work is rooted in her experience as a woman and an African-American. Complex issues of gender and race are conveyed through the use of disjointed texts combined with visual imagery, often resulting in troubling impressions. . . .

"Simpson began to question the objectivity of documentary photography early on. By the end of her undergraduate training at the School of Visual Arts in New York City in the early eighties, she felt the genre was too limited and potentially exploitative.

"She left New York and went on to graduate school at the University of California at San Diego, where she soon began to combine the visual aspect of her work with narrative. "I had always written stories and taken photographs," she explains, "but I had kept the two very separate. This was a merging of two activities, a time for reexamining the viewer's relationship to photographic imagery." . . .

"The images follow the words in a Simpson piece—and the text is worked over, often right up to the very last minute, when the work has already been hung. The imagery, however—perhaps due to purely pragmatic considerations of printing and format—must be decided upon and fixed at an earlier stage. "If I'm lucky, the words come first," she says. "When my pieces are successful, the words are far more difficult to come up with than the images." (Fig. 5.9)

"Simpson cites numerous African-American literary influences: James Baldwin, Ntozake Shange, Alice Walker, and Zora Neale Hurston—writers who have made new use of language in order to describe the black experience. This reassessment and reapplication of language is evinced in Simpson's texts, which often recharge a single word or a series of words by deploying it in new and provocative ways. Simpson maintains that her work is influenced principally by her own life—much of her work is autobiographical, yet it often addresses experiences relevant to black women collectively.

"*Proofreading,* 1989, depicts a woman's face four times, covered with plaques bearing the letters M-I, X-Y, R-U, B-Z (a phonetic rendering of "Am I sexy, are you busy?"). This is an unequivocating critique of a situation black women face constantly: being addressed and seen as sexual objects to be appraised and seduced. Another work from that year, *Three Seated Figures,* shows the same woman seated in slightly varying, rather uneasy poses, with text panels to the side of and above the images that read:

Aperture No. 133, (Fall 1993) pp. 14–23. Text by Andrew Wilkes. Copyright © 1993 by Aperture Foundation Inc.

Figure 5.9 Lorna Simpson.
Completing the Analogy, 1987.
Gelatin-silver print, engraved plastic plaque, 36" x 48" (91.4 x 121.9 cm).
Courtesy Sean Kelley Gallery, New York

"Her story," "Prints," "Signs of Entry," "Marks," and "each time they looked for proof." Here, Simpson provides enough information for us to deduce that this narrative deals with rape and with the skepticism of the media and public officials toward a woman—especially an African-American woman—and her story. These two works were among the first in which Simpson employed repetition as a way to expand a single figure—herself—into a collective persona.

"Simpson has also used the free-standing folding screen as a poignant method of presentation for her work. In *Screen 1*, 1986, three panels depict a seated black woman with a toy boat on her lap. On the front the text reads: "Marie said she was from Montreal although"; and on the back: "she was from Haiti." "The installation plays on the concept of screens and the 'screening' of identity," she notes. The panels not only confront the spectator with reference to the "hidden" self, they also hide viewers from one another.

"Around 1990 Simpson began to incorporate images of hair and symbolic objects into her work. Since that time, coiled and braided hair, African masks, shoes (often used as gender-specific stand-ins for people), and shoe boxes have served as props in her work. In 1991 she began putting together images of hair with images of African masks. But instead of presenting masks from the front, Simpson orients the audience to the *back* of the mask, putting the viewer into the position of the wearer, disrupting and challenging easily adopted cultural perspectives.

"Recently Simpson has moved away from working with the full figure to close in on different parts of the body, such as hands or lips. "I focus on details, either of the body, or of objects that represent gender, sexuality, and other themes." She purposely disrupts the viewer's vantage point, using serial images and turned-away figures—not allowing enough information for the viewer to classify the subjects. The body itself becomes a barrier, and the viewer, unable to be a voyeur, must turn from the images of bodies to the text, which does provide some disclosure. In Simpson's photolinen *Stack of Diaries,* the text describes one person's inability to continue writing in a diary and another taking it over. With this work, she has carefully created an ambiguity as to the genders involved—is this a relationship between a man and woman, or two men, or two women? Here, Simpson plays deftly with gender themes: "It's about relationships between people, individuals who have been abandoned." If a diary represents a means by which to record things that happen to you, Simpson takes the concept a step further by creating a narrative charged with issues of control: Who is keeping the record? Who is controlling what? And who is controlling whom? . . .

". . . Another recent work, *Upside Down/Right Side Up,* consists of two prints of life-size empty shoes; again, one is right-side up, and the other is upside down. "In Western art the representation of a figure upside down is death. So this is about absence of someone missing—that double absence of death." Simpson thus symbolically conveys feelings of absence and of loss; the lack of text in the work itself (almost unprecedented for the artist) testifies to her shift in this direction. . . .

"*Unavailable for Comment,* 1993, deals with the narrative of Saartje Benjamin, "the Hottentot Venus." Also known as Sarah Bartman, Benjamin was a South African woman who was brought to France in 1810 and put on display as a spectacle in Europe. Upon her death, French scientists dissected her genitals, which remain preserved in a jar in the permanent collection of Paris's Musee de l'Homme. Simpson's photograph shows a body of water and a pair of shoes standing on wrinkled velvet with a broken jar. The text, in French, reads: "Today Sarah Bartman visited the museum, this was unexpected, she disrupted the daily life of the museum." Simpson comments: "In the work I did before this, whatever discourse it had about race was more about identity—construction of identity—but is identity the race?" This piece, she feels, deals with identity. The jar is broken: the atrocity of the displayed genitals has been in some measure vindicated.

"Simpson's work is not a portrayal of victimization or a direct expression of empathy; rather, it delves into the dynamics and power of experience itself. Her subjects

are survival and survivors. The language and the makeup of Simpson's pieces serve to disrupt us, to jar us from our habitual mode of coming to terms with the photographic image. Simpson realizes it is unlikely that people will grasp the full meaning of her assemblage photography right away. She says, "The only thing I can hope the viewer will get from the work is something about the structure of the work. It would be asking too much, I think, for them to get my exact intention. But if—through the construct and use of language, the way things are juxtaposed—there is some sort of disruption of the way you would normally go about reaching photographic images . . . if that is happening, that's fine."

"Reflections on Latin American Photography." (1981)
Max Kozloff*

"This essay was originally to have dealt with the subjective experience and multiple readings of photography. You will agree that photos are often ambiguous in effect, so that this amiable topic left me free to say just about anything I wanted. Later, while serving as a juror for the second Colloquio Latino-Americano, it was suggested that I consider the images that had been submitted for the occasion, many of them displayed at the Palacio de Bellas Artes. The dilemmas of Latin American life and the puzzling attributes of photography seemed compatible themes. I planned to limit myself to about eight pictures, looking at them very closely as visual texts that both hindered and furthered an understanding of their subjects. In other words, I would analyze the special possibilities of photography itself, using illustrations from the present show. But now that aim strikes me as too limited and unresponsive.

"We are exposed to several hundred works, coming from disparate points in space, if not time. With the naiveté and ignorance, but also the foreshortened perspective of an outsider, I look upon an assemblage of photos that bears witness, frame by frame, to a passionate state of affairs. Each shot is not only weighted by its own cadence, but appears to figure in a larger, off-stage drama, a recurrent tragedy, of which it presents a fragment. The ongoing picture is, of course, ramified from country to country and then variegated within each country. While hope, pity, and grief are certainly not monopolized by Latin America, the ways of showing them have a distinct expressive aura. Struck by this phenomenon, I found, then, that my earlier question

*Max Kozloff. *The Privileged Eye*. Albuquerque: University of New Mexico Press, 1987, pp. 177–188. This article was originally given as a lecture at the Segundo Coloquio Latinoamericano de Fotographia, Palacio de Bellas Artes, Ciudad de Mexico, April–May 1981.

was reversed: what aspects of Latin-American life have been drawn into, and how have they been changed by, these photos?

"There exists a close fit between the social consciousness of such photographs and the belief of the Consejo that Latin-American societies are in crisis. It would not have been the first time a sponsor played a role in *generating,* not merely in acknowledging certain forms of communication. Just the same, no single group could account for the flood of images that describe the oppressive power relations of their scene or honor acts of confronting them. Encouraged and displayed, where many would have been censored at home, these ardent works surge forth, as if on a natural tide.

"The human face comes to haunt them as it never would in any comparable sampling of North American work. I am aware of clichés about the Latin search for identity. Here, though, the face is presented not as an apprehensive mask, but as a stage in which sorrowful experience is either remembered or awaited. Because the mobility of the features is a reflex of that experience, the face carries an active principle into this photography. More a source of action than a static portrait, it's like a gauge of outside pressures. Beyond their social class, a particular environment is always implied by these faces, one which elicits the intensity of their gaze. The Panamanian boy in Sandra Eleta's photo doesn't so much stare as drill you with his eyes. Even at moments of joy or alcoholic release and intimacy, a frantic tone is sensed. As for those scenes of carnival or ritual, when real masks appear, they only serve to emphasize a demonic impulse. The religious celebration and the saturnalia, as seen by photographers throughout Latin America, are but opposite sides of the same grotesque desperation.

"The feeling, then, of life being lived at the edge, of the extremity of the human situation being the *norm,* dominates these images. Far from imposing a dismal atmosphere, which might be inferred everywhere by the surroundings, this edginess conveys a harrowing vitality. At funerals, which for us are scenes of piety and reverence, such remorseless vision bites into the social fabric. The effect of the death is established on all faces, yet the loss they have suffered has only lent them an added sting of life. Often, too, photographers, such as the Mexican Pablo Ortiz Monasterio, bring us earlier vignettes of the individual, under the duress of fatigue and sickness, which are in the end compared with the ceremoniously arrayed corpse. Here, at last, is immobility, where the flesh has given out.

"From the psychological point of view, the face in Latin-American photography embodies a paradox. Providing an inexhaustible gallery of expression and temperament, it is studied with frank enjoyment. But it is an enjoyment of character, not a search into the nuances of ego. I don't doubt that faces here are broken down into types, more familiar to local audiences than they are to me. The campesino, the mother, those from the cantina, the old servant, the urchins of the villages, Chicano cliques, and so on. Photography has always been more adept at portraying what people are, rather than who they are. Nevertheless, we do not see any conscious mode or illusion of search into the subject's inner being. Under the circumstances, the kind of emotional knowledge thought to be gained by that inquiry would appear to be a self-indulgence. Each type is stationed in a certain place and intersects with other types, or rather, the

forces they represent mingle, either in cooperation or in conflict, with each other. It's therefore no accident that a psychological schematism is paralleled by a social schematism.

"One channel in which this schematism is realized is the area of work. To the extent people are made known, it's by their functions in the work activity (a theme comparatively underrepresented in North American photography where individuals are more typically labeled by their life-styles and are therefore shown by what they consume rather than do). That is why the frequent appearance of strike scenes in Latin America indicates a drastic form of social rupture. These shots impart an urgency felt by the strikers to mend the ties that have been broken. In this context, a strike is both an exceptional event, because it uproots a traditionalist people, and a repeated crisis, because labor unrest itself is built into the economic inequities that obviously prevail.

"Photographs, however, can clarify far less of the satisfaction or discontent of workers than of the powerful reality of work itself, defined by its particulars. The fact that harvest workers are portrayed as cheerful in Cuba, one of the few Socialist countries in Latin America, impresses one as far more polemical than documentary. Fresher and even startling is Juca Martins's photo series of a prostitute arrested and brutalized by police in Brazil. I say "startling" because no one in this ugly affair seems to have any consciousness other than of performing their work or of enduring what it requires. In the heat of action, these professionals revert to type and their cool behavior becomes wildly dissonant in a traumatic scene.

"Much less illuminating to my Northern eyes are all those scenarios in which subjects have been typecast instead of perceived as emergent from their type. By typecast I mean the rhetorical assignment of moral or sentimental values to the protagonists of the photograph. When we are intended to understand a riot victim as a martyr, a young child as an adorable pet, an armed soldier as an oppressive force, an old man as an incarnation of wisdom, we find ourselves in the one-dimensional world of ready-made judgments. As soon as the photographer *determines* that social types and their expected roles come together, then my ideological tendency is assumed ahead of time, and I can make no emotional or political discovery by means of the photograph. For me, symbolism of that sort works against itself by an effect of closure, lowering my involvement even when a subject might have historical implications.

"On the contrary, by imaging the way an environment is programmed by icons, a photograph can awaken political sensibility. The oversized renderings of saints, comic strip or TV characters, and government fixtures reflect institutional and media attempts to control a society. In simply recording, that is, stepping back from such violent presences, the photographer can dissociate us from them. The frame outflanks the message and therefore gives us the psychic room to maneuver with our consciousness. Here, the *photographer* emerges from a role, moving from passive witness or protesting ideologue to productive observer.

"The kind of space I just mentioned is peculiar to the photographic medium. A photograph arbitrarily frames a rectangular area in two dimensions, but it also cannot avoid giving the illusion of penetrating into another region, and therefore of pointing

to something. This pointedness entails a certain responsibility, a formal responsibility if you will, but I prefer to call it an expressive responsibility to the image. Most of the photographers here apparently stem from photojournalism, an expository mode absorbed with public narrative content. Pictures of this sort must describe the vectors of one or more activities as they come to a head in a unique instant of time. Time itself is a continuum of dynamic, singular, mutating instants, from which the photographer offers newsworthy stoppages.

"But in David Cardenas's picture of two men who support heavy sacks on their shoulders, the moment of perception appears stable because the conception of time is fixed. Past and future fall away before the apparent endlessness of *present* labor. Being a photograph, this picture is still highly descriptive, but it is, of course, no longer reportage. Because the darkness of the picture cavity highlights the weight of the men's burden, we can speak of a symbolist aim. Still, I'm unsure whether the men are actually workers or models, and I don't know as much about the space as I think I should know. Clearly stated facts and dubious circumstances oscillate in my mind, each to undermine the other, and I begin to question what I see.

"Or more accurately, I become aware of active thought and imagination that make claim for an order of their own. And they do that through the intervention of light and dark: the sensate stratum of tone which, more consistently in the hands of Latin American photographers than others, alters space and engenders mood. Because of that theatrical sensitivity to tone, objects, figures, and events, which may have suggested one kind of initial meaning, are ultimately perceived to have quite another. The subject is often not merely illuminated but *struck* by light or disjointed or drowned by shadow. You feel the physical force of chiaroscuro as it wrenches part unexpected zones within the frame. These recreated zones are profoundly disobedient to the natural contours of things, which are not broken down into partial accents or lost in strange depths. Subjects can still be named and described, but they are also disproportionately or inexplicably eaten away by the light, which constantly calls attention to itself. Such an element acts as the counterpart of the face in Latin American photography, a kind of physiognomy of space. Within that space is suggested limitless reserves of loneliness, ecstasy, ominous fears, regrets, and memories of all sorts.

"At the same time, I sense that this very extravagance of tonal contrast, with all its attendant tremors, is an everyday affair. It crops up incessantly, and much to the point, in Cuba, Peru, Columbia, Brazil, Venezuela, and so on, evidently because photographers and their audiences are mutually conditioned to it. The boundaries between the more historical space of photojournalism and this timeless fantasy vision are much more fluid than they are in my culture. With us, the interior life is approached through irony, artistic self-consciousness, or narcissism, and such devices are kept very separate from the modes of objective witness. It is as if the individual exists in a sovereign world, apart from communal existence or public reality. With this show, on the contrary, the easy communication between both spheres is taken for granted. As a result, many Latin American photos, despite their heavy breathing, subtly modulate the known genres of the medium. There comes into view a huge and vaguely defined ter-

rain in which the typical statement is less than a purely personal or introspective construction, and yet portentously more than a detached record.

"Take, as an example, Jose Figueroa's Cuban street scene. An apparently casual snap reveals four men, raked by slanting shadows, seated in crate-like booths, as if they were meditating in homemade confessionals. Next to them, a wall sign of a wind-whipped Cuban flag implies a chance juncture of thought and symbol. The whole of the possible meaning of this photo—a questioning of a national consciousness—is far larger than the sum of its parts, yet one can't assume the tableau to be other than itself, an ordinary sign available just then to any passerby. In any event, I am less concerned with the accuracy of a conceivable reading than with the temperament that attends to such an image. It tells me about qualities of special alertness, anxiety, and stress that are illuminating in themselves.

"Of course, no isolated case proves anything, and this particular photo could have been taken by an outsider. Still less would I argue that Latin American neighborhoods inevitably summon moody responses. Rather, with the blurred but concentrated memory of 2,000 Latin American photographs I *will* say that such neighborhoods can and have been perceived in this fashion. It goes beyond a taste for the incongruous or a delight in mystery, attitudes familiar enough on my home ground. Do we not all notice an instinctive Latin dualism, in which the things of this world can be situated unproblematically in the space of a dream?

"When that space erupts, as if from a nightmare, it's likely we're confronting a political testament. But with almost as much frequency, the interior reaches of the photograph draw us toward moments that are without directed purpose or glib schematism, and can only be described as play. I had spoken before of a passionate state of affairs, of which the photographs offered here represent fragments. Faces in themselves, and then in communities, reflected that passion. Work had a dominant role in the proceedings. Just as grave, unified, and consequential, however, is the theme of play, bridging public with private experience through distended time, that marks these photos at their best."

PHOTOGRAPHERS FROM THE PERIOD 1980–2000

1980–2000

*Aguilar, Laura (1959–), American
Barney, Tina (1950–), American
Benton, Stephen (1941–), American
Bey, Dawoud (1953–), American
Bishop, Michael (1946–), Brazilian
Burns, Marsha (1945–), American

*Chong, Albert (1958–), Jamaican
Connor, Linda (1944–), American
Cypis, Dorit (1951–), b. Israel, American
di Corcia, Philip Lorca (1951–), American
*Dureau, George Valentine (1930–), American
Fischl, Eric (1948–), American
Fontana, Roberta (1952–), Venezuelan
*Fournier, Colette (1952–), American
Gilbert & George (1943, 1942–), British
*Gray, Todd (1954–), American
*Green, Stanley (active 1970 on), American
Haya, Maria Eugenia (1944–), Cuban
*Hayashi, Masumi (1945–), American
Iturbride, Graciela (1942–), Mexican
*Karp, Leah Jaynes (active 1975 on), American
Kiefer, Anselm (1945–), American
Klett, Mark (1949–), American
Kruger, Barbara (1945–), American
Lawler, Louise (1947–), American
Leibovitz, Annie (1949–), American
Levine, Sherrie (1947–), American
*Little Turtle, Carm (1952–), American
*Lopez, Annie (1958–), American
Mann, Sally, (1951–), American
*Mapplethorpe, Robert (1946–1989), American
*Martinez-Cañas, Martina (1960–), b. Cuba, American
Misrach, Richard (1949–), American
Monasterio, Pablo Ortiz (1952–), Mexican
*Moutoussamy-Ashe, Jeanne (1951–), American
*Nagatani, Patrick (1945–), American
Neyra, Jose Luis (1930–), Mexican
Pancer, Hally (1961–), Israeli
*Piper, Adrian (active 1969 on), American
Prince, Richard (1949–), Canadian
Richter, Gerhard (1932–), German
Rosler, Martha (1943–), American
*Simpson, Coreen (1942–), American
*Simpson, Lorna (1960–), American
*Sligh, Clarissa (1939–), American
*Smith, Ming (active 1970 on), American
Spence, Jo (1934–1992), British
Starn, Mike and Doug (1961–), American

*Stewart, Frank (1949–), American
*Sunday, Elisabeth (1958–), American
Thorne-Thomson, Ruth (1943–), American
Turrell, James (1943–), American
Uribe, Jesus Sanchez (unknown), Mexican
*Vargas, Kathy (1950–), American
*Weems, Carrie Mae (1950–), American
*Williams, Pat Ward (1948–), American
Witkin, Joel Peter (1939–), American
Woodman, Francesca (1958–1981), American

*Photographers whose work is significant for the study of cultural diversity. Many, but not all, of these photographs were taken by minority photographers.

Appendix A

A Twentieth-Century Timeline of Photographic History

BY BARBARA LUCERO SAND AND RIKKE COX

EDITOR'S NOTE:

This timeline was designed to reflect our understanding of photography's history in terms of its publications, artists, exhibits, organizations and technological development. These established categories enable the reader to see both overall and specific patterns in photography. For example, by following technological changes, one discerns increasing access and ease of use in photography. Exhibit and publication information demonstrate the medium's increasing pluralism. Correlating the different categories within a time period shows some of the interrelationships formed by technological and artistic developments.

—Diana Emery Hulick

Categories:

E Exhibitions: museums and galleries
A Artists, critics, curators, and historians
T Influential technological advancements
P Publications: books, catalogs, and periodicals
O Organizations: universities, groups, galleries, and museums

1900

O/P 1896 Alfred Stieglitz assists in merging the Society of Amateur Photographers with the New York Camera Club to form the Camera Club of

New York, where he begins the journal of the club called *Camera Notes.*

E 1900 F. Holland Day of Boston organizes *The New School of American Photography* exhibition for the Royal Photographic Society in London. It includes most of the more progressive of the American pictorial photographers: F. Holland Day; Gertrude Käsebier; Clarence White; Edward Steichen; Frank Eugene; and newcomer Alvin Langdon Coburn.

O/P 1901 *The New School of American Photography* is also exhibited in Paris at the Photo-Club. *Photographic News, Amateur Photographer,* and *Photography* reported mixed criticism of the exhibition for its Impressionist style; in particular, it criticized this style's lack of definition, its replacement of texture by suggestion, its asymmetrical composition, and its extremes of lights and darks.

E 1901 Edward Steichen has the first solo exhibition of photographs in Paris.

P/A 1902 A leading German magazine, *Die Photographische,* publishes nudes by Steichen. George Bernard Shaw, art critic, and Ernst Juhl, a German art editor, review the photographs. The readers react so strongly to the reviews that Juhl was forced to resign.

O 1902 Alfred Stieglitz holds the first exhibit of the *Photo Seccession.* Participants include: A. Stieglitz, John G. Bullock, William B. Dyer, Frank Eugene, Dallet Fuguet, and Gertrude Käsebier.

E 1902 The National Arts Club exhibits American pictorial photography in their New York building.

P 1902 *Photograms of the Year* is published for the first time in England. It reproduced installation photographs showing every picture in the annual photography exhibits in London.

P 1903 Stieglitz begins publishing *Camera Work,* a quarterly review of the arts, focusing on photography.

T 1903 The single lens reflex camera is introduced by American Graflex. This camera and the British Soho Reflex, introduced in 1906, became standard for pictorial photographers.

E 1904 In England, Alvin Langdon Coburn exhibits at the London Photographic Society.

E/A 1904 Stieglitz curates the exhibition of Photo-Secessionists at the Corcoran Art Gallery in Washington D. C. and at the Carnegie Institute in Pittsburgh. The art critic Sadakichi Hartman reviews the exhibit at the Carnegie Institute in Pittsburgh and calls upon pictorialists "to work straight."

E 1904 During this period the Photo-Secessionists exhibit at art exhibitions in Dresden, Germany; Bradford, England; and at the photographic

exhibitions in The Hague, Holland; Paris, France; and Vienna, Austria.

E 1905 The Little Galleries of the Photo-Succession open at 291 Fifth Avenue in New York City.

A 1905 L. W. Hine photographs immigrants coming into the United States. The photographs are published as "human documents." The phrase "photo story" is used to describe his work.

E 1907 The first public exhibitions in the United States of color autochromes are displayed by E. Steichen, Frank Eugene and A. Stieglitz at the Little Galleries of the Photo-Seccession.

T 1907 Autochromes, called *Lumière color plates,* are introduced and marketed by the brothers Lumière.

E 1908 The London Photographic Society and the Linked Ring organizes "The London Salon of Photography." The Photo-Secession dominates this exhibition. Three of the Selecting Committee include Steichen, Coburn and Eugene, all Photo-Secessionists. More than one half of the photographs are by American photographers.

E 1909 Founded in 1892, the Linked Ring has its last exhibit.

P 1909 Willi Warstat publishes *Allgemeineaesthetik der Photographischen Kunst* (Lit. A General Aesthetic of the Photographic Art). It is the first publication to systematically examine photographic aesthetics.

1910

E 1910 The International Exhibition of Photography, organized by Stieglitz, is held at the Albright Gallery, Buffalo, New York. It is a seminal retrospective exhibit featuring European and American pictorialists. The exhibit is reviewed by art critics S. Hartman and Charles H. Caffin.

E 1910 Clarence H. White founds the Seguinland School of Photography in Seguinland, Me. In 1916 the school moves to Canaan, Connecticut.

T 1912 Color film using dye-coupling development is invented by Rudolf Fischer of Berlin.

E 1913 A. Stieglitz has a solo exhibit at "291."

E 1913 Alvin Langdon Coburn has a solo exhibit of his abstract photographs or "vortographs" at the Goupil Gallery in London.

P/T 1913 Futurist Antonio Giulio Bragaglia, an Italian photographer and filmmaker, makes time exposures of people in action and calls his work "photodynamism." He publishes the book *Fotodinamismo Futurista.*

P 1913 *Vogue* magazine publishes photographs by Baron A. de Meyer.

T 1914 The *Leica,* the first 35mm camera, is introduced just before World War I. It is designed by Oskar Barnack of the optical firm E. Leitz, in Wetzlar, Germany.

O 1914 Clarence H. White founds the Clarence H. White School of Photography in New York City which he runs until 1925. His wife, Jane White, and then his son Clarence H. White Jr. direct the school until it closes in 1942.

A 1915 Imogen Cunningham's nude photographs of her husband create a stir when exhibited in Seattle, even though they are soft-focus images and show no frontal nudity.

O 1915 Clarence H. White, Gertrude Käsebier, and Alvin Langdon Coburn form the Pictorial Photographers of America.

P/A 1916 In the last two issues of *Camera Work,* Stieglitz introduces the work of Paul Strand, an early exponent of modernism.

0 1917 The end of the Photo-Succession group, "291," and *Camera Work.*

A 1918 L.W. Hine photographs American Red Cross relief in the Middle East.

A 1918 In Switzerland, Christian Schad produces photographic abstractions made without film (photograms) and calls them *Schadographs.* Later in 1921, Man Ray and Moholy-Nagy will do the same. Man Ray dubs his photogram "Rayograms."

O 1919 The Bauhaus is founded in Weimar, Germany. Photography is a central part of its curriculum that emphasizes the relationship between art, craft, and scientific knowledge.

P 1919 The *New York Daily News* begins publication. It is the first tabloid and picture newspaper.

1920

P 1920s The tabloid emerges as a major form of journalistic publication. It makes use of a small format page with many photographs.

A 1920 Edward Weston is elected to the London Salon of Photography.

E 1920 The first Berlin Dada exhibition includes photomontage as an artistic medium.

O 1920 Members of the Bauhaus group, such as Paul Citroen, also create photomontage images.

E 1921 Stieglitz exhibits at the Anderson Galleries in New York. He acts as publisher and editor of the *Photo-Miniature* review.

P 1921 The German *AIZ: Arbeiter Illustrirte Zeitung (Workers' Illustrated Newspaper)* is one of the leading magazines in the new movement

where photographs and text are integrated into a new form of communication, later called photojournalism.

P 1922 In Paris, Man Ray publishes *Les Champs Delicieux (Delectable Fields).*

A 1923 The German Dadaists Hannah Höch and Raoul Hausmann create photomontage works and collages of magazine and other print images.

P 1923 The Russian Constructivist Alexander Rodchenko uses his photomontage images in a collaborative piece, with poems by Vladimir Mayakovski, and publishes *Pro Eta.*

P 1923 Steichen joins the staff of Condé Nast, the magazine publisher.

P 1923 *Time* magazine begins publication on March 3.

T 1924 "Solarization," which is characterized by the Sabatier effect (i.e., edge reversal), is being used by several avant-garde photographers, especially in the work of Man Ray.

T 1924 The *Ermanox* camera and the *Luna* camera by Hugo Meyer are marketed. They have the advantage of small size, coupled with a fast lens.

T 1924 The *Leica* 35mm film camera is marketed, with interchangeable lenses of varying focal lengths and apertures.

T 1925 Paul Viekotter patents a radically new method to produce flash: the flashbulb. It has an inflammable mixture inside a glass vacuum bulb. A weak electric current ignites the mixture and produces a flash of light.

P 1926 Growing interest by Surrealists leads to the recognition of the older generation of photographers, such as Jean Eugenè Auguste Atget. They reproduce some of his photographs in their magazine *La Revolution Surréaliste.*

O 1927 John H. Pledge begins the Kodak Museum collection.

P 1928 The French magazine *Vu* is founded by Lucien Vogel. It offers illustrated reporting on world events.

P 1928 The German Albert Renger-Patzch publishes *Die Welt ist Schoen (The World is Beautiful).*

A 1928 In Berlin, Erich Salomon begins to photograph famous people for the illustrated press. When an English editor saw these pictures he called them "candid photographs," and the term becomes popular with the public.

E 1929 A mammoth international exhibition, *The New Photograph,* is organized by the Deutsche Werkbund. In Stuttgart, both German and American photographers are shown. Two books were published

about the event: *Foto-auge/oeil et and photo/photo-eye.* Four films were also shown during the exhibit.

A 1929 Felix H. Man takes an approach similar to Salomon's: he begins making photographic essays that appear in international magazines.

T 1929 In Germany, the 2¼" twin lens reflex *Rolleiflex* is introduced by Franke and Heidecke.

T 1929 J. Ostermeier perfects the flashbulb by inserting aluminum foil into the bulb.

P 1929 The German photographer August Sander publishes his documentary portraits of the German people in *Antlitz der Zeit (Face of Our Time).*

1930

P 1930 *Fortune* magazine begins publication in February.

T 1930 The flashbulb is introduced in England as the *Sashalite,* and in America as *Photo Flash Lamp.*

O 1930 During the Depression, the documentary film starts to emerge.

A 1930 The photographer Berenice Abbott joins the Art Project, a branch of the Works Progress Administration (WPA).

O 1930 In New York, the Film and Photo League is founded as a volunteer arm of the Worker's International Relief.

 1930 Leitz produces a 35mm Leica with interchangeable lenses.

P 1931 The French magazine *Vu* begins publishing issues dedicated to photography and reporting on specific world events.

 1931 Agfa Super pan, (ASA 100) a high-speed small-format (35mm) film becomes available.

O 1932 The *Group f/64* is formed by charter members Ansel Adams, Imogen Cunningham, John Paul Edwards, Sonya Noskowiak, Henry Swift, Willard Van Dyke, and Edward Weston.

E 1932 M. H. de Young Memorial Museum in San Francisco holds the inaugural exhibition of the *Group f/64.*

P 1932 The German John Heartfield's photomontage, *The Spirit of Geneva,* is on the cover of *AIZ, Arbeiter Illustrirte Zeitung (Workers' Illustrated Newspaper).*

T 1932 The 35mm *Zeiss Ikon* camera with its built-in rangefinder, coupled with a focusing mechanism, enters the market.

P 1932 L.W. Hine publishes *Men at Work.*

E 1933 The French photographer Henri Cartier-Bresson has his first exhibition of 35mm camera work at the Julien Levy Gallery in New York.

O 1933 The Bauhaus, now in Berlin, is forced to close by the Nazis.

O 1933 German photojournalism collapses under Hitler.

P 1934 Stefan Lorant, a German editor, goes to London and founds *Lilliput,* and edits the *Weekly Illustrated.*

O 1935 The Photographic Society of America adopts a constitution "promoting the arts and sciences of photography and for furthering public education therein."

P 1935 Ansel Adams receives international recognition when the *London Studio* publishes his *Making a Photograph,* an instructional book with tipped-in reproductions.

A 1935 The Resettlement Administration is created by Rexford Guy Tugwell. He appoints Roy Stryker to form the Historical Section. Arthur Rothstein is the first photographer to be hired by the Resettlement Administration, followed soon by Dorothea Lange and Walker Evans.

P 1936 Bill Brandt photographs the English at home and publishes a book of the same name.

P 1936 Henry Luce forms *Life* magazine. The first November 23, 1936, issue has a cover photograph and photo-essay by Margaret Bourke-White about the Fort Peck Dam in Montana.

E 1936 Stieglitz exhibits Ansel Adams's photographs at his gallery, an American Place.

T 1937 *Kodachrome* 35mm color film is invented by Leopold Mannes and Leopold Godowsky, in collaboration with the Eastman Kodak Company.

P 1937 Gardner Cowles and his brother John Cowles form the magazine *Look.*

 1937 The Resettlement Administration is renamed the Farm Security Administration (F. S. A.).

T 1937 Margaret Bourke-White is one of the first photographers to use multiple synchroflash for *Life* magazine.

A 1937 Barbara Morgan photographs dance, using artificial lighting and synchroflash.

O 1937 Moholy-Nagy founds the New Bauhaus in Chicago, Illinois.

A 1937 Edward Weston is the first photographer awarded the John Simon Guggenheim Memorial Foundation Fellowship.

E 1937 Beaumont Newhall assembles The Museum of Modern Art's first survey of photographic history. The catalog, *Photography, 1839–1937,* which is published later as a book, becomes a major text in the history of photography.

T 1938 Xenon-filled discharge tubes, later known as strobes, are invented by Harold E. Edgerton at the Massachusetts Institute of Technology.

E 1938 Walker Evans's *American Photographs* are exhibited and published by the MOMA.

P 1938 Archibald MacLeish uses FSA photographs to illustrate his poem in the book *Land of the Free.*

P 1938 Stefan Lorant founds the magazine *Picture Post.*

P 1939 Berenice Abbott publishes *Changing New York,* and the instruction manual *A Guide to Better Photography.*

P 1939 Dorothea Lange and sociologist Paul S. Taylor publish *An American Exodus.*

1940

E/A 1940 Elizabeth McCausland, critic and curator, organizes a Lewis Hine retrospective for the Riverside Museum in New York.

O 1941 The Museum of Modern Art forms a photography department.

P 1941 Writer James Agee and photographer Walker Evans publish *Let Us Now Praise Famous Men.*

T 1942 *Ansco-Color* film and *Ektachrome* film now enable photographers to develop color slides themselves.

O 1943 Roy Stryker becomes head of the Standard Oil Project, which documents America until 1950.

A 1943 Elizabeth McCausland, an art critic who frequently writes about photography, is awarded a Guggenheim fellowship.

T 1945 The development of the electron tube and electronic scanning methods make TV systems possible.

E 1946 The Museum of Modern Art exhibits photographs by Aaron Siskind.

T 1947 *Ektacolor* is introduced, enabling photographers to develop their own color negatives.

O 1947 Robert Capa, Andre Friedman, "Chim" (David Seymour), Henri Cartier-Bresson and George Rodger found Magnum Photos, a cooperative for the distribution of journalistic photographs, located in New York City.

T 1947 Edwin H. Land invents the *Polaroid-Land* camera and process. It produces a finished print or negative in a matter of minutes. The camera uses a photoelectric meter that not only measures light, but automatically sets shutter times or lens aperture.

T 1947 Holography, a three-dimensional photographic image produced by laser scanning, is described as a theoretical possibility by the Hungarian-born physicist Dennis Gabor. He receives a Nobel prize for this invention.

T 1948 The Swedish single-lens, reflex 2¼ camera *Hasselblad* is introduced to the market.

P 1948 Ansel Adams begins his five-book basic photography series. The books, with titles such as *The Negative* and *The Print,* are systematic investigations of an aspect of photography and link the technical and the aesthetic.

O 1949 The George Eastman House of Photography is founded in Rochester, New York (Beaumont Newhall becomes curator, and Oscar Solbert is the first director).

O 1949 Clarence H. White Jr. joins the faculty at Ohio University in Athens, Ohio beginning one of the earliest university photography programs.

1950

T 1950 Xerox 1250 Standard Camera, a manually operated photocopier, is introduced.

P/A 1950 *Time in New England,* a collaborative book of photographs by Paul Strand, with text by Nancy Newhall, is published.

O 1951 The Film and Photo League, a documentary photography organization in New York City, folds under pressure from the attorney general after being listed as a "subversive" organization during the McCarthy Era.

P/E/A 1951 *Five French Photographers,* an exhibit at George Eastman House, shows the internationalism of their collection. Included are artists Brassai, Izis, Robert Doisneau, Willy Ronis, and Henri Cartier-Bresson.

P 1952 *Image,* a periodical published by George Eastman House, begins publication.

P/A 1952 *The Decisive Moment,* a book and exhibition of photographs by Henri Cartier-Bresson, is shown at the Louvre. This is the first photographic exhibition shown at this museum.

P 1952 Minor White establishes *Aperture,* a quarterly journal dedicated to fine art photography.

A 1953 Georgia O'Keefe and Ben Shahn are among the artists placed under surveillance by the F. B. I.

T 1953 *Life* magazine starts to use color photography on a regular basis.

E 1954 Limelight, the first gallery and coffeehouse devoted exclusively to the sale and exhibit of photographs, is founded in New York City by Helen Gee. It lasts seven years.

P 1954 *Foto,* a periodical devoted to photography, begins publication in Budapest, Hungary.

P/E/A 1955 *The Family of Man* is curated by Edward Steichen at the Museum of Modern Art in New York City.

P 1955 *Art in America,* an art journal, publishes its first article on photography, "The Development of Action Photography," by Beaumont Newhall.

P/A 1955 After years of successful documentary work W. Eugene Smith quits *Life* magazine due to issues of editorial control.

O 1955 Roy De Carava opens A Photographer's Gallery, devoting part of his apartment to exhibit space. During the next two years, he exhibits such photographers as Ruth Bernhard, Sid Grossman, Van Deren Coke, and Harry Callahan.

A 1955 Robert Frank is given a Guggenheim grant and makes a photographic tour of the United States.

P/A 1956 *Life is Good and Good for You in New York: William Klein Trance Witness Revels* is self-published in France by William Klein.

P 1957 *Les Americans,* a book of photographs by Robert Frank, made while on his Guggenheim grant, is published and well-received in France.

A 1958 Beaumont Newhall becomes director of George Eastman House.

P/A 1959 *The Americans,* a book of photographs by Robert Frank, with an introduction by Jack Kerouac, is published for the first time in the United States. It is criticized for its unfavorable view of Americans.

P/A 1959 *Photographs/Aaron Siskind* is published.

T 1959 First automated photocopier, the Xerox 914, is introduced.

O 1959 Image Gallery in New York's Greenwich Village becomes the world's first and only gallery devoted exclusively to the exhibit and sale of photographs.

1960

T 1960 The laser is invented making three-dimensional photographic images (holograms) possible. Emmet, Keith and Juris Upatricks make the first holograms.

P/A 1961 *The Daybooks of Edward Weston,* edited by Nancy Newhall, is a per-
 –66 sonal account by Edward Weston of his travels in Mexico and California and his thoughts on photography.

T 1962 Polacolor film, which makes a color print in sixty seconds, is introduced.

P 1962 *Artforum,* an art journal, begins publication and includes photography reviews.

O/A 1962 The Society for Photographic Education is formed by Nathan Lyons and others to promote art photography at the university level.

O/A 1962 John Szarkowski is appointed curator of photography at The Museum of Modern Art, New York City.

O 1963 Beaumont Newhall heads the department of art at the University of New Mexico and develops its photography program.

O 1963 The Kamoinge Workshop is founded and directed by Roy De Carava. Lasting until 1966, it is a workshop designed to develop an awareness of what it means to be black and photograph.

T 1963 Kodak unveils the Instamatic camera.

T 1963 Kodak introduces the Rapid Color Print Processor Model 11, which allows amateurs to produce color prints at home.

T 1963 Import controls are lifted and the Japanese outstrip Germany for the first time in camera production and camera equipment, thus becoming the world's top camera producers.

T 1964 The Olympus Pen F becomes the world's first half frame SLR.

O 1964 The Edward Steichen Photography Center, the first museum gallery to be designed solely for photography, is opened at The Museum of Modern Art, New York City.

P/E/A 1964 *The Photographer's Eye,* a book and exhibit at The Museum of Modern Art in New York, is curated and written by J. Szarkowski, who discusses how to view and understand photographs.

P/E/A 1965 *Aaron Siskind, Photographer,* an exhibition and book edited by Nathan Lyons, discusses Siskind's relationship to the Abstract Expressionist movement in American art.

P/A 1966 *Every Building On Sunset Strip,* a book of photographs by conceptual artist Ed Ruscha, is published.

E/A 1966 *Marie Cosindas's* exhibit at The Museum of Modern Art, New York, is one of the first exhibits to show color, instant-process images.

P/E/A 1966 *Toward a New Social Landscape,* an exhibition and book edited by Nathan Lyons, defines landscape as the human environment. Included are artists Bruce Davidson, Lee Friedlander, Garry Winogrand, Danny Lyon, and Duane Michels.

P/A 1966 *Photographers on Photography: A Critical Anthology* is collected and edited by Nathan Lyons. It is a collection of statements by twenty-three major photographers on the development of photographic expression.

O 1966 Cornell Capa and others form the International Fund for Concerned Photography, Inc., which later becomes the International Center for Photography.

P/A/E 1967 Cornell Capa organizes publications and exhibitions titled *The Concerned Photographer.* He focuses on the documentary photograph and includes artists such as Dan Weiner, Leonard Freed, Robert

Capa, David Seymour, Werner Bischof, André Kertész and Bruce Davidson, Larry Clark, Mary Ellen Mark, Ralph Gibson, and Danny Lyon.

O 1967 Ansel Adams, Beaumont Newhall, and others establish the Friends of Photography as an exhibit center in Carmel, California.

P/E/A 1967 *New Documents,* an exhibit and catalog (at The Museum of Modern Art, New York) by J. Szarkowski, addresses the relationship between the photographer and the subject in the formation of meaning. Artists included are Diane Arbus, Lee Friedlander, and Garry Winogrand.

P 1967 *Creative Camera,* a photography periodical, begins publication in London, England.

P/E/A 1967 *The Persistence of Vision,* an exhibition by Nathan Lyons at the George Eastman House, addresses manipulated images. Included are artists Robert Heinecken, Ray Metzker, Jerry Uelsmann, John Wood, and Donald Blumberg.

P/T 1968 Ansel Adams publishes *Camera and Lens; the Creative Approach,* completing his five-book basic photography series.

A 1968 A. D. Coleman begins writing photographic criticism for the *Village Voice.*

P/O 1968 *Exposure,* a newsletter for the Society of Photographic Education, becomes an educational journal.

E 1968 *Harlem on My Mind,* a multimedia exhibit, opens at the Metropolitan Museum of Art, N. Y. C. The exhibit includes the work of many photographers, including James Van Der Zee, whose work is rediscovered at this time.

O 1968 The National Endowment for the Arts awards its first photography grant to Bruce Davidson for his *East 100th St.* project.

 1969 Richard Rudishill becomes the first full-time photographic historian to teach at the University of New Mexico.

E 1969 *Israel/Reality,* an exhibit at the Jewish Museum in New York, curated by Cornell Capa, uses a new approach to a thematic exhibition and divides the exhibit into self-contained photo-essays by individual photographers.

P/A/O 1969 *Mirrors, Messages, Manifestations,* photographs by Minor White, addresses White's ideas on sequencing to create meaning.

O/A 1969 Nathan Lyons leaves Eastman House to found the Visual Studies Workshop in Rochester, New York. The workshop offers university-level classes and later an M. F. A. program.

O 1969 Witkin Gallery in New York City begins to sell a wide variety of contemporary and historical photographs.

P 1969 The National Association for Photographic Art in Scarborough, Canada, begins publication of *Camera Canada.*

1970

P 1970 *E. J. Bellocq: Storeyville Portraits*; photographs from the New Orleans Red Light District, circa 1912, is published. These negatives are reprinted by Lee Friedlander and are a rediscovery of a previously unknown photographer.

O 1970 Kodak moves from Grand Central Station in New York City to the new Kodak Gallery and Information Center in midtown Manhattan.

P 1970 The British photographic magazine *Album,* edited by Bill Jay, is published for a year.

A 1970 A. D. Coleman begins writing photographic criticism for the *New York Times.*

P/A 1970 *Photographs,* a book of works by Berenice Abbott, is an early monograph on a female photographer.

P/E/A 1970 *Photography into Sculpture,* an exhibition curated by Peter C. Bunnell at The Museum of Modern Art, shows work that pushes photography into three dimensions. Included are artists Ellen Brooks, Robert Heinecken, Bea Nettles, and Richard Prince.

P/E/A 1970 *Jerry N. Uelsmann,* an exhibition at the Philadelphia Museum of Art, shows his composite photographs.

O 1971 The Foundation for Photography is formed in Zürich, Switzerland.

P/A 1971 *Mirror Image: the Influence of the Daguerreotype on American Society* (by Richard Rudisill) is published.

O 1971 In New York City, Light Gallery is started on Fifth Avenue and exists at this address until 1987.

P/A 1971 *Tulsa,* a book of snapshot-style photographs about the drug culture in Oklahoma, is published by Larry Clark. It is one of the first books in which a participant in a small subculture also documents it.

O 1971 The National Endowment for the Arts establishes a special category for photographer's fellowships.

P/A 1972 *The Photographs of Margaret Bourke-White* becomes one of the first books to examine a major photojournalist.

P/E/A 1972 *Diane Arbus,* an exhibition at The Museum of Modern Art, draws enormous crowds. The accompanying book becomes one of the best-selling photography books of all time.

T 1972 The Polaroid SX-70 is introduced.

O 1972 Princeton University endows the first chair for history of photography in a department offering a Ph.D. in art history. Peter C. Bunnell holds the first chair.

P/E/A 1972 In *Lucas Samaras,* an exhibition curated by Robert Doty at the Whitney Museum of American Art, Samaras explores the color Polaroid SX-70 process.

P 1972 *Life* magazine ceases publication. Its function as a news picture magazine is usurped by the immediacy of television.

T 1972 The first drive-through express color film processing is marketed.

P/A 1972 Nathan Lyons establishes *Afterimage,* a periodical devoted to photography and film that later incorporates videography.

T 1972 Resin-coated, black-and-white printing papers are introduced.
 –73

T 1972 Xerox 6500, the first color photocopy machine, is available.
 –75

P 1972 *Black Photographers Annual* begins and is published intermittently until 1980 by Joe Crawford in Brooklyn, New York.

O 1973 California Museum of Photography in Riverside, California, is established.

P 1973 *Illuminations,* a book of essays by Walter Benjamin, is published. It includes the notable essay "Art in the Age of Mechanical Reproduction" of 1936.

P/A 1973 *On Photography,* a book of essays by Susan Sontag, examines the way we create, admire, and consume images. She cites Walter Benjamin as being influential.

P/A 1973 *The Woman's Eye,* edited by Anne Tucker, is one of the first major books to focus on women photographers. Included are Gertrude Käsebier, Margaret Bourke-White, Dorthea Lange, Berenice Abbott, Barbara Morgan, Diane Arbus, Alisa Wells, Judy Dater, and Bea Nettles.

P/E 1974 *New Japanese Photography* is exhibited at The Museum of Modern Art.

P/A 1974 *Visual Communication and the Graphic Arts* by Estelle Jussim examines photography's relationship to graphic arts.

O 1974 The International Center of Photography is established in New York City.

O 1974 John Lampkin establishes *San Francisco Camerawork,* a photographic gallery.

T 1974 The Minolta XK, the first all-electric 35mm camera, is introduced.

O 1974 *En Foco* is founded in Bronx, New York. It begins as a cooperative, supporting Puerto Rican photographers, but soon expands into an organization promoting photographers of color.

O 1974 The Los Angeles Center for Photographic Studies is established.

 1975 The first Ph.D. emphasizing the history of photography is awarded to Keith McElroy at the University of New Mexico.

O 1975 Center for Creative Photography at the University of Arizona, Tucson, is established by Dr. John P. Schaefer, president of the university, and Ansel Adams. Harold Jones is its first director.

 1975 The "Altarr "ushers in the era of the home computer. It is sold both as a kit and fully assembled.

O/T 1975 Light Impressions, a company that supplies archival photographic materials, is founded.

P/E/A 1975 *New Topographics,* an exhibition organized by William Jenkins at the George Eastman House, focused on the idea of the "man-altered landscape." Included are Stephen Shore, Robert Adams, Joe Deal, Frank Gohlke, Nichols Nixon, John Schott, B. & H. Becher, and Henry Wessel Jr.

P/E/A 1975 *Era of Exploration: The Rise of Landscape Photography in the American West,* an exhibition by Weston Naef and James Wood at the Metropolitian Museum of Art, is the first overview of nineteenth-century Western landscape photography.

P/E/A 1975 *Women of Photography: An Historical Survey* exhibits fifty women photographers at the San Francisco Museum of Art. It is curated by Anne Noggle and Margery Mann.

P/A 1976 *Photographs of the Southwest: Selected Photographs Made from 1928–1968 in Arizona, California, Colorado, New Mexico, Texas, and Utah* is published by Ansel Adams.

P/E/A 1976 *William Eggleston's Guide,* an exhibition by J. Szarkowski at The Museum of Modern Art, is considered the first major solo retrospective of color photography.

P/E/A 1976 *Photography and Language,* an exhibition and organized book by Lew Thomas, includes over thirty artists who incorporate text into images.

P 1977 *History of Photography,* a quarterly journal, begins publication.

O 1977 The Museum of Contemporary Photography, Chicago, Illinois, is established.

P/E/A 1977 *Public Relations,* by Garry Winogrand, is published. It is based on exhibitions at The Museum of Modern Art. The term "street photographer" is applied to Winogrand in the introduction by Todd Papageorge.

P/E/A 1977 *Pictures,* an exhibition and catalog by Douglas Crimp at New York Artists Space, includes Sherrie Levine, Robert Longo, Troy Braun-tuch, Jack Goldstein, and Phillip Smith. The exhibit introduces pictorial postmodernism.

T 1977 The Hunt Brother's silver scandal increases the price of silver and
 –79 makes silver recovery profitable. The price of photographic paper
 and film rises drastically.

E 1978 *Photography of the Male Nude,* an exhibition at the Marcuse Pfeiffer
 Gallery in New York City, is the first major exhibition on this theme.

E 1978 *Private Parts,* an exhibition at the Rhode Island School of Design, is
 raided and dismantled by police.

P/A 1978 *Homage to Cavafy,* a book of photographs by Duane Michels, incor-
 porates the use of text and images. It is one of the first books by a
 contemporary photographer to use a homosexual theme.

 1978 The First Latin American Photography Conference is held in Mexico
 City, along with a juried exhibition, "Hecho in Latinoamérica."

O 1978 The Council of Latino Photographers/USA is formed in Los Ange-
 les. The organization's goal is to promote Latino photography.

P/E/A 1979 *Fabricated to be Photographed,* an exhibit at the San Francisco Mu-
 seum of Modern Art, curated by Van Deren Coke, includes Ellen
 Brooks, James Casebere, Stephen Collins, Robert Cumming, Phillip
 Galgian, Leslie Krims, John Pfahl, Donald Rodan, Victor Schrager,
 and Carl Toth. These photographers construct the image before pho-
 tographing it.

E 1979 *Composite Imagery 1850–1935: The Early History of Photomontage*
 is held at the International Museum of Photography, the George East-
 man House.

E 1979 *Japanese Photography Today and its Origins* is exhibited at the In-
 stitute of Contemporary Arts, London, England.

P 1979 *Photographiconservation* is a periodical issued by the Rochester In-
 stitute of Technology as a forum of photographic preservation and
 restoration. It is published until 1985.

O 1979 AIPAD, the Association of International Photography Art Dealers, is
 founded.

1980

T 1980s One-hour color photo labs come into being.

P/A 1980 *Camera Lucida: Reflections on Photography,* a book by Roland
 Barthes, an important philosopher of language, addresses photogra-
 phy in relation to the human condition.

P/A 1980 *Heinecken,* by Robert Heinecken, is published by the Friends of Pho-
 tography. Heinecken's work comments on the way information and
 advertising is presented in our culture.

E 1980 The Friends of Photography in Carmel, California, exhibits works made by using the Diana Camera. The catalog essay is by David Featherstone.

P/E 1980 *Mirrors and Windows: American Photography since 1960* is exhibited at The Museum of Modern Art, New York City. In it, John Szarkowski traces factors affecting modern American photography.

P 1980 The periodical *European Photography* begins publication in Göttingen, Germany.

E 1980 *Photography in Printmaking,* at the Victoria & Albert Museum, London, explores the adoption of photographic imagery and techniques by printmakers.

E 1981 IBM introduces the personal computer.

T 1981 The Sony MVC-7000 camera is developed, recording still images on electromagnetic tape.

T 1981 Agfa and Ilford introduce black-and-white chromogenic films in which the final image is composed of dyes rather than silver.

P 1981 The periodical *Photovision* begins publication in Madrid, Spain.

P/A 1981 *Beauty in Photography: Essays in Defense of Traditional Values* is written by Robert Adams, photographer and critic.

P/A/O 1981 *Photographs/Roy DeCarava,* a monograph on an important African-American photographer, is published by the Friends of Photography, Carmel, California.

P/E 1981 The Los Angeles County Museum of Art mounts an exhibition called *The New Color Photography.* The catalog by Sally Eauclaire addresses issues relevant to color photography.

O 1981 The short-lived *Photography Museum* sponsors the *Los Angeles Documentary Project,* a photographic survey of the city in celebration of its bicentennial. With financial assistance from the N. E. A., the city employs eight photographers who prepare a portfolio of 120 prints.

P 1982 *Photofile,* a publication of the Australian Centre for Photography, begins.

P/E/A 1982 *Recent Color,* at the San Francisco Museum of Modern Art, includes Cindy Sherman.

P/O 1982 *Les Cahiers de la Photographie* begins publication in Paris, France. It is the journal of L'Association De Critique Contemporaine En Photographie.

P/E/A 1982 *David Hockney Photographs* is published with the exhibit at the Musée Nationale d'Art Moderne, Centre Georges Pompidou, Paris. Hockney is a painter who creates photo-assemblages.

P/A 1983 *Simulations,* written by Jean Baudrillard, includes an influential essay on "Hyper Reality."

P/E/A 1983 *We Won't Play Nature to Your Culture* is an exhibition and catalog featuring Barbara Kruger's work at the Institute of Contemporary Arts, London.

P/E/A 1983 *Image Scavengers: Photography,* an exhibit at the Institute of Contemporary Arts, University of Pennsylvania, addresses issues of appropriated imagery. Included are Ellen Brooks, Eileen Cowin, Jimmy De Sana, Barbara Kruger, Sherrie Levine, Richard Prince, Don Rodan, Cindy Sherman, and Laurie Simmons.

P/E/A 1983 *A Century of Black Photographers: 1840–1960* is a traveling exhibit originating at the Museum of Art, Rhode Island School of Design.

O 1983 Los Angeles County Museum of Art creates a Department of Photography with Cathleen Gauss as curator.

P 1984 *Camera International* begins publication in Paris, France.

O 1984 The J. Paul Getty Museum acquires several photography collections, namely those of Sam Wagstaff, Arnold Crane, and Daniel Wolf, to create a Department of Photography, with Weston J. Naef as curator.

 1984 The Macintosh home computer is introduced.

T 1984 Adobe Photoshop software is available for home computer imaging.

P 1984 *Nueva Luz,* the first periodical devoted to the photographers of color, begins publication by En Foco, Bronx, New York.

P/E/A 1984 *Second View: The Rephotographic Survey Project* includes work by Mark Klett, Rick Dingus, JoAnn Verburg, Gordon Bushaw, and Ellen Manchester. These photographers rephotograph sites by nineteenth-century Western landscape photogaphers.

P/A 1985 *In the American West,* a series of portraits by Richard Avedon, is both praised and criticized for its depiction of Americans living in the West.

P 1985 *AFT: Rivista di Storia e Fotographia,* a publication of the Archivo Fotographica Toscano, begins publication in Prato, Italy.

P/A/ 1985 *Photographs of Mother Teresa's Missions of Charity in Calcutta/*
O *Mary Ellen Mark* is published by the Friends of Photography, Carmel, California.

T 1985 Canon introduces a laser color copier, which produces a more detailed image than all previous color copiers.

P/A 1986 The *Ballad of Sexual Dependency,* a book of photographs by Nan Goldin, describes relationships between the sexes.

T 1986 Kodak introduces a new line of black-and-white professional products called TMAX, which becomes the most widely used film and processing chemistry.

P/E/A 1986 *Jenny Holzer, Cindy Sherman: Personae,* an exhibit at the Contemporary Arts Center, Cincinnati, Ohio, is curated by Sarah Rogers-Lafferty. It focuses on the self as subject.

P/E/A 1987 *Cindy Sherman,* an exhibit and catalog with essays by Peter Schjeldahl and Lisa Phillips, is exhibited at the Whitney Museum of American Art.

P/A/O 1987 *Samaras: The Photographs of Lucas Samaras,* with an essay by Ben Lifson, is published by Aperture.

P/E 1987 The Ohio State University holds the first national conference on computer-generated photographic imagery.

P/E/A 1988 *Digital Photography: Captured Images, Volatile Memory, New Montage* is one of the first exhibits focusing on digital photography. It is curated by Marnie Gillett and Jim Pomeroy at San Francisco Camerawork.

P/T 1988 *Beyond Photography: The Digital Darkroom,* a technical book by Gerard Holzmann, is published.

P/A 1988 *The All Consuming Image,* a book by Stuart Ewen, addresses the power of photography in relation to consumerism.

P/A 1988 *The Positive Image: Women Photographers in Turn of the Century America* is authored by C. Jan Gover.

P/E/A 1988 *The Perfect Moment,* a traveling exhibit organized by the Philadelphia Institute of Contemporary Art, is a controversial exhibit by Robert Mapplethorpe that features homoerotic art.

P/E/A 1989 *Photography Until Now,* an exhibit and book by John Szarkowski at The Museum of Modern Art, shows photography organized according to patterns of technological change, including distribution, economics, and professional structures.

O 1989 Friends of Photography, in Carmel, California, reestablishes itself in San Francisco as the Center for Friends of Photography.

P/A 1989 *The Democratic Forest,* a book of color photographs by William Eggleston, is published, with an introduction by Eudora Welty.

1990

P/A 1990 *Campaneras de Mexico: Women Photograph Women* is an exhibit and catalog with an essay by Amy Conger. The exhibit is held at the University of California, Riverside Art Gallery.

P/E/A 1990 *Harlem Photographs, 1932–1940 /Aaron Siskind,* at the National Museum of American Art, shows images of African-Americans living in Harlem.

T 1990 Digital cameras hit the market.

E 1990 *Language of the Lens: Contemporary Native American Photographs* is a traveling exhibit organized by the Heard Museum in Phoenix, Arizona. It features ten Native American photographers and is the first major photography exhibit of Native American work. The exhibit tours until 1995.

P 1991 *Photo Electronic Imaging,* a periodical integrating photography, electronic imaging, and graphics, is published by Professional Photographers of America, Inc.

P/E/A 1991 *Second Generation Original: Digital Photography in the 1990s,* at the University of Minnesota, is a digital photography exhibit and symposium.

P/E/A 1991 *People with AIDS,* an exhibit and catalog of photographs by Nicholas Nixon, is published. It is the first book by a major photographer to concentrate on this subject.

P/A 1991 *Photography at the Dock: Essays on Photographic History, Institutions, and Practices,* a book of collected writings, is published by Abigail Solomon-Godeau.

E 1991 The City of Arles, France, hosts Rencontres Internationales De La Photographie [International Encounters in Photography].

P/A 1991 *Photographs—Annie Leibovitz, 1970–1990* becomes a best-selling book of photographs by a popular commercial portrait photographer.

P/A 1992 *The Reconfigured Eye: Visual Truth in the Post-Photographic Era* is published by William J. Mitchell.

T 1992 Kodak introduces the photo compact disc (CD).

P/T 1992 *Digital Photography,* a technical book by Mikkel Aaland, with Rudolph Burger, is published.

P/E/A 1992 *Immediate Family,* photographs by Sally Mann, is a touring exhibit with a catalog by Aperture.

P/A 1992 *Lorna Simpson,* published by the San Francisco Friends of Photography, with a text by Deborah Willis, shows how one African-American photographer deals with issues of race and gender.

P/A 1993 *Viewfinder: Black Women Photographers* is authored by Jeanne Moutoussamy-Ashe.

P/A 1994 *A History of Women Photographers* is written by Naomi Rosenblum, author of *A World History of Photography.*

P/E/A 1994 *Evidence, 1944–1994/Richard Avedon* is a fifty-year retrospective exhibit with a catalog. This exhibit is held at the Whitney Museum of American Art.

O 1994 Harvard University endows a curatorship in photography at the Fogg Museum.

E 1994 *The Computer in the Studio,* an exhibit at the DeCordova Museum in Boston, Massachusetts, examines the relationship between computers and artistic practice.

P 1994 *Digital Imaging Technology for Preservation* is the published proceedings from a symposium held at Cornell University. The topics addressed include digital preservation and access and electronic document imaging.

T 1994 Apple introduces its own point-and-shoot digital camera, the Quicktake 100, codeveloped with Kodak.

E 1995 *Hidden Witness: African Americans in Early Photography* is an exhibit at the J. Paul Getty Museum, Malibu, California.

E 1995 *How Far Have We Come?: Past and Present Images of African-Americans* is an exhibit at the California Museum of Photography, University of California, Riverside.

E 1995 *Don't Leave Me This Way: Art in the Age of AIDS* is a group exhibit at the National Gallery in Australia.

T 1995 Kodak introduces its Digital Print Station, which allows consumers to produce their own enlargements and reprints through a touchscreen interface.

T 1995 The DC40 Kodak's point-and-shoot digital camera is developed. Kodak hopes to create affordable digital imaging for the mass amateur market.

O 1995 James Enyeart, former director George Eastman House, is hired as the new director of the Center for Photographic Arts at the College of Santa Fe, New Mexico.

Bibliography

BY RIKKE COX

<hr>

GENERAL REFERENCE SOURCES

Encyclopedias, Bibliographies, and Library Catalogs

AUER, MICHEL, AND MICHÈLE AUER. *Photographers Encyclopedia International, 1839 to the Present.* 2 vols. Hermance: Editions Camera Obscura, 1985.

BONI, ALBERT. *Photographic Literature.* 2 vols. New York: Morgan and Morgan, 1962, 1972.

BROWNE, TURNER, AND ELAINE PARTNOW, eds. *MacMillan Biographical Encyclopedia of Photographic Artists and Innovators.* New York: MacMillan Publishing Co., 1983.

BUNNELL, PETER, AND ROBERT A. SOBIESZEK, eds. *The Literature of Photography.* New York: Arno Press, 1973.

BUNNELL, PETER, AND ROBERT A. SOBIESZEK, eds. *Sources of Modern Photography.* 51 vols. New York: Arno Press, 1979.

A Catalog of the Epstean Collection on the History and Science of Photography and Its Applications, Especially to the Graphic Arts. New York: Columbia University Press, 1938. Reprint. Pawlet: Helios, 1972.

Catalog of the Library of the Museum of Modern Art, New York. 14 vols. Boston: G. K. Hall & Co., 1993.

GROVER, JAN ZITA. "Books and Audio/Visual Sources by and about Women Photographers: a Bibliography," *Exposure* 19, no. 3 (1981): 45–53.

HEIDTMANN, FRANK. *Bibliography of German-Language Photographic Publications 1839–1984; Technology-Theory-Visual.* 2 vols. Second revised and enlarged edition. München: K. G. Saur, 1989.

The International Center of Photography, Encyclopedia of Photography. New York: Crown Publishers, Inc., 1984.

KRANZ, LES. *American Photographers, An Illustrated Who's Who Among Leading Contemporary Americans.* New York: Facts-On-File, 1989.

LAMBRECHTS, ERIC, AND LUC SALU. *Photography and Literature: An International Bibliography of Monographs.* New York: Mansell Publishing, Ltd., 1992.

Library Catalog of the International Museum of Photography at George Eastman House. 4 vols. Boston: G. K. Hall & Co., 1982.

Library Catalogue. London: Royal Photographic Society of Great Britian, 1939; supplements issued in 1952 and 1953.

MORGAN, WILLARD D., ed. *The Encyclopedia of Photography: the Complete Photographer; the Comprehensive Guide and Reference of All Photographers.* 20 vols. New York: Greystone Press, 1963–4.

NAYLOR, COLIN, ed. *Contemporary Photographers.* Second edition. London: St. James Press, 1988.

NEWHALL, BEAUMONT. "Photography," in Arts in America: A Bibliography, vol. 3, section N1-N940. Washington: Smithsonian Institution Press, 1979.

PALMQUIST, PETER E., ed. *A Bibliography of Writings by and about Women in Photography, 1850–1950.* Arcata: P. E. Palmquist, 1990.

PALMQUIST, PETER E., ed. *Photographers: A Source Book for Historical Research.* Brownsville: Carl Mautz Pub., 1991.

Photographica: A Subject Catalog of Books on Photography Drawn from the Holdings of the New York Public Library, Astor, Lenox, and Tilden Foundations. New York: G. K. Hall, 1984.

ROOSENS, LAURENT, AND LUC SALU. *History of Photography: A Bibliography of Books.* 2 vols. New York: Mansell Publishing, Ltd., 1989.

STROEBEL, LESLIE, AND RICHARD ZAKIA, eds. *The Focal Encyclopedia of Photography.* Third edition. Boston: Focal Press, 1993.

WILLIS-THOMAS, DEBORAH. *Black Photographers, 1840–1940: An Illustrated Bio-Bibliography.* New York: Garland Publishing, Inc., 1985.

WILLIS-THOMAS, DEBORAH. *An Illustrated Bio-Bibliography of Black Photographers, 1940–1988.* New York: Garland Publishing, Inc., 1989.

WITKIN, LEE D., AND BARBARA LONDON. *The Photograph Collector's Guide.* Boston: New York Graphic Society, 1979.

GENERAL HISTORY OF PHOTOGRAPHY

BEATON, CECIL, AND GAIL BUCKLAND. *The Magic Image: The Genius of Photography from 1839 to the Present Day.* Boston: Little Brown & Company, 1975.

BRAÏVE, MICHEL F. *The Photograph: A Social History.* New York: McGraw-Hill Book Co., 1966.

COKE, VAN DEREN. *The Painter and the Photograph, from Delacroix to Warhol.* Revised edition. Albuquerque: University of New Mexico Press, 1972.

DAVENPORT, ALMA. *The History of Photography: An Overview.* Boston: Focal Press, 1991.

DAVIS, KEITH F. *An American Century of Photography, from Dry-Plate to Digital: The Hallmark Photographic Collection.* New York: Harry N. Abrams, Inc., 1995.

DOTY, ROBERT M., ed. *Photography in America.* New York: Random House, 1974.

DOWER, JOHN. *A Century of Japanese Photography.* New York: Pantheon Press, 1980.

EAUCLAIRE, SALLY. *The New Color Photography.* New York: Abbeville Press, 1981.

EAUCLAIRE, SALLY. *New Color/New Work: Eighteen Photographic Essays.* New York: Abbeville Press, 1984.

EDER, JOSEF MARIA. *History of Photography.* New York: Dover Publications, Inc., 1978.

ENYEART, JAMES, ed. *Decade by Decade: Twentieth-Century American Photography from the Collection of the Center for Creative Photography.* Boston: Bulfinch Press, 1989.

FREUND, GISÈLE. *Photography and Society.* Boston: David R. Godine, Publisher, 1980.

FRIEDMAN, JOSEPH S. *The History of Color Photography.* New York: Focal Press, 1968.

GASSAN, ARNOLD. *A Chronology of Photography; a Critical Survey of the History of Photography as a Medium of Art.* Athens: Handbook Co., 1972.

GERNSHEIM, HELMUT AND ALISON. *The History of Photography: From the Camera Obscura to the Beginning of the Modern Era.* Second edition. New York: McGraw-Hill Book Co., 1969.

GLENDINNING, PETER. *Color Photography: History, Theory and Darkroom Technique.* Englewood Cliffs: Prentice-Hall, 1985.

GREEN, JONATHAN, ed. *The Snapshot.* New York: Aperture Foundation, 1974.

GREENOUGH, SARAH, JOEL SNYDER, DAVID TRAVIS, AND COLIN WESTERBECK. *On the Art of Fixing a Shadow: One Hundred and Fifty Years of Photography.* Washington: National Gallery of Art, 1989.

JEFFREY, IAN. *Photography: A Concise History.* New York: Oxford University Press, 1981.

KAHMEN, VOLKER. *Art History of Photography.* New York: Viking Press, 1974.

LEMAGNY, JEAN-CLAUDE, AND ANDRÉ ROUILLÉ, eds. *A History of Photography: Social and Cultural Perspectives.* English edition trans. by Janet Lloyd. New York: Cambridge University Press, 1987.

LEWINSKI, JORGE. *The Naked and the Nude: A History of the Nude in Photographs, 1839 to the Present.* New York: Harmony Books, 1987.

MANN, MARGERY, AND ANNE NOGGLE, eds. *Women of Photography: An Historical Survey.* San Francisco: San Francisco Museum of Art, 1975.

MONTOUSSAMY-ASHE, JEANNE. *Viewfinders: Black Women Photographers.* New York: Dodd, Mead, 1986.

NEWHALL, BEAUMONT. *The History of Photography: From 1839 to the Present.* Revised and enlarged edition. New York: Museum of Modern Art, 1982.

NORTH, IAN, ed. *International Photography, 1920–1980*. Canberra: Australian National Gallery, 1982.

POLLACK, PETER. *The Picture History of Photography: From the Earliest Beginnings to the Present Day*. Revised and enlarged edition. New York: Abrams, 1969.

ROSENBLUM, NAOMI. *A World History of Photography*. New York: Abbeville Press, 1984.

ROSENBLUM, NAOMI. *A History of Women Photographers*. New York: Abbeville Press, 1994.

SULLIVAN, CONSTANCE, ed. *Women Photographers*. New York: Abrams, 1990.

SZARKOWSKI, JOHN. *Photography Until Now*. New York: Museum of Modern Art, 1989.

TAUSK, PETR. *Photography in the 20th Century*. London: Focal Press, 1980.

TUCKER, ANN, ed. *The Women's Eye*. New York: Alfred A. Knopf, 1973.

WEAVER, MIKE, AND DANIEL WOLF, eds. *The Art of Photography, 1839–1989*. New Haven: Yale University Press, 1989.

WILLIAMS, VAL. *The Other Observers: Women Photographers in Britain, 1900 to the Present*. London: Virago, 1991.

GENERAL HISTORY BY PERIOD

1900–1920

ADES, DAWN. *Photomontage*. London: Thames and Hudson, 1986.

COAR, VALENCIA HOLLINS. *A Century of Black Photographers: 1840–1960*. Providence: Rhode Island School of Design, 1983.

COE, BRIAN. *Colour Photography: The First Hundred Years, 1840–1940*. London: Ash & Grant, 1978.

FLUKINGER, ROY. *The Formative Decades, Photography in Great Britain 1839–1920*. Austin: University of Texas Press, 1985.

GERNSHEIM, HELMUT. *Creative Photography: Aesthetic Trends, 1839–1960*. New York: Dover Publications, 1991.

GOVER, C. JANE. *The Positive Image: Women Photographers in Turn-of-the-Century America*. Albany: State University of New York Press, 1988.

HARKER, MARGARET. *The Linked Ring: The Secession Movement in Photography in Britain, 1892–1910*. London: Heineman, 1979.

HOMER, WILLIAMS INNES. *Alfred Stieglitz and the Photo-Secession*. Boston: Little, Brown, 1983.

NAEF, WESTON. *The Collection of Alfred Stieglitz: 50 Pioneers of Modern Photography*. New York: Metropolitan Museum of Art, 1978.

PALMQUIST, PETER E., ed. *Camera Fiends and Kodak Girls: 50 Selections by and about Women in Photography, 1840–1930*. New York: Midmarch Arts, 1989.

PULTZ, JOHN, AND CATHERINE B. SCALLEN. *Cubism and American Photography, 1920–1930.* Williamstown: Sterling and Francine Clark Art Institute, 1981

TAYLOR, JOHN, ed. *Pictorial Photography in Britain 1900–1920.* London: Arts Council of Great Britain, 1978.

THORNTON, GENE. *Masters of the Camera: Stieglitz, Steichen, and Their Successors.* New York: Holt, Rinehart and Winston, 1976.

TRACHTENBERG, ALAN. *Reading American Photographs: Images as History: Matthew Brady to Walker Evans.* New York: Hill & Wang, 1989.

TRAVIS, DAVID. *Photography Rediscovered: American Photographs, 1900–1930.* New York: Whitney Museum of American Art, 1979.

1920-1940

COKE, VAN DEREN, UTE ESKILDSEN, AND BERND LOHSE, eds. *Avant-Garde Photography in Germany, 1919–1930.* San Francisco: San Francisco Museum of Modern Art, 1960.

DANIEL, PETE, MERRY A. FORESTA, MAREN STRANGE, AND SALLY STEIN. *Official Images: New Deal Photography.* Washington: Smithsonian Institution Press, 1987.

DIXON, PENELOPE. *Photographers of the Farm Security Administration: an Annotated Bibliography, 1930–1980.* New York: Garland, 1983.

FIEDLER, JEANNINE, ed. *Photography at the Bauhaus.* Cambridge: MIT Press, 1990.

FISHER, ANDREA. *Let Us Now Praise Famous Women: Women Photographers for the U.S. Government, 1935–1944: Esther Bubly, Marjory Collins, Pauline Ehrlich, Dorothea Lange, Martha McMillan Roberts, Marion Post Wolcott, Ann Rosener, Louise Rosskam.* New York: Pandora Press, 1987.

FLEISCHHAUER, CARL, AND BEVERLY BRANNAN, eds. *Documenting America, 1935–1943.* Berkeley: University of California Press, 1988.

GIDAL, TIM N. *Modern Photojournalism: Origins and Evolution 1910–1933.* New York: MacMillan Publishing Co., 1973.

HAMBOURG, MARIA MORRIS, AND CHRISTOPHER PHILLIPS. *The New Vision: Photography Between the World Wars.* New York: Metropolitan Museum of Art, 1989.

HOMER, WILLIAM INNES. *Alfred Stieglitz and the American Avant-Garde.* Boston: New York Graphic Society, 1977.

HURLEY, F. JACK. *Portrait of A Decade: Roy Stryker and the Development of Documentary Photography in the Thirties.* Baton Rouge: Louisiana State University Press, 1972.

KRAUSS, ROSALIND, AND JANE LIVINGSTON, eds. *L'Amour fou: Photography and Surrealism.* Washington: Cocoran Gallery of Art, 1985.

LISTA, GIOVANNI. *Photographie Futuriste, Italienne—1911–1939.* Paris: Musée d'Art Moderne de la Ville de Paris, 1982.

MELLOR, DAVID, ed. *Germany: The New Photography, 1927–33.* London: Arts Council of Great Britain, 1978.

PHILLIPS, CHRISTOPHER, ed. *Photography in the Modern Era: European Documents and Critical Writings, 1913–1940.* New York: Metropolitan Museum of Art, 1989.

1940-1960

GEE, HELEN. *Photography of the Fifties: An American Perspective.* Tucson: Center for Creative Photography, 1980.

GREEN, JONATHAN. *American Photography: A Critical History, 1945 to the Present.* New York: Harry N. Abrams, Inc., 1984.

GRUNDBERG, ANDY, AND KATHLEEN GAUSS. *Photography and Art: Interactions Since 1946.* New York: Abbeville Press, Inc., 1987.

LIVINGSTON, JANE. *The New York School: Photographs, 1936–1963.* New York: Stewart, Tabori & Chang, 1992.

TURNER, PETER. ed. *American Images: Photography 1945–1980.* New York: Viking Press 1985.

1960-1980

GAUSS, KATHLEEN MCCARTHY. *New American Photography.* Los Angeles: Los Angeles County Museum of Art, 1985.

HOY, ANNE H. *Fabrications: Staged, Altered, and Appropriated Photographs.* New York: Abbeville Press, 1987.

NICCOLINI, DIANORA, ed. *Women of Vision: Photographic Statements by Twenty Women Photographers.* New Jersey: The Unicorn Publishing House, 1982.

SZARKOWSKI, JOHN. *Mirrors and Windows: American Photography Since 1960.* New York: The Museum of Modern Art, 1978.

1980-2000

WARREN, KATHERINE, ed. *Companeras de Mexico: Women Photograph Women.* Riverside, California: University of California, 1990.

AESTHETICS, CRITICISM, AND INTERVIEWS

ADAMS, ROBERT. *Beauty in Photography: Essays in Defense of Traditional Values.* New York: Aperture Foundation, 1981.

BARTHES, ROLAND. *Camera Lucida, Reflections on Photography.* New York: Hill & Wang, 1981.

BARTHES, ROLAND. *Mythologies.* London: J. Cape, 1972.

BARTHES, ROLAND. *Image-Music-Text.* New York: Hill & Wang, 1971.

BENJAMIN, WALTER. *ILLUMINATIONS*. Hannah Arendt, ed. New York: Schocken Books, 1969.

BOLTON, RICHARD, ed. *The Contest of Meaning: Critical Histories of Photography*. Cambridge: MIT Press, 1989.

BUNNELL, PETER, ed. *A Photographic Vision: Pictorial Photography, 1889–1923*. Salt Lake City: Peregrine Smith, 1980.

BUNNELL, PETER, ed. *Degrees of Guidance: Essays on Twentieth-Century American Photography*. New York: Cambridge University Press, 1993.

BURGIN, VICTOR, ed. *Thinking Photography*. London: MacMillan Education Ltd., 1982.

CAFFIN, CHARLES H. *Photography as Fine Art*. Facsimile edition. New York: Morgan and Morgan, Inc., 1971.

COLEMAN, A. D. *Light Readings: A Photography Critic's Writings, 1968–1978*. New York: Oxford University Press, 1979.

COLEMAN, A. D. *Critical Focus: Photography in the International Image Community*. Munich: Nazraeli Press, 1995.

DANZIGER, JAMES, AND BARNABY CONRAD. *Interviews with Master Photographers*. New York: Paddington Press, 1977.

DIAMONSTEIN, BARBARALEE. *Visions and Images: American Photographers on Photography*. New York: Rizzoli, 1981.

GOLDBERG, VICKI, ed. *Photography in Print: Writings from 1816 to the Present*. Albuquerque: University of New Mexico Press, 1981.

GOLDBERG, VICKI, ed. *The Power of Photography: How Photographs Changed Our Lives*. New York: Abbeville Press, 1991.

GREEN, JONATHAN, ed. *Camera Work: A Critical Anthology*. New York: Aperture Foundation, 1973.

GRUNDBERG, ANDY. *Crisis of the Real; Writings on Photography, 1974–1989*. New York: Aperture Foundation, 1990.

HILL, PAUL, AND THOMAS COPPER, eds. *Dialogue with Photography*. New York: Farrar, Straus, Giroux, 1979.

JOHNSON, BROOKS, ed. *Photography Speaks: 66 Photographers on Their Art*. New York: Aperture Foundation, 1989.

JUSSIM, ESTELLE. *The Eternal Moment: Essays on the Photographic Image*. New York: Aperture Foundation, 1989.

KOZLOFF, MAX. *Photography & Fascination: Essays*. Danbury: Addison House, 1979.

KOZLOFF, MAX. *The Privileged Eye: Essays on Photography*. Albuquerque: University of New Mexico Press, 1987.

LYONS, NATHAN, ed. *Photographers on Photography: A Critical Anthology*. Englewood Cliffs: Prentice-Hall, 1956.

MITCHELL, MARGARETTA K. *Recollections: Ten Women of Photography*. New York: Viking Press, 1979.

NEWHALL, BEAUMONT, ed. *Photography: Essays and Images.* New York: Museum of Modern Art, 1980.

PETRUCK, PENINAH, ed. *The Camera Viewed: Writings on Twentieth Century Photography.* 2 vols. New York: E. P. Dutton, 1979.

SEKULA, ALLAN. *Photography Against the Grain: Essays and Photo Works 1973–1983.* Halifax: Nova Scotia College of Art and Design, 1983.

SOLOMON-GODEAU, ABIGAIL. *Photography at the Dock: Essays on Photographic History, Institutions, and Practices.* Minneapolis: University of Minnesota, 1991.

SONTAG, SUSAN. *On Photography.* New York: Farrar, Straus, and Giroux, 1973.

SQUIERS, CAROL, ed. *The Critical Image: Essays on Contemporary Photography.* Seattle: Bay Press, 1990.

SZARKOWSKI, JOHN. *The Photographer's Eye.* New York: Museum of Modern Art, 1966.

SZARKOWSKI, JOHN. *Looking at Photographs.* New York: Museum of Modern Art, 1973.

TRACHTENBERG, ALAN, ed. *Classic Essays on Photography.* New Haven: Leete's Island Books, 1980.

YOUNGER, DANIEL P., ed. *Multiple Views: Logan Grant Essays on Photography, 1983–89.* Albuquerque: University of New Mexico Press, 1991.

WALLIS, BRIAN, ed. *Art After Modernism: Rethinking Representation.* New York: New Museum of Art, 1984.

MAJOR PERIODICAL SOURCES

AFT: Rivista di Storia e Fotografia. Prato, Italy: Archivo Fotografico Toscano. 1985–.

Afterimage. Rochester, NY: Visual Studies Workshop. 1972–.

Aperture. New York, NY: Aperture Foundation. 1952–.

Archive. Tucson, AZ: Center for Creative Photography. 1976–.

The Black Photographers Annual. Brooklyn, NY: Black Photographers Annual, Inc. 1973–.

Les Cahiers de la Photographie. Paris, France: L'Association de Critique Contemporaine en Photographie. 1982–.

Camera Austria. Graz, Austria: Camera Austria. 1980–.

Camera Canada. Scarborough, Canada: National Association for Photographic Art. 1969–.

Camera International. Paris, France: Camera International. 1984–.

Camera Work, A Photographic Quarterly. Edited and published by Alfred Stieglitz, 1903–1917. Reprint. New York: Kraus Reprints, 1969.

Camerawork Quarterly. San Francisco, CA: San Francisco Camerawork. 1984–.

Center Quarterly. Woodstock, NY: Center for Photography at Woodstock. 1979–.

Creative Camera. London, England: CC Publishing. 1968–.

European Photography. Göttingen, Germany: Andres Müller-Pohle. 1980–.

Exposure. New York, NY: Society for Photographic Education. 1963–.

Foto. Budapest, Hungary: Foto. 1954–.

Fotogeschichte. Marburg, Germany: Jonas Verlag für Kunst und Literatur. 1981–.

Frame-work. Los Angeles, CA: Los Angeles Center for Photographic Studies. 1986–.

History of Photography. London, England: Taylor and Francis. 1976–.

Image. Rochester, NY: International Museum of Photography at the George Eastman House. 1952–.

Katalog. Odense, Denmark: Museet for Fotokunst. 1988–.

Nueva Luz. Bronx, NY: En Foco. 1984–.

October. Cambridge, MA: MIT Press. 1976–.

Perspektief. Rotterdam, The Netherlands: Perspektief Centrum voor Fotografie. 1980–.

Photo Review. Langhorne, PA: The Photo Review. 1976–.

Photofile. Paddington, NSW: Australian Centre for Photography. 1982–.

Photograph Collector. New York, NY: Consultant Press. 1980–.

Photographie Ouverte. Brussels, Belgium: Musée de la Photographie. 1979–.

Photovision. Madrid, Spain: Photo Vision. 1981–.

Spot. Houston, TX: Houston Center for Photography. 1983–.

Ten.8 Photo Paperback. Birmingham, England: Ten.8 Ltd. 1979–.

Untitled. San Francisco, CA: Friends of Photography. 1972–.

Index*

*****Page numbers** in italic indicate illustrations.

T

U